Biedermeier
1815–1835

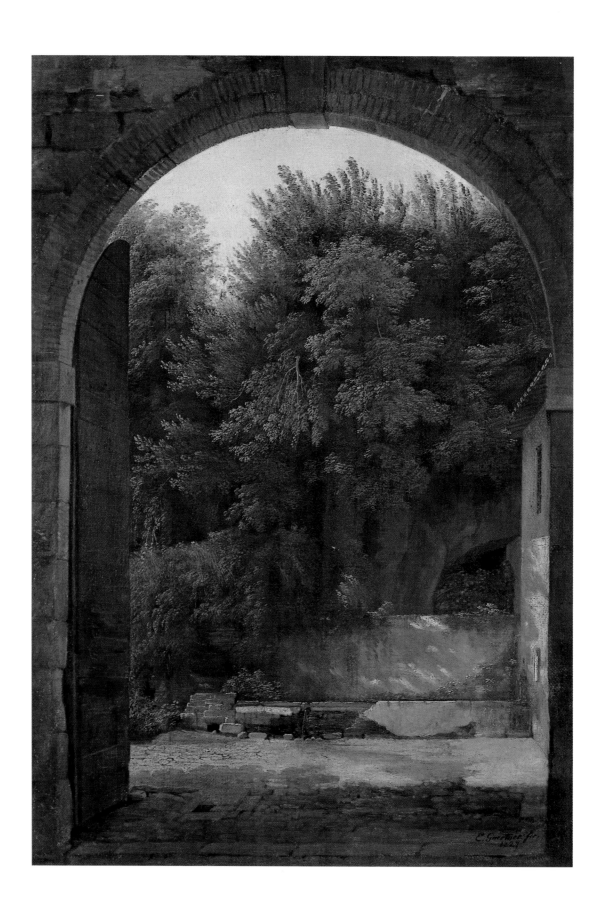

GEORG HIMMELHEBER

Biedermeier

1815-1835

Architecture · Painting

Sculpture · Decorative Arts

Fashion

Prestel

This book is an abridged and revised version of
Kunst des Biedermeier 1815–1835:
Architektur, Malerei, Plastik,
Kunsthandwerk, Musik, Dichtung und Mode,
first published in 1988 in conjunction with the exhibition of that name
organized by the Bayerisches Nationalmuseum, Munich, and
held at the Haus der Kunst,
Munich, from December 1988 to February 1989.

Translated from the German by John William Gabriel

Front Cover:
Wilhelm von Schadow, *Portrait of Felix Schadow,* c. 1830
(see no. 59, p. 198, and plate, p. 93)

Spine:
Detail of a cup. Berlin, 1819
(see no. 144, p. 222, and plate, p. 117)

Frontispiece:
Eduard Gaertner, *View into a Courtyard,* 1827
(see no. 26, p. 190)

Endpapers:
Paul Mestrozi, Textile sample, 1820
(see no. 247, p. 250, and plate, p. 154)

© 1989 Prestel-Verlag
Mandlstrasse 26
D-8000 Munich 40
Federal Republic of Germany

Distributed in continental Europe and Japan by
Prestel-Verlag, Verlegerdienst München GmbH & Co KG,
Gutenbergstrasse 1, D-8031 Gilching, Federal Republic of Germany

Distributed in the USA and Canada by te Neues Publishing Company,
15 East 76th Street, New York, NY 10021, USA

Distributed in the United Kingdom, Ireland,
and all other countries by Thames & Hudson Limited,
30–34 Bloomsbury Street, London WC1B 3QP, England

Composition: Max Vornehm, Munich
Offset lithography: Brend'amour, Simhart GmbH & Co., Munich
Printing and binding: Passavia Druckerei GmbH, Passau

Printed in the Federal Republic of Germany

ISBN 3-7913-1023-2

Contents

Foreword

The Biedermeier period is very much in vogue at the moment. After collectors and connoisseurs had rediscovered its simple furniture and elaborately decorated glassware, cultural historians organized major exhibitions that set a number of false notions about the era to rights. However, no one has investigated the question of Biedermeier style. To most writers on the subject, such non-artistic labels as "cozy" and "idyllic," "self-satisfied" and "an untroubled world" have seemed adequate to define the concept and to characterize the period. Yet they are far from adequate, and the aim of this book is to advance the first consistent definition of the Biedermeier style by examining its formal means in all media, from architecture and sculpture to painting and the decorative arts.

The present volume was first published in German, as the catalogue to an exhibition titled *Kunst des Biedermeier 1815–1835*, which was organized by the Bayerisches National-museum, Munich, and held at the Haus der Kunst in Munich from December 1988 to February 1989. A number of corrections have been incorporated in the slightly different English edition, which includes a larger number of color illustrations.

In my research on the subject I was aided over a period of many years by my wife, Dr. Irmtraud Himmelheber, who also wrote the commentaries in the section on jewelry. Dr. Hertha Wellensiek was kind enough to prepare the entries on porcelain cups, and the late Dr. Brigitte Thanner, a tireless helper in all matters, those on glassware and iron. Further commentaries were written by Dr. Winfried Baer, Dr. Saskia Durian-Ress, Dr. Otto Krätz, doctoral candidate Melanie Maier, and Dr. Lilla Tompos. Suggestions and support were also provided by Dr. Helmut Börsch-Supan, Berlin; Richard R. Brettell, Dallas, Texas; Dipl.-Arch. Hermann von Fischer, Bern; Dr. Klaus Maurice, Berlin; Dr. Kasper Monrad, Copenhagen; Dr. Waltraud Neuwirth, Vienna; Dr. Robert Scherb, Munich; Dr. Gert Schiff, New York; and Dr. I. M. W. Baron Voorst tot Voorst, Warmond, Holland. To all of the above I wish to express my sincere gratitude.

Georg Himmelheber

Introduction

Reviled and ridiculed during the second half of the nineteenth century, the Biedermeier style and its special qualities were rediscovered by the interior designers and craftsmen of the early twentieth century. Art historians followed suit. Between 1902 and 1906 important books by Joseph Folnesics, August Schestag, and Joseph August Lux provided a first definition of the Biedermeier style in furniture. In 1908 Adolf Rosenberg, in the second edition of his *Handbuch der Kunstgeschichte*, outlined the "unique style of the Biedermeier period," finding it in painting as well as in the decorative arts. The climax of this early research into the period – and one that remains unsurpassed – was *Biedermeier: Deutschland von 1815–1847*, a superbly illustrated tome of 615 pages by the cultural historian Max von Boehn which was first published in 1910 by Bruno Cassirer. It was an enormous achievement on the part of both author and publisher.

A second wave of Biedermeier research came in the 1920s and early 1930s, again paralleled by a reawakened interest in the style among artists. It had been preceded in 1918 by an excellent and stimulating collection of source material, *Das Biedermeier im Spiegel seiner Zeit* by Georg Hermann [Borchardt], which was republished in an attractive edition in 1965. From the 1920s on, the stylistic term "Biedermeier" was applied increasingly to painting as well: Paul Ferdinand Schmidt's *Biedermeier-Malerei* appeared in 1923, Käte Gläser's *Das Bildnis im Berliner Biedermeier* in 1932. The latter contained an extraordinarily perceptive and comprehensive introduction that has lost none of its validity or readability.

Research was also devoted to the architecture of the period, if not exclusively to that of the Biedermeier, a term which architectural historians avoided. Fundamental observations in this field were made by Siegfried Giedion, in

Spätbarocker und romantischer Klassizismus (Munich, 1922), and by Wolfgang Herrmann, in *Deutsche Baukunst des 19. und 20. Jahrhunderts* (Basel, 1932), the second volume of which was not published until 1977. In 1933 this stream in German art history was brutally interrupted, with grave consequences. Still, two important books did appear during the war years, Ann Tizia Leitich's *Wiener Biedermeier* and Paul Weiglin's *Berliner Biedermeier*.

It was not until the 1960s that German-speaking art historians again turned their attention to the nineteenth century, if almost exclusively to its second half. An exception was *Biedermeier in Österreich* by Rupert Feuchtmüller und Wilhelm Mrazek, a good survey published as part of a series on Austrian art in 1963. It was followed eleven years later by my own *Biedermeier Furniture*, which for the first time aroused interest in the period in the English-speaking world. My purpose in that volume (which has since appeared in two German editions, 1978 and 1987) was to attempt a definition of the specific characteristics of the period's furniture design.

In the 1920s and early 1930s, the existence of a Biedermeier literature became the subject of fierce controversy among German literary historians, led by Paul Kluckhahn together with Wilhelm Bietak, Adolf von Grolmann, Hermann Pongs, and Benno von Wiese. The topic was revived with the publication, between 1971 and 1980, of an important three-volume work by Friedrich Sengle: *Biedermeierzeit: Deutsche Literatur im Spannungsfeld zwischen Restauration und Revolution.*

The third wave of Biedermeier research is still underway at the time of writing. The year 1987 witnessed two large-scale exhibitions devoted to the cultural history of the period, as well as the publication of three lavish volumes, two of which, significantly, were in English.

That by Angus Wilkie is especially notable for its illustrations of a number of fine, previously unknown pieces of furniture; Geraldine Norman's book gives a useful overview of *Biedermeier Painting*; and Gerbert Frodl's *Wiener Malerei der Biedermeierzeit* provides a wealth of new insights into Viennese painting of the period.

Nevertheless, a critical analysis of Biedermeier art in all areas of the fine and decorative arts, and in every country of Central Europe where it flourished, had yet to be attempted. Such an analysis reveals that the two political events that, for historians, mark the beginning and end of the Biedermeier period – Napoleon's defeat and the 1848–49 revolutions – had little relevance to developments in art. Viewed as a consistent style, Biedermeier came to a close between 1830 and 1835. (These dates, too, are paralleled by non-artistic events: the revolts that followed the July Revolution of 1830 and the beginning of the industrial age when the first German railroad went into operation in 1835.)

In Central Europe this period was anything but idyllic, and the art of the time accordingly reflects no idyll. On the contrary, developments in the arts were wrought with tension and the results were in many respects revolutionary. One finds beauty, of course, but it is neither of the ostentatious or status-enhancing sort nor of the innocuous and sentimental variety so often associated with Biedermeier art. Its beauty lies in an entirely new approach to the everyday and the simple, in a love of truth and objectivity. As early as 1834, Adalbert Stifter characterized Biedermeier art as "noble, solid, simple, brilliant." It is a democratic art: neither heroic nor grand, it nonetheless reveals the grandeur inherent in plain, everyday things. It is an art suffused with truth and dignity, or, as Theodor Fontane put it, an art of "rigorous simplicity."

Time, Place, and Name

The Biedermeier period in art began as the Napoleonic Wars drew to an end, around 1814–15. It was a time of pervasive ferment and innovation, for profound changes came in the wake of the French occupation of continental Europe. Patriotism had become a force to reckon with, and everywhere people had begun to question the forms of government under which they had lived. During the war, an order was created in Germany – that of the Iron Cross – that for the first time was awarded not on the basis of rank and name, but on that of merit alone. After the war, memorials were erected for the first time to all those who had fought and not merely to individual generals. The German princes granted their subjects' demand for constitutional government; freedom of trade and freedom of the press were introduced.

People hungered for education. Lending libraries and reading circles came into being; public museums were established, some by monarchs, as in Munich and Berlin, others by private collectors, as in Cologne and Frankfurt. University lectures were held in German, not Latin, and the students formed gymnastic associations and *Burschenschaften*, fraternities dedicated to national unity and loyalty to the liberal, constitutional state.

Soon, however, the rulers of the German principalities, whose power had burgeoned during the Age of Absolutism, began to grow chary of this wave of innovation. After a brief triumph of liberal ideas, a reaction of unparalleled force set in. The bureaucracy became omnipotent, and every attempt at change was answered with police brutality and incarceration. The tradesmen's educational associations, hardly established, were prohibited, and the fledgling press subjected to censorship. Hypocrisy and bigotry spread apace. The police took action against all the liberal movements; professors were deprived of their posts; searches, confiscations, and arrests became daily occurrences. There was a numbing fear of spies and informers. By 1830/35 the spirit of rebellion and renewal had been stifled completely; a "leaden sleep of death"[1] descended on Germany; the Biedermeier period was at an end.

The emergence of the Biedermeier style, then, coincided with a profound political and social upheaval; indeed, it was part of this upheaval. The long-awaited end of the Napoleonic era was also the end of the Napoleonic style, the Empire style, whose cool grandeur was too pompous for a period of poverty and need, and too aristocratic for an age suffused with liberal ideas. When the last German princes abandoned Napoleon after the

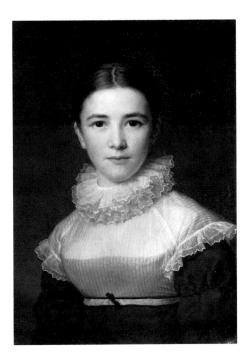

Fig. 1 Friedrich Karl Gröger,
Portrait of Foster Daughter Lina, 1815 (detail).
Kunsthalle, Hamburg

Battle of Leipzig, the Empire style fell out of favor with the German courts. Now the country to be emulated was England, in every field, for it was from there that technical and industrial innovations were coming, along with new directions in the arts and crafts and in fashion. There emerged a new variety of the Neoclassical styles that had begun in the last third of the eighteenth century with Louis Seize. Biedermeier was a Neoclassical style – not a last, weak variant, but a consciously created new phase, impelled by a confident middle class.

In architecture, forms grew more lucid, more clearly articulated, simpler. In painting, new subject matter supplanted scenes from classical mythology (see fig. 2)[2] and "heroically" composed Mediterranean landscapes with antique accessories in the style of Claude Lorrain or Nicolas Poussin. Artists began to depict what lay close at hand, the towns they lived in, the familiar countryside, their own homes. The Empire style had come to seem too austerely pompous, too pretentious, for a country ravaged and impoverished by war; this, and conscious humility, were reasons enough to seek beauty in simplicity. Status-consciousness gave way to dignity and honesty, pomp to respectability. Craftsmen and middle-class entre-

preneurs developed a style that was freely and voluntarily adopted by princes and courts, for times had changed – it had become noble to be bourgeois.

The Biedermeier style came to an end between 1830 and 1835, the years in which the Historical Revival in all its varieties ousted Neoclassicism from its dominant position. In the second half of the eighteenth century, a reawakened interest in classical antiquity had already been accompanied by a new taste for Gothic and other styles of the past.[3] In Britain, this turning away from the absolutist styles of Baroque and Rococo had begun around the mid-eighteenth century, when the first Neoclassical building, a garden temple in pure Greek form, was erected in Hagley, and the first Neo-Gothic castle was built at Strawberry Hill. Soon, Neo-Gothic buildings were going up in Germany as well.

Ever since this changeover in the second half of the eighteenth century – and this was unprecedented – no single, unified style had been able to establish itself. Architects turned to the past for models, and they found several that could be adapted to serve the diverse needs of the present. Emergent pluralistic society developed a corresponding style, a liberal style.

Neo-Gothic played a role in the Biedermeier period as well. The finest architects of the time mastered both classical and Gothic idioms, sometimes even blending their forms, a feature also found in the decorative arts.[4] In painting, the doctrines of Neoclassicism were rejected by a group of young artists, the Nazarenes, who devoted themselves to reviving German religious art. After leaving the Vienna Academy in 1809, they went to Rome, lived in community like medieval monks, and studied fifteenth-century Italian painting. Artists also increasingly sought prototypes in the Renaissance, the Baroque, and even non-European styles. Finally, between 1830 and 1835, the dominance of Neoclassicism was broken and any style from almost any period and nation became a valid point of departure (see figs. 3[5], 4[6]).

In reviewing the great story of the past, artists discovered humble, everyday stories as well, and the heyday of genre painting – anecdotes in historical costume – was soon reached (see fig. 5).[7] Suddenly, it seemed that the Beautiful and the True, the pithy, touching, or humorous human story, had existed only in the past, no matter how recent. It was only now, after 1835, that artists began recalling the Napoleonic Wars, but here too with a penchant for genre, as they created pictures full of dramatic action that took place under a sky that seemed perpetually stormy.

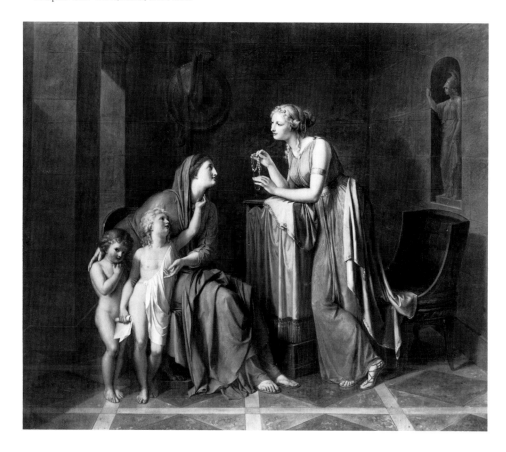

Fig. 2 Philipp Friedrich Hetsch,
Cornelia, Mother of the Gracchi, 1794.
Staatsgalerie, Stuttgart

In the final analysis, however, it was the nascent industrial age and its machines that revolutionized a society still organized along almost medieval lines. The railroads in particular changed the world fundamentally.[8] The Biedermeier epoch, which had still belonged largely to the preindustrial world, became hopelessly outmoded, almost over night, and a target of ridicule on the part of a self-satisfied and saturated posterity. Artists such as Carl Spitzweg and Johann Peter Hasenclever invented a distorted image of the Biedermeier period, a world inhabited by eccentric cranks, awkward young lovers, absentminded professors, and poor poets. Ludwig Richter, on the other hand, became the painter of nostalgia for the long-since vanished, ostensibly Good Old Days when the world was supposedly a preindustrial paradise. This is why Spitzweg and Richter were precisely *not* representatives of the Biedermeier, though they are continually categorized as such. The former was a critic who heaped ridicule of a rather cheap kind on the recent past; the latter saw it through rose-tinted spectacles. Both artists contributed materially to the erroneous image of the Biedermeier that still prevails today.

In keeping with the multipartite political map of Central Europe, a great number of cultural and artistic centers existed during the Biedermeier period. In this respect nothing had changed since the eighteenth century; new centers of art could hardly arise in a political vacuum.[9] Perhaps most open to innovation and most blessed with creative energy was northern Europe, with centers in Copenhagen – around whose Academy there developed a painting of extreme mastery – Hamburg, and Berlin. The Prussian capital, expanding rapidly and by means of careful planning (an aspect that proved exemplary), harbored three of the greatest artists of the epoch: Karl Friedrich Schinkel, Christian Rauch, and Karl Blechen. Scholars of the caliber of Friedrich Hegel, Leopold von Ranke, and Friedrich Schleiermacher taught at Berlin University; developments in the arts and sciences were inspired and furthered by Wilhelm and Alexander Humboldt.

As regards the decorative arts, Vienna was a key center during the Biedermeier period. The Empire style had never been consistently applied there; after 1800 the delightful forms of

Fig. 3 Upholstered chair. Designed
by Friedrich Bürklein, 1851.
Bayerisches Nationalmuseum,
Munich

Fig. 4 Table. Stuttgart, c. 1850.
Württembergisches Landesmuseum, Stuttgart

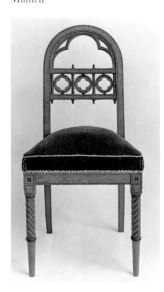

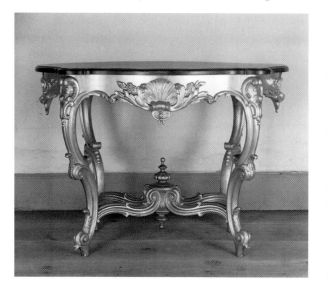

Theresian Louis Seize were modified in that direction without ever becoming wholeheartedly French in character. A further modification then led without a break into the Biedermeier. In Vienna, transitions between the styles were fluid.

Vienna was a great middle-class city, from whose court very few new artistic impulses emerged. The bourgoisie there enjoyed a high standard of living. During the Congress of Vienna, all eyes turned to the capital of the Habsburg Empire. Enormous amounts of furniture had to be made in order to ensure that the visiting dignitaries and their retinues were properly accommodated. These people were in turn receptive to the products of the arts and crafts that they saw there.

Art was developing along similar lines everywhere in that broad band of Central Europe extending from the Austro-Swiss Alps in the south to Scandinavia in the north. Where the western border ran was clear. Although France and Britain had also entered a bourgeois phase, their art acquired forms quite different from those in Central Europe. François Gérard, Dominique Ingres, Théodore Géricault, and Eugène Delacroix took other paths; only Camille Corot, during his stay in Rome, exerted a certain influence on the German artists living there. The influence of England, especially in the applied arts, was incomparably greater.

To the east, thanks to the huge Habsburg Empire, the borders were much less clearly defined. Hungarian and Czech artists looked to Vienna for inspiration; Vienna exported its wares to Hungary and to Bohemia and Moravia. Russia was traditionally receptive to influences from the West.

The German craftsmen who were forced to leave their homeland in such enormous numbers during those years, whether because of material need or political persecution, took not only their skills and knowledge, but also the forms of the Biedermeier style with them across the Atlantic. Hence Biedermeier arts and crafts – especially furniture, but ceramics too – are found throughout North America, wherever German immigrants gathered and settled.[10]

In sum, the Biedermeier style can be characterized as a middle-class, Neoclassical style that prevailed in the arts of the German-speaking countries – Austria, Switzerland, and Germany – and in Scandinavia from 1815 to 1830/35.

The term "Biedermeier" is an encumbrance. As a stylistic category it entered art-historical literature at the end of the nineteenth century. In a study of 1891, Wilhelm Heinrich Riehl noted that "Biedermeier" was used to denote the style of the 1820s and 1830s; Georg Bötticher employed it in 1894, and Fritz Minkus the following year.[11] Gottlieb Biedermaier was the name of a comic-paper figure invented around mid-century to satirize the recent past – that allegedly so boring and hidebound period following the Napoleonic Wars. He was the fic-

titious author of unintentionally comic poems, and even his name contained an element of ridicule: the German word "Bieder" means simple, innocuous, "square" but honest and upstanding, while "Maier" (in its various spellings) is among the most common German family names.[12] Looking back from the late nineteenth century, and especially from its pompous final years, no one could find anything to praise in the austere, lucid, and unpretentious art of 1815 to 1835. A style invented for the lack of anything better (*Verlegenheits-Stil*), Georg Hirth called it in 1886,[13] and Fritz Minkus thought it "a ridiculous style of infinite dryness and unredeemed tastelessness."[14]

Even today, the word "Biedermeier" carries derogatory connotations in Germany. Although historians have long since shown that the period following the Napoleonic Wars was

anything but idyllic,[15] and although Biedermeier furniture and glassware have long since become sought-after (and expensive) collector's items, the noun *Biedermeier* and its adjective *biedermeierlich* still signify in everyday parlance the epitome of petty-bourgeois innocuousness, of sentimental superficiality. Yet among those who lived and worked during the period were such figures as Hegel and Humboldt, Goethe and Grillparzer, Beethoven and Schubert, Schinkel and Rauch.

The terms "Gothic" and "Baroque," as stylistic categories, were also originally intended to denigrate. Just as we use these terms without being conscious of the criticism they imply, we ought to continue using the term "Biedermeier" – since it has taken root anyway – and not be afraid of subsuming the names of great artists under it.

Fig. 5 Theodor Hildebrandt, *The Warrior and His Child*, 1832. Kunstmuseum, Düsseldorf

Architecture

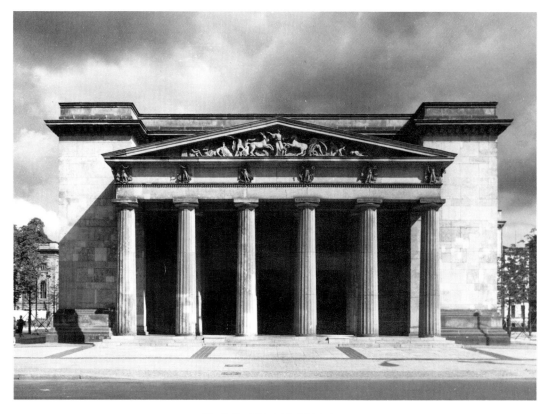

Fig. 6 Karl Friedrich Schinkel,
Neue Wache,
Berlin, 1816–18

The year 1816 was a key date in the history of late Neoclassical architecture in Germany, marking the commencement of work on Schinkel's Neue Wache in Berlin and, in Munich, on Klenze's Glyptothek. Both were architectural tasks of an unprecedented kind, and for both, their designers found a new formal language.

Architects had begun to turn away from the absolutist styles of Baroque and Rococo much earlier, in the second half of the eighteenth century. This was in Rome, where a group of young French artists succumbed to the fascination of antique ruins – and to that of the artist-cum-archaeologist, Giovanni Battista Piranesi.[16] In addition, the patrons of architecture themselves, the absolutist princes and noblemen, had grown weary of their role of personifying the state, and felt the need to retire to their *petits appartements* or to take refreshing strolls in landscape gardens carefully designed to look as natural as possible. In other words, it was not always middle-class contractors who furthered the new style, which soon reached Germany from two sources: from France, as

seen in the monastery church of St. Blasien in the Black Forest (begun in 1768), and from Britain, as exemplified by Wörlitz Palace, near Dessau (begun a year later). Also in 1769, the first independent museum building in Germany was erected, the Fridericianum in Kassel, designed by Simon Louis du Ry. The structure represented the solution to an entirely new architectural problem – the design of a building for a progressive public institution typical of the period.

This initial phase of German Neoclassicism was largely shaped by architects born in the 1730s, such as Karl Philipp Christian Gontard, Carl Gotthard Langhans, and Friedrich von Erdmannsdorf. They were followed by a generation that included Heinrich Gentz, Johann Jakob Friedrich Weinbrenner, and David Gilly, who were born between 1748 and 1772 and who again purposely sought their inspiration in Rome and Paris.

Alongside buildings derived from Greek and Roman antiquity – prime examples are Wilhelmshöhe Palace in Kassel (1786), the

Marble Palace in Potsdam (1787), and the Brandenburg Gate in Berlin (1789) – there were others erected in (initially fanciful) medieval styles. These, too, served rulers as refuges from responsibility and public display, indeed as refuges from the age they lived in: examples are the Gotisches Haus in Wörlitz (1773), the Burg in Wilhelmsbad (1781), the Löwenburg near Kassel (1793), the little castle on the Pfaueninsel on the outskirts of Berlin (1794), and the Franzensfeste in Laxenburg Park near Vienna (1798). Another early instance of German Neo-Gothic was a city gate begun as early as 1755, the Nauener Tor in Potsdam, which owed its inception to the truly revivalist notion that a city gate was an essentially medieval building type.

The early years of the nineteenth century were overshadowed by the destruction and destitution resulting from the Napoleonic Wars. For the south German states belonging to the Rhenish Confederation, however, they brought an initial upswing, as evidenced by the buildings of Karl von Fischer in Munich (Prinz

Karl Palais, 1804; National Theater, 1811) or those of Weinbrenner in Karlsruhe (Margrave's Palace, 1803; Lutheran City Church, 1807).

Karl Friedrich Schinkel

Unlike the states of the Rhenish Confederation, the city of Berlin, where Karl Friedrich Schinkel trained as an architect, undertook no large building projects during the first decade and a half of the nineteenth century. Schinkel, born in 1781, became a pupil of Friedrich Gilly in 1798, impelled by admiration of Gilly's design for a monument to Frederick the Great. Gilly was the first in Berlin to employ the monumental architectural idiom based on lucid, geometric forms which had been current for years in Paris and Rome. However, working with Gilly – whose father, David, was also an architect – Schinkel was also involved in the restoration of the Gothic Marienburg in East Prussia and the historical studies it entailed. On his year-long journey through Italy in 1803/4 Schinkel, unlike most of his colleagues, showed a particular interest in medieval buildings, and he was a great admirer of Strasbourg Cathedral and of Notre Dame in Paris.

Schinkel's great talent for painting helped him to survive the difficult years of the Napoleonic Wars, until, in 1810, he was appointed to the Prussian Chief Board of Architecture. Thus began a life's work that, for many decades, exerted an influence on architecture throughout Prussia that was unparalleled in its exclusiveness.

His first great project was the Neue Wache (New Guardhouse) in Berlin, which was begun in May 1816 and completed in August 1818 (fig. 6). Friedrich Wilhelm III, being, as P.O. Rave noted, "more burgher than king," decided to retain his apartments in the Crown Prince's Palace instead of moving to the Royal Palace. This necessitated the building of a

guardhouse nearby. The resulting free-standing structure is a simple cube on an almost square plan (fig. 7), built of bricks that were left visible, the first time this had been done for centuries. This central block is enclosed at the corners by towers of precisely arranged sandstone ashlar that project more toward the front than at the sides, and temple porticos extend across the resulting "niches" on the front and rear elevations. The porticos, with six Doric columns each, emerge from the mass of the building, and have a second row of four columns, between antas and aligned with the towers. This sophisticated interplay of architectural elements, of which neither the pediment nor the corner towers overtop the basic cube, creates the impression of a structure composed of two "slabs" between which the actual building is sandwiched – a brick cube between two ashlar slabs. The slab of the front elevation, in turn, consists of three flat layers: the colonnade with entablature and pediment; the corner towers with connecting, secondary colonnade; and, behind both, the actual exterior wall of the building. The fact that a solid building – a two-story building at that – is concealed behind this three-layered slab becomes quite irrelevant. The spaciousness of antique temple architecture is completely absent. A functional military building has been transformed by the portico structure – it is more than a mere facade – into a monument in the direct tradition of Gilly (and could thus be turned into a memorial without further ado after World War 1).

Nevertheless, the Neue Wache reveals Schinkel as the representative of a new generation. The principle of composing a building of separate geometric masses, the preference for smooth, sparingly articulated wall surfaces, and the tendency to conceive buildings on a monumental scale may all stem from Gilly and the first generation of architects to employ Neoclassical forms in Italy and France. Yet the high drama of Gilly's designs is lacking

in Schinkel's work, for it was no longer considered desirable.

In Gilly's design for a National Theater (fig. 8) mass after mass projects from the central cube, while in Schinkel's Neue Wache, by contrast, every component is subordinated to a simple outline. The tension Gilly creates by contrasting cylinders with cubes and round arches with horizontals does not exist in Schinkel's design, which is composed entirely of verticals and horizontals whose tranquillity is accented, not disturbed, by the gentle diagonals of the pediment. Every form is integrated in the whole by means of a lucid contour. Surfaces are embedded in surfaces or superimposed on them. Even the portico columns have the effect of a flat grid; the building's "cyclopic character is offset by means of articulation."[17] For all its seriousness and dignity, the design remains plain, concise, and well-ordered; no one component dominates the others. A characteristic device is the new way in which the portico has been made to function as an integral part of the whole. Circumscribed by the rectangular outline of the structure, it no longer works as a central focus, which it would if set on a high base with its pediment projecting above the roofline, as in most previous Neoclassical buildings, from Wörlitz Palace and the Fridericianum in Kassel to the Prinz Karl Palais and National Theater in Munich.

There is a second Schinkel design in which a cubic structure is concealed behind a "slab" of architecture: the (Old) Museum in Berlin, erected between 1824 and 1830 (fig. 9). Behind the long colonnade one would hardly expect to find a building with four wings arranged around a central, domed hall and two courts (fig. 10). The rectangular structure in front of which the shallow, colonnaded porch extends, has an aperture taking up the middle third of its length in which an open stairway is situated – the most brilliant idea Schinkel ever had, according to Alfred Lichtwark. The space thus

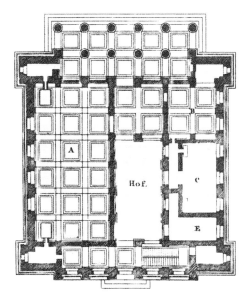

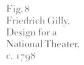

Fig. 7
Karl Friedrich
Schinkel,
Neue Wache: Plan

Fig. 8
Friedrich Gilly,
Design for a
National Theater,
c. 1798

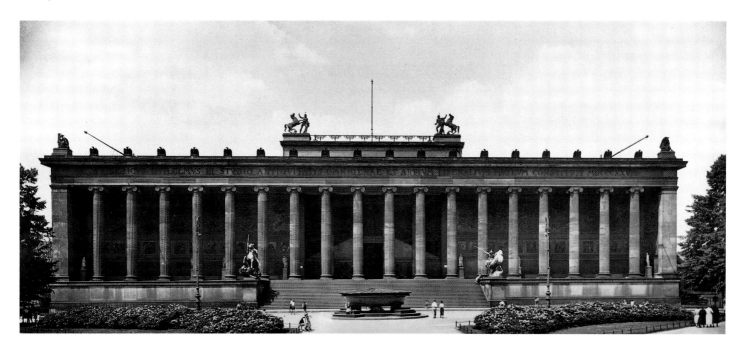

Fig. 9 Karl Friedrich Schinkel,
(Old) Museum, Berlin,
1824–50

created, twice as deep as the vestibule, is divided into three sections by two double stairs. This plan gives rise, behind the first layer of space in the long, colonnaded porch, to a second layer at the center; this is bounded on the lower level by a smooth wall to which the two upper flights of stairs give a gablelike shape. The lower flights of stairs are concealed behind this wall and are accessible from a central door. The stairs lead to a gallery (fig. 11) that forms a third layer of space. This featuring of, and emphasis on, an interior stairwell, which is expressed even in the building's exterior, is accompanied by a deliberate lack of any particular, hierarchical goal for the stairs, which have thus, so to speak, been rendered "bourgeois." Even in Klenze's imposing King's

Tract of the Munich Residence (1826–35) a four-flight stairwell is arranged parallel to the facade (and moreover off axis) without direct orientation to a goal. This aspect, and the concealment of the stairway – comparable in Western architecture only to Gothic practice – are features specific to Biedermeier architecture and have no prototypes in the classical canon.

The lucid, all-encompassing rectangular outline of Schinkel's (Old) Museum is not interrupted by the round of the cupola, simply because it, too, is encased in a rectangular solid. Not even the diagonals of a pediment occur here – only verticals and horizontals, as in the Neue Wache. Verticals dominate the front elevation, which here, too, is not so much a facade in the classical sense as a grid

stretched in front of the main mass and its central opening.

This colonnade, in which the number of columns seems to be arbitrary, is not related to the wall in front of which it extends. There are no corresponding pilasters on the wall, as was canonical practice up to this time. The same lack of relation between columns and wall is repeated in the interior, the domed hall, where the columns ranged just in front of the unarticulated wall surface serve to support not the cupola, but a narrow gallery at the height of the upper floor. The domed hall comes as a complete surprise when one enters from either floor. The immediacy with which the structure reveals itself to the observer represents a considerable part of its grandeur. "Simplicity of

Fig. 10 Karl Friedrich Schinkel, (Old) Museum: Plan

Fig. 11 Karl Friedrich Schinkel, (Old) Museum: Gallery

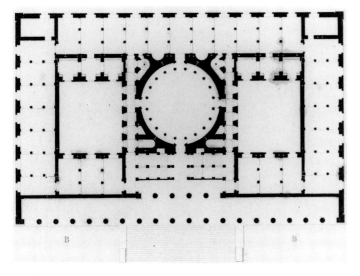

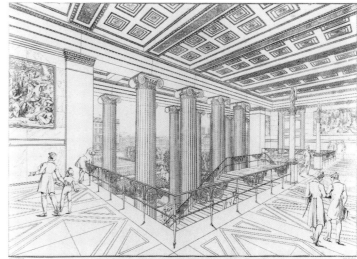

main forms" and "grandeur of relationships" were, in Schinkel's own words, the two most important considerations in his design of the Museum.[18]

Both Neue Wache and Museum, begun eight years apart, were architectural solutions of a highly innovative order. Their only direct link with the Neoclassical buildings of the eighteenth and the beginning of the nineteenth century consists in their employment of classical elements. The point is that these elements no longer determine the character of the whole. Just as the number of columns in the Museum could be increased at will, so the cornice and console frieze of the Neue Wache represent not an architectural necessity, but an ornamental band just below the top of the building which extends around all of its masses, comparable to the string courses running around the responds and engaged columns of a Gothic church. With such delightful details on the one hand, and their "rigorous plainness"[19] on the other, these two buildings represent a new approach within Neoclassicism.

The device of enclosing a volume between two "slabs," noted in the Neue Wache and the Museum, has been detected by Goerd Peschken in a number of small churches Schinkel designed between 1829 and 1852 (see fig. 12).[20] The wide nave with galleries is conceived as a "hall between head buildings," which contain, respectively, the altar and pulpit, and the organ platform and gallery stairways. "The congregation area is marked on the exterior by three large windows; its ends are denoted by vertical slits extending from cornice to base," which separate visually the "head

Fig. 12
Karl Friedrich Schinkel,
Design for a small church,
1826/28

buildings" from the congregation area, even though the walls of all three elements lie in the same plane.

Besides the museum, another new – and democratic – architectural task of the time was the independent theater building, separated from the complex of a royal palace. The old Berlin Schauspielhaus by Langhans burned down in June 1817, and work on Schinkel's replacement began the following year, only two years after the commencement of the Neue Wache. Completed in 1820, the Schauspielhaus (fig. 13) was inaugurated on June 18, 1821, with the premiere of Carl Maria von Weber's opera *Der Freischütz*.

The structure is a well-ordered assembly of blocks of various sizes and proportions. The high main building is flanked by lower, narrow, stepped masses with two projecting wings, and thus resembles a basilica with transept. Although the portico is integrated in the complex by means of its cornice, it nevertheless appears grafted onto the main structure "in a strange, almost dissonant contrast" to the facade.[21] The repetition of the pediment, which has occasioned criticism ever since the theater was built, can be explained only by the fact that Schinkel decided to add a portico to his pedimented building for purely aesthetic reasons. Since all the entrances and the ves-

Fig. 13
Karl Friedrich Schinkel,
Schauspielhaus,
Berlin, 1818–20.
Aquatint by
Friedrich Jügel,
after Schinkel

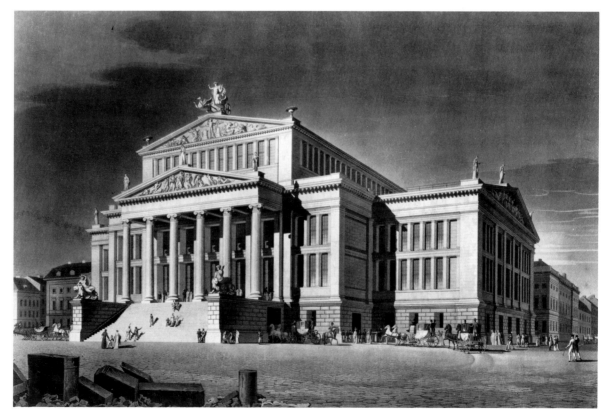

tibule are located on the ground floor, the wide stairway that leads up to this portico – and this is typical of the Biedermeier attitude to stairways – really has no function.[22] The portico stands in front of a wall whose simple, almost graphic articulation extends uniformly around the entire building. The pilasters at the corners are so broad as to be almost wall sections in themselves. At any rate, they express no supporting function, serving, with projecting base and architrave, to frame the wall surfaces. These surfaces in turn are divided into a two-story grid consisting of two horizontal rectangular openings with rows of pillars that frame the individual window spaces. All of this is carried out with almost no recourse to Neoclassical decoration. The design anticipates a system Schinkel was to apply with much greater consistency in such later buildings as the Packhof (Custom House) and the Bauakademie (Academy of Architecture), where Neoclassical surface articulation was combined with a Gothic approach to construction. Some contemporary observers found this disconcerting: "The architects miss a pure style," wrote the composer Karl Friedrich Zelter to Goethe shortly after it was opened. "Too many corners and miters; too many narrow windows, which they consider disturbing."[23] Even after the passage of fifteen years, Heinrich Laube could still comment that "it is rather tiresome, however, to be reminded of a palm house by all those mullions."[24] Other observers were more perspicacious. Writing in 1842, Franz Kugler realized that Schinkel's Schauspielhaus represented "an outstandingly characteristic point in the history of recent architecture," owing to its "strict logic," the "harmony of proportions, both of the parts to one another and of the parts to the whole," and the "freedom with which Greek forms…have been combined into a whole whose composition is quite unprecedented."[25]

In 1824–25 Schinkel's New Pavilion was erected in the park of Charlottenburg Palace (fig. 14). Friedrich Wilhelm III had requested the architect to design a simple refuge for himself and his second wife, Auguste, Princess of Liegnitz, that would serve as a reminder of a stay in Naples.[26] The result was a smooth-walled rectangular solid, horizontally articulated only by string courses: a low base, narrow projections beneath the windows, a shallow balcony with plain railing, and a stronger projection at the top which, despite the fasciae, does not function as a cornice capping the whole, particularly as the body of the building extends beyond it. The walls on all four sides are "pierced" to form loggias that are flanked by pilasters and, on the long sides, divided by two columns. These loggias are really no more than deepened niches over which, where they threatened to become too wide – on the long sides – a grid has been spread to emphasize and maintain the exterior plane. The building is a trifle in terms of architecture or style; but it is a masterpiece in terms of proportioning and rhythmic articulation of the plane.

Christian Frederik Hansen

Schinkel's device of grafting a portico onto the main body of a building had been foreshadowed in the Church of Our Lady in Copenhagen, designed by Christian Frederik Hansen and built between 1811 and 1829 (fig. 15). All the elements of Biedermeier architecture were already employed in this building, and with astonishing consistency. A completely smooth cube is placed in front of the nave and distinguished from it only by a minimal projection. In the width of the portico, the front wall extends somewhat above the cornice; above this, and in the same plane, stands a tower consisting of three superimposed blocks. The surfaces of the uppermost block have three openings that look as if they have been cut out from the top downward, forming pilasters – or rather elongated battlements – capped by a low, pyramidal roof. Incised into the smooth, unarticulated sections of the front surface of the tower are arched and pedimented openings whose balustrades, columns, and pediments, instead of functioning as integ-

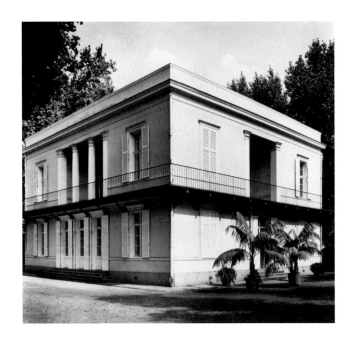

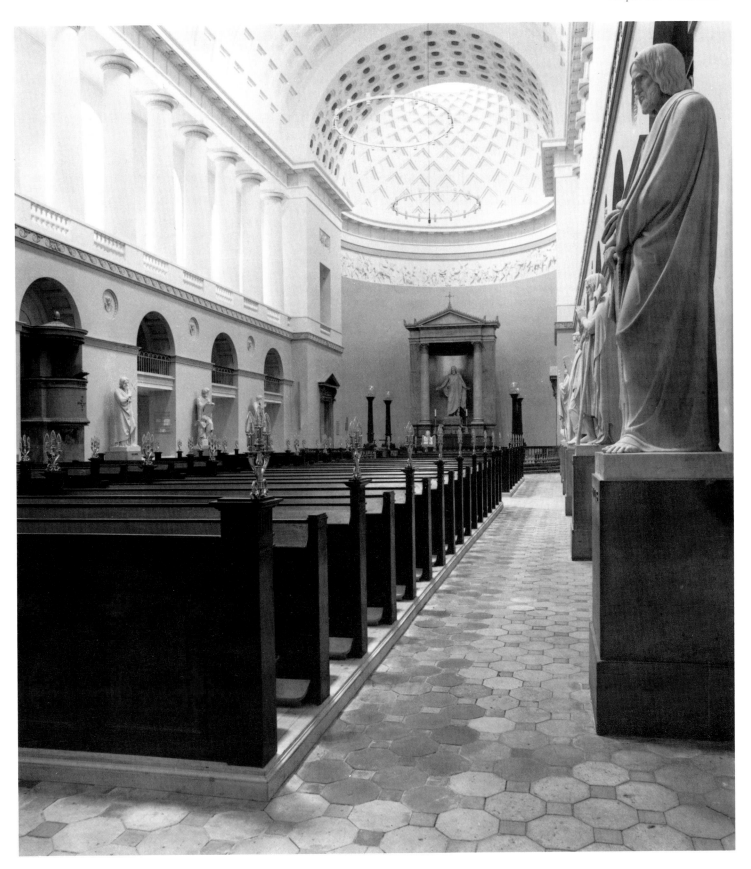

Opposite:
Fig. 14 Karl Friedrich Schinkel, New Pavilion in Charlottenburg Palace Park, Berlin, 1824–25
Fig. 15 Christian F. Hansen, Church of Our Lady, Copenhagen, 1811–29

Fig. 16 Christian F. Hansen, Church of Our Lady, Copenhagen: Interior

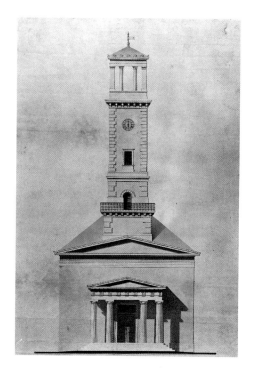

Fig. 17 Carl Ludwig Wimmel,
Design for the west facade of St. Paul's Church,
Hamburg, 1816

ral parts of the structure, give the impression of ornamental fillips.

Window openings incised into the surface and devoid of frames are also found in the nave, onto the east end of which are grafted, as completely autonomous volumes, two cylinders inserted one into the other – apse and gallery. The wall socle has a delicately articulated rustication that, almost devoid of plasticity, works like a planar, graphic ornament. The interior (fig. 16) is an elongated but spacious room with barrel vaulting, flanked by two narrow passageways which are not aisles in the full sense of the word. Nor is it an arcade that separates them from the nave, whose round arches seem to have been cut out of the wall. The surface remains a plane, undisturbed by niches or aedicules; Thorvaldsen's statues of the apostles stand – as he himself desired – against the wall, almost as if on display in a museum. The gallery colonnade likewise betrays little tectonic character, appearing rather as a continuation of the wall beneath, like a grid. This impression is increased by the fact that the columns bear no clear axial relation to the arches. The colonnade, too, is set before two pierced wall surfaces; the wall is diaphanously structured both above and below.

Everything has been reduced to what is architecturally absolutely necessary. The arches have no frames or accentuating moldings; the low-relief cornice, like the band along the floor-line of the gallery, might almost be made of nailed-on boards. The space is lucid, comprehensible at a glance, austere, devoid of dark corners and zones, without surprises. It is dignified and discreet, well-conceived and harmonious.

How rapidly Hansen's church became a model to emulate is indicated by a design for the west facade of St. Paul's in Hamburg (fig. 17), drawn up as early as 1816 by the city's director of architecture, Carl Ludwig Wimmel.[27]

Leo von Klenze

Only three years younger than Schinkel, Leo von Klenze was a fellow student of his at the Berlin Academy of Architecture, where his teachers were Gentz, Langhans, and David Gilly.[28] After sojourns in Paris and Italy, Klenze was appointed court architect to King Jérôme Bonaparte in Kassel in 1808. He was thus entrusted with building projects – a theater and the royal stables – at a time when Schinkel still had to be content with painting panoramas.

Klenze was not among those who bore arms in the war against Napoleon; architect to a king loyal to the French ruler, he was even in Paris during the Hundred Days. Before that, however, he had made the acquaintance of Crown Prince Ludwig of Bavaria, who finally managed to find a position for him in Munich, despite the fact that Karl von Fischer, his elder by only two years, was working to the satisfaction of the court there.[29]

Klenze's activity in Munich began in 1816, the same year as Schinkel's in Berlin, and it proved to be of equal significance in shaping the city. From 1816 to 1821 he built the Leuchtenberg Palais, and between 1816 and 1830 the Glyptothek. In February 1814 a competition had been held for a "building in which

to display works of the art of sculpture," which was to be in the "purest antique style." Karl von Fischer's first design, created the year before (fig. 18), was a very austere, almost forbidding, elongated structure with two corner pavilions, a large, eight-column portico dominating the facade, and a huge domed hall looming above the roof. The pediment, relatively steeply pitched, rises above the flat roof, as do the round roofs of the pavilions, their shape echoing that of the cupola. In a later version (fig. 19), Fischer simplified the building's outline in keeping with Biedermeier practice, omitting the dome and raising the roofline of the main building to match that of the pavilions.

Klenze was permitted to enter the competition late, at the intervention of the Crown Prince. In full knowledge of Fischer's entry, and of its positive reception by the selection committee, he based his own designs on it. Yet since, like Schinkel, he did not adhere exclusively to the Greek style, he submitted three entries, one in the Greek mode, one in the Roman, and a third in fifteenth- and sixteenth-century Italianate.

The finished building (fig. 20) appears only to take Fischer's designs a step further toward Biedermeier architecture. Again, the portico is separated from the main body of the building, but in this case, rather than looking as though it were grafted onto a central structure, it is so autonomous that the flanking wings would seem to be grafted onto it. Their cornices stop dead at the portico. The columns, much closer together than in Fischer's design, create an anterior pierced plane that appears superim-

Fig. 18 Karl von Fischer, First design for the Glyptothek, Munich, 1813
Fig. 19 Karl von Fischer, Second design for the Glyptothek, Munich, 1816

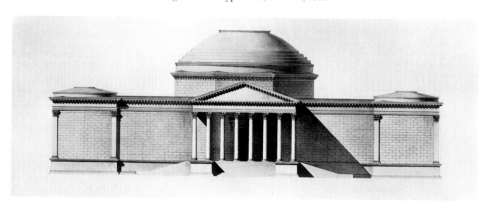

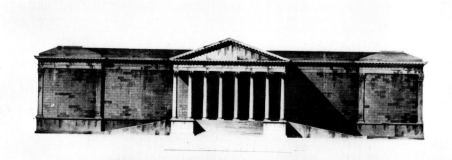

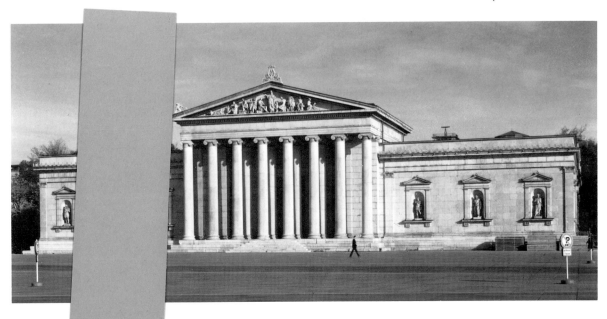

Fig. 20
Leo von Klenze,
Glyptothek, Munich,
1816–31

posed on a second plane compose[...] [...]dingly long wall surfaces that were [...]cteristic of the previous phase of Neoclas[...], to which Fischer's designs belonged.

columns and of wall sections in line[...] flanking wings. A third plane is form[...] vestibule wall. The result is an interp[...] of exterior and interior space, as in [...] Museum. The pediment is more gen[...] than in Fischer's entries – a detail in[...] the harmony of the overall outline. [...] Klenze also provided the wings [...] domed pavilions, these remain inv[...] the outside. While in Fischer's [...] pilasters are used to emphasize t[...] corners and to support the entabl[...] Klenze they merely flank the two wings, being spaced so far apart as to have no supporting function and serving merely, with socle and entablature, to frame the wall plane.

The final plan of the Glyptothek was a square, with four wings arranged around a spacious interior courtyard. Much as in Schinkel's Museum, this was carried out by adding a second long, but narrower, building parallel to the front elevation and its portico. These two "slabs" were then connected by means of two lateral sections (fig. 21). The ends of the "slabs" are emphasized by a pair of aedicules and by two pilasters, an articulation repeated, this time quite without motivation, on the central axis of the connecting buildings. In the ornamentation and interior design, Klenze was still strongly influenced by the French Empire style.

Klenze's easy command of classical models is revealed in his simultaneous use of a Greek portico and Roman aedicules, which his contemporaries criticized as "stylistic impurity."[50] Yet the exterior of the Glyptothek suggests what is to be seen within. "The building itself was meant, as it were, to visualize the history of Greek and Roman sculpture,"[51] a principle that Gabriel von Seidl was to apply with total consistency at the close of the century in his Bayerisches Nationalmuseum in Munich. Perhaps the most important function of Klenzes aedicules, however, is to break up the

[...]lements of Architecture

[...]ormal idiom of German architecture dur[...]he Biedermeier period, from about 1810/[...] 1830/35, developed out of the repertoire [...]assical elements in use since the second [...] of the eighteenth century. Its originality, [...]ever, lay precisely in the conscious avoid[...] of an all-too strict reliance on classical [...]els. "Why should we always build in the style of another age?" asked Schinkel; and as early as 1818 Heinrich Hübsch declared that, "even treated with the greatest liberty, antique architecture is not suited to our contemporary buildings." Early Neoclassical buildings of the late eighteenth century had rhythmically articulated and carefully composed exteriors, divided by projections into well-defined stories of which the main floor dominated, as well as axial relations along the vertical that extended

from socle to attic. Biedermeier buildings lacked all these features, having exteriors that were planar and sparingly articulated. And whereas buildings erected around 1800 consisted of geometric blocks from which further cubic or spherical masses projected with almost brutal force, with forbiddingly smooth walls into which unframed window openings were incised, Biedermeier architecture tended to favor expansive, slablike elements arranged in parallel layers with inserted niches and generally quiet, unbroken outlines. This layering is found both inside and out: planes are indented in planes, and colonnades or arcades define the plane and stand in front of walls that, instead of being correspondingly articulated, are themselves planes, a structural combination comparable to that found in Gothic architecture. With Biedermeier the classical canon became a collection of decorative appurtenances. In late eighteenth-century Neoclassicism the portico – the temple front – was always an integral part of the building, the socle matching the entablature, the pediment projecting above the

Fig. 21
Leo von Klenze,
Glyptothek: View of
rear and side
elevations

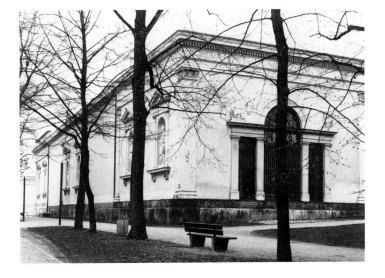

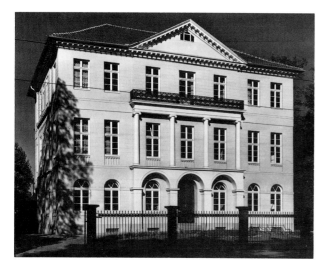

Fig. 22 Georg Laves,
The architect's house,
Hanover, 1822–24

Fig. 23 Peter von Nobile,
Burgtor, Vienna, 1821–24

Fig. 24 Johann Philipp
Mattlener, Antikenhalle,
Speyer, 1826

were not without dignity. When, in the course of restoring the Vienna city fortifications, Peter von Nobile erected the Burgtor (Castle Gate, 1821–24; fig. 23), he made this piece of functional architecture so impressive that it could be simultaneously dedicated as a monument to the liberation of Austria from Napoleon. The austere, tranquil, and dignified design of the Antikenhalle (Hall of Antiquities) in Speyer (fig. 24) – whose round arches on Doric columns throw "stylistic purity" to the winds – permitted this small public museum building to be converted without further ado into a war memorial after 1871. Designed to house Roman relics found in the Palatinate, it was the work of Johann Philipp Mattlener, erected in 1826 in a landscape garden laid out at the same time.[32] Open to everyone, the Antikenhalle was a modest, middle-class example of that new building type, the museum, which arose during the Neoclassical period.

roofline and thus dominating the whole. Biedermeier architects reduced the portico to a "sculptural" addition by placing it in front of a smooth wall; some even flattened it to a planar ornament, raised to the second floor and separated from its pediment, as in the house of the architect Georg Laves, built in Hanover between 1822 and 1824 (fig. 22). Pilasters and beams lost the strictly tectonic function they had possessed in the earlier phases of Neoclassicism; as applied decorative elements, they merely define surfaces or provide continuous friezes.

Lucidity and comprehensibility characterize both the exteriors and the interiors of Biedermeier buildings, which, for all their plainness,

The examples given above suffice to define Biedermeier architecture, its unique idiom and its high quality. An analysis of other buildings of the period by, for instance, Georg Moller in Darmstadt (St. Ludwig's Church, begun 1822; Chancellery, begun 1825), Johann Peter Cremer in Aachen (Theater, begun 1822), Nikolaus Börm in Lübeck (Reformed Church, begun 1824), or Giovanni Salucci in Stuttgart (Rosenstein Palace, begun 1824), would lead to the same conclusions.

That a clearly defined and original style in architecture developed over these twenty years or so becomes obvious not only by comparison to the foregoing Neoclassical styles, but also with regard to buildings of the immediately following period. In the 1850s a noticeable change took place, as the austere, concise volumes of Biedermeier architecture began to be increasingly overlaid with plastic elements. Facades and interiors became more richly articulated, contours were interrupted to create tension and interest, moldings and cornices became heavier, buildings as a whole more monumental – instances are Schinkel's St. Nicholas's Church in Potsdam, commenced as early as 1829, or Klenze's rather unimaginative imitation of a classical model in the Valhalla near Regensburg, which was begun in 1850. Another feature revived during this period of increasing political reaction was the imposing, goal-oriented stairway, as may be seen in Gärtner's Staatsbibliothek in Munich (begun 1852) or in Klenze's St. Petersburg Hermitage (begun 1839). Along with a more sculptural articulation of wall surfaces came an increased emphasis on color, obtained by the use of highly varied materials, as in Schinkel's Bauakademie in Berlin, begun in 1831 and a highly prophetic building in every respect. At the same time, architects again set great store by fidelity to past styles, whether Greek or Roman, Gothic or Renaissance, or the recently revived Romanesque. This multiplicity of stylistic models, each as valid as the other, finally broke the monopoly of Neoclassicism on the architecture of Central Europe.

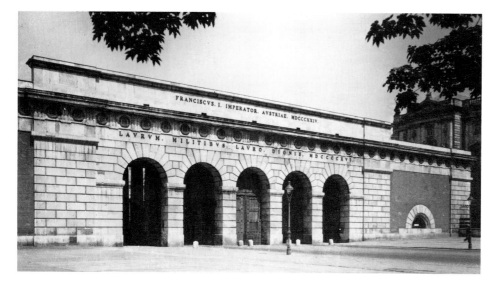

Sculpture

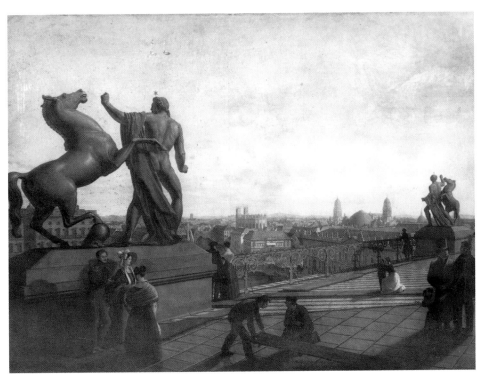

Fig. 25 View from the roof of Schinkel's (Old) Museum, Berlin.
Painting by L. A. Most, 1830.
Muzeum Narodowe, Pòznan

Ever since the Renaissance, German painters and sculptors had flocked to Rome to study. The city's attraction was naturally irresistible to the artists of Neoclassicism, since in Rome they felt closest to the sources of the new style. Rulers and academies granted stipends to gifted artists, while others began the arduous journey south on their own; some spent the rest of their lives in the mecca of the visual arts. For pursuing the ideal of a free and liberal artistic life, there was probably no better place at that time than Rome. The Swiss sculptor Alexander Trippel arrived there in 1779, followed in 1785 by Johann Heinrich Dannecker from Swabia and Gottfried Schadow from Berlin, in 1792 by Asmus Jakob Carstens from Schleswig, and in 1797 by Bertel Thorvaldsen from Denmark. The last of these was to become the admired and influential mentor of several generations of German sculptors, and the great model for all Europe.

Sculpture in Architecture

Schinkel set great store by the enrichment of his buildings with sculptural ornament, making highly detailed drawings to which the sculptors had to conform. This could hardly be expected to encourage true collaboration between figures of comparable stature, but then, in any case, the general conditions were not especially favorable to such an exchange of ideas. To put it bluntly, Biedermeier sculpture had no relationship with architecture. The unrelieved flatness of Biedermeier walls offered the sculptor little opportunity or inspiration in the way of collaborative effort. Sculpture was either subordinated to architecture or divorced from it; at best, it was an adjunct, something to be superimposed on, or juxtaposed to, a building. Not that Biedermeier sculptors felt discriminated by this state of affairs, for it was very much in keeping with an approach that emphasized the relationship of sculpture to the plane rather than to space.

The extent to which Schinkel liberated himself from classical models, this time in the case of sculptural ornament, is again shown by the Neue Wache (fig. 6). On the frieze there is neither an alternation of triglyphs and metopes nor a continuous pictorial relief – only a sculpture placed above each column, a Victory with outspread wings, decoratively conceived and cast in zinc.[35]

Schinkel's designs show that he intended the tympanum to contain a great number of figures that completely filled it. No single figure was emphasized, or even emerged from the rest, the purpose of these compositions being merely to enliven the pediment.

While the pediment sculptures were not executed in Schinkel's lifetime, his Victories were translated into three dimensions by no less a sculptor than Gottfried Schadow, who was head of the Royal Sculpture Atelier from 1788 and director of the Berlin Academy of Arts from 1815. With reference to these goddesses of victory Schadow remarked, "I modeled them and adhered faithfully to his [Schinkel's] designs, which appealed to me very much," though in another place he said he had cautioned Schinkel that "the dimensions given were hardly conducive to creating a good effect."[34] The fact that a master who, twenty-five years earlier, had provided a superb example of Neoclassical architectural sculpture with his Quadriga on the Brandenburg Gate, could express himself with such modesty about a work he had carried out with his own hands, speaks volumes on the situation of sculpture in architecture during the Biedermeier period.

Another typical example of this situation is the sculpture on Schinkel's Schauspielhaus (fig. 13): an Apollo in a griffin-drawn chariot

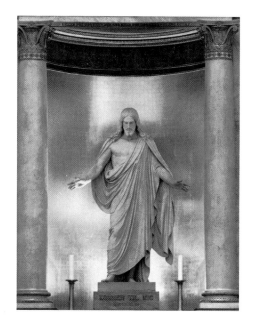

Fig. 26 Bertel Thorvaldsen, *Christ*, 1821.
Church of Our Lady, Copenhagen

crowning the entire structure (and requiring a rather awkward pedestal of its own on the pediment) and figures of the Muses stuck like candles on the lower pediments.[35] The models for the sculptures were made on the basis of Schinkel's suggestions by Christian Friedrich Tieck, who had returned to Berlin from Carrara in 1819.

In 1826 Tieck also created maquettes for the sculptural ornamentation of the (Old) Museum (fig. 9), again based on Schinkel's sketches. Whereas in the Neue Wache, Victories had replaced triglyphs, in the Museum eagles were arrayed along the main cornice, where they look completely out of proportion and are, in fact, superfluous. The horse tamers set up at the corners of the rectangular solid enclosing the dome also seem entirely without relation to the architecture and can really only be seen and appreciated from the roof (see fig. 25).

Not even Thorvaldsen was able to create a meaningful relationship between sculpture and architecture. The positioning of the Apostles in front of the walls in the Church of Our Lady in Copenhagen has already been mentioned (fig. 16). Nor did the greatest sculptor of Neoclassicism ever manage to find a convincing solution to the central problem of architectural sculpture since antiquity – the design of the tympanum (see fig. 15). He treated the tympanum like a box in which to place, at large intervals, a certain number of individual figures or groups of two, some standing, others seated. St. John, standing on an outcrop in the middle, is preaching into some imaginary distance, without any link whatsoever to his listeners on either side, who in turn do not communicate with each other. In order to appreciate the quality of these figures, which were modeled in 1822–23 and executed in terra-cotta for the tympanum, one must see them in isolation (fig. 27 and no. 90). Thor-

valdsen's treatment of the drapery here is striking, since, far removed from classical practice, it relies strongly on Italian sculpture of the Trecento. This conscious combination of antiquity and Middle Ages would seem to be a key design criterion for Biedermeier sculpture.

The Human Figure

The finest accomplishments of Biedermeier sculpture were in the field of individual depictions of human beings, whether full-figure or as busts. This, of course, had always been the foremost task of sculpture, and especially so since early Neoclassicism. Yet in the Biedermeier period sculptors no longer depicted gods and saints, or the heroes of antiquity, but the living people around them, notwithstanding their penchant for Greek and Roman costume. "The first aim of all sculpture," wrote Goethe in 1817, "is that human dignity shall be represented within the human shape."[36]

Naturally, there was still great reliance on classical models, just as Christian subject matter – Christ and the saints – continued to be considered an acceptable task. The creation of Christian art had nonetheless become a problematic undertaking in the aftermath of the French Revolution. Dannecker began wrestling with his image of Christ in 1815; Thorvaldsen, after several attempts, modeled his *Christ* for the Church of Our Lady in Copenhagen in 1821 (fig. 26). Even his contemporaries differed in their opinions of this depiction of the Son of God. Klenze, writing in 1833, declared that it was to be "preferred above all images of Christ from any period";[37] Schadow, on the other hand, considered it "one of his weakest works."[38]

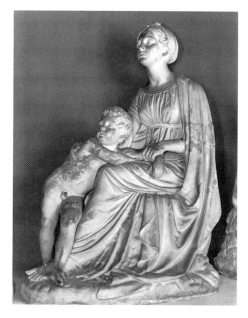

Fig. 27 Bertel Thorvaldsen, *Mother and Child*,
1821–22. From the typanum of the Church
of Our Lady, Copenhagen

The influence of Thorvaldsen's sculpture on the nineteenth-century image of Christ was lasting and widespread. It was copied and exploited again and again, in countless variations, down to the funerary sculpture of the *fin de siècle*. "The pose and gestures of this figure relate to the observer with an immediacy not found either in the cult statues of antiquity or in Christian altar images.... [Christ's] gesture is one of opening out, of welcoming, as He inclines his face toward us."[39] Neither divinely superior nor suffering, neither triumphing nor

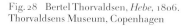

Fig. 28 Bertel Thorvaldsen, *Hebe*, 1806.
Thorvaldsens Museum, Copenhagen

Fig. 29 Bertel Thorvaldsen, *Hebe*, 1816.
Thorvaldsens Museum, Copenhagen

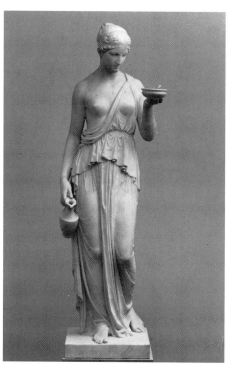

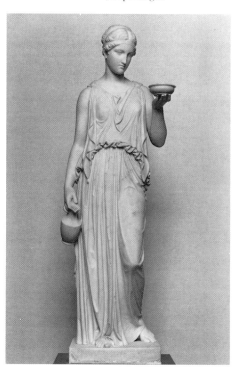

judging, nor even forgivingly condescending, but patiently waiting, a human being stands ready to receive other human beings.

One surprising feature of Thorvaldsen's *Christ* is the expansion of the figure in the plane. The richly draped garment serves to bind the figure to an imaginary pictorial plane defined by the two columns and by the entablature and pediment of the altar superstructure. At the same time, the shallow ripples of the expanse of cloth help to underscore the quiet and undisturbed contour of the sculpture, from which, despite the grand gesture, only the hands emerge. Here, "the haptic quality of sculpture has merged into the optic quality of painting."[40]

The differences between Biedermeier sculpture and that of the beginning of the century are clearly evident in another work of Thorvaldsen's, the statue *Hebe*. He created two versions of this youthful female figure, one in 1806 (fig. 28) and the second exactly ten years later (fig. 29). Both represent the same girl in the same pose and holding the same vessels in her hands. And yet what a difference! No doubt the later figure's garment, with its high neckline and voluminous folds completely concealing the load-bearing leg, represents a conscious reduction of sensual appeal. Yet this is not all. As in *Christ*, the treatment of the drapery in the second *Hebe* creates a planar extension of the figure that diminishes its corporeality. The cloth "stands" on the floor on the left like a solid wall, while in the earlier version it undulates upward. The relaxed leg reaches less further back and more to the side; all that is visible of the right leg are the toes. The upper body, and especially the head, are inclined less further forward in the later version, which seems to reduce the spontaneity of the pose. The arms lie close to the torso, their contours echoed by drapery folds that create a link between the volumes of the upper body and the arms. Nothing projects beyond, or disturbs, the tranquil, closed overall contour of the piece. Thorvaldsen's *Hebe* of 1816 is a consummate work of Biedermeier sculpture.

Very close artistic ties existed between Thorvaldsen and the sculptors of the Berlin school. Thanks to Gottfried Schadow, Berlin became the center of German sculpture during the first half of the nineteenth century. Schadow's pupils included, among many others, Friedrich Tieck, Christian Rauch, his son Rudolf (called Ridolfo), Emil Wolff, and Reinhold Begas. They, too, all went to Rome and came under Thorvaldsen's spell, becoming his pupils or working in his studio.

Meanwhile, a development that was to be of great consequence for the nineteenth century as a whole had reached a mature phase in Berlin – the erection of monuments. Previously, public monuments had been reserved for kings and emperors. It was Frederick the Great who, from 1769 onward, broke this monopoly by commemorating his generals in monuments by François Gaspard Adam and Sigisbert Michel, by the Räntz brothers, and by Antoine Tassaert

and his follower, Gottfried Schadow. The last of these created the first monument ever to a common citizen, a civilian, a thinker – Martin Luther. First sketches were made as early as 1805, the cornerstone laid in 1817, and in 1821 the monument, with a cast-iron Neo-Gothic canopy designed by Schinkel, was unveiled in Wittenberg (see no. 87).

The rise of Christian Rauch to become the leading sculptor of German Neoclassicism began with a monument to Queen Louise, designed in competition with Schadow and erected in 1810. Rauch was soon commissioned to create a whole series of monuments: to generals Scharnhorst, Bülow, and Blücher in Berlin, another to Blücher in Breslau (Wroclaw), to August Hermann Francke in Halle, and to King Maximilian I Joseph of Bavaria in Munich.

August Hermann Francke, theologian and educationalist, was the founder of an orphanage and several other educational institutions in Halle. Rauch depicted him in his official robes, flanked by two children and with his right hand raised in a gesture of instruction (fig. 30 and no. 84). With this charming everyday scene of a teacher and his devoted pupils, Rauch created a seminal work of middle-class monument art that was a far cry from the classical revival tradition and yet had none of the sentimental, storytelling character of later work in this genre. Rauch's straightforward

approach to form enabled him to evoke humility and love without recourse to embarrassing borrowings from medieval Christian symbolism. He relied on the formal principles of Biedermeier sculpture as noted above in the work of Thorvaldsen. The group is conceived in a planar, almost relief-like fashion; indeed, it has no side view to speak of (fig. 31). The outspread gown is employed to fill the plane and create a largely continuous outline, resulting in a "stately monument."[41]

In October 1825 Rauch was commissioned by Ludwig I of Bavaria to design a monument to his father, the recently deceased first king of Bavaria, Maximilian I Joseph (fig. 32 and no. 85). The suggestion for the monument had come, during the king's lifetime, from the city magistrate. Klenze had submitted initial designs for a seated figure in 1823, but Maximilian I was not pleased. The idea of a seated ruler was disconcerting, and remained so for many critics, even after Rauch's monument had been unveiled. Bettina von Arnim called it a "beastly work" and fumed about the "box on which the goblin sits."[42] Sulpiz Boisserée noted in his diary: "Not a happy idea of Rauch's to represent King Maximilian seated."[43] Klenze's idea, which Rauch enthusiastically adopted, was indeed a completely new type of sculpture, one perfectly suited to the representation of a popular king. A Neoclassical artist, could, of course, find any number of

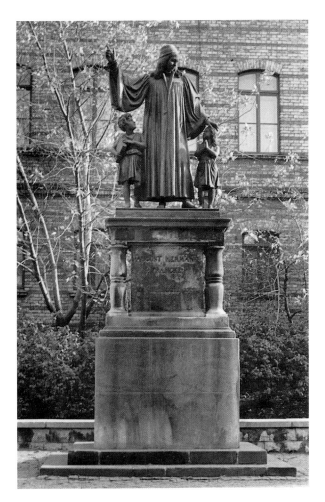

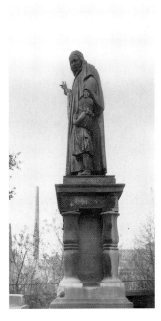

Fig. 30 Christian Daniel Rauch, Francke Monument, Halle, 1825–28

Fig. 31 Christian Daniel Rauch, Francke Monument: Side view

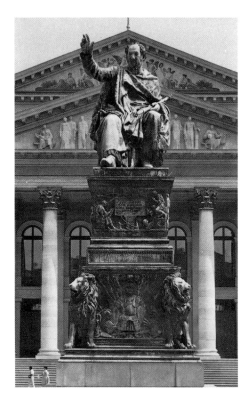

Fig. 32 Christian Daniel Rauch, Monument to
Maximilian I Joseph of Bavaria, Munich, 1825–35

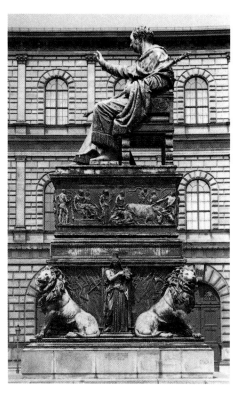

Fig. 33 Christian Daniel Rauch,
Monument to Maximilian I Joseph: Side view

past models to rely on – for example, seated
Roman emperors and philosophers of anti-
quity. On the other hand, the teaching Christ
was also depicted seated. Apparently, the
sculptor's educated contemporaries found it
difficult to reconcile this tradition, which had
found its continuation in the sepulchers of the
popes, with the depiction of royalty.[44]

Maximilian I Joseph is represented in con-
temporary costume, wearing his uniform. This,
however, is hardly visible, thanks to the corona-
tion robe wrapped around his shoulders, a
garment which, together with the scepter, rep-
resents royal dignity and honor of the highest
order. Suggesting an antique toga, this device
conforms to tradition in depicting the king as a
being apart from, and above, the run of man-
kind.[45] But has this end really been achieved?
Does it not rather seem that the seated
monarch has casually wrapped himself in a
blanket and pulled it over his knees?

His gesture of blessing has been interpreted
as representing "the king invoking the con-
stitution."[46] Yet is it not more likely that
Maximilian I Joseph is merely giving his sub-
jects a friendly wave, just as today's dignitaries
wave from balconies or automobiles?[47]

Rauch had executed the model for the
monument immediately on receipt of the com-
mission and presented it to the king personally
in Munich in April 1826. Klenze wrote to Mar-
tin von Wagner, his collaborator on the initial
designs, that Rauch's "sketch has exceeded all
expectations and is truly superb."[48] Together
with that for the Francke monument, it was dis-
played that year in the Berlin Academy exhibi-
tion.[49]

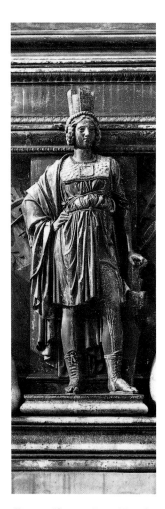

Fig. 34 Christian Daniel Rauch,
Monument to Maximilian I Joseph:
Bavaria

The execution, in Munich, required a great
deal of time. It was largely supervised by the
25-year-old Ernst Rietschel, who kept Rauch
continually informed on the progress of the
work.[50] The casting was the first major project
undertaken by Johann Baptist Stiglmaier, the
doyen of German bronze casters. After several
unsuccessful attempts, the cast was completed
in 1835 and ceremoniously unveiled during the
Oktoberfest. Although the monument was
erected in close proximity to the Residence, it
was placed neither directly before it nor in rela-
tion to it, but instead, in front of the National
Theater, an expressly public building.

As compared to the model, the final version
evinces considerable changes in the two-part
pedestal. On each side, between the lions,
Rauch added a standing female figure, a
Felicitas Publica on the left (fig. 33) and a
Bavaria on the right (fig. 34).[51] The reliefs on
the upper section of the pedestal conform to
tradition in illustrating the ruler's virtues. On
the side elevations, these are protection and
furtherance of justice and agriculture – in an-
tique garb, like the *Felicitas Publica* below –
and of religion and the arts – in contemporary
costume, like the *Bavaria*, though she also
wears the traditional breastplate and crown
symbolizing town walls. Grouped around the
inscription tablet on the front are figures per-
sonifying the protection and furtherance of the
sciences and, on the back, the presentation of
the constitution to the three estates, peasantry,
citizenry, and nobility. The depictions relate to
actual reforms introduced during the reign of
Maximilian I Joseph.[52]

In terms of site and the manner in which the
monarch is represented, this monument repre-
sents a new and bourgeois type. However, it
remained the only example of its kind, since all
too soon conceptions of monument sculpture
changed once again.

Here, too, we find the characteristic traits of
Biedermeier sculpture. There are no relation-
ships to the surrounding space of the square, in
any direction; the surfaces of the piece are as
compressed and contained as they could pos-
sibly be. Accordingly, the "much too narrow
pedestal" was soon criticized.[53] The lions,
instead of having a supportive function, are tied
like reliefs to the plane of the pedestal, so much
so that the trophies "appear to issue from the
lion's backs."[54] Only their heads are turned out
of the plane, but at such an angle that they
appear to lie in the plane of the front elevation.
The individual sculptural volumes of the
seated figure are masked and unified by the
drapery folds wherever possible. The figure's
contour – apart from the right arm – is contin-
uous. There is really only one valid view, that
from the front.

In 1836, a year after the unveiling of the
Munich monument, Rauch began work on the
long-planned monument to Frederick the
Great in Berlin (fig. 35). This is a superb exam-
ple of the post-Biedermeier monument type
that dominated the second half of the
nineteenth century. The pedestal has a broad

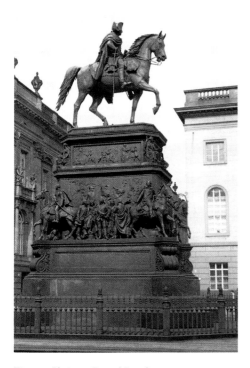

Fig. 35 Christian Daniel Rauch,
Monument to Frederick the Great, Berlin, 1836–51

base and tapers stepwise toward the top; there
is nothing compressed or boxlike about this
substructure. Even the huge volutes and their
bases project diagonally, underscoring the
direction of the generals on horseback above
them. All the figures emerge bodily from the
relief, forming active, agitated groups, and
there are no allegories in the classical revival
manner. The historically accurate rendering of
the uniforms extends even to highly detailed
leathers and medals. Once again, Rauch
created a seminal work – *the* seminal work for
monument design during the period of mature
Historicism.

Memorials were naturally not the only genre
in which Biedermeier sculptors treated the
human figure. Ridolfo Schadow, Italian-born
son of Gottfried Schadow and twenty years
younger than Rauch, created marble statues of
tranquil, self-absorbed young girls – *Girl Tying
Her Sandal* and *The Spinner* (fig. 36) – that so
captured the imagination of the age that he had
to make several replicas. It is interesting to hear
the opinion of a contemporary, Johann Fried-
rich Boehmer, cofounder of the *Monumenta
Germaniae Historica*, who in 1828 wrote: "On
the whole, I think one should choose natural
and naive motifs (like Schadow's *The Spinner*)
if one wishes to follow the path of antique
sculpture nowadays, rather than mythological
ones, for which we no longer have the heart."[55]

That the seated girl with raised left arm was
intended to be seen, like the works discussed
above, from a single viewpoint, becomes obvi-
ous when one walks around it (figs. 37, 38). This
piece, and such early works by the Danish
sculptor Hermann Wilhelm Bissen as *Flower
Girl* (fig. 39), indicate the extent to which these

artists – whose careers began in the Bieder-
meier period – had already shaken off the influ-
ence of Thorvaldsen. *Flower Girl* puts one in
mind neither of Greek mythology (though Bis-
sen was probably alluding to Glycera, the
wreathmaker; see no. 62) nor of some figure
from a romantic fairy tale. The piece is a pure
embodiment of youthful beauty and quiet
expectation.

Otto Sigismund Runge, born in 1806, was
the son of the painter Philipp Otto Runge. His
group *A Girl Teaching Her Brother How To
Fish* (fig. 40) of 1827–28 stands at the end of the
period under discussion and yet is still – though
only just – a true work of Biedermeier
sculpture. This becomes obvious by compari-
son to a marble piece on a very similar theme by
Heinrich Kümmel, *The Education of Bacchus*
(fig. 41), which dates from 1846. While Runge
depicts two children completely absorbed in
play, Kümmel shows a young girl playing a
dubious game with a boy who seems to suspect
what this education is all about. Runge's fig-
ures stand close together and yet seem hardly
to touch; their pose is simple, natural. Every
effort has been made to keep the outline of the
group as clear and uninterrupted as possible;
the lines of the girl's arms lead the eye inward.
The corner of her garment falls between her
knees, a device that serves to repeat and link
the separate volumes of the legs and close the
opening between them. How different all this is
with Kümmel! The girl's right hand breaks the
smoothness of the outline, and her left arm is
not directed inward into the group. The left leg
thrusts back violently; the knees are wide apart.
The boy leans back between them in a rather
contrived pose. His torso, and the girl's right
thigh, left lower leg, and right forearm, create a
number of separate axes that lead the eye out of
the spatial matrix of the group in various direc-
tions. Runge's group, by contrast, appears
almost as flat as a relief, an image of calm
absorption and peace of mind.

Small-Scale Sculpture

During the Biedermeier period the plastic arts
entered the home as never before. Members of
the prosperous upper middle class had them-
selves portrayed in the form of busts; but it was
miniature sculpture that enabled wider sectors
of the populace to acquire three-dimensional
works of art by more or less famous sculptors.
Such new materials and methods as zinc cast-

Fig. 39 Hermann Wilhelm Bissen,
Flower Girl, 1828–29.
Ny Carlsberg Glyptothek, Copenhagen

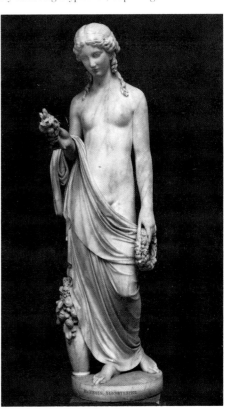

Figs. 36–38 Ridolfo Schadow, *The Spinner*, 1814. Wallraf-Richartz-Museum, Cologne.
Main view, front view, three-quarter view

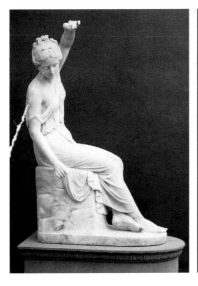
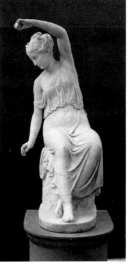
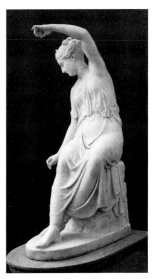

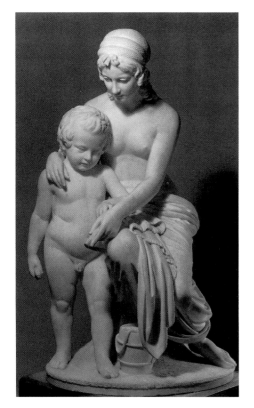

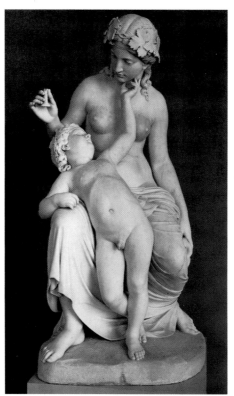

Fig. 40 Otto Sigismund Runge,
A Girl Teaching Her Brother How to Fish,
1827–29. Kunsthalle, Hamburg

Fig. 41 Heinrich Kümmel,
The Education of Bacchus, 1846.
Niedersächsisches Landesmuseum, Hanover

Fig. 43 Gustav Bläser,
Statuette of the artist's brother, 1854.
Kunstmuseum, Düsseldorf

Fig. 42 Christian Daniel Rauch,
Goethe Wearing a Housecoat, 1828.
Schloss Tegel, Berlin

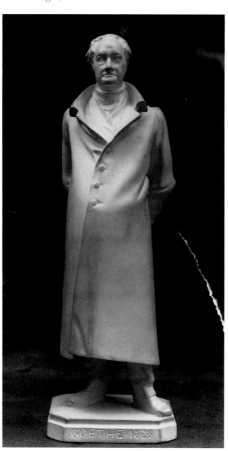

ing and, especially, iron casting, but also older ones – bisquit porcelain, for example – permitted editions of small-scale sculptures to be made, whether they were reductions of monuments (see nos. 86, 87) and other types of large sculpture, or autonomous works conceived on a small scale. After 1815 the iron foundries continually improved their technical and artistic methods to meet the demands of sculptors.

During a visit to Goethe's house in September 1828, Rauch modeled a statuette of the poet, standing, clad in a housecoat, his hands clasped behind his back (fig. 42). This is an objective and realistic rendering, unpretentious, typical in pose and gesture (and with respect to the *embonpoint*, too realistic for Goethe's taste), yet full of inner greatness, even monumentality. The ample expanses of the long coat encase the figure, lending it a blocklike solidity; buttons, necktie, and folds are all there, but do not call attention to themselves through excessive detail. The collar, which seems to have slipped to one side, opens out to form a base for the head. The statuette is both true to life and dignified, the qualities Goethe himself thought important in the representation of the human figure.[56]

How differently, six years later, Gustav Bläser represented his brother, the painter I. W. Bläser (fig. 43). The young man stands tensely, his knees flexed, his right shoulder thrown back,

and his head extended in the opposite direction as he absentmindedly pushes the skirt of his coat aside with his mahlstick. The numerous folds at this point, together with those on the sleeves and trouser legs, lend the surface a flickering restlessness, just as the protruding coat hem and narrow waist produce an agitated contour. This almost Baroque agitation, even nervousness, places the small sculpture far outside the bounds of the Biedermeier style.

Painting

For architects and sculptors working in the style that supplanted Rococo in the late eighteenth century, it was relatively easy to find appropriate forms and conventions in a rediscovered classical antiquity. This was not the case with painting. The monochrome and, to a certain extent, abstract vase painting of the Greeks and Etruscans seemed suitable for occasional ornaments at best, the wall painting of Pompeii or Herculaneum merely for interior decoration. Painters were forced to look elsewhere for inspiration, doing justice to the classical ideal by choosing corresponding subject matter – in other words, themes from antique mythology.

When the Biedermeier period began around 1815, such painters as Joseph Anton Koch, Caspar David Friedrich, Peter Cornelius, and Wilhelm von Kobell were active in Germany, each of them seemingly worlds apart from the other. At the academies, a rigorous Neoclassicism was the order of the day, and the group of young German artists who fled to Rome, the Nazarenes, merely exchanged it for the ideal of Christian art of the early Renaissance. The truly progressive developments took place in the cities, where independent painters, working for a new, middle-class clientele, focused their attention on the here and now, the countryside around them, and the people they met in their daily lives. In other words, the finest achievements of the period lay in the fields of portraiture and landscape, depictions of human beings and nature. Artists concentrated on representing things true to life and as objectively as possible, an aim entirely in keeping with the tastes of their clients.

This "Biedermeier objectivity," of course, was not without models in the past.[57] It was easy to find related concerns in the likewise bourgeois art of seventeenth-century Dutch painters – perhaps not in Frans Hals or Rembrandt, but certainly in the Ruisdaels, in Paulus Potter, Jan van Huysum, Rachel Ruysch, and others. Yet the Biedermeier painters approached their subjects – whether human beings or landscapes, still lifes or townscapes – with an interest that was well-nigh scientific, striving for individuality and complete verisimilitude. Observation replaced composition, the soberly objective report supplanted heroics. This love of the object resulted in images of familiar phenomena, rendered without stage arrangement or lighting, without melodrama – indeed, without plot or action of any kind. Artists sought "natural nature... where everything fits together truly and easily and creates the impression of an integral whole."[58]

Fig. 44 Christoffer Wilhelm Eckersberg, *Portrait of the Sculptor Bertel Thorvaldsen*, 1814. Det kongelige danske Kunstakademi, Copenhagen

Centers

In no other city did Biedermeier painting emerge in such pure form as in Copenhagen. Unlike schools in Germany and Austria, the Copenhagen Academy, founded in 1754, was an open-minded and progressive center where modern, French-inspired classicism had reigned from the start. Nicolai Abildgaard and Jens Juel had "made painting an essential element of the cultural life of their country,"[59] thus paving the way for "the Golden Age of Danish painting." Its inception is quite rightly dated to the year 1817, when Christoffer Wilhelm Eckersberg returned to Copenhagen from Italy. A pupil of Abildgaard's, Eckersberg had studied with Jacques Louis David in Paris and with Thorvaldsen in Rome; his *Portrait of the Sculptor Bertel Thorvaldsen* is among his finest accomplishments (fig. 44). Both in Paris and Rome he faithfully depicted the city and its environs, preferring the quiet, less familiar streets and squares to the grand views of famous buildings. Appointed professor at the Copenhagen Academy in 1818, Eckersberg taught there for the remainder of his life, leaving behind a great number of pupils, including many instructed outside the Academy.[60] Most important among them was probably Christen Købke, in whose art Danish painting reached its culmination. His precise renderings of land-

scape and architecture were enhanced by a brilliant light that lent his imagery buoyancy and freedom.

Thanks to their loving observation of reality, their deep penetration into the individual traits of landscapes, buildings, and human beings, the Danish painters achieved a veracity in their work that far transcended mere illustration. Uninfluenced by – or oblivious to – contemporaneous romantic or historicizing developments (as represented by the Nazarenes), they retained these qualities of lucidity and authenticity in both subject matter and treatment beyond mid-century.

The majority of Danish painters were not specialists in any one genre. Eckersberg, who in his early period even tried his hand – none too successfully – at mythology, devoted himself equally to landscape and cityscape, portraiture and seascape. He also spent years working on a handbook of perspective. Købke's subject matter was just as diverse, including landscapes and architectural views, figures out of doors and in interiors, portraits, and even a picture of a farmwagon and nothing else. It was on people in their everyday surroundings, indoors and out, that Danish artists concentrated most, as may be seen from the work of Wilhelm Bendz (see fig. 45), Jørgen Roed, and Martinus Rørbye. However, there were also a few pure portraitists, such as Christian Albrecht Jensen (see no. 34) and Ditlev Blunck (see nos. 9, 10).

The Copenhagen Academy was a key center not only for Scandinavia but for northern Germany as well. Carstens, Runge, and Friedrich were students there, and for many artists from Hamburg it was a place of schooling and inspiration. The great commercial harbor, at that time a close neighbor of Denmark, had no great artistic tradition of its own. But then, in 1803, the brilliant Philipp Otto Runge returned to his native town. Trained at the Copenhagen Academy, where he was a favorite student of Abildgaard's, he had received further important stimuli in Dresden. His influence in Hamburg was considerable, encompassing even the much younger artists Julius Oldach, Friedrich Wasmann, and Victor Emil Janssen.

Active in Hamburg from 1814 was the portrait painter Friedrich Karl Gröger, who had gathered a large clientele in Lübeck and Kiel during the final decade of the eighteenth century. Although his numerous commissions led to a rather routine facility of manner, this did not prevent him from creating sensitive renderings of certain individuals. His *Portrait of Foster Daughter Lina* (fig. 1), despite the fact that it is still very much in the tradition of French por-

Fig. 45 Wilhelm Bendz, *The Artist's Brothers*, c. 1830. Den Hirschsprungske Samling, Copenhagen

nals have become unimportant, illuminated by a light that leaves nothing unrevealed without being merciless.

The same is true of Julius Oldach's *Portrait of an Old Lady* (fig. 46), in which the woman's thoughts have carried her far away from her knitting and cup of coffee. This image, too, is devoid of space and action. It is a penetrating depiction of an individual human being, and the objectiveness of its approach is not limited to the lace and brooches but captures the sitter's personality with equal precision.

The landscape painters active in Hamburg discovered the expansive flatlands around the city and depicted them straightforwardly in views that frequently seem almost arbitrary. The rapid oil sketch on paper, made outdoors, was a favorite medium and soon became valued in itself, as an autonomous work of art. Hamburg artists observed the landscape closely, yet with a certain objective detachment, just as the portrait painters respected the privacy of their sitters. In addition to direct influ-

traiture, shows how receptive the 49-year-old artist was to innovations, especially in Copenhagen painting. Focusing on the sitter's head and shoulders, set against a neutral background and undisturbed by accessories of any sort, this lovingly observed depiction of a young girl gazing straight at the viewer is certainly one of the most beautiful portraits of the early Biedermeier period.

Although *Judge Jacob Wilder* (no. 43) dates from just four years later, 1819, it is obviously the work of an artist of the next generation –

Johann August Krafft. Here, there is no evidence of routine whatsoever; on closer scrutiny, one even detects a certain awkwardness, as in the overlarge hand. Still, the artist is a master of precise description, of his sitter as well as of the objects in the picture, such as the spectacles or the water glass. A corner of a room has been suggested, with a table in the foreground; but the space is really too constricted for the table or for the old man behind it. What Krafft has depicted is not so much a retired judge in his favorite room as an old man for whom all exter-

Fig. 46 Julius Oldach, *Portrait of an Old Lady*, 1829. Kunsthalle, Hamburg

Fig. 47 Carl Gustav Carus, *View from Montanvert to the Mont Blanc Group*, 1824. Staatsgalerie, Stuttgart

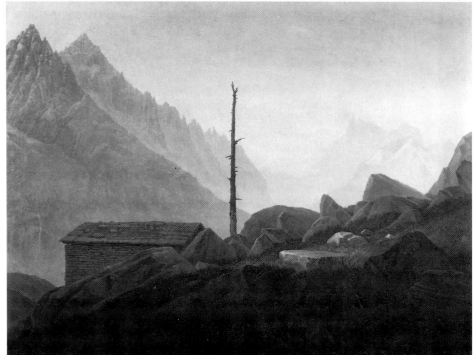

ence from Denmark, English qualities are clearly detectable in their work, deriving from such artists as Constable, Bonington, and even Turner, whose landscapes had been admired – and criticized – in Germany since the 1820s.

Almost all the Hamburg Biedermeier painters had studied for a shorter or longer period not only in Copenhagen but in Dresden as well. For a generation interested in the art of the past, Dresden was attractive as the site of Germany's finest picture gallery. It also had an academy and, in particular, a number of significant artists whose presence promised inspiration and an exchange of ideas. Among those

who settled in Dresden were, in 1798, Caspar David Friedrich; in 1805, Gerhard von Kügelgen; in 1808, Georg Friedrich Kersting; and in 1818, Johan Christian Dahl. Carl Gustav Carus, physician to the King of Saxony, was a friend of these artists and an accomplished painter in his own right who had developed a scientific theory of landscape painting.[61] His close friendship with Friedrich led to mutual influence. Carus, too, advocated an objective rendering of landscape, but to an extent that far transcended mere observation. To paint a landscape, he believed, one had not only to see it but to know it, down to its geological formation. Carus viewed landscape as an animate organism that was subject to moods of the most varied kind. "The good conscience of realism," one later commentator called him.[62] In his *View from Montanvert to the Mont Blanc Group* (fig. 47), Carus painted a realistic depiction of a mountainous landscape very much in the Biedermeier mode, especially in terms of the composition built up of sharply contoured and superimposed layers. The dead tree, and the flat rock lying in the clearing before it, might conceivably occur in nature, though they carry immediate and obvious symbolic overtones of death and redemption.

Even more obviously symbolic is the work of Johan Christian Dahl, a Norwegian artist who was also a close friend of Friedrich's and shared a house with him for twenty years. Dahl painted storms at sea with survivors of shipwrecks being saved at the last moment; he also depicted the eruption of Vesuvius, moonlight nights, and dark stormy landscapes. Nonetheless, these dramatic subjects were suffused with a certain cool objectivity, no different from that of his peaceful interiors and flower gardens (see no. 12).

Perhaps the most delightful Biedermeier painter of all was Georg Friedrich Kersting. Louise Seidler, herself an artist, said of his pic-

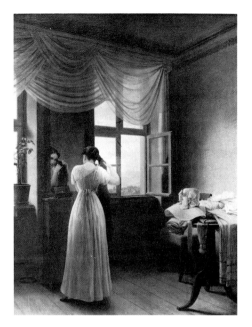

Fig. 48 Georg Friedrich Kersting, *In Front of the Mirror*, 1827. Kunsthalle, Kiel

tures: "Everyone found pleasure in the happy idea, which he often put into practice, of depicting the persons he was to portray in full figure … in the interior of their home. It is truly interesting to see beloved or excellent people in surroundings indicative of their calling and therefore characteristic of their entire nature." Seidler herself modeled for some of Kersting's intimate interiors (see fig. 48) and reported that they brought their author "undivided praise."[63] Kersting's love of detail, his precision, and his joy in narrative provide an insight into middle-class lives and homes of the period – humble but neither sentimental nor straitlaced (see no. 37).

Berlin was a modern, pulsating metropolis, both a royal seat, with aristocracy, diplomatic corps, and the military, and a middle-class city that was inhabited by some of Germany's most renowned scholars, jurists, and theologians. It was enlivened by the unostentatious but intellectually high-ranking salons of famous women, and blessed with regular and outstanding art exhibitions.[64] More than 470 painters lived and worked in Berlin during the Biedermeier years, though most of them are admittedly known today only by name.[65] The sculptor Gottfried Schadow had established the reputation of the Berlin Academy, where, from 1809, Johann Erdmann Hummel was Professor of Architecture, Perspective, and Optics. His book *Free Perspective, Elucidated by Means of Practical Exercises and Examples, Principally for Painters and Architects* – two volumes of text and two of plates – was published in 1824–25. Hummel's exactitude in rendering Berlin street scenes, in which he liked to include the figures' reflections, set standards for the younger architectural painters Johann Heinrich Hintze, Eduard Gaertner, Karl Hasenpflug, and Friedrich Klose. These had all studied and collaborated with Karl Wilhelm Gropius, a painter of decorations and stage sets who devoted himself principally to grand panoramas. Working with him amounted to a superb course of training in perspective, lighting, and choice of vantage point.

The city of Berlin comes alive in the views of its streets and squares that Eduard Gaertner depicted with well-nigh scientific accuracy. In some pictures the beholder is given a distant vantage point (see fig. 49), while in others he is allowed to mingle with the inhabitants or is left quite alone in a deserted square (see fig. 50). Gaertner takes us up to the rooftops or to lofty palace platforms that were not open to the public, or lets us gaze from attic windows. The view generally includes some important building,

Fig. 49 Eduard Gaertner, *Klosterstrasse in Berlin*, 1830. Staatliche Museen Preussischer Kulturbesitz, Nationalgalerie, Berlin

Fig. 50 Eduard Gaertner, *The Workshop of the Gropius Brothers*, 1830. Staatliche Museen Preussischer Kulturbesitz, Nationalgalerie, Berlin

whether newly erected or a traditional landmark, but they appear as if glimpsed by accident, half-hidden, seen from the side or obliquely, rather than from in front of the main elevation. It was not so much the city of Berlin that Gaertner depicted as the city of the Berliners; and it was they who bought his paintings.

The principle of chance, applied so often in the cropping of motifs during the Biedermeier period, is also evident in the illumination of these cityscapes. Frequently, the main building lies in shadow, dominating the composition without the aid of highlighting (see fig. 50). This lends even more vitality to the brightly lit parts of the picture and, with the cast shadows on the ground, creates lucid spatial relationships and atmosphere.

Among the Berlin artists of the older generation, the most influential as a teacher was probably Wilhelm Wach. After training in Paris with Antoine-Jean Gros and François Gérard, he opened a private school of painting in 1817 and also taught at the Berlin Academy from 1820. The year before, Wilhelm Schadow, the sculptor's second son, had also become a professor there. He had spent almost nine years in Rome, where he had formed close contacts with the Nazarenes and was involved in the decoration of the Casa Bartholdy. Although he had converted to Catholicism in Rome, Schadow's Prussian level-headedness prevented him from becoming just another minor painter of madonnas. In his portraits he digested his Italian impressions in a very personal way, combining objectivity of description with the compositional principles and palette of Raphael, whose work he had studied extensively in Rome. His *Portrait of Agnes d'Alton* (fig. 51) is a characteristic painting of the Biedermeier period in its frankness of approach, its lighting that leaves nothing hidden, its shallow space cut off from the background by a "backdrop" landscape, and in the extreme care lavished on the rendering of gown and coiffure. Yet the color scheme and composition – the young woman's pose recalls a Virgin

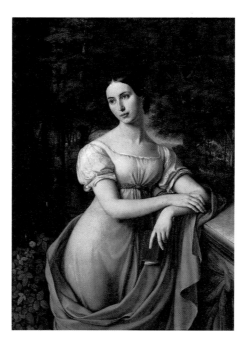

Fig. 51 Wilhelm Schadow, *Portrait of Agnes d'Alton*, 1825. Kunsthalle, Hamburg

of the Annunciation[66] – the symbolically evocative forest, and the rose bush show Schadow's sensitivity to the High Renaissance, whose idiom he mastered with a certain Prussian severity.

In 1826 Wilhelm von Schadow was appointed director of the Academy in Düsseldorf. He left Berlin together with a number of his students – Theodor Hildebrandt, Karl Sohn, Julius Hübner, Karl Friedrich Lessing, and Eduard Bendemann. These artists formed the nucleus of the Düsseldorf school, which very soon abandoned the Biedermeier style. Also active at the Düsseldorf Academy at that time was the portraitist Heinrich Christoph Kolbe, who was of the same generation as Gröger in Hamburg. His Paris training – Kolbe was a pupil of Gérard in 1800 – can be clearly

detected in all his portraits, even those of his final period. He remained at odds with Schadow and his circle.

The extent of Schadow's influence on his pupils may be seen from a large painting completed in 1833, *The Bendemann Family and the Schadow Circle*, a group portrait of Eduard Bendemann's parents with their two sons, daughter, granddaughter, and son-in-law (the painter Julius Hübner) surrounded by Bendemann's artist friends Wilhelm von Schadow, Karl Sohn, and Theodor Hildebrandt (fig. 52).[67] The composition is based on a sketch by Hübner of 1830, but all the artists portrayed actually worked on it, painting each other's portraits in a style so homogeneous that no individual "hands" can be discerned. In the relieflike structure of the painting, with the figures disposed in layers within a shallow space, in the objective rendering of clothing and objects, and in the sensitive precision with which the friends depicted one another, this painting represents a last flowering of the Biedermeier style. Soon the Düsseldorf school would become famous for its sentimental renderings of religious, historical, and genre motifs, which totally relinquished the principles of Biedermeier painting (see fig. 5).

In Munich, a number of diverse talents were active in 1815. Dominating the Academy, which was founded in 1808, was its director, Peter von Langer, a pedantic Neoclassicist who ran the composition class with his son, Robert von Langer.[68] The late eighteenth-century tradition of portrait painting was carried on, excellently but in almost complete obliviousness to recent developments, by Johann Georg Edlinger, Moritz Kellerhoven, and Joseph Hauber. Even a member of the younger generation in Munich, Karl Joseph Stieler, could remain a highly regarded portraitist in the Empire style throughout the entire Biedermeier period, much employed by Munich royalty and in Vienna.

Among the landscape painters of note were Simon Warnberger, Johann Jakob Dorner, and Max Joseph Wagenbauer, all of whom relied heavily on seventeenth-century Dutch painting. Head of the landscape class at the Academy was Georg von Dillis who, though he never completely divorced himself from the eighteenth century, had such a fine feeling for nature that he became the founder of the naturalistic school of landscape painting in Munich. His brilliant, on-the-spot sketches made an especially lasting impression on his younger contemporaries despite the vestiges of nervous, Rococo brushwork they contain. Two other artists working in the Dutch style were the talented, but not particularly outstanding, genre and battle painters Albrecht Adam and Peter von Hess.

True Biedermeier objectivity was actually achieved in Munich by only two artists: Wilhelm von Kobell, who had moved there from Mannheim in 1792, and Domenico Quaglio, a man twenty years his junior. Kobell was appointed professor at the Academy in

Fig. 52 Julius Hübner and Karl Sohn, with Eduard Bendemann, Theodor Hildebrandt, and Wilhelm Schadow, *The Bendemann Family and the Schadow Circle*, 1830–33. Kaiser Wilhelm Museum, Krefeld

1814 and ennobled in 1817. He also had his roots in the Rococo, and he too studied the Dutch painters of the seventeenth century. He took a huge step forward in his artistic development with the large battle pictures commissioned by the Court and executed between 1808 and 1815. The bird's-eye view, a seventeenth-century principle that he adopted to do justice to the assignment, took on a new expansiveness and a new quality of light in these canvases, features which, combined with sober objectivity in the rendering of details, pointed to the future. The charm of Louis Seize painting merged here with the sharply focused objectivity of the Empire style. For the 50-year-old Kobell it was only a short, and almost inevitable, step to Biedermeier realism, and with his small-format landscapes with staffage – or rather, depictions of horsemen and farmers against a landscape foil – he became the most significant representative of Biedermeier painting in Munich.

These compositions almost invariably show a hill or rise whose foreground appears to tip sharply upward and which is populated by a few figures and animals seen from very low down but very close up and illuminated by strong light from the side (see nos. 39, 40). Although the figures are by no means without relation to one another, there is no "plot" in the sense of a genre painting. Absolute calm reigns, as if it were always Sunday. Behind the foreground "stage," in a second, darker-hued stratum, extends a distant and usually lower-lying landscape – always based on a real topographical situation – which, despite its precise depiction, remains inaccessible to the viewer, who observes it as if through a window. The figures generally found in this zone, sometimes in great numbers, are far-off and tiny. This shallow strip of landscape is bounded at the back by

Fig. 54 Ferdinand Georg Waldmüller, *Lake Gosau*, 1852. Kunsthalle, Bremen

Fig. 53 Ferdinand Georg Waldmüller, *The Mother of Captain Stierle-Holzmeister*, 1819. Staatliche Museen Preussischer Kulturbesitz, Nationalgalerie, Berlin

a mountain panorama or the silhouette of a town that stands out sharply against an expanse of sky.

The perpetual Sunday mood in Kobell's small canvases certainly cannot be said to reflect the social realities of the period. Bathed in light reminiscent of stage illumination, these silent scenes, with their minutely rendered details of clothing, harnesses, and the like, give the impression of a moment of suspended animation, a pause for breath before some violent imminent change. However, this imagery is far removed from romantic idealization or sentimental prettiness.

Domenico Quaglio, like the Berlin cityscape painters, was trained in stage design, and, like his brothers Simon and Angelo and his father Giuseppe, was originally a scene painter. His absolute mastery of atmospheric and linear perspective resulted from this training. His views of Munich amount to archaeological

reports, and some of them were indeed commissioned by the king as records of the city before and during the profound alterations it underwent as a result of the tremendous increase in building activity that set in at that time (see nos. 51, 52). That it was basically still a medieval city that Quaglio depicted is hardly noticeable from his compositions, for he had a penchant for the spacious and airy parts of town and was adept at transforming even narrow lanes into wide thoroughfares.

King Ludwig I appointed Peter Cornelius to replace Langer as director of the Academy, granting him "the powers of an absolute tyrant in the field of art."[69] Under Cornelius the Academy continued to oppose the Biedermeier artists, a state of affairs which led in 1824 to the founding of the Kunstverein, an art association devoted to providing independent painters of middle-class life with an opportunity to exhibit and sell their work. This followed the example

set by craftsmen and tradesmen, who had earlier established cooperative shops to market their products. Founding members of the Kunstverein were Domenico Quaglio, Karl Joseph Stieler, Peter von Hess, and the architect Friedrich Gärtner; they had to contend with resistance both from the Academy and from the Court.[70]

Toward the end of the Biedermeier period a number of artists from the north came to Munich: Thomas Fearnley from Norway, Christian Morgenstern (see no. 46), Friedrich Wasmann (see no. 73), and Louis Gurlitt from Hamburg, Christian Ezdorf from Saxony (see no. 23), Carl Morgenstern from Frankfurt, and Andreas Achenbach from Düsseldorf. Each of them was highly influential in his own way, and together they brought a refreshing breath of Copenhagen *plein air* painting to Munich. It was they who recognized the innovatory importance of Dillis's oil sketches and who subsequently raised this genre to a valued art form in its own right.

In Vienna, Heinrich Füger, a strict Neoclassicist, was appointed vice-director of the Academy in 1783 and its director in 1795. Although he was an excellent and popular teacher, no great creative achievements emerged from the Academy under his leadership. Most Viennese painters made a living from portraiture, for which there was a continually increasing demand, particularly during the Congress of Vienna. They found competition – and a great deal of inspiration – in such artists of European standing as Jean-Baptiste Isabey, François Gérard, and especially the Englishman Thomas Lawrence, who rushed to Vienna for the Congress.

The emergence of a new, characteristically Biedermeier approach to portraiture can best be traced in the work of the most significant Viennese artist of the day, Ferdinand Georg Waldmüller. In his polemical essay on the teaching of art, Waldmüller described a portrait commission he had received: "Captain von Stierle-Holzmeister requested me to paint a portrait of his mother. But, he declared, I want you to paint her just as she is. In accordance with his request, I attempted to reproduce nature with the greatest possible fidelity – and succeeded! It was as if a blindfold had suddenly been torn from my eyes. The only true path, the eternally inexhaustible source of all art – observation, comprehension, and understanding of nature – had been revealed to me."[71] With a verisimilitude that concealed nothing, Waldmüller depicted the worthy and venerable Hofrätin in her dressing gown – *The Mother of Captain Stierle-Holzmeister* (fig. 53). Precisely as a result of careful observation, he was able to capture the personality of his sitter so fully that her expression of kindness and delightful frankness makes one oblivious to the over-fashionable artificial locks around the matronly face and to her rather barrel-shaped figure. Compressed into the frame, she fills the picture plane almost entirely, and is placed against a neutral background whose character, indeed

Fig. 55
Johann Christian Dahl,
View of Pillnitz Palace,
after 1824.
Museum Folkwang, Essen

existence, is rendered totally unimportant by her immediacy of presence.

Portraits played a key role in Waldmüller's extensive oeuvre, particularly during the Biedermeier period. He set standards in the field for some time to come, influencing even such gifted artists as Johann Ender, Erasmus Engert, and Leopold Kupelwieser (see no. 44). It was only the much younger Friedrich von Amerling, born after the turn of the century, who developed new forms of expression. After graduating from the Academy, Amerling went, in 1825, to London, where he spent the better part of a year in the studio of Lawrence, who continued the English portrait tradition of George Romney and Sir Henry Raeburn into the nineteenth century. The effect of this late eighteenth-century approach on Amerling's work is immediately obvious, especially in the easy confidence with which he portrayed not so much individuals in themselves, as Viennese society as it was embodied in each of his sitters. Thanks to a virtuosity of handling learned from Lawrence, Amerling was able to lend his paintings considerable spontaneity, while providing ample space for his sitters and for the necessary props, an arrangement which gives the impres-

sion that they have freedom to act (see no. 3). Even in the close-cropped portraits with a neutral background there is a sense of space around the figure. By taking late eighteenth-century English painters as his models, Amerling anticipated future developments in painting and soon passed beyond the modest verisimilitude of the Biedermeier approach – just as the people he portrayed were to advance from the middle to the upper middle class.

In contrast to Berlin or Copenhagen, there were almost no artists in Vienna who concentrated on architectural views, yet several landscape painters of outstanding merit worked in the city.[72] One was Johann Christian Brand, from 1771 Professor of Landscape Painting at the Academy and an influential mentor to a great number of students. Such artists as Joseph Fischer and Josef Mössmer carried on the tradition of idealized landscapes, as represented by Brand, far into the nineteenth century. Important for Viennese landscape painting of the Biedermeier period were the projects undertaken by various publishers and by Archduke Johann, who commissioned his *Kammermaler* to depict the mountainous Steiermark region. Thomas Ender's studies of

glaciers were among the works to result from the archduke's initiative (see no. 22). Without attempting to evoke mood or atmosphere by painterly means, these completely straightforward depictions still convey the awesome grandeur of the natural scene.

Waldmüller's approach to nature has been described as an "uncompromising involvement with visible reality" (see fig. 54).[73] His objective representations of a certain place and the view from it are bathed in bright, undramatic sunlight and executed in dry, but by no means pedantically meticulous brushwork. The beholder's standpoint is always clearly defined. Waldmüller continued to work in this manner until, with the pictures of his late period, he abandoned the principles of the Biedermeier style.

Genres and Forms

The finest achievements of Biedermeier painting were undoubtedly in landscape. During the second decade of the nineteenth century, artists liberated themselves more and more from past ideals and models and opened their eyes to the world around them, depicting what they saw without additions or changes, without trimming or prettification, in views selected as if by chance. Nature herself now came to figure as the artist's best teacher, and the classroom moved outdoors, as artists began to discover the beauty of their natural surroundings. The first criterion of a good painting had once been composition; now it was choice of view and its effective cropping. Most landscape artists of the period generally chose a low viewpoint corresponding to their own position, with the result that hills, mountains, and trees tower up before the beholder and obscure the sky. Frequently, sections of landscape will jut into the picture from the sides like stage flats arranged parallel to the picture plane (see nos. 23, 56) and with precisely defined contours that set them off from the sky or from other, more distant layers. This layering effect, characteristic of the Biedermeier style, works against a feeling of depth, even in cases where a higher viewpoint would have enabled great distances to be evoked.

The landscape is usually cut off abruptly by the edges of the canvas, and there is no visual framing of rocks or trees to delude us into thinking that it actually stops there. The foreground poses certain problems. In contrast to the eighteenth-century approach, an objective depiction of reality entailed a closeup view of the landscape foreground. But where was the picture to begin – at the tips of the painter's shoes? The device of setting up a "spatial threshold" – some arrangement of tree trunks, rocks, a fence, or whatever – ran counter to the demand for verisimilitude, so the foreground had to be depicted just as the painter saw it. In consequence, the terrain in these paintings appears to tip sharply forward toward the viewer, excluding him from the scene and providing no visual aids to ease accessibility.

There was one variation of Biedermeier landscape art that cleverly avoided this problem of lateral and frontal boundlessness: the window view (see fig. 55). Here, a window or an archway is used to frame the view and to contain it visually on all sides. Actually, this device amounted to shifting the picture frame into the image itself, adding a further layer, that of the interior, to the stratified structure of the landscape.

In general, the countryside in Biedermeier landscapes is devoid of human and animal life. Where figures or animals do appear, they are tiny, arbitrarily placed, insignificant (see nos. 21, 56). Nor is nature herself particularly animated – the air is clear and there is neither wind nor rain. Apart from running water, a favorite motif, nothing moves. Yet no attempt is made to render nature harmless; where she is awesome and violent, she is depicted as such. Although a landscape may be intrinsically threatening, it evokes no imminent threat (see no. 22).

All of this changed when the Biedermeier period came to a close in the early 1850s. No longer satisfied with pure description, artists

Fig. 56 Joseph Prestele, "Hibiscus radiatus." From Franz von Paula von Schrank, *Sammlung von Zierpflanzen* (Munich, 1819)

began to add an anecdotal element to their landscapes. The countryside became populated with countryfolk resting from the harvest (and bearing little resemblance to real farmers), with lovers, praying pilgrims, and bathing girls. Cattle went down to the stream to drink, and peasants rushed home with their haywagons to escape the oncoming storm. The weather began to symbolize and suggest a wide range of moods, sunsets suffusing the landscape with melodramatic light.

There was a concomitant change in technique, as loose brushwork replaced the

carefully rendered, smooth surfaces of Biedermeier painting. Colors took on an intrinsic, no longer purely descriptive value of their own. The artist's viewpoint was raised high above the countryside to evoke the boundless space of nature.[74]

Closely related to the landscape was the genre of cityscape, which likewise received a highly characteristic treatment in the Biedermeier period. Instead of topographical views seen from a distance or architectural landmarks depicted as centers of interest, Biedermeier cityscapes appear to represent random glimpses of the kind one has when walking through a town (see nos. 52, 57). Although important buildings occasionally come into view, it is apparently more by chance than intention. This statement must be qualified, of course, because the great painters of architecture, Gaertner in Berlin and Quaglio in Munich, frequently received commissions to depict certain buildings. Yet since they avoided frontal, let alone axial, views and chose ones that have a decidedly casual, accidental character, the great edifices appear part and parcel of the city and of the daily life of its inhabitants.

Unlike the landscapes, Biedermeier cityscapes are invariably enlivened by figures. It would have been unrealistic to depict streets and squares devoid of life. Still, the people in these paintings are noticeably small, playing the role of inhabitants but having little significance as individuals.

As in the landscapes, there is little sense of depth in Biedermeier town views. Frequently, the image is developed in planes parallel to the picture plane, and gaps and openings through which a view might be had tend to be obstructed (see no. 58).

During the 1850s cityscapes, too, underwent a transformation, developing away from the sober objectivity of the Biedermeier approach. Gaertner's later views were more imposing and larger in format, and were characterized by self-conscious compositions and by evocations of depth. Artists now began to orient themselves to the cityscapes of the Rococo, in which cities were depicted as built works of art. Great expanses of sky engendered a sense of space; cloud formations and sunlight created a dramatic scenery of their own. It was as though the gauzy veils of Rococo skies had descended over nineteenth-century cities.

The third great theme of Biedermeier painting was the portrait.[75] A rising and self-confident bourgeoisie became the foremost patron of art and artists, almost all of whom devoted some of their effort to portraiture. A few specialized in supplying certain clienteles, traveling from city to city to paint literally hundreds of portraits – Johann Peter Krafft is said to have done over two thousand. At any rate, more portraits were painted during the Biedermeier period than at any other time before or since.

The late Baroque portrait, principally devoted to illustrating the sitter's status, had long become outmoded, but the distance established between artist and model had continued

to be *de rigueur*. Biedermeier painters were the first to overcome this invisible wall. They approached their sitters as equals, depicting them sympathetically but without flattery. As a result, the viewer, returning the sitter's gaze, enters into a human relationship with him or her.

The background is almost invariably neutral, insubstantial; only rarely is there a suggestion of an interior with furniture or other accessories. The sitters are illuminated by a bright, but not glaring, light whose source seems to be some distance away.

The most common type of Biedermeier portrait was the frontal bust, slightly less than lifesize, just as one sees oneself in the mirror. Miniature portraits were also very popular. More importantly, an entirely new format, in between lifesize and miniature, came into use at this time and enjoyed special favor (see no. 34). The sitters are generally closely contained by the frame, the bottom edge of the picture frequently cutting across the upper arms and the top edge sometimes touching the head (see no. 19). Even where an interior space is suggested, there is no real feeling of depth; the back wall of the room always runs parallel to the picture plane, and even landscape backgrounds appear to close the image off like a tapestry.

The persons represented are immobile, simply sitting for their portrait. Group portraits are rare in the Biedermeier period, and even when several people are depicted together, they remain unrelated by any shared activity. The group portrait tends to be a combination of several individual portraits (see nos. 7, 49).

As with other genres, the early 1830s marked a watershed. The quiet togetherness of Biedermeier group portraits no longer sufficed; action entered the pictures and transformed them into genre scenes. Waldmüller, for instance, in his 1834 painting *The Family of Dr. Eltz*, tells the story of a father returning home, evoking his feelings for his favorite son, his surprise at how the youngest boy has grown, and suchlike. Amerling's *Rudolf von Arthaber and His Children* of 1837 is also really more a genre painting than a pure group portrait in the Biedermeier sense.

In individual portraits, too, a new approach became evident that led away from strictly objective renderings of the human image. In 1835 Franz Eybl portrayed *The Innkeeper of Krottensee* in his public parlor, a half-emptied beer stein in his hand, a suspicious look in his eye as he gazes off into the distance; and in 1838 Amerling dressed one of his clients, a Vienna society lady, as a Spanish *Lute Player*, lost in reverie over the strains of her music.

Although still life in general was not a key theme of Biedermeier painting, flower pieces certainly were. Flowers played an unprecedented role in the life of the period. Everyone who could, grew them in gardens – in town or in the suburbs (see no. 12) – in private greenhouses, or in their homes. Botanical works, with pictures by specialist illustrators,

appeared in large editions (see fig. 56). There were numerous journals and manuals devoted to flowers; everybody knew their names and was adept at "saying things with flowers." As decoration for porcelain and glassware, on samplers and in albums, there was no better or more popular motif. In 1812 a class in flower painting was even established at the Vienna Academy.

Initially, artists quite naturally created flower pieces along the lines of the seventeenth-century Dutch masters, but these models were soon abandoned. Favorite motifs of Biedermeier painters were flower arrangements in vases, freshly picked wildflowers (see no. 63), or bouquets made up of only a single variety, gathered in the garden (see no. 18). The occasional seashell or extinguished candle provided a symbol of transience of the kind found in every Dutch flower piece (see no. 18). Such symbolism, however, was secondary, for the main concern was to depict only varieties that actually bloomed at the same time and to arrange them as naturally as possible, even in cases where the flowers were distributed evenly across the canvas (see no. 18). It was not until the late Biedermeier years that the influence of Dutch still lifes resurfaced: flowers and fruit once again began to be depicted in artfully composed profusion, and flower arrangements in exquisite vessels were placed in niches created for the purpose (see no. 61).

Genre scenes were quite definitely not a theme of Biedermeier painting. Indeed, genre pictures put an end to the objectivity so characteristic of the period.

Eybl's *Young Girl Placing a Wreath on a Cemetery Cross*, which dates from 1828, is neither a portrait nor an objective rendering of a rural graveyard. The painting tells the touch-

Fig. 57 Meissen cup bearing a reproduction of Theodor Hildebrandt's painting *The Assassination of the Sons of Edward IV*, after 1855. The Metropolitan Museum of Art, New York

ing story of a daughter visiting the grave of her mother, who died in childbirth, and it is a story to which everyone who sees the picture can provide his own ending. That same year, Josef Danhauser painted *The Scholars' Room*, a studio where young art students are apparently fooling around instead of working, and are caught out by their instructor when he suddenly appears at the door. This, too, is a story, a lighthearted anecdote to be finished by the viewer, and it has nothing in common with Biedermeier depictions of studios. A humorous twist has replaced the sober record. Another example dating from 1828 is Johann Michael Neder's *Coachmen's Quarrel*, which again depends on a plot whose beginning and ending one is encouraged to imagine for oneself. Also in 1828, Waldmüller created two sentimental genre scenes – *The Old Fiddler* and *A Boy Who has Received a Prize Medal at School* – which roll out the entire repertoire of blind grandfather, proud parents, rural atmosphere, and so forth. Not surprisingly, literary themes also became increasingly popular. Still in 1828, Karl Sohn painted *Rinaldo and Armida*, and Julius Hübner, inspired by Goethe's poem "The Fisherman," his *The Fisherboy and the Mermaid*. Finally, narrative elements even entered landscape. Carl Friedrich Lessing's *Castle on the Cliff*, likewise dated 1828, is a fantastic fairy-tale scene that bears not the slightest resemblance to any actual site.

Just as sentimental as Eybl were Peter Fendi, with his picture of a servant girl hesitating to enter *The Lottery Arcade* (1829), Emil Ebers, depicting a mother and her daughter surprised by an *Approaching Storm* (1831), or Adolf Schroedter, in his evocation of *Tanners in Mourning* (1832). An enjoyment of covert eroticism became apparent in scenes with poor officers' widows languishing in négligés and in various views through keyholes, while good clean masculine fun was had at endless wine tastings and bowling meets.

Again in that watershed year of 1828, Johann Peter Krafft began his extensive cycle of scenes from the life of Emperor Franz I in the Vienna Hofburg. A year later, Franz Krüger, working for Grand Duke Nicholas of Russia, produced his large picture of a parade on Opernplatz. With this work, an entirely new quality entered depictions of contemporary events, and it spread to history painting as well, which proved as susceptible as any genre to the pervading sentimentality. Significantly, *The Assassination of the Sons of Edward IV* (1835) by Theodor Hildebrandt was one of the most popular paintings of the period (see fig. 57).

History and genre – "the history of everyday life"[76] – were themes that, anticipating the future, supplanted the straightforward and unassuming objectivity of the Biedermeier style. The innovations and developments that produced the art of the second half of the nineteenth century, which was far more closely related to the new approach than to Biedermeier, were introduced during these few years between 1828 and 1835.

The Decorative Arts

Furniture

That Biedermeier was a middle-class style first became apparent to historians from the furniture produced in the period following the Napoleonic Wars, and it remains the best area for demonstrating the fact.[77] While in the foregoing Empire style furniture designs had been provided by architects, now they were the responsibility of craftsmen themselves. Hence craftsmanship, with all its advantages and limitations, became one of the key formal elements of Biedermeier furniture. Its forms arose from artisans' ideas and reflected the conditions of their craft.

The principal aim of Biedermeier furniture-makers was to do justice to their materials. The foremost of these was naturally wood, and the main form in which it was used was the board. As never before, wood was valued for its qualities as a material, serving both as the basic source of ornament and, in the shape of the flat board, as the determining formal element. Glued together into large panels and covered with veneer, such boards formed smooth surfaces broken only by battens and pilasters. These, in turn, were simply flat, applied strips with no load-bearing function, rather than the tectonic or sculptural elements they had been in previous styles (see fig. 58). Bases, cornices, and pediments were similarly reduced for the most part to simple battens and strips. Far from concealing the technical procedures used in making their furniture, Biedermeier craftsmen consciously emphasized them.

Apart from the properties of the material, the function of the finished piece was the main concern of these furnituremakers. Practicality was, of course, no discovery of the Biedermeier period, but the purposes to which furniture was put had changed. Up to and including the Empire period, every piece of furniture had its appointed place in the composition of a room, serving not only a practical function, but also – and perhaps more importantly – as a status symbol, a sign of its owner's place in the world: it was a permanent part of interior design. Biedermeier furniture, by contrast, was for the first time truly mobile, its relationship to the interior being as flexible and changeable as the lives of those who lived with it.

The typical round Biedermeier table, for instance, instead of being impressively placed in the middle of the room, usually stood in a comfortable corner, where it was used for dining[78] but also as a place for sitting and talking, for knitting or reading. Bureau-cabinets stood against the wall; in addition to functioning as writing desks, they were used to lock away all

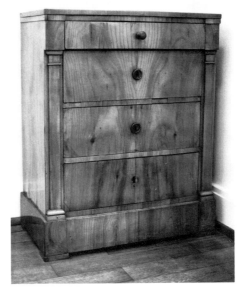

Fig. 58 Chest of drawers.
Western Germany, 1820/30.
Ernst Moritz Arndt-Haus, Bonn

Fig. 59 Console with drawer and cupboard.
Southwest Germany, c. 1825.
Rosgartenmuseum, Constance

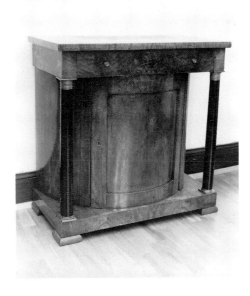

the letters, diaries, and albums that played such an important role in the life of the period. The point is that it really made no difference in what corner the table was placed or against which wall the bureau-cabinet stood. The pieces were interchangeable; the furnishing of interiors remained flexible, variable.

Functionality and truth to materials, then, were the principles that determined the formal character of Biedermeier furniture. The consistent use of boards gave rise to planarity, which is a trait typical of the Biedermeier style as a whole. Planarity in turn led to emphasis on a single point of view. Biedermeier cabinets and chests have a definite display side; they were not conceived in three-dimensional terms, nor were they made to be walked around. Even chairs and couches are strictly frontal in design. This quality of flatness extends to every component of Biedermeier furniture, including ornamentation. Rows of columns, caryatids, and even horizontal moldings, rather than interrupting the plane or extending it sculpturally into the third dimension, merely form an additional layer.

Obviously, all furniture is by definition three-dimensional, for when planes intersect, the result is a solid. Biedermeier furniture, however, never takes the form of a simple rectangular solid, but is built up of several solids fitted onto or into one another. The feet of chests and cabinets have the appearance of blocks grafted onto the larger block of the base; chests of drawers often have a top drawer conceived as a rectangular solid projecting beyond the front plane (see no.102). Superstructures generally take the form of additional solids, sometimes arranged stepwise (see no.94), and their pediment is usually a flat board superimposed on a block, or just a triangular shape outlined on the surface by flat strips of wood. Such details lend Biedermeier furniture a composite character which emphasizes the process of its making and its functional purpose.

Curved shapes do exist in Biedermeier furniture. However, they are never of the Rococo type but, as it were, bent planes or rods (see fig. 59 and no. 116). Surfaces seem to curve backward; they never bulge outward. Even completely circular pieces or components, instead of containing space, have the appearance of simplified, sometimes cut-out, geometric solids. This tendency to clear, geometric forms can even lead to spherical components, especially in the case of small pieces (see no.108), and these provide particularly eloquent testimony to the cabinetmaker's skill.

A desire for comfort is also evident in the size of Biedermeier furniture. It hardly ever exceeds human scale, the tops of cabinets or chests usually lying at or slightly above eye level. Even wardrobes are often astonishingly small. The frequently constricted space of Biedermeier rooms led to the invention of multipurpose furniture – small cabinet-bureaus that could be converted into fire screens, sew-

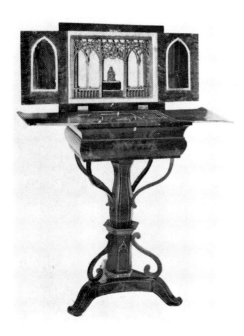

Fig. 60 Sewing table with altarpiece. Berlin, c. 1830. Whereabouts unknown

Fig. 61 Upholstered chair. Vienna, c. 1830/35. Österreichisches Museum für angewandte Kunst, Vienna

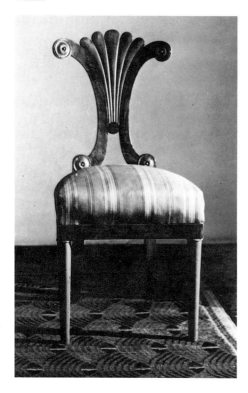

ing tables that doubled as domestic altars (see fig. 60) or as pianos. There were grand pianos whose case containing the strings was placed vertically, against the wall (the so-called *Giraffenklavier*), or which were disguised as bookcases, just as there were wardrobes made to resemble bureau-cabinets.

The most important ornament of Biedermeier furniture was provided by the wood itself. Its grain was emphasized to the greatest possible effect. Even for the largest pieces of furniture, sheets of veneer were always taken from a single tree trunk. They were butted together, usually with one or more vertical joints, but remained continuous and uninterrupted from the bottom to the top of the piece, revealing the growth pattern of the tree (see no. 101). This is yet another example of the planar approach to material typical of Biedermeier furniture.

Inlay work was far less common in, if not completely absent from, the furniture of the period (see no. 103). The surfaces of a piece were never entirely covered with inlays. Occasionally, recessed areas were given wood of a different color or grain (see no. 100). In some of the more elaborate pieces, pictorial images in another material were inlaid into the wood – for instance, painted porcelain tablets or engravings under glass. Otherwise, the entire formal canon of Neoclassicism, which cabinetmakers had mastered since the Louis Seize period, remained the norm for Biedermeier furniture.

Columns continued to be as popular as ever, though very rarely did they extend to the full height of the piece. They were usually inserted into a space in the body of a piece, and thus no longer fulfilled a load-bearing function, but served only to decorate or articulate the plane. Caryatids and herms were adopted from Empire furniture. Frequently, they had heads in the Egyptian style and highly naturalistic human feet, but also lion's paws, which were an extremely popular motif at the time. Sphinxes, dolphins, and especially swans were common ornamental motifs, particularly on sofas and beds. Extremely widespread was the lyre which, though also derived from the Empire repertoire, did not occur there to anything like the extent or in such variety as in the Biedermeier. Apart from being used as a small ornamental form, lyres were employed as the sidepieces of small tables and sometimes even determined the overall shape of a piece of furniture.

Ideally, a Biedermeier piece could do entirely without ornamentation and fittings (see no. 100). In practice, of course, this was very rarely the case. The traditional material of bronze for drawer handles and escutcheons was employed in Biedermeier furniture as well, though it was often replaced by thin sheet brass with embossed ornaments. Here too, most forms were adapted from the Empire style, but original Biedermeier motifs were also developed – drapery, vases, bouquets, cornucopias, and the like – which revealed a certain reliance on Louis Seize. In addition to embossed brass fittings, there existed imitations molded from paste and then gold- or bronze-plated to resemble metal.

There is no denying the origins of the Biedermeier style in the furniture of the foregoing Empire period. It would have been inconceivable without this austere style derived from Roman antiquity. Even the most creative masters of the Biedermeier had their roots in the epoch they rejected.

Ample, smooth, unornamented surfaces were also a feature of Empire furniture, but, in contrast to the Biedermeier, they were invariably framed by heavy moldings that made them into self-contained forms. The rectangular solid, too, was a typical Empire feature; indeed, it was employed there with far greater logic and consistency than in Biedermeier furniture. Empire furniture designers conceived the rectangular solid as a true, three-dimensional body, granting almost equal importance to all three surfaces, front and sides. Motifs at the corners often formed a meaningful transition from plane to plane (see fig. 62).[79]

The lucid, open construction of Biedermeier furniture had also been anticipated in the Empire period. Yet here, too, there were considerable differences. In Empire furniture, the constructive approach of the architect, his fine sense for the distribution of forces and loads, predominates. Unlike those of the Biedermeier, Empire columns and caryatids really do have a weight to bear. In sum, the architectonic prevails over the craftsmanlike. Fittings in the Empire period were decidedly large; such was the fondness for metal that sometimes entire pieces were gilded (see fig. 63).[80]

In conscious opposition to their predecessors, Biedermeier craftsmen sought ideals of a different order, for, despite superficial resemblances, Biedermeier furniture has, in essence, very little in common with the Empire style. The charm, comfort, and less heavy forms of Biedermeier derived from the first Neoclassical style, Louis Seize, and primarily from the German variant of this style known as *Zopfstil*. A preference for small, delicate furniture, and for light-colored wood, had already emerged during this period, which was also the source of the tapering, rectangular chair legs and of the multifarious forms of chairback found in the Biedermeier style. The bureau-cabinet, so widespread during the Biedermeier period, had also been very popular in the Empire period, but the frequently rich and imaginative design of the compartments behind the folding desktop in Biedermeier pieces exhibits far greater affinities with Louis Seize bureau-cabinets. Even such details as crowning vases or miniature balustrades were obviously derived from Louis Seize furniture. On the other hand, it was the strong reduction in detailing that set in about 1800 which became the norm for cabinetmakers of the Biedermeier period.[81]

In Germany, as in other countries, Empire remained first and foremost a French style, and the opposition to it on the part of Biedermeier craftsmen may thus have been, at least in part, politically motivated. French rule had been shaken off; French art, past or present, was considered undesirable. In consequence, there was no connection between Biedermeier furniture design and that of the contemporaneous French Restauration style.[82]

All eyes turned to England, the nation whose economic and industrial development was so far in advance of the Continent. All the im-

portant innovations and inventions, especially machine production, which was soon to revolutionize furnituremaking as well, came from England. It was almost a matter of course that English furniture design should have become the third key source of the Biedermeier style. The single point of view, for instance, one of Biedermeier's primary stylistic traits, is also found in contemporaneous English furniture, as is the method of designing in terms of an assembly of individual rectangular solids.[83] The collections of engravings by English cabinetmakers had long been known in Germany. Michael Angelo Nicholson's *The Practical Cabinet-Maker*, published in 1826, was certainly not without influence on Biedermeier craftsmen: for example, their penchant for sofas with strongly curved armrests, with delicate legs shifted slightly toward the center, and with a single-viewpoint design was prefigured in Nicolson's book. There were also small tables with lyre-shaped legs and sharply curving feet, drop-leaf tables with curved legs grafted onto a lower surface and ending without transition in small lion's paws, and small-scale pieces that served as flower stands or handiwork tables with basketlike containers made of thin, curved rods.[84]

It was not only the contemporary production of English furnituremakers, known through journals or, especially in northern Germany, through actual examples, that influenced Biedermeier craftsmen. As in their search for German models, they turned to English work of the late eighteenth century. Furniture from the later Sheraton period came to have considerable influence on German furniture design.

In sum, three sources contributed to the emergence of the Biedermeier style: Empire, Louis Seize, and English furniture.

Glass

The art of glass vessel making and decorating flourished during the Biedermeier period to an unprecedented extent.[85] New inventions, technical improvements, and an apparently inexhaustible creativity went hand in hand with an enormous increase in production. Toward the end of the period, the annual output of some glass factories reached the million mark.[86]

The undisputable center of glassmaking during the Biedermeier period was Bohemia, with the glassworks around Haida (Nový Bor) near the border with Saxony, Count Harrach's factory at Neuwelt (Novosvět) on the Silesian border, and finally, in the south, Count Buquoy's works on the outskirts of Gratzen (Nové Hrady). As early as 1803, there were already sixty-six glass factories in Bohemia.[87] Their products were exported throughout the world.

Plain glass for everyday use was naturally manufactured by factories outside Bohemia as well, some of which had existed for centuries and a few of which, in Lower Austria and Silesia, successfully competed with the Bohemian works for a time. Competition in general

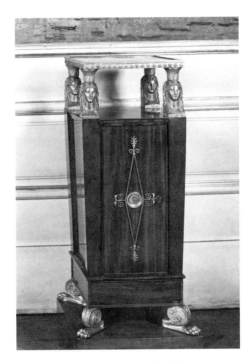

Fig. 62 Bedside table. Designed by Nikolaus Thouret, Stuttgart, 1804/12. Schloss Ludwigsburg

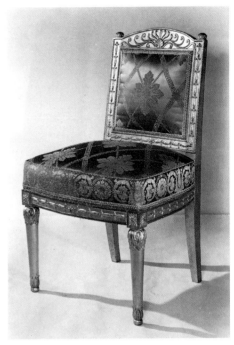

Fig. 63 Upholstered chair. Designed by Andreas Gärtner, Munich, 1810. Bayerisches Nationalmuseum, Munich

was extremely stiff, initially coming from the English lead glass that flooded the Continent after the blockade was lifted, but particularly strong among the Central European factories themselves. This competition spurred improvements, leading to the extraordinary variety of forms and decoration seen in the cut glass of the period.

Every conceivable type of vessel was made of glass during the Biedermeier period, including

Fig. 64 *Ranftbecher*. Gutenbrunn, Lower Austria, 1830. Engraved by Franz Gottstein. Österreichisches Museum für angewandte Kunst, Vienna

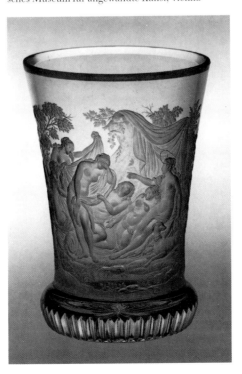

many that had previously been manufactured only in ceramics. Especially characteristic of the time, however, was the tumbler, which in its simplest form was cylindrical or slightly conical, tapering outward at the top. Glass tumblers were, of course, no invention of the years after 1815, the strictly cylindrical ones of the early Biedermeier period being based, like the other decorative arts of the day, on products in the Louis Seize style. Initially, thin, blown glass was employed, but soon after 1815 the sides of tumblers began to curve outward and the base to become thicker, sometimes displaying cut ornament around its edge or on the bottom.

What Biedermeier glassmakers did invent, however, was the form of tumbler known as *Ranftbecher* (see fig. 64). These were made of thick glass with cut and engraved surfaces. Their sides, which almost always curved slightly outward, were either left round to receive painted decoration or facetted when they were to be decorated by further cutting or engraving. The thick bases of these tumblers projected beyond the sides and, like the underside, were ornamented with cut patterns. In the early Biedermeier period these consisted of simple vertical, closely spaced notches, but soon decoration became more varied, with the base ring even transformed into a series of separate balls or cylinders in some later pieces. By 1830 the sides of these tumblers had become considerably flared, sometimes curving back in upon themselves to produce a graceful bell shape.

Glass finishing was generally the responsibility of specialists employed by the factories. After the "angle graver" had facetted the piece, the "cutter" executed further ornament in patterns composed of "rollers" and "eyes," "tur-

bans," "rattles," and "sheaves," to name only a few of the graphically descriptive craftsman's terms. Most popular was the "stone cut," a variety of diamond cut originally influenced by English crystal.

The exceptional variety of this cut ornament resulted from the conditions of the craft, from the technical possibilities available to the cutters. It was they who determined the forms and patterns of the decor; the style of Biedermeier cut glass was thus the exclusive product of the craftsman's imagination. The cutters were also responsible for preparing the smooth, oval surfaces that were to receive engraved work. Engravers were not generally employed by a factory, but worked on a freelance basis, obtaining cut glass from the glassworks. Many traveled, at least during the vacation season, to the great spas at Karlsbad (Karlovy Vary) and Teplitz (Teplice), Marienbad (Mariánské Lázně), Franzensbad (Františkovy Lázně), and Warmbrunn (Cieplice Ślaskie Zdrój). Bohemian engravers even went as far afield as the west German resorts of Wiesbaden, Baden-Baden, and Bad Ems, where they engraved portraits of the guests, views of the town, or just the wealthy customer's initials on the glassware.

The most outstanding glass engravers were Dominik Biemann and Franz Gottstein. Whereas only two signed glasses by the latter have survived, the preserved oeuvre of Biemann is quite considerable. His earliest extant piece is dated 1826. Biemann was so renowned for his superb portraits that he received commissions from royal houses (see no. 202), but he also produced religious and mythological scenes. Biemann submitted work to the exhibitions regularly held in Prague and won many awards. From 1825, he spent the summer of each year in Franzensbad, where he soon took up permanent residence, maintaining his workshop and living quarters in the resort's "wooden colonnade."

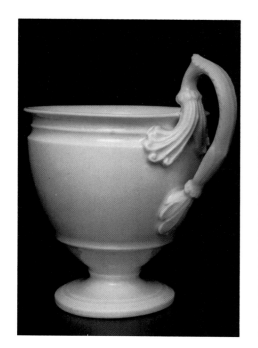

Fig. 65 Cup prototype. Vienna, 1825. Probably designed by Michael Neubich. Österreichisches Museum für angewandte Kunst, Vienna

Fig. 66 Pattern card of the Meissen Porcelain Factory, 1821/23. Staatsarchiv, Dresden

Franz Gottstein was active in Gutenbrunn, near the Viennese resort of Baden. Technically, he was perhaps even more gifted than Biemann, as evinced by the scene with Diana and Callisto on one of the signed pieces (fig. 64). The model for this was provided by an engraving from a more than sixty-year-old edition of Ovid's *Metamorphoses*. The use of such an "outmoded" design might seem surprising, yet it was by no means uncommon at the time.[88] Engravings after Rubens, Jean Bérain, Johann E. Riedinger, and other artists were continually drawn upon by Biedermeier craftmen, and this is indicative of the historical situation. On the one hand, these middle-class artisans were thrown back upon themselves; they were not employed by courts or aristocratic patrons, who would have brought artist and craftsman together or taken it upon themselves to obtain the latest patterns for the craftsman's use. Hence, Biedermeier artisans had to stay on the lookout for what was available. On the other hand, recourse to past works of art was considered entirely legitimate in the nineteenth century, as instanced by painters' reliance on seventeenth-century Dutch art.

In addition to cutting and engraving, translucent enamel painting was a technique highly characteristic of Biedermeier glassware. An important impulse was provided by the Gothic Revival, for the castles built in this style, their owners felt, would not be complete without colored windows like those of Gothic churches. Since craftsmen of the time were unfamiliar

with the techniques of medieval stained and leaded glass windows, they substituted enamel painting, which soon came to be employed for the decoration of glass vessels as well. Ceramics and porcelain were also highly influential. Samuel Mohn, a decorator of porcelain at the Dresden factory, was the first to apply the methods of porcelain painting to glassware. He established a small workshop and maintained several assistants and pupils, including his son, Gottlob Samuel Mohn (see no. 212). In 1811 Gottlob Samuel moved to Vienna, where at the porcelain factory he met Anton Kothgasser, his elder by twenty years. Soon the two were collaborating on the Neo-Gothic glazing of the Franzensburg in Laxenburg Park.

Kothgasser had been an employee of the Vienna porcelain factory for thirty-two years.[89] In 1816 he left the firm to establish his own workshop for the painting of glass vessels, selling his products to notions shops in Vienna. He also succeeded in gaining the assistance of some of the best porcelain decorators from the factory. His enterprise was devoted exclusively to painting on the new *Ranftbecher* type of tumbler, in motifs ranging from views of Vienna (see no. 217) to a great variety of Biedermeier themes, such as flowers and grasses, butterflies and fish (see nos. 216, 219), and anything else that lent itself to glassware intended as a gift. Kothgasser also produced views of spas and places of pilgrimage, as well as portraits and religious subjects. Although he had no qualms about repeating himself, execution was of a consistently superb quality, and this remained so even in those cases where the preliminary work was done by assistants. Indeed, Kothgasser's tumblers were among "the finest things to emerge from the decorative arts in the Biedermeier period."[90]

An entirely new invention of the Biedermeier period was colored glass and glass tinted to resemble semiprecious stones. While glassmakers had previously done their utmost to produce crystal-clear vessels, a new demand for bright color to replace the cool monochrome wares of early Neoclassicism led to the emergence of a new branch of glassmaking. Another motive for the development of colored glassware was a penchant, characteristic of the Biedermeier, for surrogates. The popularity of black Wedgwood china, for instance, led Count Buquoy to experiment with black glass, which he invented in 1817 and patented in 1820 under the trade name "Hyalith" (see no. 188). On the other hand, an effort to compete with porcelain brought improvements in the production of white or bone glass. A whole range of other hues, from blue and green to golden yellow, were produced by adding various metal oxides to the molten glass.

The reawakened interest in color, perhaps abetted by the traditional competition between stonecutters and glass cutters, inspired Friedrich Egermann, a glass painter, to develop a type of glass that resembled semiprecious stones, which he produced at Blottendorf, near Haida. In allusion to the trade name Hyalith he christened the result of his experiments with red glass obtained from Georgenthal or Neuwelt "Lithyalin." Egermann took out a patent on his discovery in 1828, but it did not protect him for long; soon, Count Buquoy, Joseph Zich in Lower Austria, and others had succeeded in producing similar wares (see nos. 190, 201, 208). While most of Egermann's glassware is of a red hue recalling carnelian, there are others in all variations of agate, from deep brown to amber yellow, from blue to light green. The full beauty of the marbled surface is revealed by the cutting.

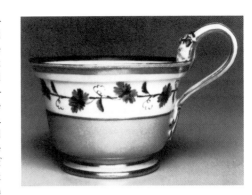

Fig. 67 Cup. Model no. E 191, Vienna, 1814. Österreichisches Museum für angewandte Kunst, Vienna

The prerequisites for the emergence of the Biedermeier style in glassware were, therefore, innovations in processing the raw material, alongside new methods and tools applied to finishing and decoration which – especially with engraving and translucent enamel painting – led to results of consummate artistry.

Porcelain

The state of European porcelain factories in the wake of the Napoleonic Wars was extremely precarious.[91] War and devastation, the Continental blockade, and such political changes as the territorial losses sustained by the Kingdom of Saxony (affecting Meissen) and the dissolution of the Kingdom of Westphalia (affecting Fürstenberg) inevitably had grave consequences for a feudally organized industry devoted to the manufacture of luxury goods. In addition, the heyday of the great factories – Vienna, Berlin, Meissen, Nymphenburg – had long since passed. The material and its processing and design were so

Fig. 68 Cup prototype. Model no. E 205, Vienna, 1816. Österreichisches Museum für angewandte Kunst, Vienna

Fig. 69 Cup prototype. Model no. D 241, Vienna, 1818. Österreichisches Museum für angewandte Kunst, Vienna

Fig. 70 Cup prototype. Vienna, 1825. Österreichisches Museum für angewandte Kunst, Vienna

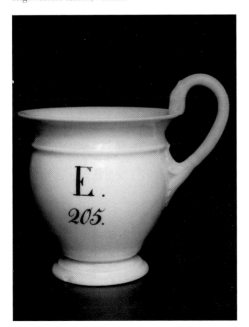

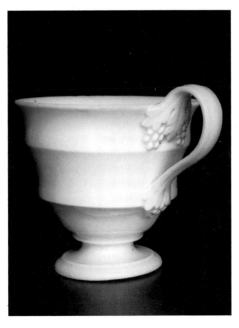

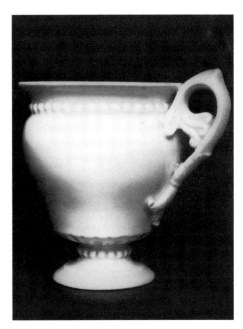

closely bound up with the Rococo that the factories had difficulty in adapting to the new, Neoclassical style of the late eighteenth century. They managed this best in tableware, where enough patterns for designs *à la greque* existed, be it the *krater, kalathos,* or *kyathos,* the "Campana" or the "Etrurian" forms. As in glassware, purely cylindrical designs also enjoyed great popularity. Tasteful decoration and continually improving painting helped the factories to a number of fine achievements before the eighteenth century was out.

After the end of the wars, porcelain manufacture experienced an unexpected upswing. The Congress of Vienna brought the factory there a business boom of unprecedented proportions, while the Berlin factory had its greatest turnover ever in the years 1816/17, doubling its decorators' salaries and its outlays for gold. Once again, it was the courts of Europe that spurred this revival. To honor the Duke of Wellington, the victor of Waterloo, Louis XVIII of France, Franz I of Austria, Friedrich August II of Saxony, and Friedrich Wilhelm III of Prussia commissioned their porcelain factories to produce elaborate services decorated with depictions of the most important events and places in the life of the duke.[92] By 1819 the Berlin factory had finished 470 pieces, that in Vienna 195, and the Meissen works 154. Concurrently, the Berlin factory received an order from the Prussian king to design the Field Marshal's Service for six other distinguished military leaders, as well as a further service to commemorate the marriage of Princess Charlotte and Grand Duke Nicholas of Russia.

In Bavaria, manufacture was improved by separating decoration from production, the latter remaining in Nymphenburg while painting was now carried out in Munich. Located near the Picture Gallery and the Academy of Visual Arts, the painting department was promoted to the rank of an Art Institute. All the decorators' salaries were raised and a general manager appointed to run the enterprise.

This flowering of the great porcelain works, however, was short-lived. Sèvres in France was a strong competitor for the market, as were the smaller, private factories in Bohemia and Thuringia, which, unspoiled by royal patronage, had long devoted themselves to the manufacture of less expensive wares for everyday use. Serious competition was also provided by cream-colored earthenware, which had been invented in the late eighteenth century. Produced in great quantities by English and German factories alike, this simple, undecorated, and low-priced ware enjoyed increasing popularity.

At Nymphenburg, an attempt was made in 1820 to improve the finances of the factory by auctioning the unsold stocks. In 1822 the royal house agreed to make annual aid purchases to the amount of 5,000 florins. Meissen was in such dire straits in 1820 that the king was advised to close the factory, but in 1824 it was decided to decrease prices radically in an attempt to save it. In Berlin, a drastic reduction

Figs. 71, 72 Pattern designs of the Vienna Porcelain Factory. Österreichisches Museum für angewandte Kunst, Vienna

in staff took place in 1821. Yet none of these measures noticeably improved the economic situation of the enterprises concerned.

When Ludwig I became King of Bavaria in 1825, he commissioned Nymphenburg to produce replicas on porcelain tablets of the major paintings in his gallery. The manufacture of these tablets, some of which measured over fifty by sixty centimeters, was a technical feat in itself, and the copies, authentic even in details of the paintings' colors, were masterpieces of porcelain decoration. However, the execution of a single tablet sometimes took as long as three years, so the project was hardly calculated to restore the firm to financial health.

Only a complete reorganization of manufacturing and sales would have helped, but this was not to occur in the porcelain industry until the 1830s. However, there were a number of inventions and improvements in production methods during the Biedermeier period. In Meissen, for instance, the multilevel kiln was

introduced in 1817, which led eventually to a fourfold increase in output and to savings in personnel and fuel costs. That same year, also in Meissen, Gottlob Kühn developed chrome green as a new color for painting on the biscuit, an invention apparently made at the same time by Georg Frick in Berlin. An important step toward lowering production costs was taken ten years later, when Kühn invented a powdered gold for decor that not only replaced the more expensive gold leaf but saved labor because it did not require polishing. This was the first instance of a reduction in quality made expressly for mercantile reasons.

On the other hand, the porcelain factories made great efforts to expand and improve their production lines. In 1820 the Nymphenburg works were requested by the Bavarian government to develop new forms of tableware in collaboration with the Academy of Visual Arts. With the same end in mind, the Vienna factory organized an internal design competition in

Despite the continual increase in design variations, Biedermeier porcelain remained functional. The original working process – throwing on the wheel – remained visible in the final result; edges, projections, and convexities were emphasized; rims were straight and relief work was unknown. Curved vessel sides had a tensile character and were never merely bulky, as they had often been in the Empire style, while the vessels as a whole appeared more voluminous.

Biedermeier porcelain designers lent their imagination free rein when it came to handels, much as did the cabinetmakers in their treatment of chair backrests. In this case, too, they modified an Empire form, extending the handles far above the rim. They might be twined around rosettes, given the shape of snakes, dolphins, or swans (see nos. 154, 155, 157), end in lion's heads (see no. 172), taper into palmettes or acanthus leaves (see no. 151), or spiral upward in open volutes (see no. 156). Never before had there been such a variety of handle designs, one that was echoed, if to a lesser extent, in the spouts of pots. It was the combination of simplified, concise, and harmonious vessel bodies with gracefully elaborate appurtenances that lent Biedermeier porcelain its specific character. The various factories differed little from one another in this regard. Initially, they all looked to Sèvres for inspiration, but later had no qualms about imitating each other's models. They all continually purchased samples from their competitors, as indeed Sèvres did from the German manufacturers.

In porcelain painting the Biedermeier period witnessed accomplishments of the highest order. Vienna led the field here, for it was in that city that Josef Leithner made his numerous pigmental discoveries, laying the groundwork for the elaborate and sophisticated painting techniques of the period. Following the lead of Vienna, all the great factories soon divided their decoration department into history and landscape painting, flower painting, and patternwork. A diploma from the Vienna Academy was required of all decorators, who, moreover, were expected to polish their skills by regular attendance at evening courses. Most of their designs were copied from existing imagery, but each pattern painter was expected to decorate a cup with an original design every three months, and the figure painters to submit a motif of their own devising every six months.

Floral motifs had always played an important role in ceramic decoration. From the late eighteenth century on, the large, elaborate plates in the new botanical publications served as models (see fig. 56). This tradition was carried on into the early Biedermeier period with the botanical decor of the Berlin Service (no. 143). Soon, however, floral compositions began to take the form of allover patterns (see no. 155) or to resemble framed pictures applied to the individual pieces. Naturally, flowers also appeared in the shape of simplified, continuous patterns (see fig. 72).

1826, resulting in new prototypes (see fig. 65). These were the first, belated attempts to improve upon the vessel designs of early Neoclassicism, which all porcelain factories in Central Europe had continued to manufacture well into the Biedermeier period.

A key production sector was coffee services, consisting of a coffee- and a teapot, a creamer, a sugar bowl, and cups and saucers (see fig. 66 and nos. 149, 157). Although plates were not included, a tray often was (see nos. 143, 156). All factories also produced great quantities of individual cups, which, like glass tumblers, enjoyed great popularity as gifts.[95]

Biedermeier designers quite naturally relied on the plain, cylindrical vessel forms of the late eighteenth century, particularly for coffee cups. Empire designs also continued to be produced, however, especially the form known as Campana – a low cup with slightly convex sides and a handle issing from the rim (see no. 150). The factories gradually developed an astonishing

range of new cup designs, based for the most part on the Empire models produced by Sèvres – bell-shaped cups on an indented base, or cups with bulging sides that flared outward at the rim. The latter design, known as *kalathos*, was fitted with the Campana handle and became the most popular Biedermeier model. Around the mid-1820s three lion's paws were sometimes added to the bases of cups in this design (see no. 155). The bell-shaped cup with indented base was produced in a great number of variants, with sides ranging from the almost straight to the gently bulging and bases ranging from the high and sharply defined to the low, indented ring (see no. 172). Berlin seems to have led the field in varying designs of this kind, while, from 1814, Vienna developed entirely new models (see fig. 67), some with widely flared rims (see no. 173), others with sharp projections (see fig. 69), sometimes elaborated with beading and invariably fitted with imaginatively designed handles.[94]

Fig. 73
Bureau-cabinet.
Vienna, c. 1830/35.
Muzeum
hlavního města
Prahy, Prague

lands in 1813 gave the country and its arts a new lease of life. Dutch silversmiths of the Biedermeier period simplified the forms of their designs still further, achieving a clarity and logic that almost puts one in mind of twentieth-century functionalism. It was characterized by an emphasis on the gleaming metal itself, shaped in accordance with the conditions of the craft and very seldom decorated by chasing or engraving. The sophisticated elegance of these pieces relied solely on shapes and contours that were simple yet full of tension.

Iron was a typical Biedermeier material. It was beginning to play an important role in the construction of machines, and became more and more crucial to industry as the century advanced. As early as 1790, the German foundries adopted key technical improvements in iron casting from Britain. New types of furnace, innovations in smelting methods, and sand molds formed the prerequisites for the casting of works of art. The Prussian foundries in Berlin, Gleiwitz, Malapane, and Lauchhammer soon played a leading role in this field. The first large replica of a classical sculpture was cast in Lauchhammer in 1782; from 1802, monuments were being cast in Malapane. By 1808 the annual production of medals in Gleiwitz had approached the forty thousand mark.

To raise funds for the war against Napoleon, the King of Prussia, in March 1813, issued an "Appeal to Women" to contribute all their gold jewelry to the cause of "saving the fatherland." An offshoot of this appeal was a revival of fine iron casting, for it had become patriotic to wear iron jewelry (see nos. 269, 275). These extremely delicate and finely crafted pieces were by no means inexpensive, however, and with them, the Berlin foundry, and especially the small casting firm run by the Berlin jeweler Johann Conrad Geiss, achieved worldwide fame. "Fonte de Berlin" was as much in demand in Paris as "Berlin iron" was in New York. The superb craftsmanship devoted to what was basically a common and locally available raw material was highly typical of the Biedermeier approach to art.

In 1816 the sculptor Friedrich Beyerhaus expanded the production lines in Gleiwitz and Berlin to include such household utensils as paperweights, fumigators, mirror stands, boxes, dishes, candelabras, pocket-watch holders, writing implements, chessmen, and seals (see nos. 276-78). At New Year the foundries thanked their patrons and customers by sending them plaques bearing reliefs that usually depicted some item from their line or a famous building.

When the Biedermeier period came to an end in the 1830s, fine iron casting had already passed its apex.

The 1830s

On view at the 1829 Arts and Crafts Exhibition in Prague was a large crystal centerpiece "in the Gothic style" and two vases "in Hetrurian form."[96] These presaged a new development in

A particularly widespread form of decoration on presentation cups was the depiction of landscapes or cities, which usually covered the entire front half of the cup. Famous monuments were popular, as were interiors (see nos. 160, 171). Since a large proportion of the souvenir cups of the period were specially commissioned, they often bore portraits, depictions of the client's residence or living room (see no. 19), or flowers arranged so that the first letters of their names spelled out a message (see no. 158).[95]

A highly characteristic Biedermeier motif was the vine leaf pattern (see no. 177). Designed by Johann Samuel Arnhold in Meissen immediately after the invention of chrome green, it became a popular ornament that was much imitated throughout the nineteenth century, probably on account of its mixture of classical reference and natural form. It was frequently employed not only in ceramics, but also in metalwork and in book illustration (see nos. 233, 275, 277).

Metal

Biedermeier silver, too, acquired new forms, in designs that emphasized the properties of the material but also attached great importance to utility and function. Shapes were reduced to their simplest common denominator, especially by the master craftsmen in Amsterdam, The Hague, and Rotterdam (see nos. 224, 226).

The art of Dutch silversmiths had reached an absolute peak in the seventeenth century, but came to dominate Europe again later. The outstanding quality of Dutch work during the Biedermeier period was matched only by a handful of designs produced by one or two silversmiths in Vienna.

Since about 1780, Dutch craftsmen had taken English Neoclassicism as their model. Despite the subjection of Holland to Napoleon, the Empire style found almost no foothold there, the simple and elegant forms of early Neoclassicism retaining their popularity. The proclamation of the Kingdom of the Nether-

the decorative arts, a revival of past styles that were soon to displace the unpretentious Neo-classical forms of the Biedermeier. An exhibition of 1850 in Bern included a table that, according to a contemporary review, "would have been more admired at the court of Louis XIV than at the present time and place," from which one can assume that it was Neo-Baroque or, more likely, Neo-Rococo.[97] On exhibition in Prague the following year were a glass *jardinière* "partly executed in the Gothic style" and a "*bouteille* with a sheath made to resemble a Turkish temple." In the furniture pattern book *Practische Zeichnungen von Meubles im neuesten...Geschmack* by Wilhelm Mercker, which was published in many annual installments, furniture in "the Arabian-Moorish mode" was illustrated as early as 1851, followed by pieces in "the Chinese mode" in 1852. Another pattern book of the same period, Marius Woelfer's *Modell- und Musterbuch*, put the emphasis on Neo-Gothic designs. In 1852 the architect Karl Heideloff began publishing patterns which juxtaposed furniture in the "antique" and "modern style," "from the fourteenth century," or "in the antique German [*altdeutsch*] mode." According to a review of the 1854 Munich Exhibition, it contained "objects in the most multifarious of modes, ranging from Chinese to Greek, by all present-day schools," and the following year it was reported to include pieces inlaid with tortoiseshell and metal, that is, in the style of the period around 1700. Designs in the Egyptian style appeared as early as 1854, in Wilhelm Mercker's pattern book. In short, there emerged the "stylistic hodgepodge" of Historicism which, though deplored early on, would soon completely supplant the simple and unified canon of Biedermeier forms.

In the course of the 1830s this canon itself gradually lost much of its original character. Furniture, porcelain, and glassware began to grow exaggeratedly voluminous and their once so concise and simple contours to bulge and break. What was once lucidly and functionally designed became unsettled, agitated, and overgrown with ornament. The tense and elastic curves and convexities of the Biedermeier style were replaced by great sweeps and bellying bulges. In furniture design there was a qualitative and, above all, quantitative increase in lathe-turned shapes and carved ornament (see fig. 73). Design was no longer based on the properties of wood and the methods used to work it; instead, these were forced to conform to preconceived ideas.

In cut glass, too, ornament began to proliferate, as such details as scrolls, palmettes, arcs, and ovals grew in size and their combinations became more awkward and cumbersome until hardly any smooth surfaces were left uncovered. The glass engravers began to compose densely packed images full of figures, adopting an increasingly "picturesque" style. New pigments were discovered – the greenish-yellow, opaline uranium glass at the end of the 1830s, ruby glass tinted with coprous oxide as early as 1828, imitation onyx and chrysoprase in 1831. Light pastel tones were combined with wholly opaque black or white. In Neuwelt a method was invented in 1828 to case clear glass in a tinted layer, and from 1836 glasses were produced with two casings, their polychromy skillfully emphasized by cut patterns in the oriental style.

Colored glass was sometimes additionally decorated in impasto painting, with Moorish motifs alternating with classical, Gothic with Rococo (see fig. 74). The technique of Venetian filigree glass was also revived, following a competition held in 1839 by the Prague Association for the Furtherance of Industry.

Developments in porcelain took a similar path. In Meissen the search for new models led in 1831 to vessels shaped in molds taken from pieces in crystal glass. Tableware designs became generally more varied, with carving and openwork, increased use of angular forms, and a revival of both Empire and Rococo ornamentation. In 1833 a decor was introduced in what was known as the "antique Germano-Grecian mode," and replicas of original Rococo models were made for the first time. By the early 1830s, Bohemian factories were already producing cups in the shape of seashells, conches, and roses, and there were elaborately facetted designs with imitation gems in imitation mounts and Rococo designs with naturalistic blossoms in full relief. A tendency to the bombastic led in Berlin, from 1834 on, to the manufacture of entire tables from porcelain and of ever-larger and more elaborately ornamented vases.

In the final analysis, it was the emergent industrial age that brought about the demise of the Biedermeier style. Ever since the start of the nineteenth century special machines had been introduced into the arts and crafts, and the interest in them spread apace. As early as 1817 a circular saw was patented in Vienna, though similar tools had long been in use in Britain. The first bandsaw was set up in Berlin in 1851. The first steam-driven veneer saws in Germany went into operation in 1856, at the Pallenberg furniture factory in Cologne. In 1833 the Vienna porcelain factory introduced transfer printing on a large scale for the decoration of its products. Significantly, a chemist was appointed director there in 1827, and he was succeeded in 1833 by a physicist. Pressed glass, invented in the United States, went into mass production in 1836 at the Adolf works in the Bohemian Forest. Other glass factories soon followed suit.

After the establishment of the *Zollverein* (customs union) in 1834, and as a result of the improvements in transportation brought about by a rapidly expanding railroad system, trade conditions for manufacturers improved considerably. Machines enabled them to increase production enormously, but at the cost of quality. The demand for handmade products crafted by skilled and devoted artisans diminished; the Biedermeier style became a thing of the past.

Fig. 74 Alabaster glass with relief decoration in gold and silver. Bohemia, c. 1840. Bayerisches Nationalmuseum, Munich

The Biedermeier Revival

The first signs of the demise of the Biedermeier style appeared in the late 1820s, and by 1835 only a few artists and craftsmen were continuing to base their work on its tenets. Its Neoclassical idiom had soon been entirely eclipsed by Historicism in all its multifarious variants. The Romantic beginnings of this process, which antedated the Biedermeier period by decades, were now developed further in a highly original, experimental phase which led, after mid-century, to ever-increasing perfection and, finally, to a canonization of the revival styles.

Then came the year 1894, which brought a series of epoch-making decisions on the part of young artists determined to break the hold of Historicism. The Belgian artist Henry van de Velde gave up a promising career in painting to devote himself exclusively to the design of the human environment. That same year, independently of van de Velde, Otto Eckmann stopped painting and turned entirely to the applied arts, in which he saw the hope of artistic and social renewal. In Berlin, under the leadership of the writer Otto Julius Bierbaum and the art historian Julius Meier-Graefe, artists and lovers of art joined forces to found the journal *Pan*, which, likewise in reaction to Historicism, aimed at a "comprehensive furtherance of all the arts based on an organic definition of art." Finally, in the wake of the 1893 Chicago World's Fair strong new impulses from the most advanced decorative arts of the day reached Germany from Britain and America. Functionality, practicality, comfort, indeed hygiene, had long been design watchwords for the Arts and Crafts movements across the Channel and the Atlantic.[98] British products, imported since the early 1890s, had become increasingly popular in Germany and Austria.

Although artists agreed that a renewal was necessary, not all of them were willing to be associated with the new style, Art Nouveau, which skeptics in Germany had soon christened *Jugendstil* (style of youth), an allusion to the popular illustrated magazine *Jugend* that carried a suggestion of adolescent frivolity.[99] To those artists and craftsmen who, through habit or training, considered stylistic development in terms of historical continuity, a renewal in art seemed possible by reference to the past, particularly to the lucid, simple forms and light colors of the Biedermeier period. This revival had been anticipated in the field of fashion design. For the 1893/94 season, a "Genre 1830" had been created and the *Biedermännerzeit* – the period of the Biedermeier men – hailed as worthy of emulation.[100]

At the 1898 Munich Glaspalast exhibition, in addition to Art Nouveau furniture, it was the

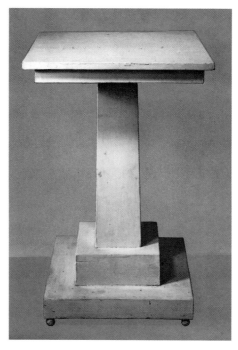

Fig. 75 Josef Hoffmann,
Table, c. 1905.
Whereabouts unknown

room designed by architects Henry Helbig and Charles Haiger in obvious reliance on the Biedermeier style that attracted great attention. A review of this interior noted how "the Biedermeier period has already begun to seem historical to us...and its style a historical style."[101]

Probably at about the same time, these two architects designed a cupboard (fig. 76) which clearly exhibits Biedermeier influence in the smooth, uninterrupted, light-colored surfaces, the relative lack of moldings, the black grids over the glass of the flanking doors, and in the way that the superstructures atop the lateral wings lie in the front plane of the piece.[102] Yet the cupboard does not represent a slavish copy of Biedermeier models, for it also possesses characteristics in common with contemporaneous *Jugendstil* furniture.

The adherents of Art Nouveau did not spare with ridicule of the Biedermeier revival, and a hotly fought critical battle ensued in the pages of the most important journals. In a programmatic essay titled "Biedermeier as a Model," Hartwig Fischel wrote in 1901: "Even the most modern...efforts have only served to underscore the fact that, for us, a link quite naturally occurs when we look back to the early nineteenth century, to the period in which an

unpretentious, middle-class style in interior decoration emerged and, just as suddenly, appeared to peter out." Nonetheless, Fischel warned against merely imitating the "genuine achievements of the Empire and Biedermeier period... solid, simple, practical, unpretentious furnishings"; rather, he felt that they should be "emulated and kept in view as a continual reminder."[103]

Scoffed at by Art Nouveau modernists as "revivalists,"[104] the Biedermeier apologists nevertheless shared their view that rationality and functionality should be the fundamental tenets of the new design movement. United by the same basic goal, both groups naturally influenced each other. The formal repertoire of the turn-of-the-century Neoclassical revival would have been inconceivable without Art Nouveau, just as many Art Nouveau artists never entirely severed their ties with tradition. After its quickly reached climax, Art Nouveau did, in fact, develop into a variety of Neoclassicism. Biedermeier had become the style to emulate and, as early as 1905, the Munich architect Friedrich Thiersch, who had always remained a revivalist, proclaimed triumphantly: "Misunderstood *Jugendstil*... has been overcome and has made way for an approach to art that employs simple, geometric forms."[105]

At the Third German Exhibition of Arts and Crafts, held in Dresden in 1906, the new Neoclassicism finally carried the day – although no representative of the style would countenance the use of the term "Biedermeier" in connection with his work. In a review of the exhibition by Erich Haenel, Paul Schulze-Naumburg's contribution was castigated with the words: "Biedermeier *redivivus*, whether its creator likes it or not."[106] Art Nouveau, on the other hand, with its "undiscriminating preference for whatever is strange, incredible, and bizarre... would only meet with a pitying smile." The author goes on to note with satisfaction that the "most outstanding representatives of the movement include not only painters and sculptors, but also architects and even educated craftsmen and engineers." He praises the new buildings for the "great rationality, indeed logic, and also the great feeling and love" they evince, admiring both their "balance and functionality" and their "comfortableness."

All major architects and interior designers of the period were represented at this exhibition, and almost all employed a Neoclassical idiom – among them, Peter Behrens, Karl Bertsch, Erich Kleinhempel, Albin Müller, Adelbert Niemeyer, Bruno Paul, and Fritz Schumacher. Schulze-Naumburg, attacked for the imitativeness of his designs, replied with a seven-page

essay in *Der Kunstwart*.[107] "When, in connection with an acceptance of tradition, I recommended relying on forms whose essence was most related to our own era, the early nineteenth century…was quite naturally uppermost in my mind. For this was the epoch closest to us in time which brought forth forms redolent of a new, comprehensively educated bourgeoisie." As Fritz Ehmcke pointed out in 1908, it was "not weariness in the struggle for the new idea that led us to the forms of the past, but a strong yearning for lucidity and balance."[108] In the Biedermeier style, he went on, "all the potentialities of perfected technology lay dormant…waiting to be realized by an industry that the future would create…and hence it remains for the present day to bring them to light again." It was thus not a return to Biedermeier that Ehmcke recommended, but rather that Biedermeier be taken as a point of departure, that its style be adapted and developed to meet the requirements of the day.

In Vienna, too, 1894 was a key date, for in that year Otto Wagner was appointed head of a special class for architecture at the Vienna Academy and, in his inaugural lecture, outlined his principles for a "modern" architecture. In his later capacity as artistic adviser to Vienna's Commission for Transportation Facilities Wagner was to contribute decisively to the appearance of the city as it exists today. Yet he was even more influential as a teacher. Among his many gifted students were Josef Hoffmann and Koloman Moser, two of the most important representatives of the geometric variant of Viennese *Jugendstil*. They also deliberately turned for inspiration to the plain, geometric forms of the Biedermeier style. A table, made in 1905 to a design by Hoffmann, may serve as an example (fig. 75). The only previous period to have produced furniture designs so rigorously composed of geometric solids was the Biedermeier (see no. 107).[109]

Another pupil of Wagner was Josef Maria Olbrich, who was invited to take up residence in Darmstadt by the Grand Duke of Hesse in 1899. His last building, whose interior was still unfinished when he died in 1908, was the Feinhals House in the Marienburg district of Cologne (fig. 77). While its high mansard roof recalls late eighteenth-century architecture, a definite Biedermeier influence is evident in the articulation of the structure by added cubic volumes and of the walls by indented panels. Six massive Doric columns form a pierced plane that is placed in front of the facade and, as it were, stretched between the two projecting lateral cubes – a final, simplified allusion to Schinkel's Museum in Berlin (fig. 9). "The blessing of the ancients," said Olbrich himself, "lies between the lines."[110]

Between 1908 and 1910 Peter Behrens, who had also been invited to become a member of the artists' colony in Darmstadt, erected two villas in the Eppenhausen district of Hagen that provide a further illustration of the way in which Biedermeier became a model for the leading architects of the day. The Schroeder

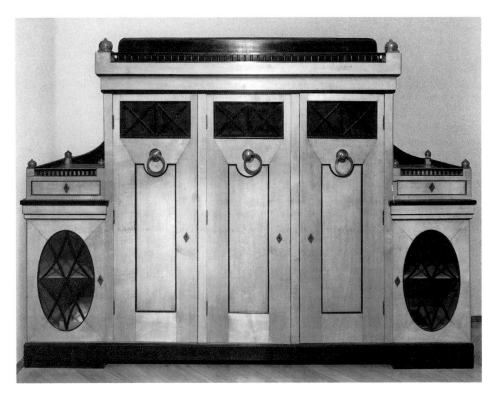

Fig. 76 Henry Helbig and Charles Haiger, Cupboard, 1898/1900. Whereabouts unknown

House (fig. 78), completed in 1909, is an undecorated rectangular solid with string courses marking the stories and providing a cornice, above which rises a hipped roof. The windows on the ground floor are incised into light-colored rectangular fields, which in turn are set into the darker wall surface and demarcated from it by a wide joint. This lucid separation and juxtaposition of individual elements, this visualization of the construction process, had been a characteristic feature of the Biedermeier approach to architectural design.

Another composition of plain, undecorated blocks was Behrens's Cuno House, which was

Fig. 77 Josef Maria Olbrich, Feinhals House, Cologne (Marienburg), 1908

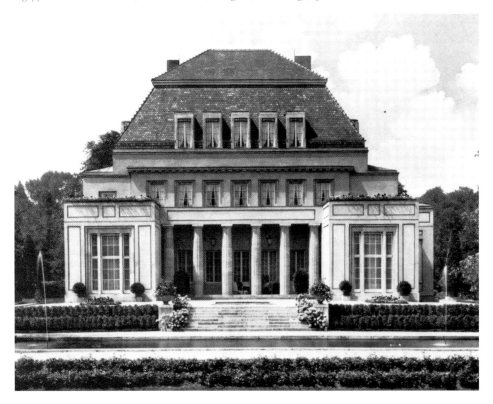

Fig. 78 Peter Behrens,
Schroeder House, Hagen (Eppenhausen), 1909

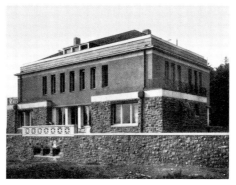

Fig. 79 Peter Behrens,
Cuno House, Hagen (Eppenhausen), 1910

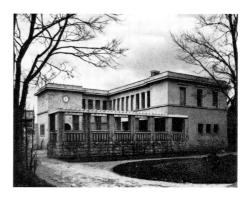

Fig. 80 Peter Behrens,
Annex of the Mertens Villa, Potsdam, 1910

finished in 1910 (fig. 79). This building also exhibits the favorite Biedermeier device of projecting layers executed in a contrasting material – in this case, rubble masonry. The cornice runs around the house in a thin strip, producing a kind of attic story above; the windows are frameless openings cut into the walls. All these elements are also found in Biedermeier architecture (see fig. 14). Even stronger reminiscences of Schinkel – of his Charlottenhof and Glienicke palaces – are seen in Behrens's annex for the Mertens Villa in Potsdam, which was completed in 1910 (fig. 80). Here, too, we find the volume of the building continued through and beyond the

cornice, the juxtaposition of separate rectangular solids, and the pergola grafted onto the main structure. The colonnaded window openings, moreover, recall Schinkel's Schauspielhaus in Berlin (fig. 13).

Behrens also designed the furniture for both the Schroeder and Mertens residences (see fig. 84), and it, too, shows obvious Biedermeier influence. In the cupboard now in Hamburg (fig. 81), it is not only the lack of decoration and the contrast of dark elements with the light birchwood, but also the interpenetrating geometric volumes and the emphasis on a single, frontal viewpoint that reveal an adaptation of the Biedermeier aesthetic to the princi-

ples of modern design.[111] In his furnishings for the living room of the Mertens Villa, designed in 1912, Behrens's reliance on Biedermeier features was likewise astonishingly great.

As time passed, architects' borrowings from the Biedermeier style became ever more direct, as instanced by a living room suite of 1913 (fig. 83). This tendency finally resulted in the unimaginative, standardized copies that were produced in great numbers during these years and that still cause confusion among dealers and collectors. Slavish imitation of Biedermeier forms was an all too frequent feature of architecture and the decorative arts right up to the late 1930s. Mentors to generations of German architecture students in this regard were, above all, Paul Schulze-Naumburg and Paul Schmitthenner.

Yet the great architects of the day employed Biedermeier as a model in a different way. A prime example was Adolf Loos, who in 1910 blazed the trail with his highly controversial new building on Michaelerplatz in Vienna (fig. 82), which proved his confident hypothesis that "lack of ornament [can be] a sign of intellectual power." The functions of the smooth block are revealed on the exterior: a lower section housing business premises with a superimposed layer of heavily textured, colored material, and, above it, a plain, middle-class apartment building with smooth, plastered walls. The frameless windows are simple apertures cut out of the wall surface; in the lower section, they are expanded into large, indented niches in which columns are placed – Neoclassical elements without tectonic function, of the kind found over and over again in Biedermeier architecture. The block is demarcated at the roofline by a strongly molded cornice, and the broad band beneath it, although it may recall a classical entablature frieze, merely serves to articulate the plane and has no tectonic function. Conforming to the shape of the lot, the side walls meet the facade at an oblique angle, but, instead of being placed flush with it, the edges of these flat, rectangular slabs project slightly beyond the front plane. The vestibule ceiling also has the appearance of a slab, whose front edge is supported by the columns on the entrance side.

Fig. 81 Peter Behrens, Cupboard for the Schroeder House, 1908.
Museum für Kunst und Gewerbe, Hamburg

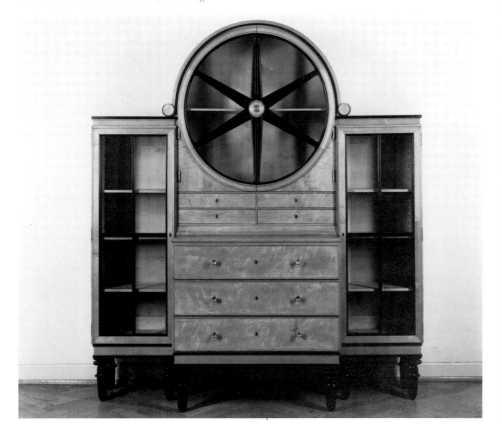

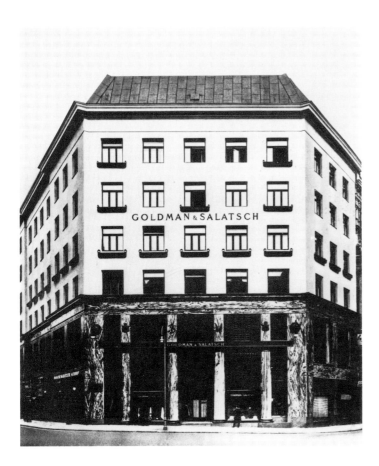

Fig.82
Adolf Loos, Building
on Michaelerplatz,
Vienna, 1910

House (fig.85), a building that justified the high praise accorded it by contemporaries and that, again, shows considerable Biedermeier influence.[112] A facade articulated in terms of stepped planes, rectangular niches flanking the door, recessed arches over the windows, string courses as the sole decoration – all this adds up to a lucid, simple design which is developed entirely out of the plane.

With buildings of this kind, the ground was prepared for a final reduction to the unornamented block, divested of all moldings and of all traces of color, as it was first built by the Bauhaus architects after World War I (see fig. 87). This reduction of design to basic, geometrical forms, whether in architecture, furniture, or household appliances, has since become widespread practice among artists and craftsmen, and there can be no doubt that the Biedermeier style exerted a strong influence on this process.

The following year, 1911, Ludwig Mies van der Rohe built the Perls House in the Zehlendorf district of Berlin (fig.86). The influence of Schinkel, presumably transmitted to Mies by Behrens, is quite evident in this debut work by the man who was to become probably the greatest architect of the twentieth century (see

fig.14). Purity of form, dignity, and truth to materials characterize this plain rectangular solid, which is interrupted only by a cornice stretching, as in the previous examples, around the building in a simple, unbroken strip.

For the Werkbund exhibition of 1904 in Cologne, Bruno Paul designed The Yellow

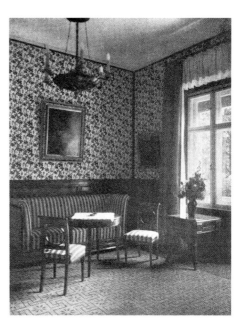

Fig.84 Peter Behrens, Living room of the
Mertens Villa, 1912

Fig.83 J. H. Rosenthal, Suite of furniture in the Sliwinski House, Weissenbach am See, 1915

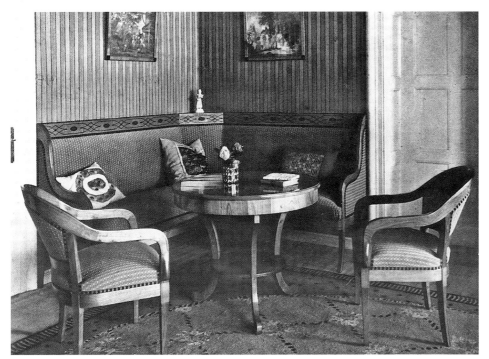

Fig. 85 Bruno Paul,
The Yellow House.
At the Werkbund exhibition,
Cologne, 1914

Fig. 86
Mies van der Rohe,
Perls House,
Berlin (Zehlendorf),
1911

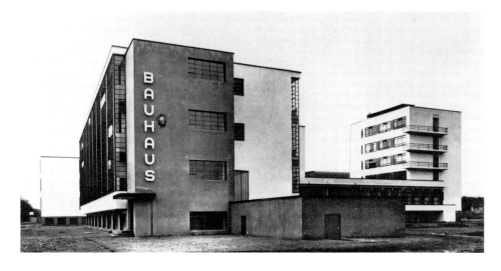

Fig. 87 Walter Gropius,
The Bauhaus,
Dessau, 1926

NOTES

1 *Ludwig Tieck und die Brüder Schlegel: Briefe*, ed. Edgar Lohur (Munich, n.d.), p.180.

2 Philipp Friedrich Hetsch (1758–1858), *Cornelia, Mother of the Gracchi*, 1794; oil on canvas, 40⅛ x 53½″ (112 x 136 cm); Staatsgalerie, Stuttgart.

3 See Alfred Neumeyer's fundamental, but largely forgotten essay, "Die Erweckung der Gotik in der deutschen Kunst des späten 18. Jahrhunderts," *Repertorium für Kunstwissenschaft*, 49 (1928), pp. 75–123.

4 See Georg Himmelheber, "Biedermeier Gothic," *Furniture History*, 21 (1985), pp. 121–26.

5 Upholstered chair in the early Gothic style after a design by Friedrich Bürklein; Munich, 1851, for the furnishings of Weyhern Palace; oak, 29¾ x 32¾ x 15¼″ (75.5 x 83 x 39 cm); Bayerisches Nationalmuseum, Munich, inv. no. 71/483. See *Münchner Jahrbuch der bildenden Kunst*, 23 (1972), p. 229.

6 Table, Neo-Rococo, from the Royal Württemberg Collection; Stuttgart, c. 1850; wood, gilded throughout, 30¼ x 42½ x 29″ (77 x 108 x 73.5 cm); Württembergisches Landesmuseum, Stuttgart, inv. no. STE 7212.

7 Theodor Hildebrandt (1804–1874), *The Warrior and His Child*, 1852; oil on canvas, 41⅜ x 36⅝″ (105 x 93 cm); Kunstmuseum, Düsseldorf, on loan from Nationalgalerie SMPK, Berlin.

8 See Thomas Nipperdey, *Deutsche Geschichte 1800–1866* (Munich, 1983), p. 195.

9 One author has tried to deny the middle-class character of the Biedermeier period by referring to the continued existence of the royal residence towns. See Hans Ottomeyer, "Von Stilen und Ständen in der Biedermeierzeit," *Biedermeiers Glück und Ende*, exhibition catalogue (Munich, 1987), cat. p. 100.

10 Charles van Ravenswaay, *The Arts and Architecture of German Settlements in Missouri* (Columbia, 1977); Charles L. Venable, "Philadelphia Biedermeier: Germanic Craftsmen and Design in Philadelphia, 1820–1850," master's thesis, University of Delaware, 1986.

11 See the important study by Bernward Deneke, "Biedermeier in Mode und Kunsthandwerk 1890–1905," *Anzeiger des Germanischen Nationalmuseums* (1967), pp. 163–79.

12 On the genesis of the term "Biedermeier," see Adolf Kussmaul. *Jugenderinnerungen eines alten Arztes* (Stuttgart, 1890), p. 486 ff.; A. Kennel, *Ludwig Eichrodt: Ein Dichterleben* (Lahr, 1895), p. 75 ff.; and Charles A. Williams, "Notes on the Origin and History of the Earlier Biedermaier," *The Journal of English and Germanic Philology*, 56 (1958), p. 403 ff.

Gottlieb Biedermaier has received a second Christian name in the meantime. Both Angus Wilkie (in *Biedermeier* [New York and Cologne, 1987]) and Geraldine Norman (in *Biedermeier Painting* [London and Freiburg, 1987]) refer to the comic-paper character as "Wieland Gottlieb Biedermeier." A confusion between the German "ei" and "ie" has transformed the *deceased* Gottlieb (*weiland* Gottlieb) into a Wieland.

13 Georg Hirth, *Das deutsche Zimmer*, 3rd ed. (Munich and Leipzig, 1886), p. 46.

14 Fritz Minkus, "Unter dem Zeichen des Empire," *Illustrierte kunstgewerbliche Zeitschrift für Innen Dekoration*, 6 (1895), p. 158.

15 See Max von Boehn's early, yet still standard work, *Biedermeier: Deutschland von 1815–1847* (Berlin, 1911), and Georg Hermann's compendium of contemporary sources, *Das Biedermeier im Spiegel seiner Zeit* (Berlin, 1915; new ed., Oldenburg and Hamburg, 1965).

16 The most significant recent publication on the emergence of Neoclassicism is Svend Eriksen's excellent book, *Early Neo-Classicism in France* (London, 1974).

17 Hans Kauffmann, "Berliner Baukunst von Schlüter bis Schinkel," *Jahrbuch Preussischer Kulturbesitz*, 13 (1976), p. 35.

18 Quoted in Paul Ortwin Rave, "Berlin, Erster Teil," in *Karl Friedrich Schinkel: Lebenswerk* (Berlin, 1941), a standard, multivolume work on the architect. On Schinkel, see also the bicentenary publications: *Karl Friedrich Schinkel: Werke und Wirkungen*, exhibition catalogue (Berlin, 1981): *Karl Friedrich Schinkel: Sein Wirken als Architekt* (Berlin, GDR, 1981); *Karl Friedrich Schinkel: Eine Ausstellung aus der DDR* (Hamburg, 1982).

19 Theodor Fontane, *Von Zwanzig bis Dreissig: Sämtliche Werke*, Hanser edition, vol. 3 (Munich, 1973), p. 547.

20 Goerd Peschken, "Technologische Ästhetik in Schinkels Architektur," *Zeitschrift des Deutschen Vereins für Kunstwissenschaft*, 22 (1968), pp. 45–81.

21 Wolfgang Herrmann, *Deutsche Baukunst des 19. und 20. Jahrhunderts*, new impression of the unpublished 1933 edition (Basel and Stuttgart, 1977), p. 43.

22 See Andreas Bekiers, "Schauspielhaus und Gendarmenmarkt," in *Karl Friedrich Schinkel: Werke und Wirkungen*, p. 170.

23 Ludwig Geiger, ed., *Briefwechsel zwischen Goethe und Zelter*, vol. 2 (Leipzig, n.d.), p. 135.

24 Heinrich Laube, *Reisenovellen, 1833/37: Reise durch das Biedermeier* (Hamburg, 1965), p. 523.

25 Franz Kugler, *Kleine Schriften und Studien* (Stuttgart, 1854), p. 322.

26 Johannes Sievers, "Das Vorbild des 'Neuen Pavillons' von Karl Friedrich Schinkel," *Zeitschrift für Kunstgeschichte*, 23 (1960), pp. 227–41.

27 Eckart Hammann, *Carl Ludwig Wimmel: Hamburgs erster Baudirektor* (Munich, 1975).

28 One of the best recent publications on Klenze, which contains an extensive bibliography, is Adrian von Buttlar, "Es gibt nur eine Baukunst? Leo von Klenze zwischen Widerstand und Anpassung," in *Romantik und Restauration*, exhibition catalogue (Munich, 1987), pp. 105–15.

29 See Adrian von Buttlar, "Fischer und Klenze: Münchner Klassizismus am Scheideweg," in *Ideal und Wirklichkeit der bildenden Kunst im späten 18. Jahrhundert* (Berlin, 1984), pp. 141–62.

30 See, for example, Ernst Kopp, *Kritische Blätter über das neuere Bauwesen* (Jena, 1853), pp. 62–65.

31 Sulpiz Boisserée, *Tagebücher*, vol. 1 (Darmstadt, 1978), p. 575.

32 Clemens Jöckle, "Die Antikenhalle in Speyer," *Mitteilungen des Historischen Vereins der Pfalz*, 75 (1977), pp. 227–36.

33 "Great black blowflies," Bettina von Arnim called them. Quoted in *Achim und Bettina in ihren Briefen*, 2nd. ed., vol. 1 (Frankfurt, 1985), p. 157.

34 Johann Gottfried Schadow, *Kunst-Werke und Kunst-Ansichten 1849*, with an introduction by Helmut Börsch-Supan (Berlin, 1980), p. 162 f., and "Aufsätze und Briefe," ibid., p. 96 f.

35 In typically ironic fashion, Berliners referred to the basins at the ends of the upper pediment as "spittoons of the Muses."

36 Johann Wolfgang Goethe, *Sämtliche Werke*, Gedenkausgabe Artemis, 2nd ed., vol. 13 (Zurich and Stuttgart, 1965), p. 735.

37 Leo von Klenze, *Anweisung zur Architektur des christlichen Kultus* (Munich, 1853).

38 Schadow, *Kunst-Werke*, p. 273.

39 Rudolf Zeitler, *Die Kunst des 19. Jahrhunderts*, Propyläen Kunstgeschichte, vol. 11 (Berlin, 1966), p. 38.

40 Siegfried Gohr, "Die Christusstatue von Bertel Thorvaldsen in der Frauenkirche zu Kopenhagen," in *Bertel Thorvaldsen: Untersuchungen zu*

seinem Werk, exhibition catalogue (Cologne, 1977), p.348.

41 Schadow, *Kunst-Werke*, p.236. Originally, the monument was to be erected on the square in front of the orphanage founded by Francke but, in spite of the period's love of monuments, the site was considered too prominent for a member of the bourgeoisie. Friedrich Wilhelm III ordered the monument to be placed in the interior court.

42 Reinhold Steig, ed., *Bettinas Briefwechsel mit Goethe* (Leipzig, 1922), p.279. Achim von Arnim, incidentally, did not agree with his sister on this point. In August 1830 he wrote to her that the monument had "turned out much better than any other of Rauch's statues." Quoted in *Achim und Bettina in ihren Briefen*, vol.2, p.891.

43 Boisserée, *Tagebücher*, vol.2, p.454.

44 Several proposals for monuments with seated monarchs had been made before Rauch's and Klenze's, but, characteristically, none of them was carried out. See H. Schmitz, "Die Entwürfe für das Denkmal Friedrichs des Grossen und die Berliner Architekten um das Jahr 1800," *Zeitschrift für bildende Kunst*, n.s.20 (1909), p.207.

45 There were endless controversies about whether rulers ought to be represented in contemporary costume on monuments or in the guise of Roman emperors. Goethe and Schadow also argued the issue, the former in 1800, in *Propyläen*, the latter in 1801, in *Eunomia*.

46 Friedrich Pecht, *Deutsche Künstler des 19. Jahrhunderts* (Nördlingen, 1887), p.257.

47 Lankheit sees the secularization of religious motifs as a significant development in nineteenth-century art. Klaus Lankheit, "Der Stand der Forschung zur Plastik des 19.Jahrhunderts," in Hilda Lietzmann, *Bibliographie zur Kunstgeschichte des 19.Jahrhunderts* (Munich, 1968).

48 Quoted in Oswald Hederer, *Leo von Klenze*, 2nd ed. (Munich, 1981), p.373.

49 *Schorns Kunst-Blatt*, 8 (1827), p.10.

50 *Briefwechsel zwischen Rauch und Rietschel*, ed. Karl Eggers, vol.1 (Berlin, 1890), pp.14–206.

51 In 1845 Rauch reworked the *Felicitas Publica* as a full-scale figure in the Vincke Monument in Ruhrort; Heinrich Berges produced a marble version for Klein Glienicke, Berlin, in 1850. See Herbert Lehmann, "Die Ruhrorter Vincke-Säule," *Duisburger Forschungen*, 14 (1970), pp.17–42.

52 See Barbara Eschenburg, "Die Reliefs am Max-Joseph-Denkmal," in H.E. Mittig and V. Plagemann, eds, *Denkmäler im 19.Jahrhundert* (Munich, 1972), pp.49–68.

53 Pecht, *Deutsche Künstler*, p.257.

54 Kopp, *Kritische Blätter*, p.29.

55 *Johann Friedrich Boehmer's Leben, Briefe und kleinere Schriften*, ed. Johannes Janssen, vol.2 (Freiburg, 1868), p.182.

56 Zelter wrote to Goethe on November 13, 1830: "Your bust, and those of Schiller and our king, are displayed everywhere, in all shapes and sizes, on cupboards and sideboards in the humblest abodes. The makers of plaster replicas hawk them in the streets all day long.... You can buy all three busts for six silver groschen, and probably for less if you haggle.... But the castings are so thin you have to handle them with kid gloves." Geiger, ed., *Briefwechsel*, vol.3, p.324.

57 The very apt term *Sachlichkeit* was proposed as a characterization of Biedermeier painting by J.A. Schmoll gen. Eisenwerth in his essay "Naturalismus und Realismus: Versuch zur Formulierung verbindlicher Begriffe," *Städel Jahrbuch*, n.s.5 (1975), p.256.

58 B. Speth, *Ernstere Würdigung der Kunstausstellung zu München im Oktober 1817* (Munich, 1817), p.40f.

59 Vagn Poulsen, *Dänische Maler* (Königstein, 1961), p.3. On Danish painting, see especially *Danish Painting: The Golden Age*, exhibition catalogue (London, 1984), which includes detailed biographical information on the artists by Kasper Monrad.

60 *C.W. Eckersberg og hans elever*, exhibition catalogue (Copenhagen, 1983).

61 Carl Gustav Carus, *Neun Briefe über Landschaftsmalerei* (Leipzig, 1831, and numerous subsequent editions, down to the present day). Admittedly, Carus's views stood in a long tradition, beginning with C.L. von Hagedorn's *Betrachtungen über die Mahlerey* (1762).

62 Paul Ferdinand Schmidt, *Biedermeier-Malerei* (Munich, 1923), p.50.

63 Hermann Uhde, ed., *Erinnerungen der Malerin Louise Seidler* (Berlin, 1922), p.43.

64 Helmut Börsch-Supan, *Berliner Biedermeier von Blechen bis Menzel*, exhibition catalogue (Bremen, 1967), pp.14–20.

65 Käte Gläser, *Das Bildnis im Berliner Biedermeier* (Berlin, 1932), p.26. The author was able to find archive records for about 3,500 portraits between the years 1820 and 1850, not including works in pastel, chalk, and pencil or the miniatures created in great numbers at the time.

66 See Helmut Börsch-Supan, "Das Frühwerk Wilhelm von Schadows und die berlinischen Voraussetzungen der Düsseldorfer Schule," in *Die Düsseldorfer Malerschule*, exhibition catalogue (Düsseldorf and Darmstadt, 1979), pp.56–67.

67 Felix Eberty saw the picture while it was being painted in Düsseldorf in 1833/34. Felix Eberty, *Jugenderinnerungen eines alten Berliners* (Berlin, 1878), p.326.

68 In 1825 Ernst Förster complained of the "unimaginative facility, without creative force, without warmth or vitality, that is now being practiced at the Academy under the tutelage of Langer, father and son." Ernst Förster, *Aus der Jugendzeit* (Berlin, 1887), p.244.

69 Rudolf Oldenbourg, *Die Münchner Malerei im neunzehnten Jahrhundert* (Munich, 1922), p.94.

70 Barbara Eschenburg, "Landschaftsmalerei in München zwischen Kunstverein und Akademie," in *Münchner Landschaftsmalerei 1800–1850*, exhibition catalogue (Munich, 1979), pp.93–115.

71 Ferdinand Georg Waldmüller, *Das Bedürfnis eines zweckmässigen Unterrichts in der Malerei und plastischen Kunst* (Vienna, 1846; 2nd ed., 1847). Reprinted in Arthur Roessler and Georg Pisko, *Ferdinand Georg Waldmüller*, vol.2 (Vienna, 1907), p.4.

72 See Peter Pötschner, *Wien und die Wiener Landschaft: Spätbarocke und biedermeierliche Landschaftskunst in Wien* (Salzburg, 1978).

73 Gerbert Frodl, *Wiener Malerei der Biedermeierzeit* (Rosenheim, 1987), p.40.

74 See especially Eschenburg, "Landschaftsmalerei in München," p.112f.

75 See the excellent observations by Gläser, *Das Bildnis*, pp.88–101.

76 Bruno Grimschitz, *Maler der Ostmark* (Vienna, 1940), p.14.

77 In what follows I draw upon my book *Biedermeier Furniture* (London, 1974).

78 "We dined at a round sofa table, where it was very comfortable," noted Lili Parthey in her diary on January 5, 1823. See also *Zwölf Blätter Kinder-Bilder zur Unterhaltung und mündlichen Belehrung: Heft für Knaben* (Nuremberg, 1823), pl.5.

79 Bedside table after a design by Nikolaus Thouret; Stuttgart, 1804/12; mahogany, gilded bronze fittings, 39¾ x 16 x 15¼" (101 x 41 x 38.5cm); Schloss Ludwigsburg, Neuer Hauptbau, inv. no. KRGT 790.

80 Upholstered chair after a design by Andreas Gärtner; Munich, 1810; from the former State Councillor's Room, Munich Residence; beech, gilded throughout, 38 x 21¼ x 19¼" (96.5 x 54 x 49cm); Bayerisches Nationalmuseum, Munich, inv. no.52/105.

81 Despite the resemblances, it is mistaken to refer to late Louis Seize furniture, as one author recently has, as Biedermeier furniture. See the speculative statements by Hans Ottomeyer, "Von Stilen und Ständen in der Biedermeierzeit," in *Biedermeiers Glück und Ende*, pp.91–128, esp. 102f., and 317–19.

82 See J. Robiquet, *L'Art et le Goût sous la Restauration 1814–30* (Paris, 1928); Y.Amico, "Le Mobilier Restauration," *Art & Décoration*, 21 (1951), p.24; Y.Brunhammer and M.Ricour, "Le Style Restauration," *Le Jardin des Arts* (1957–58), p.121; Y.Brunhammer, *Meubles et Ensembles: Restauration, Louis Philippe* (Paris, 1960).

83 C.Musgrave, *Regency Furniture* (London, 1961), pl.8B.

84 Ibid., figs.52A, 61ff., 66A.

85 See especially Walter Spiegl, *Biedermeiergläser* (Munich, 1981).

86 Walter Spiegl, *Böhmische Gläser* (Munich, 1980), p.105.

87 Gustav E. Pazaurek and Eugen von Philippovich, *Gläser der Empire- und Biedermeierzeit* (Brunswick, 1976), p.4.

88 Eighteenth-century faience and porcelain decorators also sometimes relied on earlier models, but these did not diverge so much from the art of the period as did Baroque or Rococo patterns from Neoclassicism.

89 Waltraud Neuwirth, "Anmerkungen zur Kothgasser-Forschung," *Keramos*, 84 (1979), pp.69–92.

90 Pazaurek and Philippovich, *Gläser*, p.184.

91 See Antoinette Faÿ-Hallé and Barbara Mundt, *Europäisches Porzellan vom Klassizismus bis zum Jugendstil* (Stuttgart, 1983), which contains an extensive bibliography.

92 Erich Köllmann, "Die Porzellanservice des Herzogs von Wellington," *Keramos*, 10 (1960), pp.86–97.

93 Hertha Wellensiek, *Hundert alte Tassen aus Porzellan* (Munich, n.d.).

94 Waltraud Neuwirth, *Biedermeiertassen: Formen und Dekore am Beispiel des Wiener Porzellans* (Munich, 1982).

95 There was a spate of literature on this subject, including Delachénaye, *Abécédaire de Flore ou langage des fleurs* (Paris, 1811); Johann Daniel Symanski, *Selam oder die Sprache der Blumen* (Berlin, 1820); and Carl F. Müchler, *Die Blumensprache oder Symbolik des Pflanzenreichs* (Berlin, 1820).

96 Pazaurek and Philippovich, *Gläser*, p.51. For what follows, see also Spiegl, *Biedermeiergläser*, passim, especially p.49ff.

97 Himmelheber, *Biedermeier Furniture*, p.16. References are also given here for the furniture patterns and inventions discussed below.

98 Richard Streiter, "Das deutsche Kunstgewerbe und die englisch-amerikanische Bewegung," *Innen Dekoration*, 7 (1896), p.108.

99 The following is based largely on the account, first published in 1973, given in my *Die Kunst des deutschen Möbels*, vol.3: *Klassizismus, Historismus, Jugendstil*, 2nd ed. (Munich, 1983), p.207ff.

100 See the important essay by Bernward Deneke, "Biedermeier in Mode und Kunsthandwerk 1890–1905," *Anzeiger des Germanischen Nationalmuseums* (1967), pp.163–79. Deneke was the first to investigate closely the rediscovery of Biedermeier art by both artists and art historians at the turn of the century. His work had been anticipated by Ernst Schleyer's remarks on "Biedermeier II," in "Biedermeier in Literatur und Kunstgeschichte," *Aurora*, Eichendorff-Almanach 20 (1960), pp.13–25.

101 *Kunstgewerbeblatt*, n.s.10 (1899), p.67. The room is illustrated there on p.53, and also in

Innen Dekoration, 9 (1898), facing p.172. See also the critical remarks by Leopold Gmelin, in *Kunst und Handwerk*, 47 (1897–98), p.429.

102 A chair from the set is illustrated in Himmelheber, *Die Kunst des deutschen Möbels*, fig.931.

103 Hartwig Fischel, "Biedermeier als Vorbild," *Das Interieur*, 2 (1901), p.65.

104 The magazine *Jugend* poked fun at the Biedermeier revival in 1903 (p.130): "Lächerbar ist diese Mode/Mit dem Biedermeierstil,/Den man jetzt pflegt mit Methode/Auswärts und im Domizil" (Ridiculous, this fad/Of the Biedermeier style/Which is now applied methodically/Without and within the domicile).

105 Friedrich Thiersch, in *Kunst und Handwerk*, 55 (1904–5), p.96.

106 Erich Haenel, "Die dritte deutsche Kunstgewerbe-Ausstellung Dresden 1906," *Die Kunst*, 14 (1906), p.395 ff.; also the source of the quotations below.

107 Paul Schulze-Naumburg, "Biedermeierstil?" *Der Kunstwart*, 19 (1905–6), pp.130–37. An astonishingly perceptive analysis of the Biedermeier style is found on pp.130–31.

108 F.H. Ehmcke, "Rückkehr zum Biedermeier," *Die Kunst*, 18 (1908), p.274 ff.

109 Numerous examples from all fields of decorative art are found in the comprehensive catalogue of the exhibition *Moderne Vergangenheit: Wien 1800–1900* (Vienna, 1981).

110 Quoted in an essay by Max Creutz, in *Die Kunst*, 26 (1912), p.60.

111 The chairs from this suite are illustrated in Himmelheber, *Die Kunst des deutschen Möbels*, figs.947, 950.

112 Fritz Stahl, "Bruno Pauls 'Gelbes Haus'," *Die Kunst*, 32 (1915), pp.1–24.

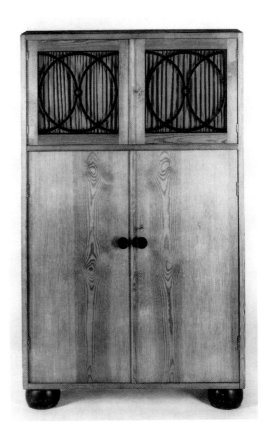

Fig.88 Hermann Münchhausen,
Cupboard, 1911.
Hessisches Landesmuseum,
Darmstadt

Plates

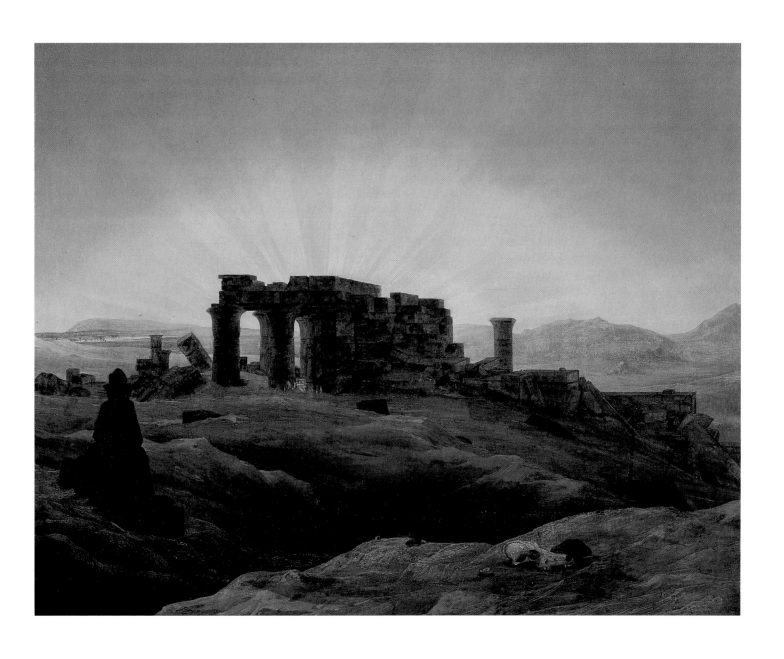

Wilhelm Ahlborn, *The Temple of Kôm Ombo in Egypt*, 1830. No. 1

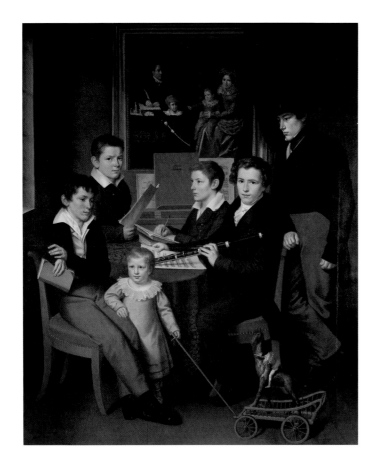

Kaspar Benedikt Beckenkamp
The Sons of Herr Heinrigs, Calligrapher, 1828. No. 6

Kaspar Benedikt Beckenkamp
Herr and Frau Heinrigs with Two Sons, 1824. No. 5

Karl Begas, *The Begas Family*, 1821. No. 7

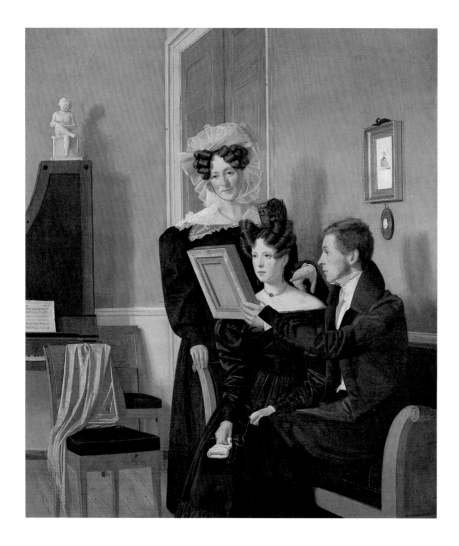

Wilhelm Bendz, *The Raffenberg Family*, 1830. No. 8

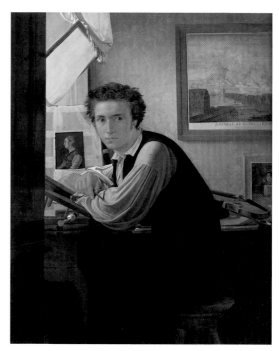

Detlev Konrad Blunck
The Engraver C.E. Sonne, 1826. No. 9

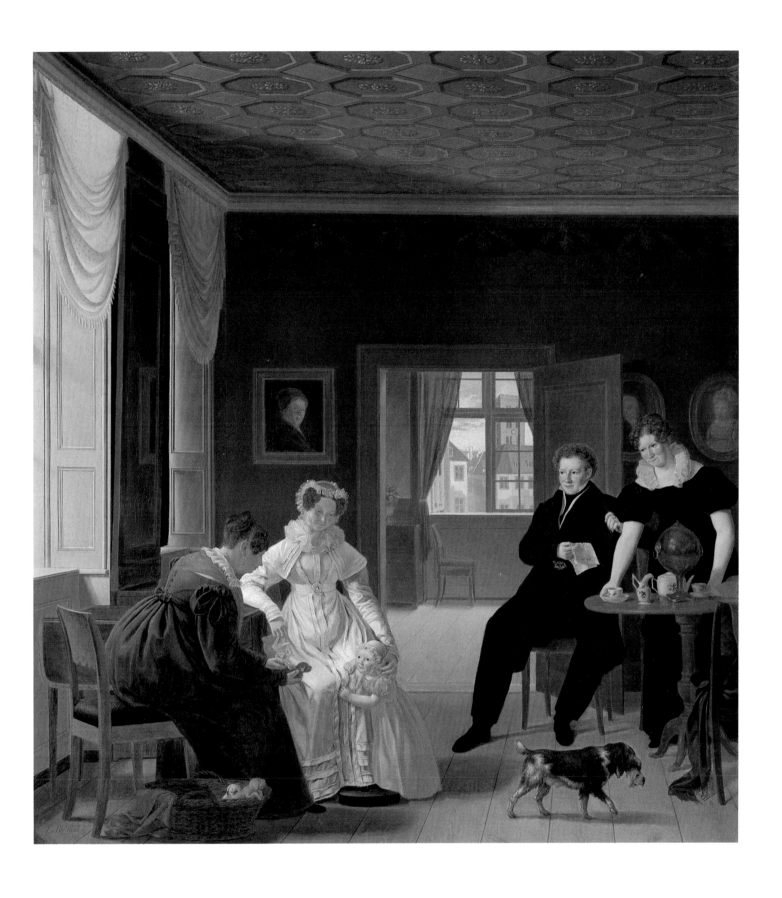

Emilius Ditlev Baerentzen, *The Winther Family*, 1827. No. 4

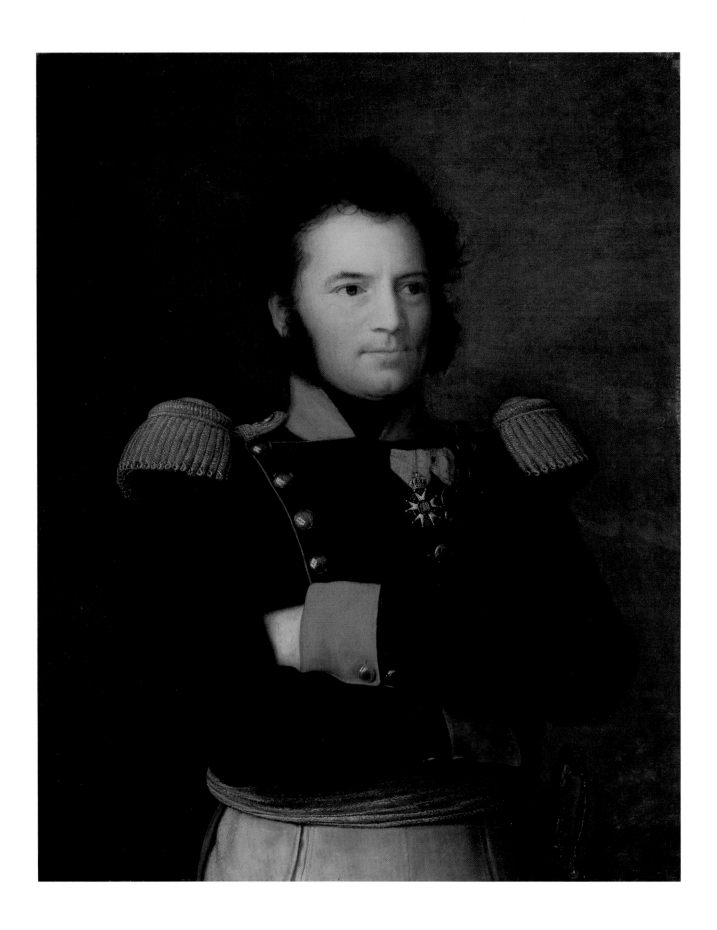

Felix Maria Diogg, *Portrait of Colonel Joachim Forrer*, 1827. No. 15

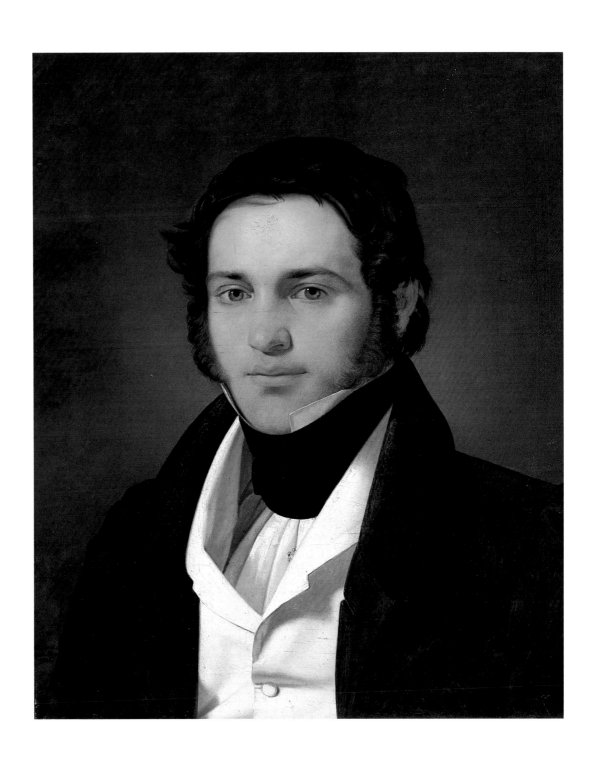

Detlev Konrad Blunck, *Portrait of the Painter Frederik Thöming*, 1831. No. 10

Johann Hermann Carmiencke, *Morning on the Alster River near Poppenbüttel*, 1833. No. 11

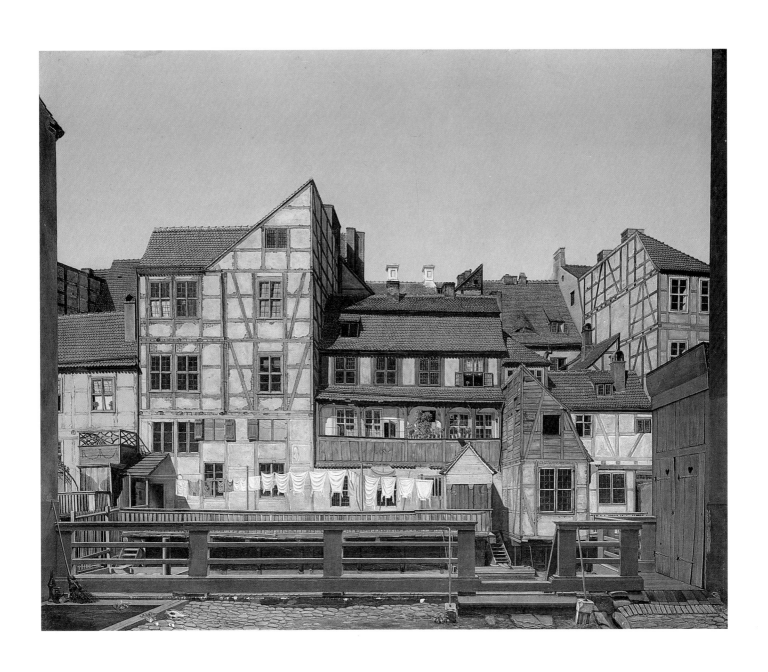

Christoffer Wilhelm Eckersberg, *View of Nyholm*, 1826. No. 17

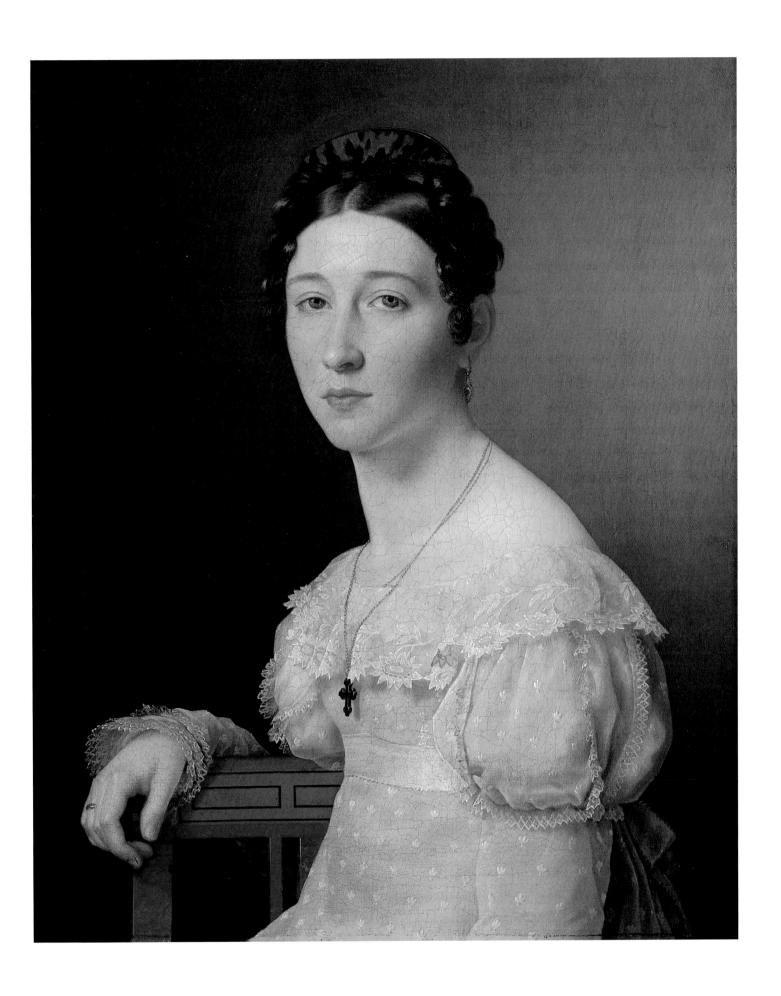

Christoffer Wilhelm Eckersberg, *Portrait of Emilie Henriette Massmann*, 1820. No. 16

Marie Ellenrieder, *Self-Portrait*, 1818. No. 19

Johann Heinrich Christian Eli, *Flower Still Life*, 1833. No. 18

Thomas Ender, *Courtyard of the Palazzo Venezia*, 1819/23. No. 21

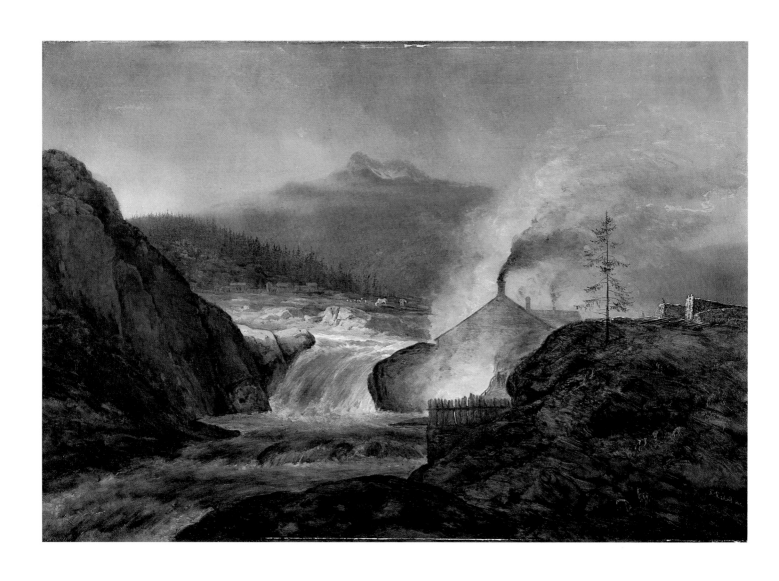

Christian Ezdorf, *An Iron Forge in Scandinavia*, 1827. No. 23

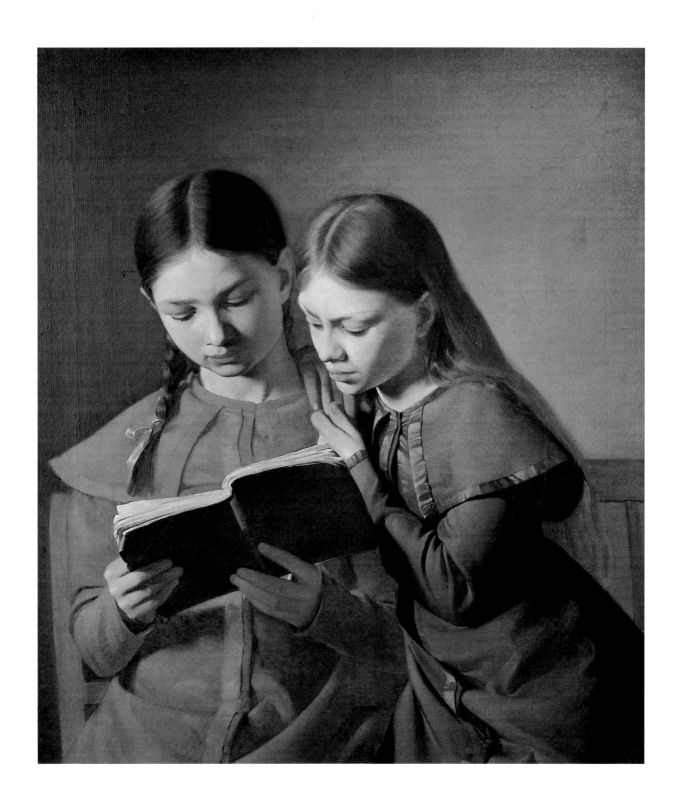

Constantin Hansen, *The Artist's Sisters*, 1826. No. 30

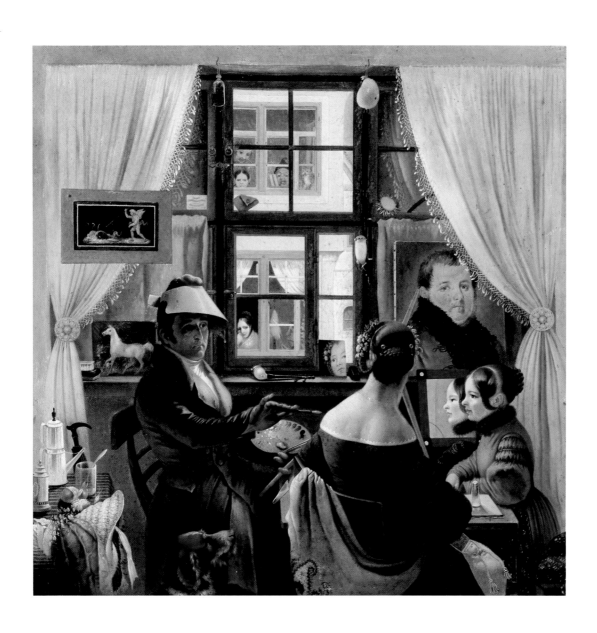

Karl Friedrich Göser, *Self-Portrait in the Studio*, 1835. No. 29

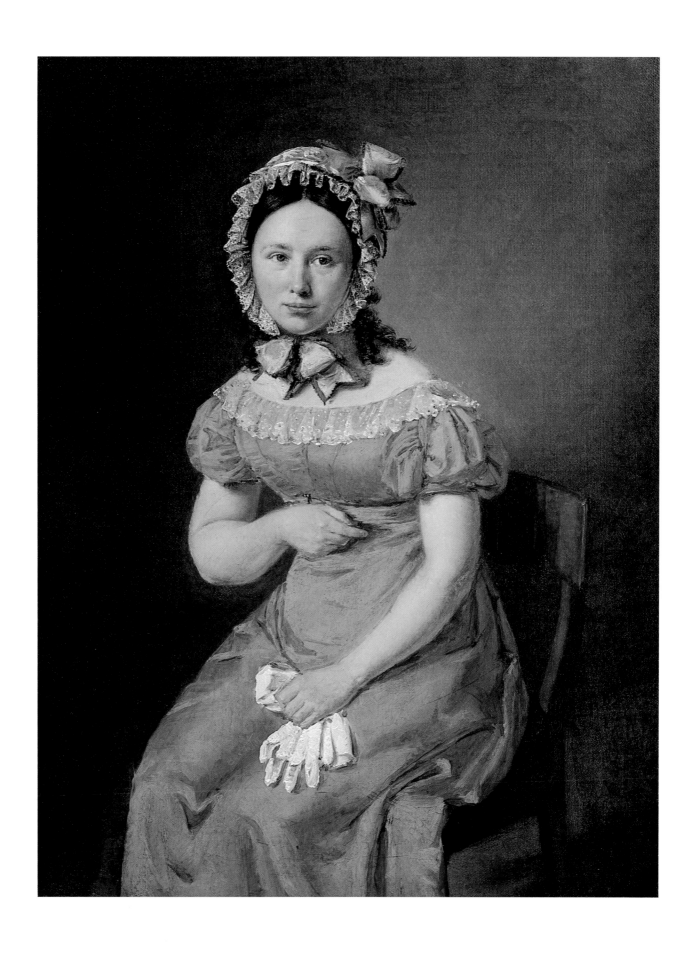

Christian Albrecht Jensen, *Portrait of the Artist's Wife*, c. 1825. No. 34

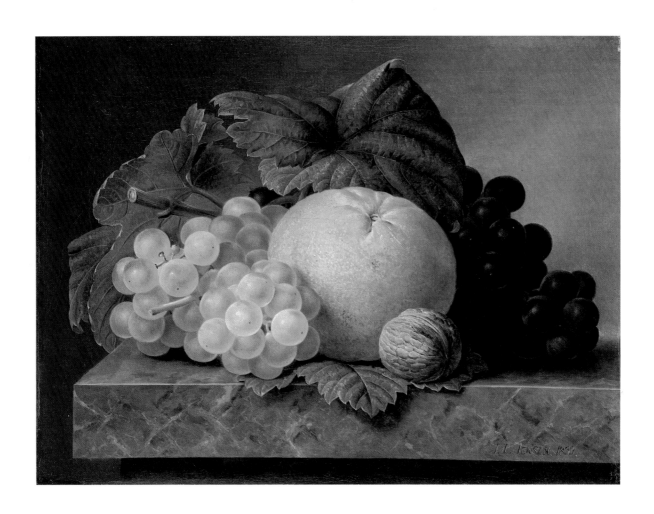

Johan Laurentz Jensen, *Still Life with Fruit*, 1833. No. 35

Johann Erdmann Hummel, *Ernst Wilhelm Brücke as a Boy*, 1823. No. 33

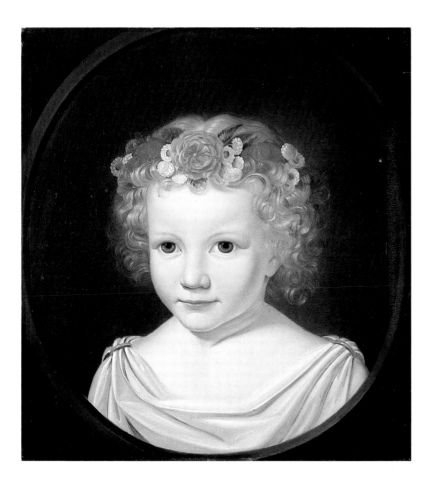

Johann Jakob Gensler, *Hollyhock*, 1827. No. 28

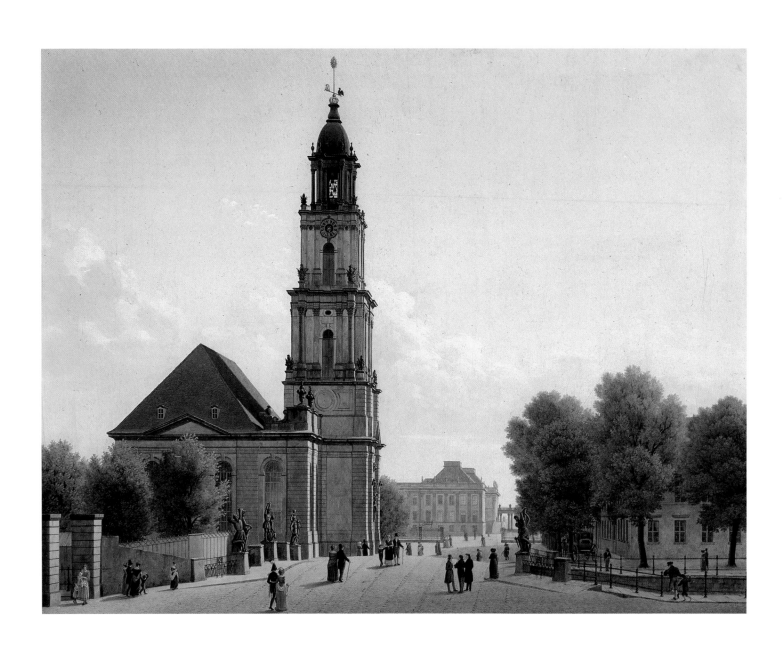

Karl Hasenpflug, *The Garrison Church in Potsdam*, 1827. No. 31

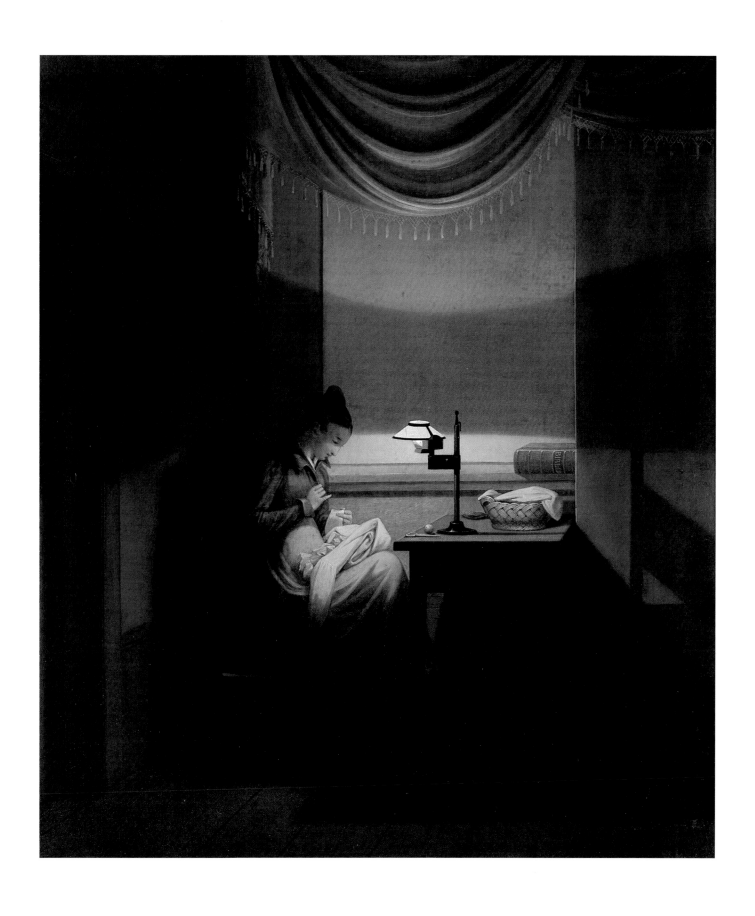

Georg Friedrich Kersting, *Woman Sewing by Lamplight*, 1828. No. 37

Just Ulrich Jerndorff, *Landscape with Cliffs*, c. 1830. No. 36

Friedrich Wilhelm Klose, *The Astronomical Observatory, Berlin*, c. 1835. No. 38

Wilhelm von Kobell, *Alpine Meadow*, 1829. No. 40

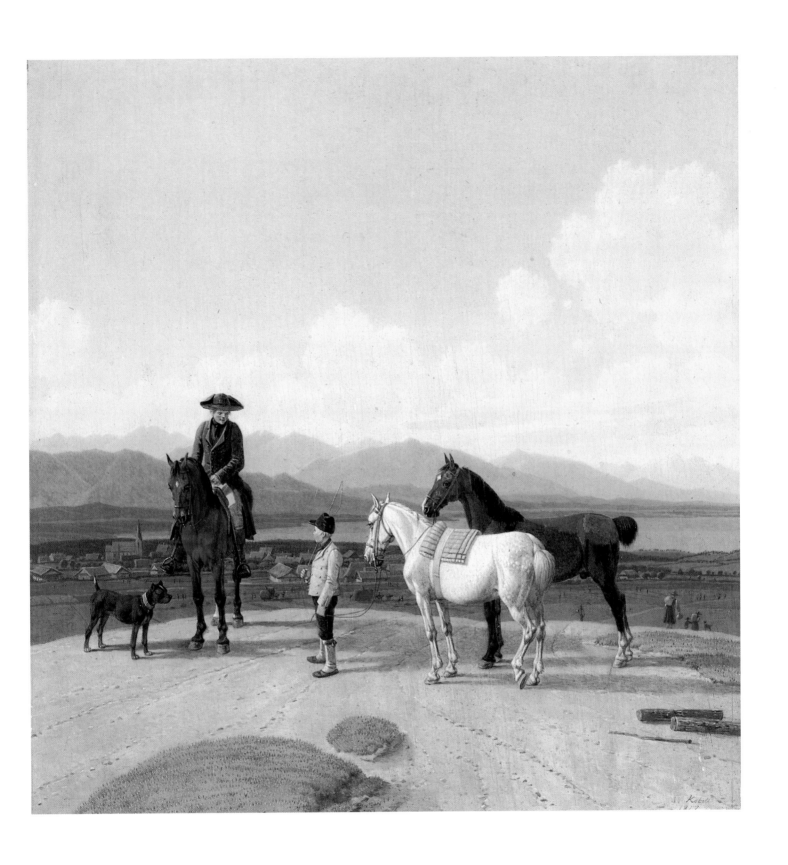

Wilhelm von Kobell, *Horseman and Stable Boy*, 1827. No. 39

Christen Købke, *View of Langelinie from Copenhagen Citadel*, c. 1832. No. 41

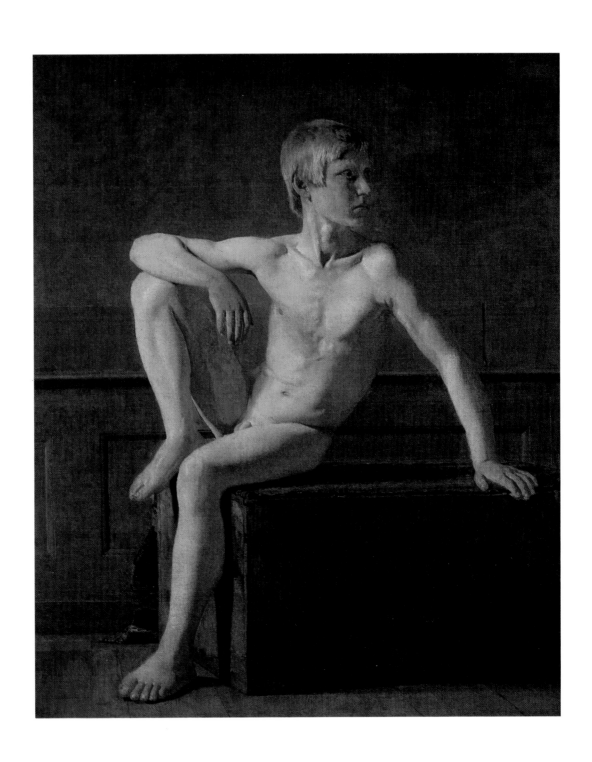

Christen Købke, *Study of a Nude Boy*, 1833. No. 42

Johann Christian Tunica
Portrait of A. Giem, 1823. No. 67

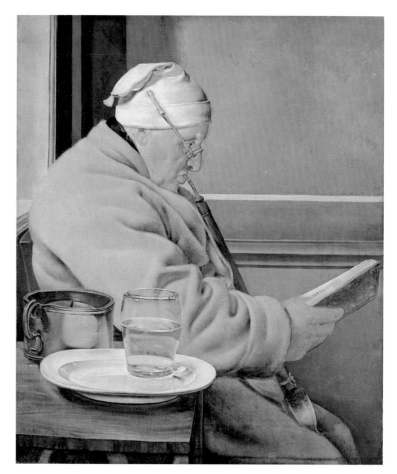

Johann August Krafft
Judge Jakob Wilder, 1819. No. 43

Christian E. B. Morgenstern, *On the Swedish Coast*, 1828. No. 54

Hans Jakob Oeri, *Portrait of Johann Jakob Stolz*, 1818. No. 47 Moritz Daniel Oppenheim, *Portrait of Ludwig Börne*, 1833. No. 50

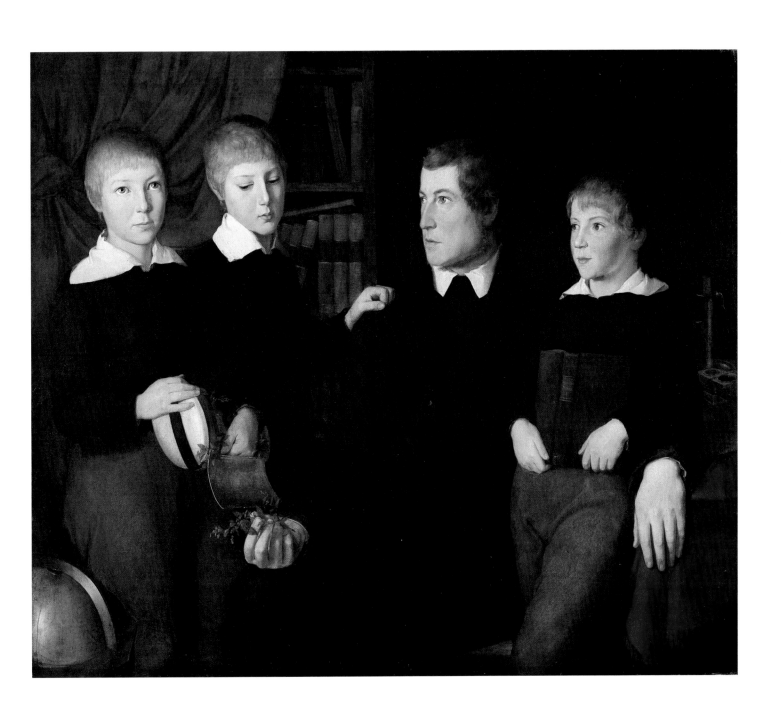

Moritz Daniel Oppenheim, *The Jung Brothers with their Tutor*, 1826. No. 49

Domenico Quaglio, *Residenzstrasse, Munich*, 1826. No. 52

Josef Rebell, *View of the Gulf of Naples*, c. 1815. No. 54

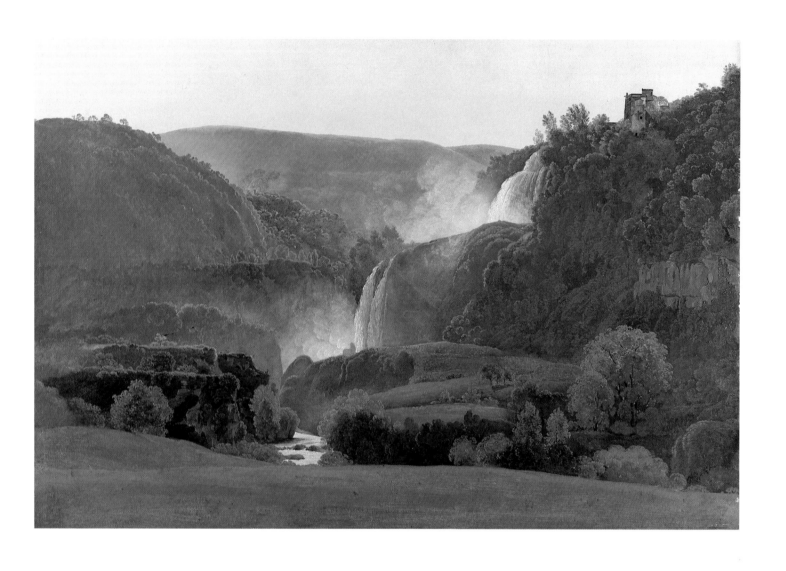

Johann Martinus von Rohden, *Tivoli seen from the West*, c. 1815. No. 56

Jørgen Roed
Portrait of Emil Wilhelm Normann, 1830. No. 55

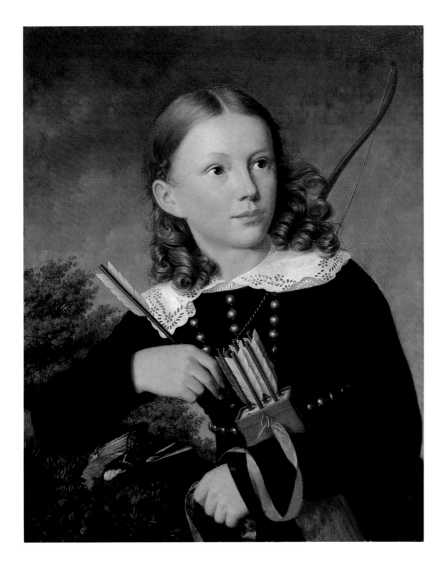

Peter von Rausch, *Boy with Bow and Arrow*, 1826. No. 53

Karl von Sales
Portrait of Magdalena von Erstenberg, 1816. No. 58

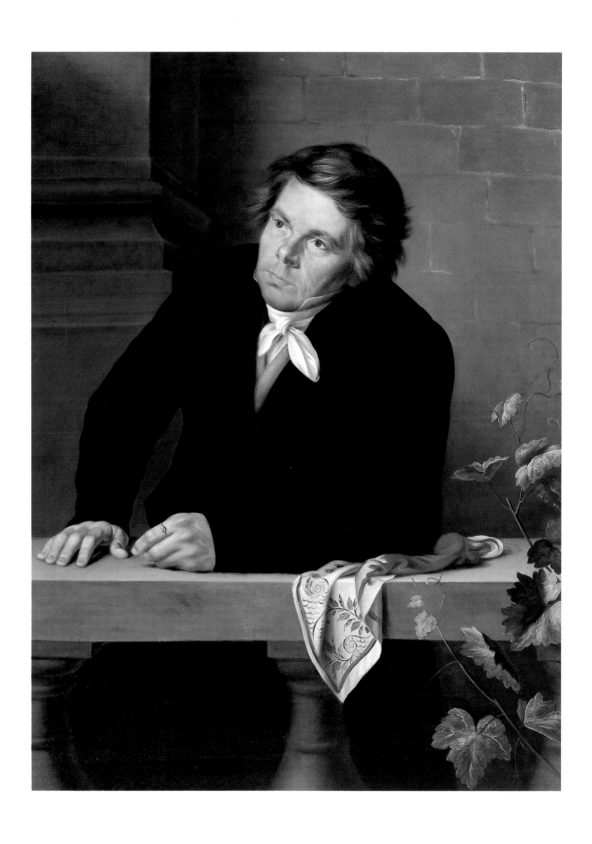

Jakob Schlesinger, *Portrait of Christian Philipp Köster*, c. 1827. No.60

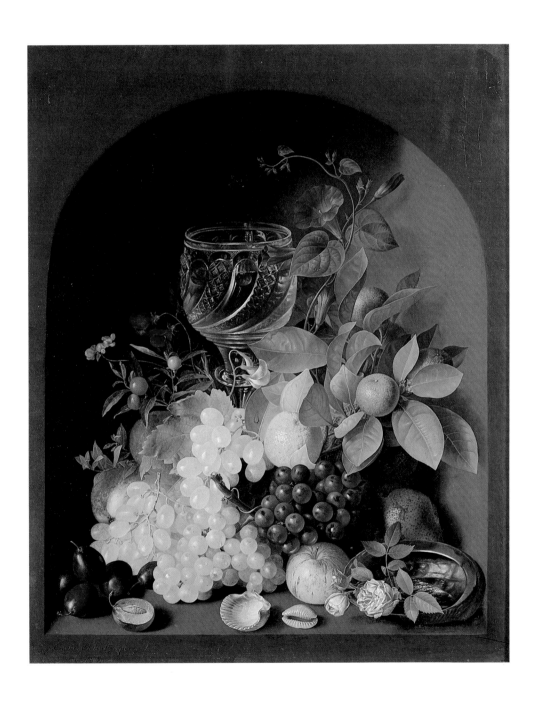

Erdmann Schultz, *Still Life with Fruit*, 1831. No.61

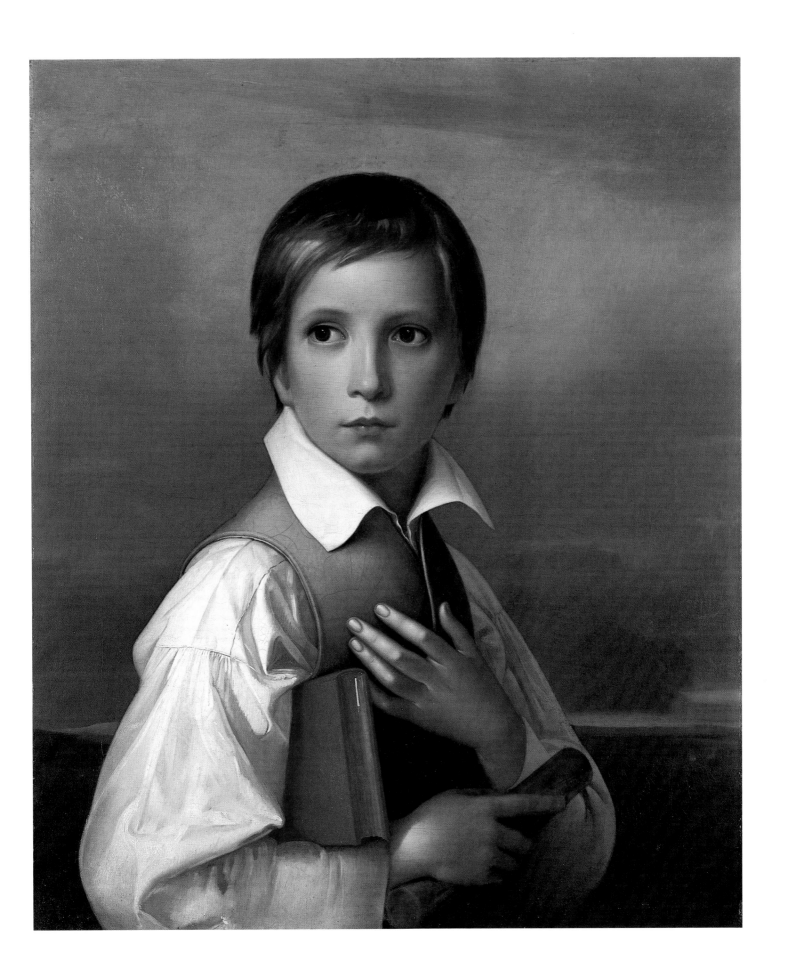

Wilhelm von Schadow, *Portrait of Felix Schadow*, c. 1830. No. 59

Karl Adolf Senff, *Antique Vase with Bunch of Flowers*, 1828. No. 63

Karl Adolf Senff, *The Wreathmaker*, 1828. No. 62

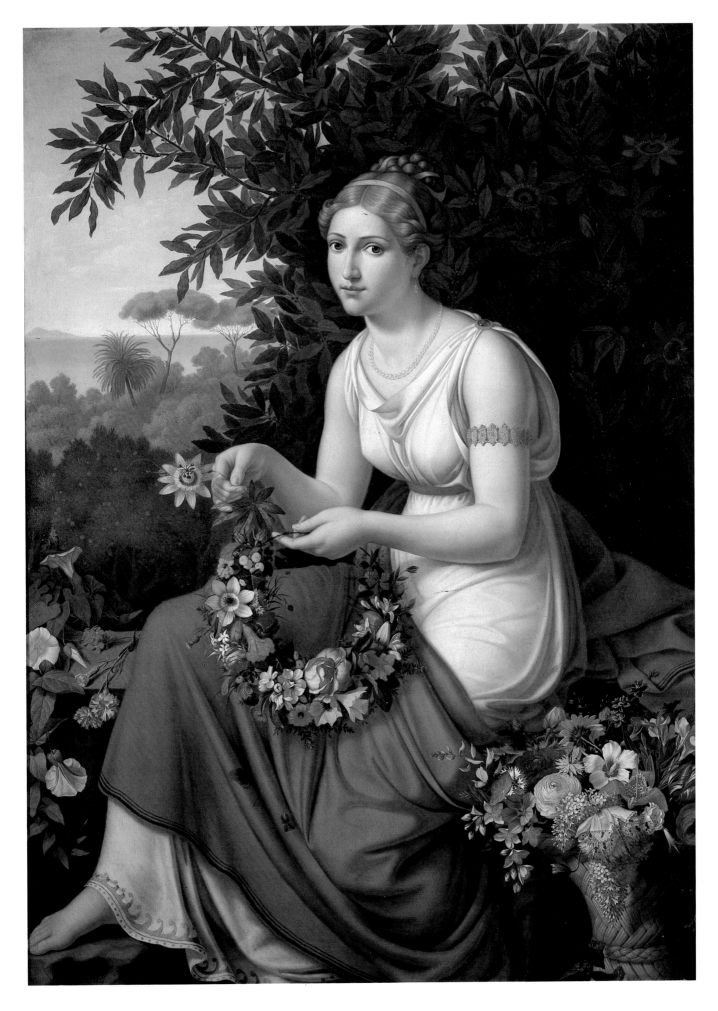

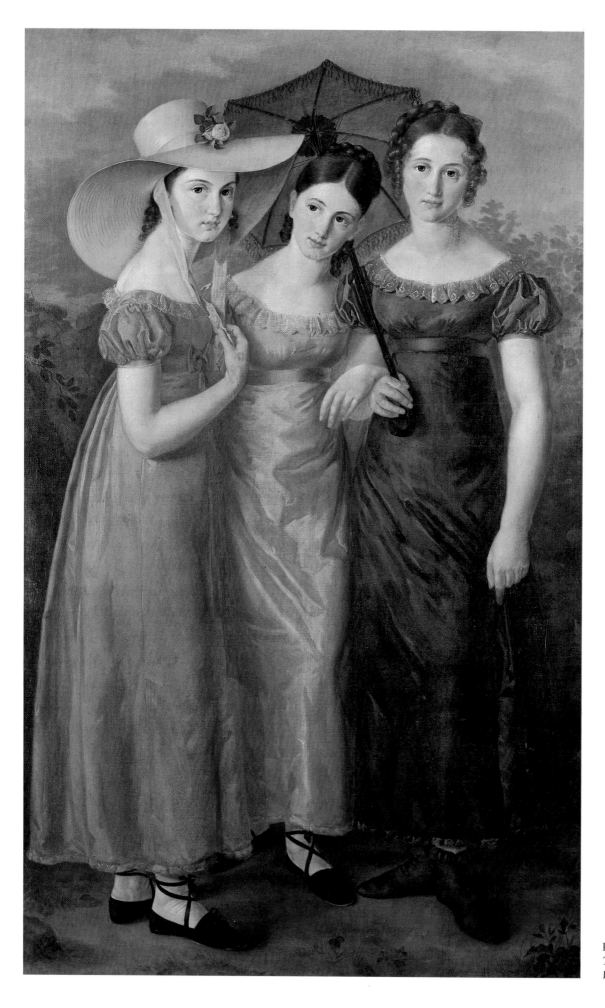

David Sulzer
*Three Young Ladies of
Winterthur*, 1822. No.66

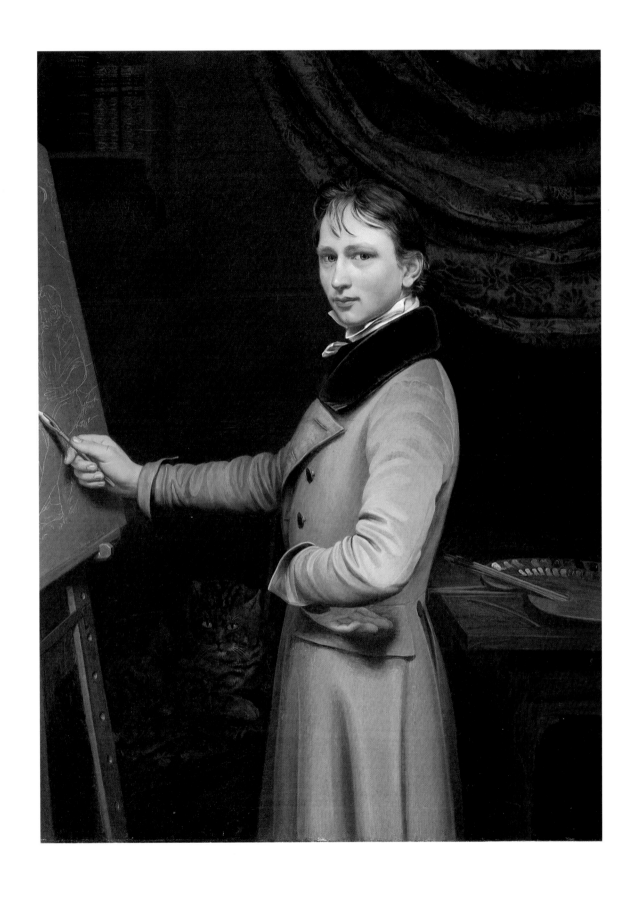

Eduard David Steiner, *Self-Portrait*, 1832. No.64

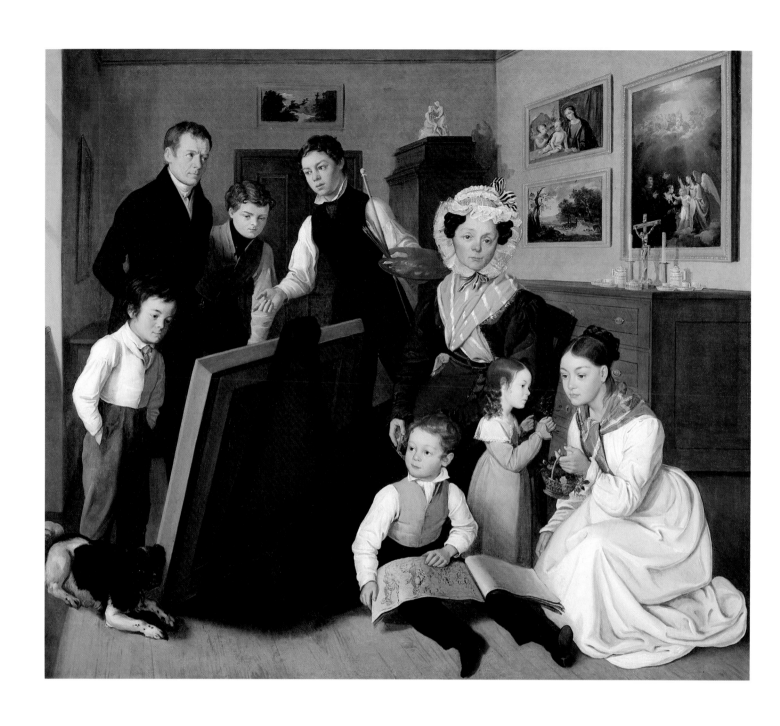

Leopold Stöber, *Self-Portrait with Family*, 1827. No. 65

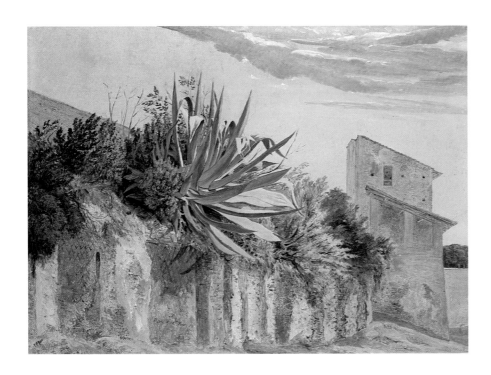

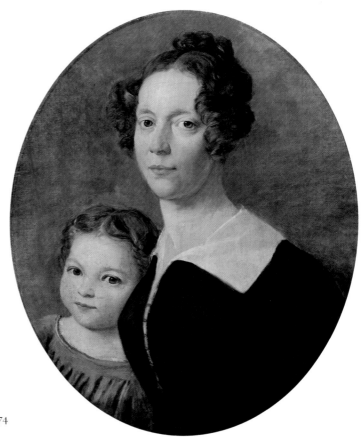

Johann Eduard Wolff, *Susanne Schinkel and her Daughter*, c. 1826. No. 74

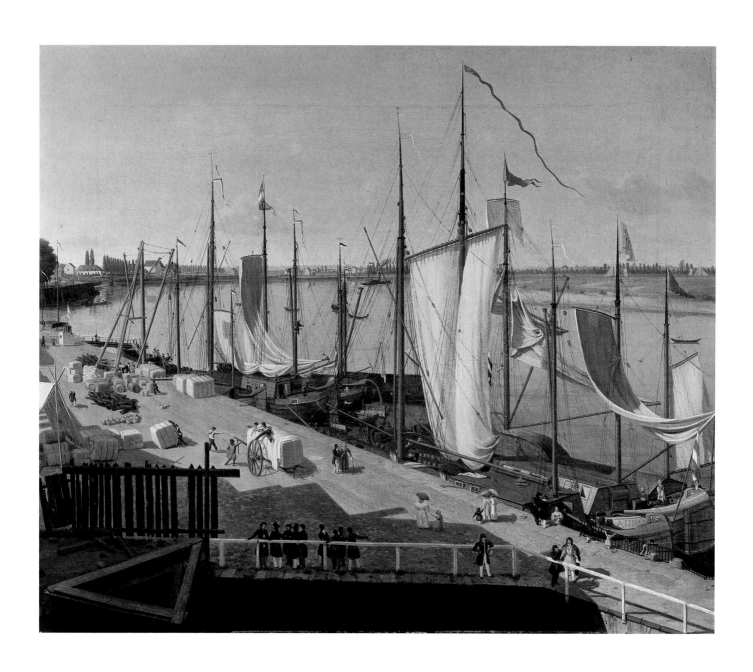

Jan Velten, *Düsseldorf Harbor*, 1832. No. 68

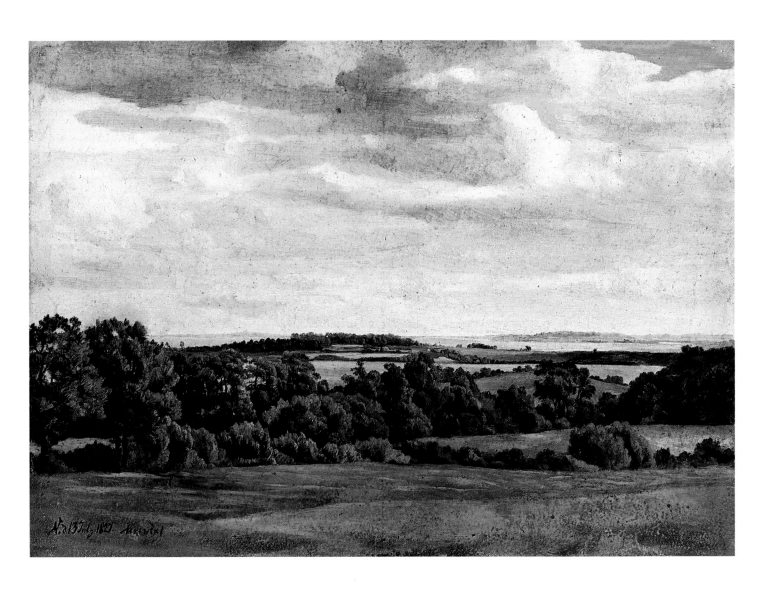

Adolf Friedrich Vollmer, *Landscape in Holstein*, 1827. No. 69

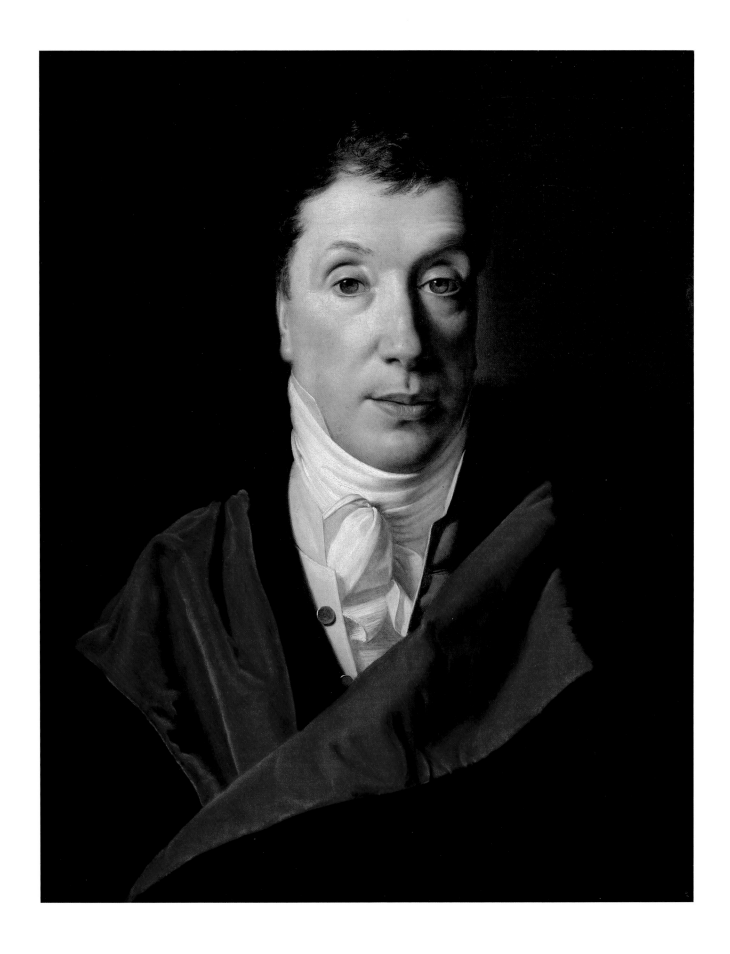

Ferdinand Georg Waldmüller, *Portrait of Joseph Noé*, 1821. No. 71

Karl Friedrich Schinkel, Set design for Rossini's *Otello*, 1821. No. 77

Karl Friedrich Schinkel, Set design for Spontini's *Olympia*, 1821. No. 78

Giuseppe Quaglio, Set design for Poissl's *Prinzessin von Provence*, 1825. No. 76

Severin Buemann
Interior of the Theater in Leopoldstadt, 1852. No. 75

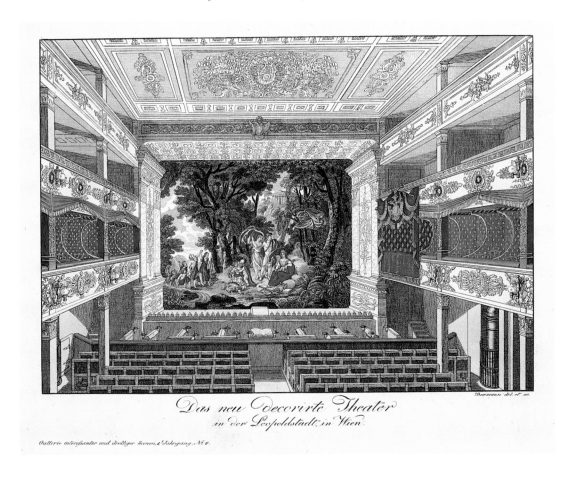

Johann Christian Schoeller
A Scene from Ferdinand Raimund's
Der Alpenkönig und der Menschenfeind, 1829. No. 79

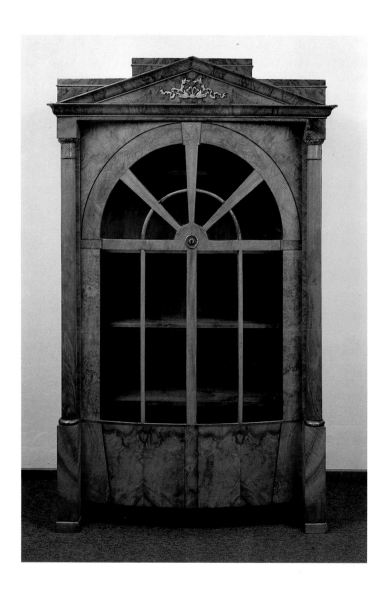

Vitrine. Southern Germany, c. 1815. No. 94

Bureau-Cabinet. Mark Brandenburg, c. 1815/20. No. 96

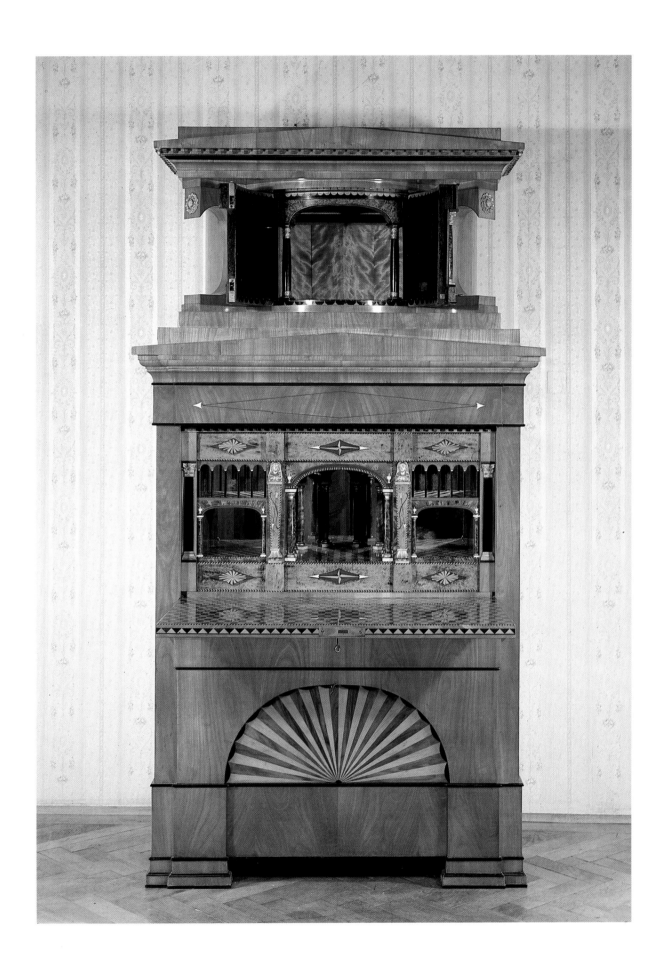

Bureau-Cabinet. Asch, Johann Friedrich Wunderlich, 1826. No. 98

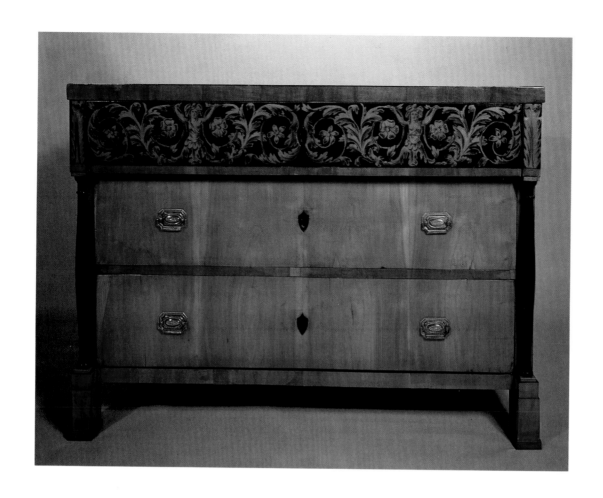

Chest of Drawers. Munich, c. 1825. No. 102 Chest of Drawers. Mark Brandenburg, c. 1815/20. No. 100

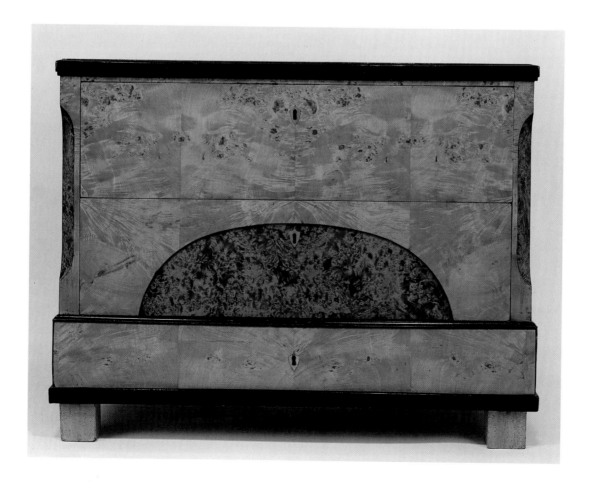

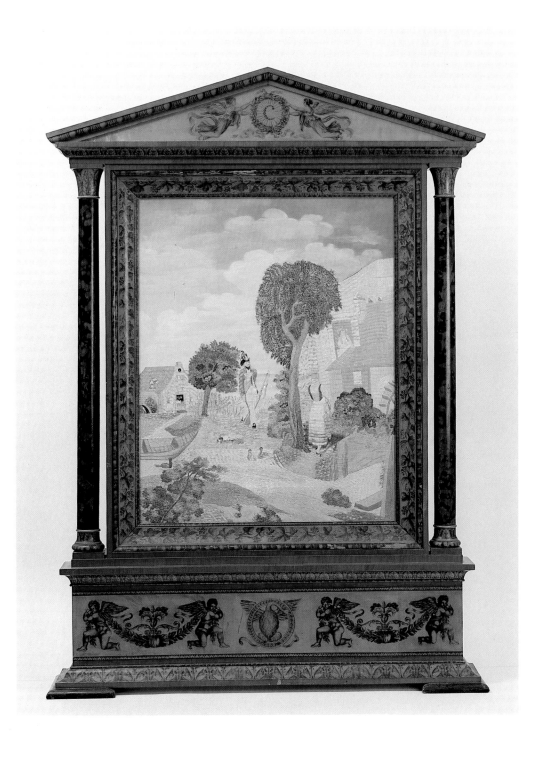

Pole Screen.
Netherlands,
c. 1815. No. 124

Fire Screen.
Munich,
Johann Georg Hiltl.
1821. No. 125

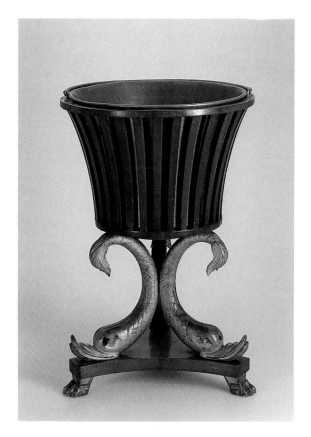

Portable Stove. Netherlands, c. 1815. No. 128

Globe Table. Vienna, c. 1820. No. 108

Table. Vienna, Josef Danhauser, c. 1820. No. 104

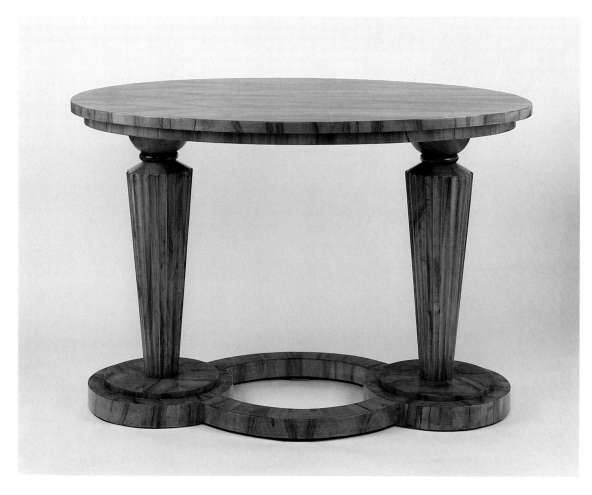

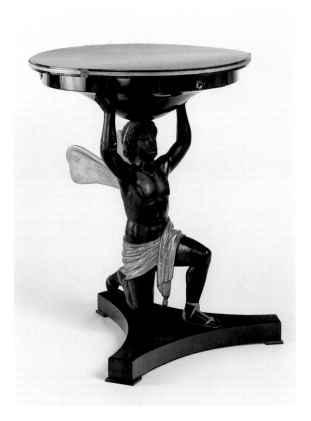

Table.
Vienna, c. 1820. No. 105

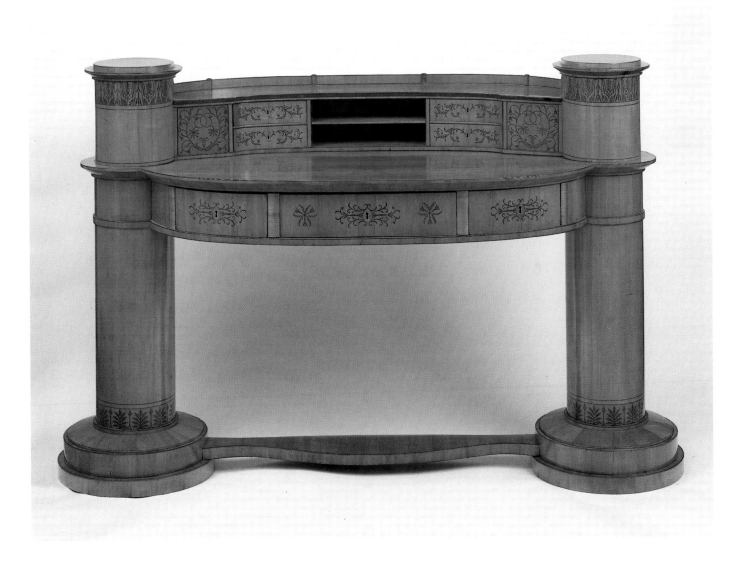

Desk.
Vienna, c. 1830. No. 103

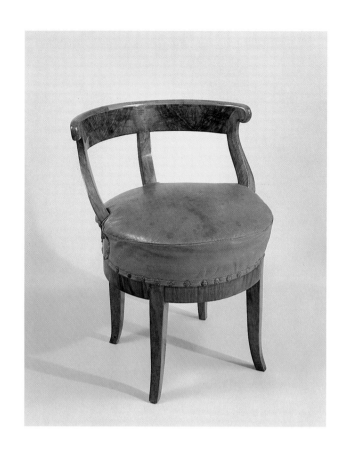 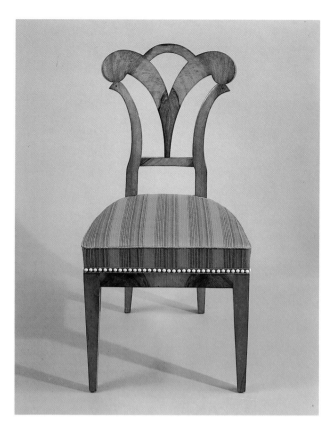

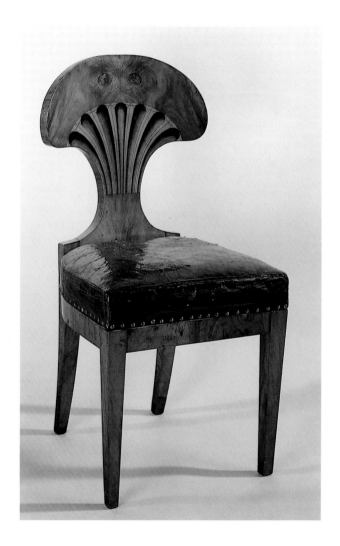 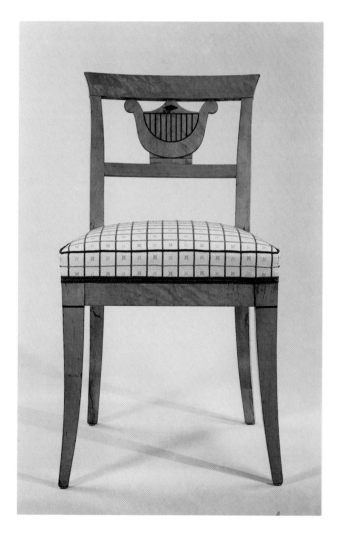

Upholstered Chair. Vienna, c. 1815. No. 113

Upholstered Chair. Vienna, c. 1830. No. 122

Upholstered Chair. Vienna, c. 1825. No. 121

Upholstered Chair. Westphalia, c. 1825. No. 119

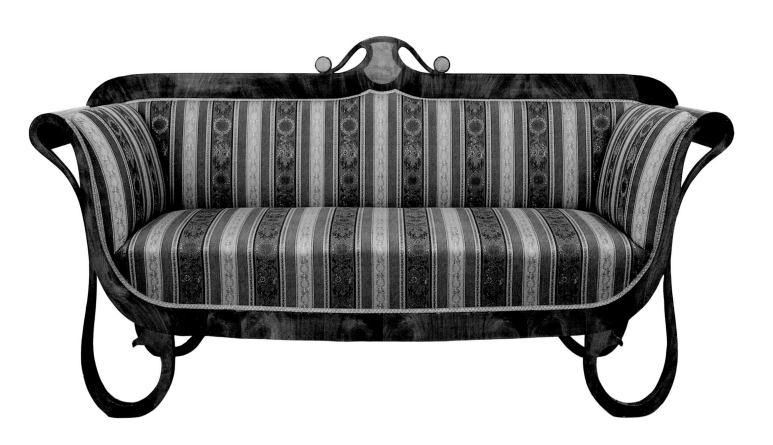

Sofa. Vienna, c. 1825. No. 112

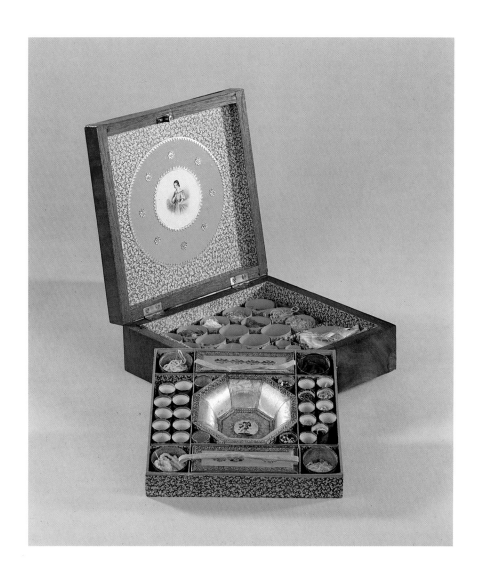

Needlework Box. Northern Germany, c. 1835. No. 137

Sewing Box. Switzerland, c. 1830. No. 156

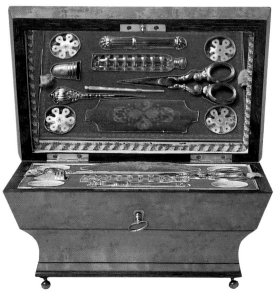

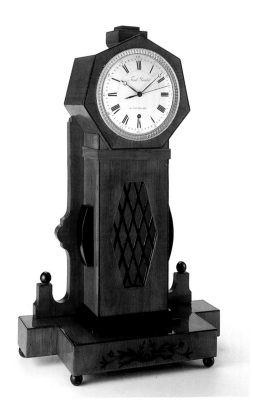

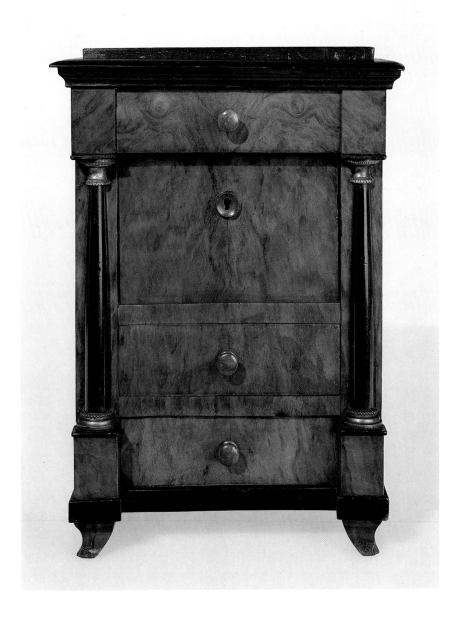

Jewel Casket.
Southern Germany, c. 1825. No. 135

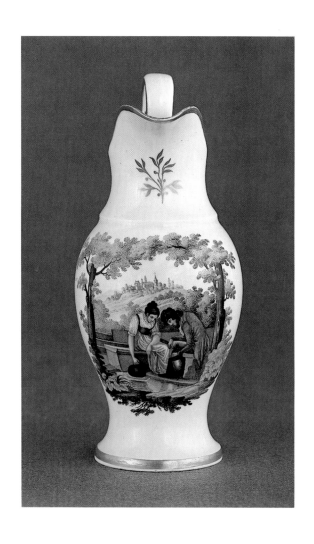

Milk Jug. Ansbach, c. 1815. No. 141

Breakfast Service. Berlin, 1828. No. 146

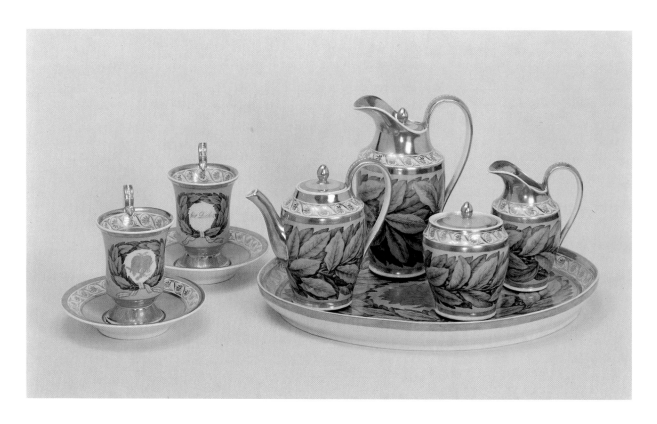

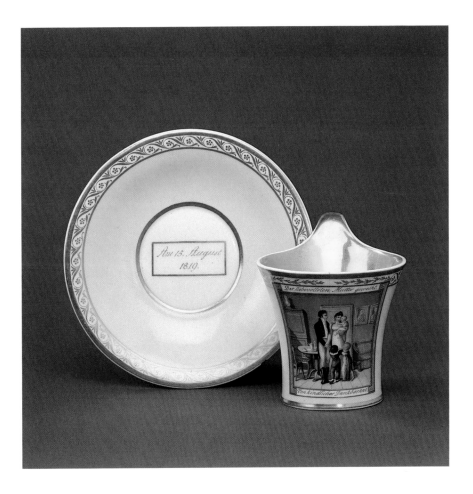

Cup and Saucer. Berlin, 1819. No. 144

Lidded Cup and Saucer. Berlin, 1814. No. 142

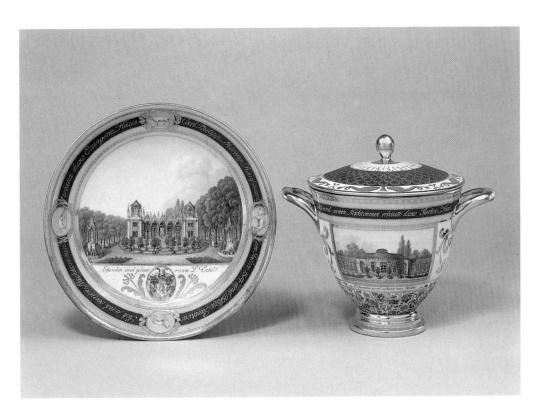

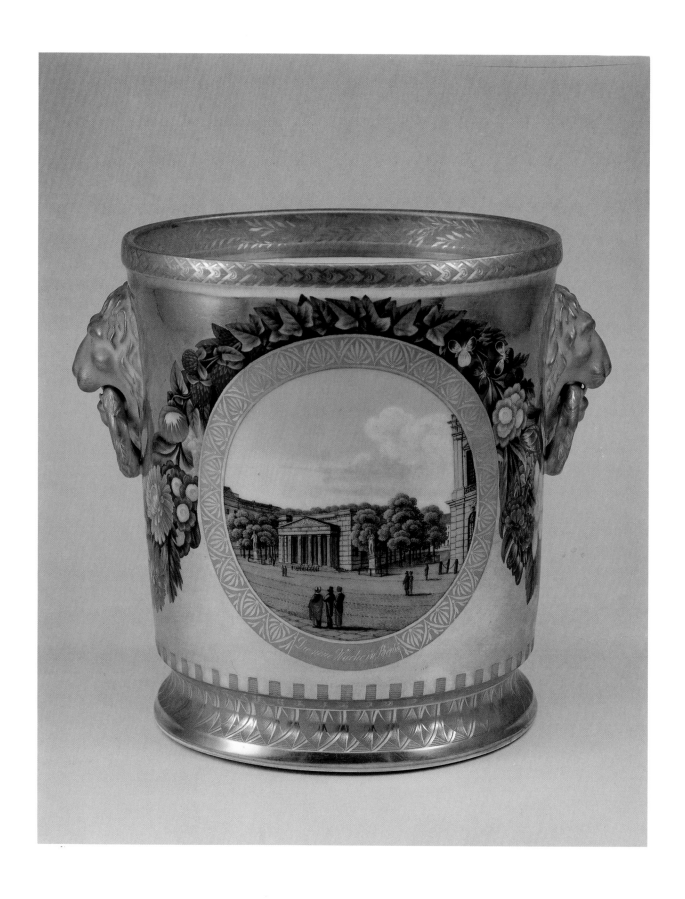

Wine Cooler. Berlin, 1825. No. 145

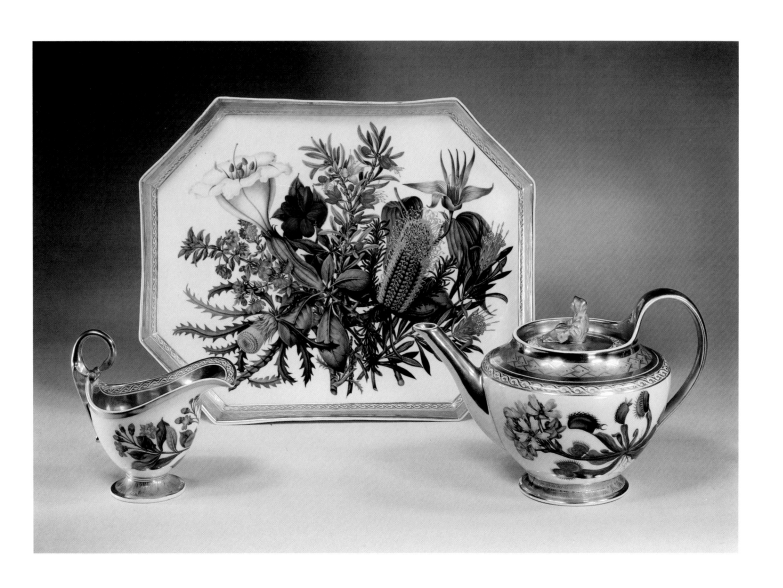

Creamer, Tray, and Teapot from a Coffee and Tea Service. Berlin, 1817/23. No. 143

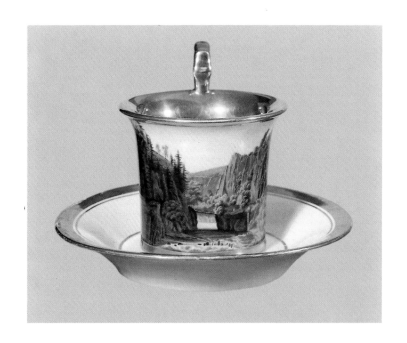

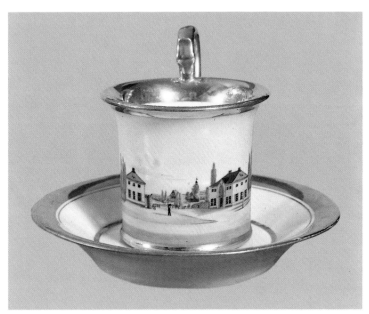

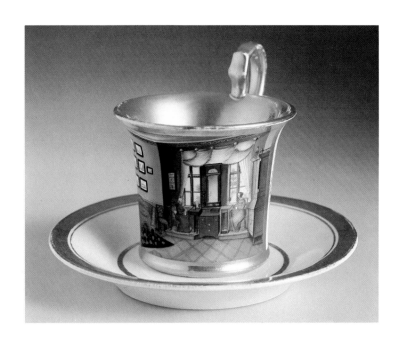

Cup and Saucer. Fürstenberg. c. 1830/35. No. 152

Cup and Saucer. Fürstenberg. c. 1830/35. No. 153

Cup and Saucer. Fürstenberg. c. 1830/35. No. 154

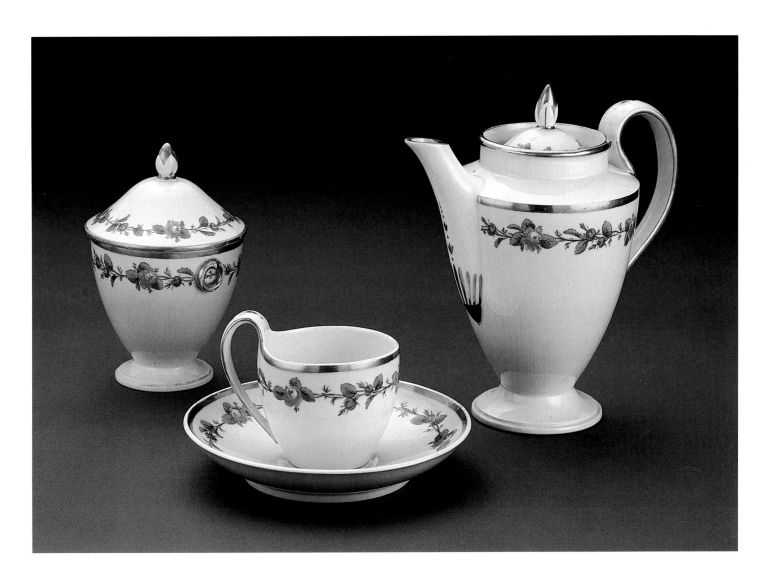

Coffee Service. Fürstenberg. c. 1820. No. 149

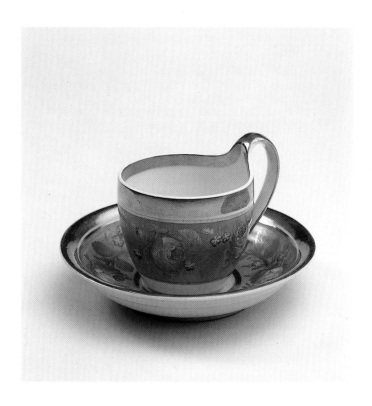

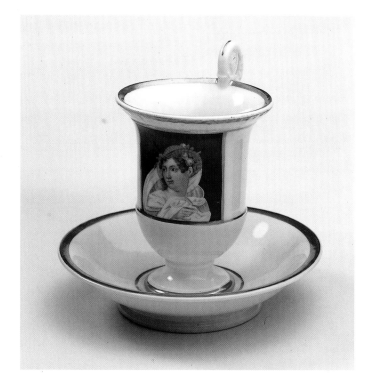

Cup and Saucer. Fürstenberg, c. 1825. No. 150

Cup and Saucer. Fürstenberg, c. 1825. No. 151

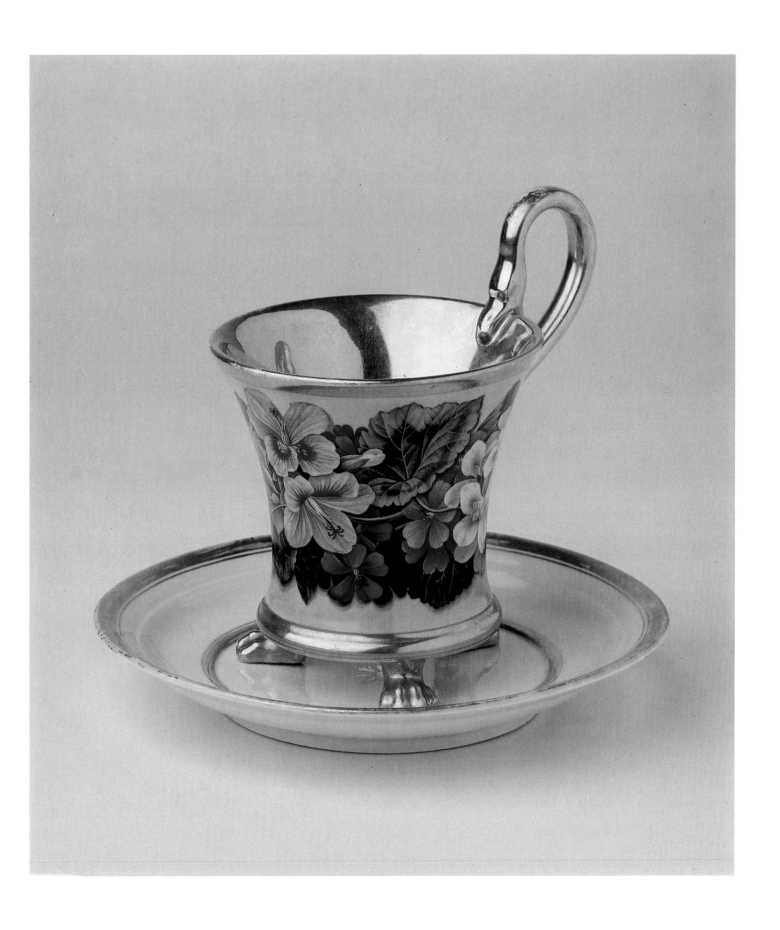

Cup and Saucer. Fürstenberg. c. 1855. No. 155

Cup and Saucer.
Meissen, 1820. No. 158

Coffee Service.
Meissen, 1817/18 No. 157

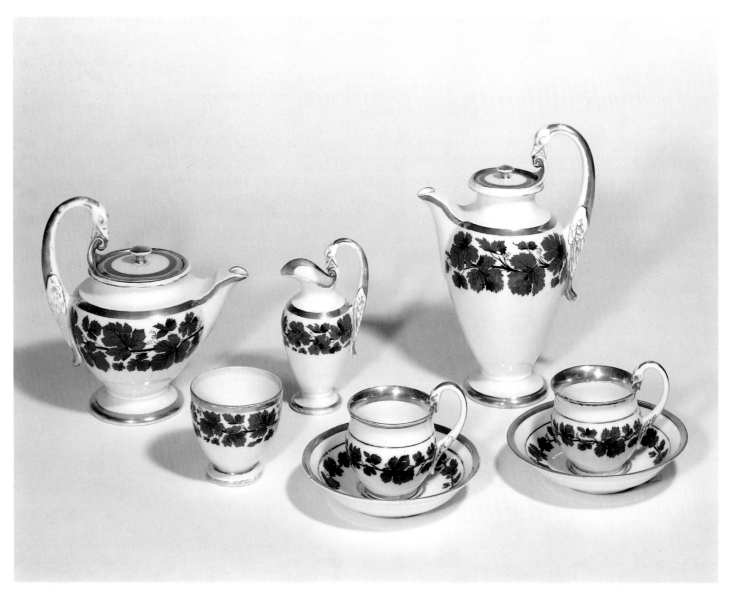

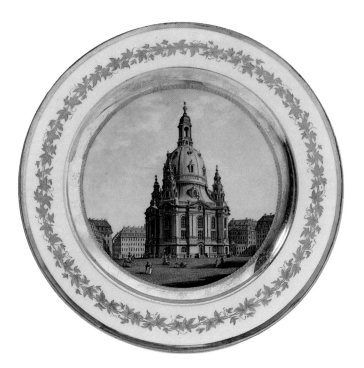

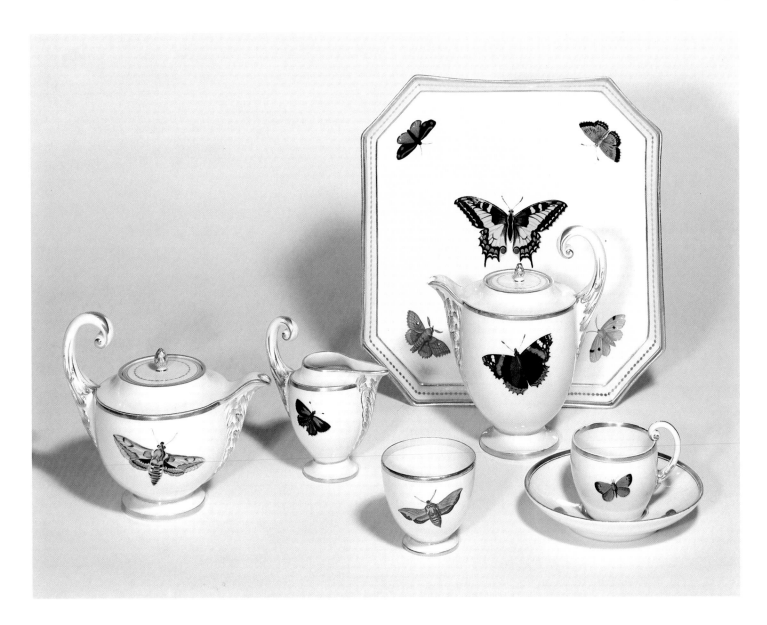

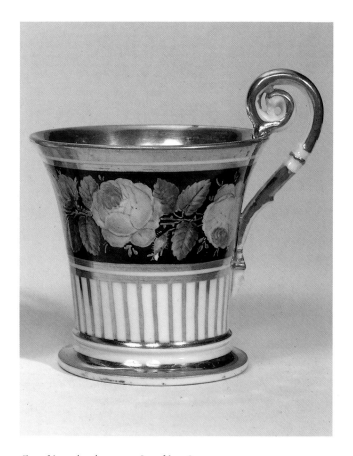

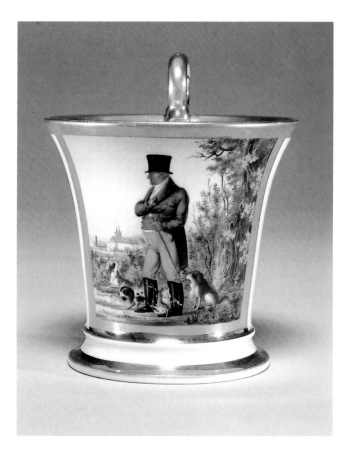

Cup. Nymphenburg, c. 1820. No. 162

Cup. Nymphenburg, c. 1820/25. No. 163

Bouillon Cup. Nymphenburg, c. 1825/30. No. 167

Cup. Nymphenburg, c. 1825/30. No. 168

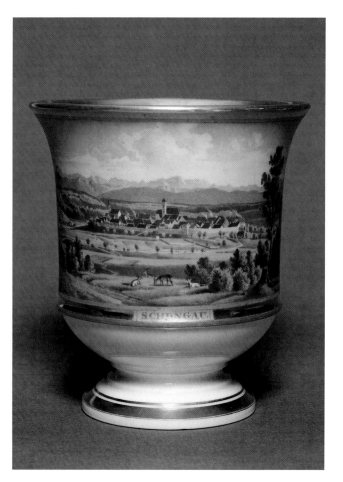

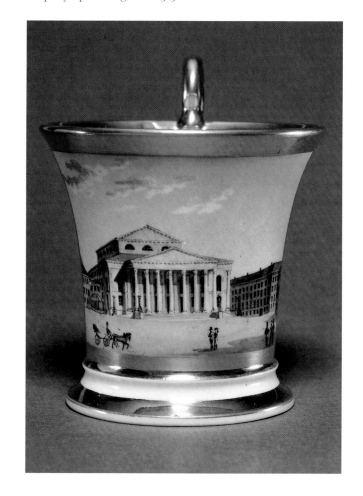

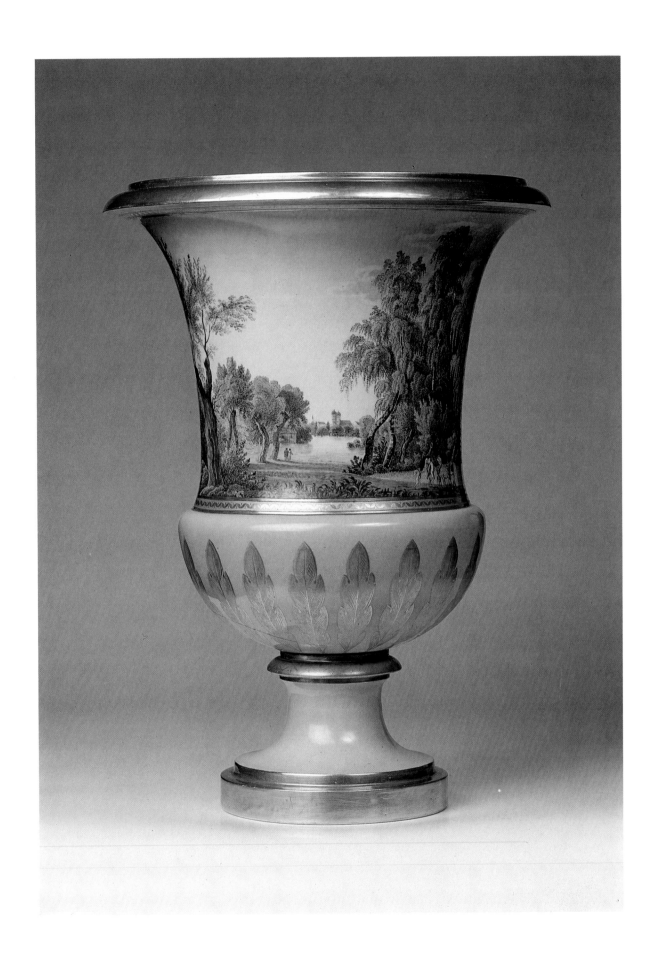

Vase. Nymphenburg. c. 1825. No. 165

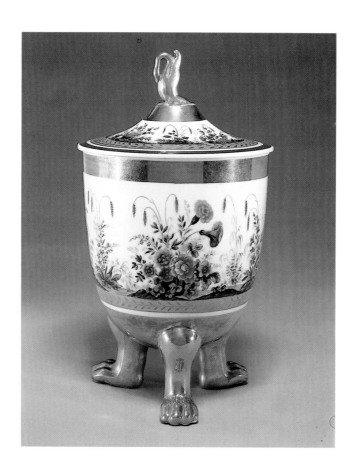

Sugar Bowl.
Nymphenburg,
c. 1825.
No. 166

Cup and Saucer. Nymphenburg, probably 1824. No. 164

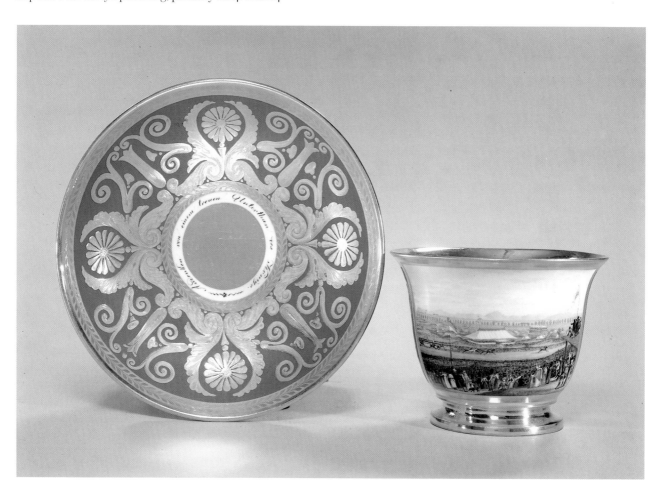

Vase.
Schrezheim. c. 1820.
No. 170

Cup. Vienna, 1824/25. No. 174 Cup. Vienna, 1815. No. 172

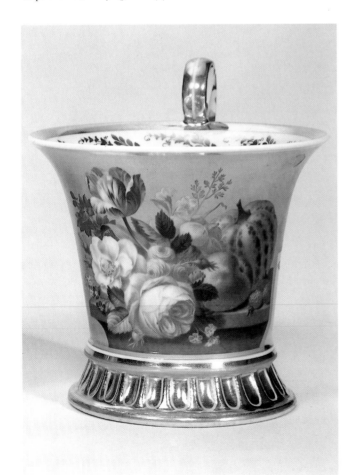 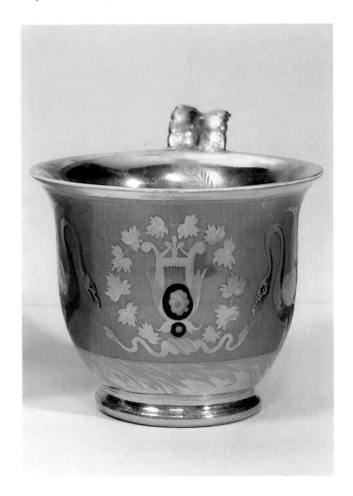

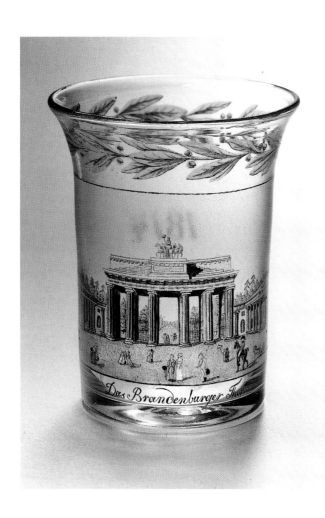

Tumbler. Berlin, Karl von Scheidt, 1816. No. 178

Tumbler. Dresden, Karl von Scheidt, c. 1815. No. 205

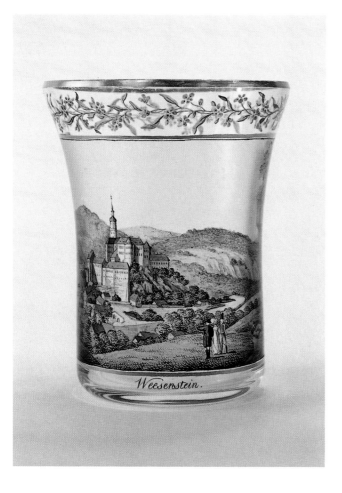

Tumbler. Dresden, Wilhelm Viertel, 1817. No. 206

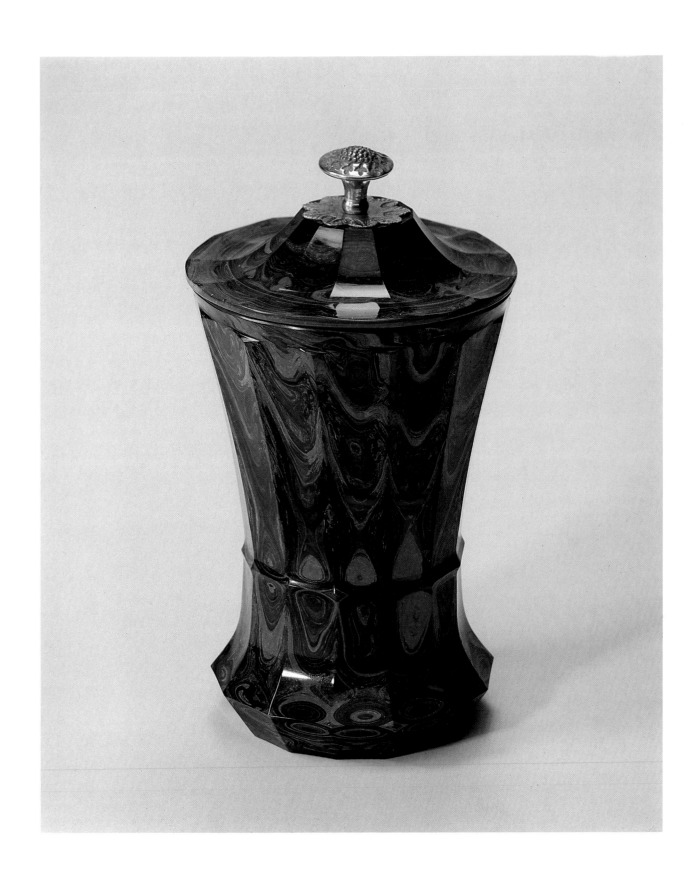

Lidded Tumbler. Bohemia, Friedrich Egermann, 1830. No. 196

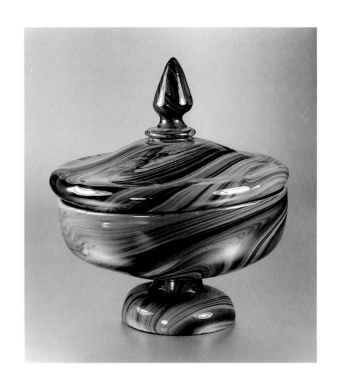

Lidded Bowl.
Bohemia, c. 1830.
No. 200

Tumbler. Bohemia, Friedrich Egermann, c. 1830. No. 195

Tumbler. Bohemia, Friedrich Egermann, c. 1830. No. 198

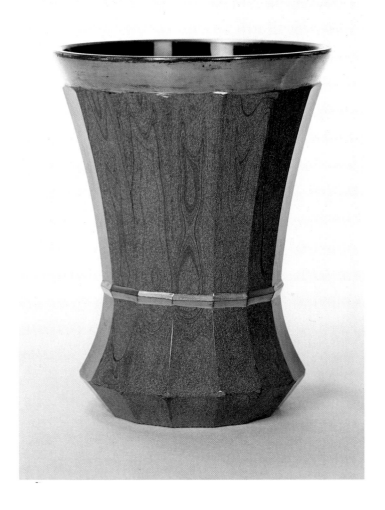

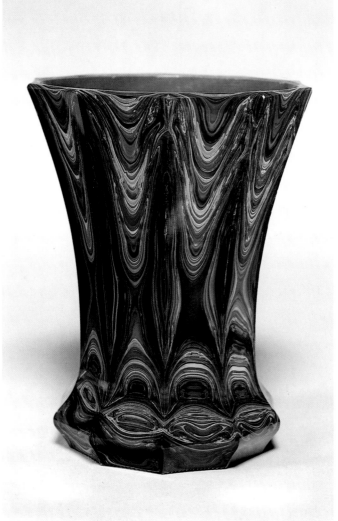

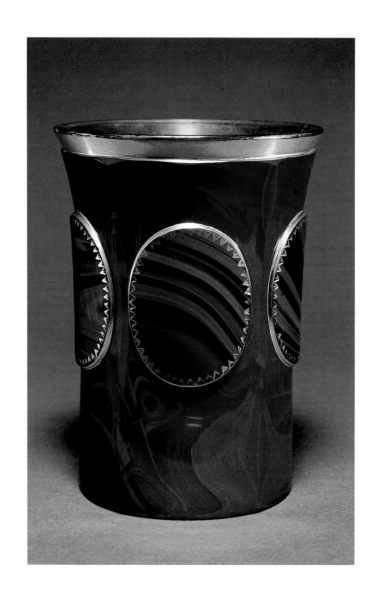

Tumbler. Bohemia, Friedrich Egermann, c. 1830. No. 197

Lidded Box. Bohemia, c. 1830. No. 202

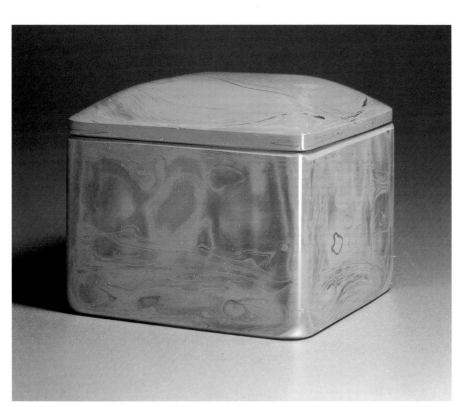

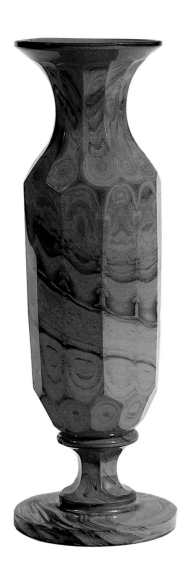

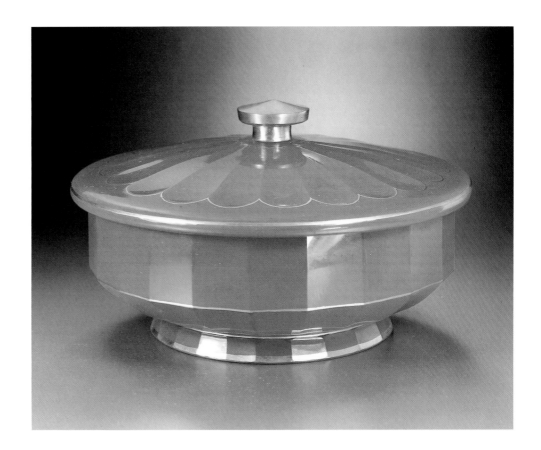

Vase. Bohemia, c. 1830. No. 199

Lidded Bowl. Bohemia, c. 1830. No. 201

Lidded Jar. Bohemia, c. 1825. No. 190

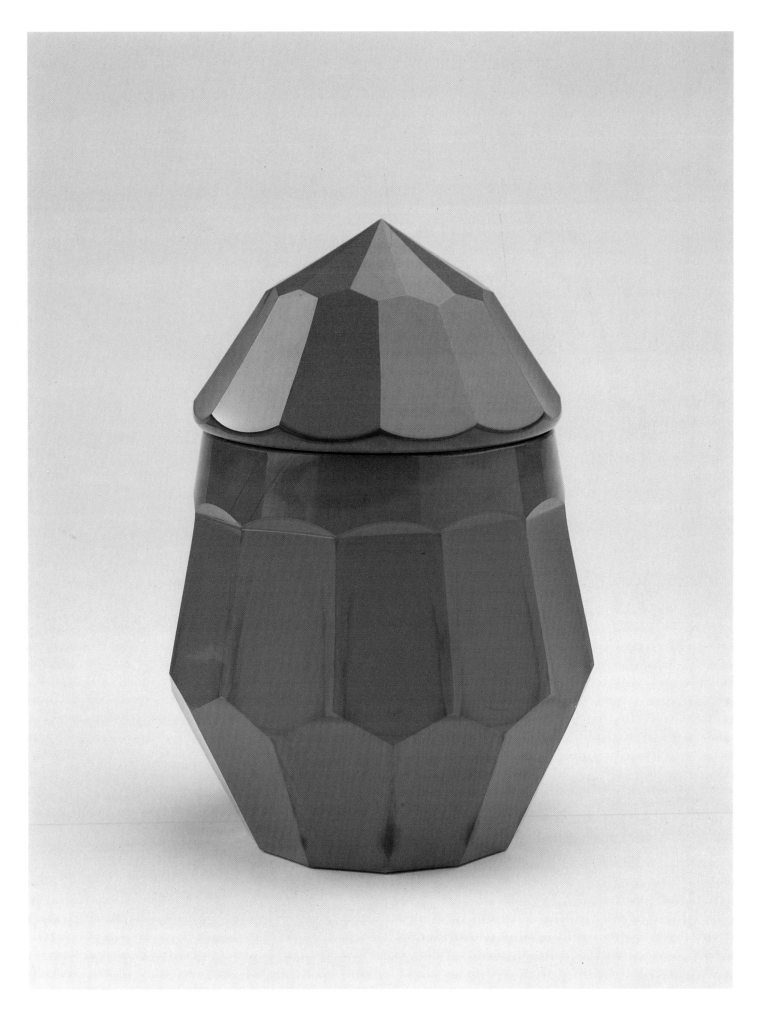

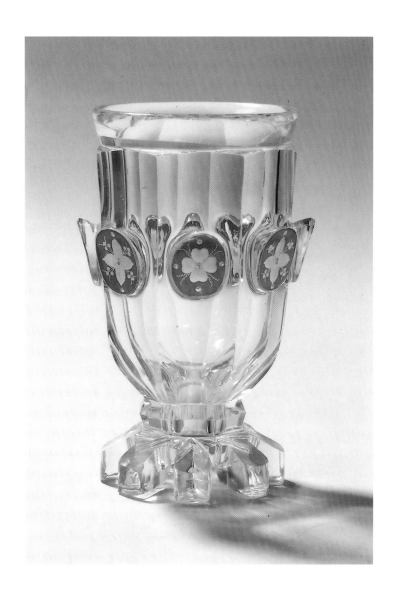

Tumbler. Bohemia, c. 1830. No. 192

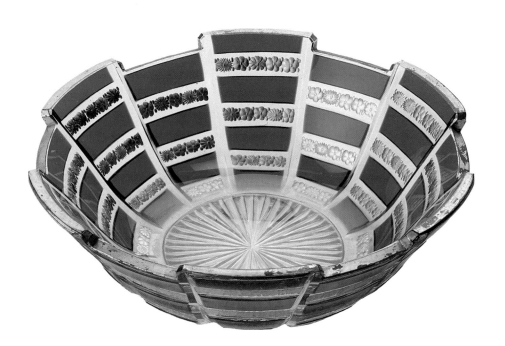

Bowl. Bohemia, 1820/30. No. 186

Cup and Saucer in Original Case.
Bohemia, 1820/30. No. 188

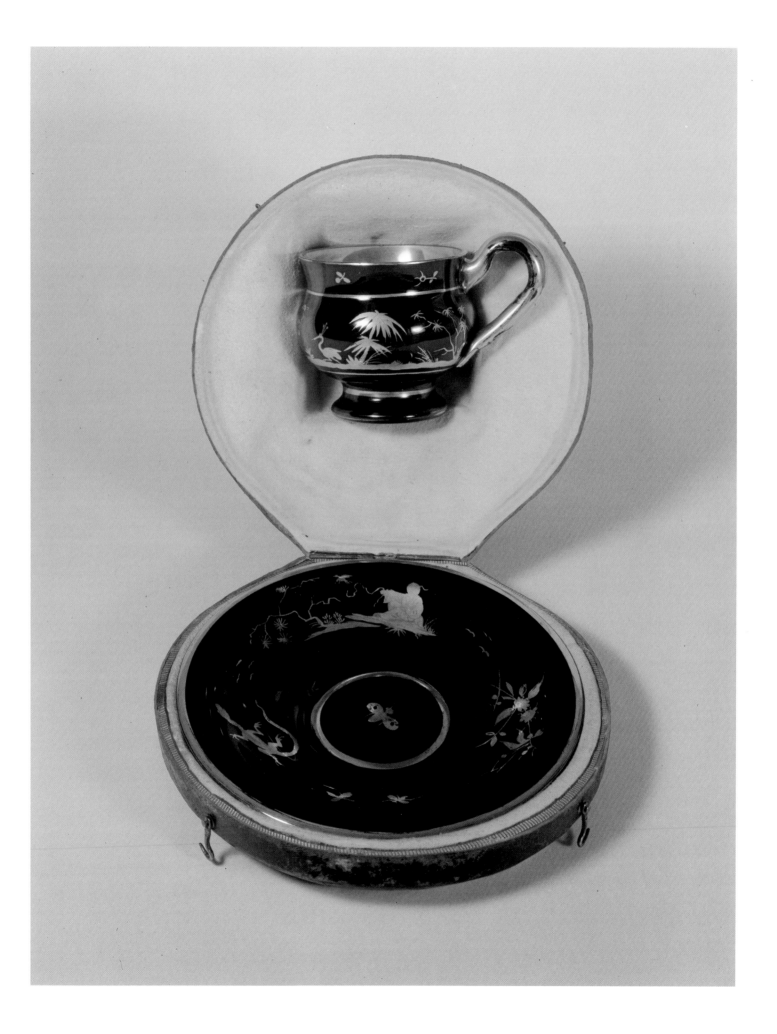

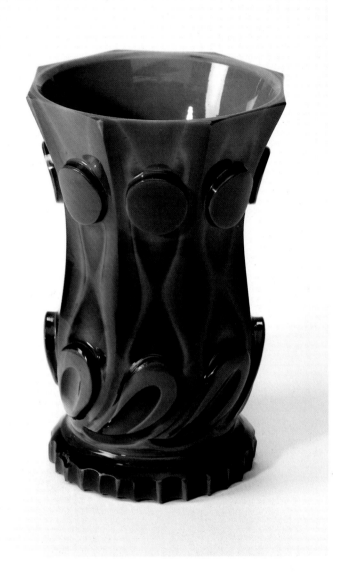

Tumbler. Joachimsthal, Josef Zich, 1832. No. 208

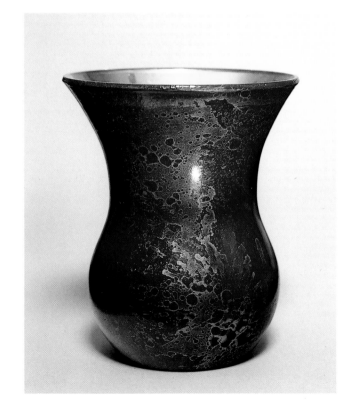

Tumbler. Saxony or Northern Bohemia, c. 1830/35. No. 211

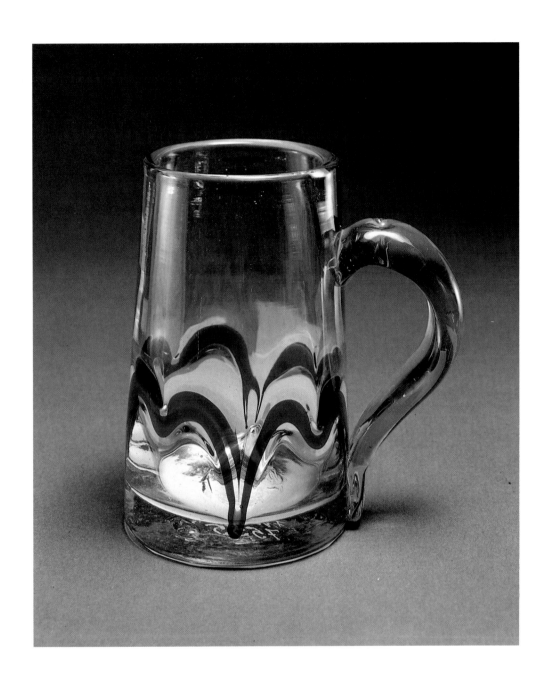

Tankard. Black Forest,
c. 1825. No. 179

Bowl. Northern Germany,
1815/25. No. 207

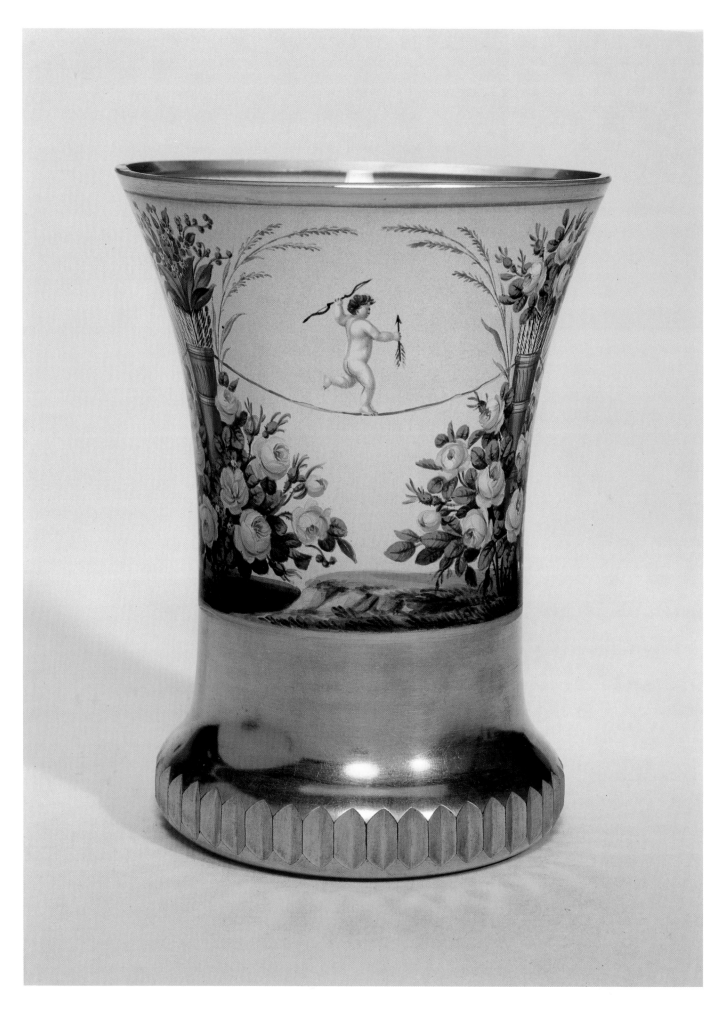

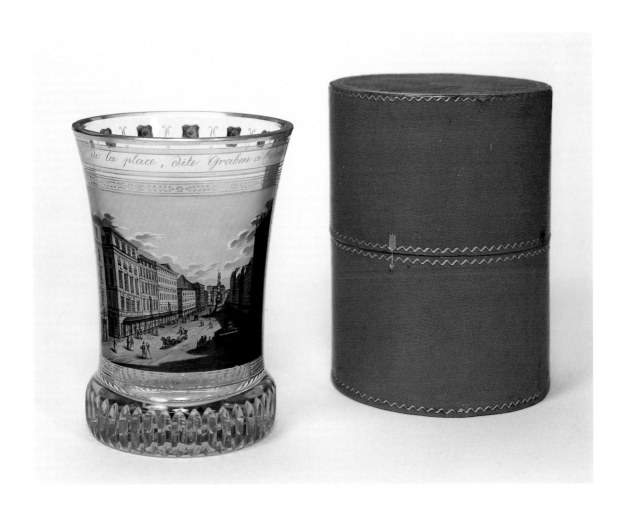

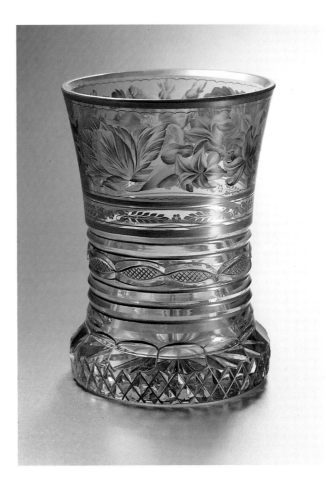

Tumbler (*Ranftbecher*)
with Leather Case.
Vienna,
Anton Kothgasser,
c. 1820. No. 217

Tumbler
(*Ranftbecher*).
Vienna,
Anton Kothgasser,
c. 1825. No. 218

Left:
Tumbler. Vienna,
Anton Kothgasser,
c. 1830. No. 221

Tumbler. Vienna, Gottlob Samuel Mohn, 1814. No. 212

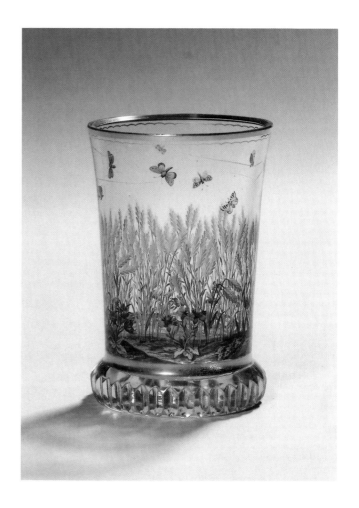

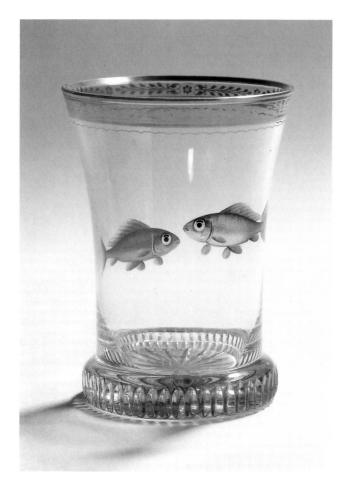

Tumbler (*Ranftbecher*). Vienna, Anton Kothgasser, c. 1820. No. 216

Tumbler (*Ranftbecher*). Vienna, Anton Kothgasser, c. 1825/30. No. 219

Tumbler with Glass Bead Band. Vienna, c. 1825/30. No. 220

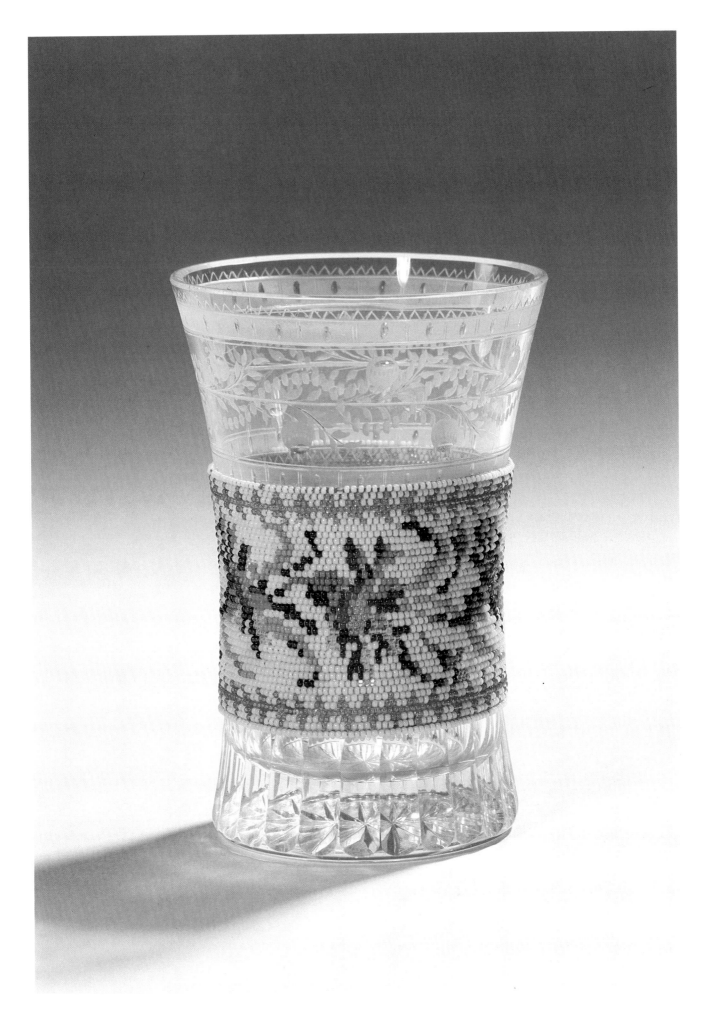

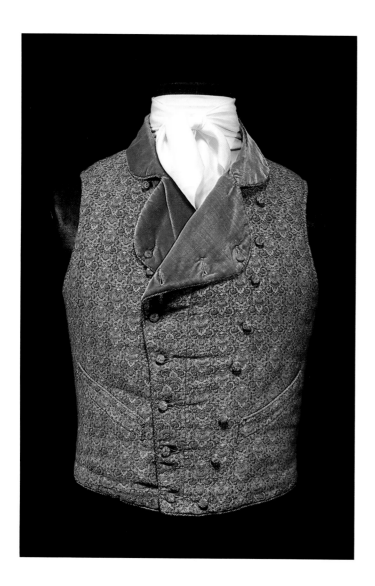

Vest of King Ludwig I of Bavaria. Germany, 1837. No. 255

Vest of King Ludwig I of Bavaria. Germany, c. 1832/35. No. 254

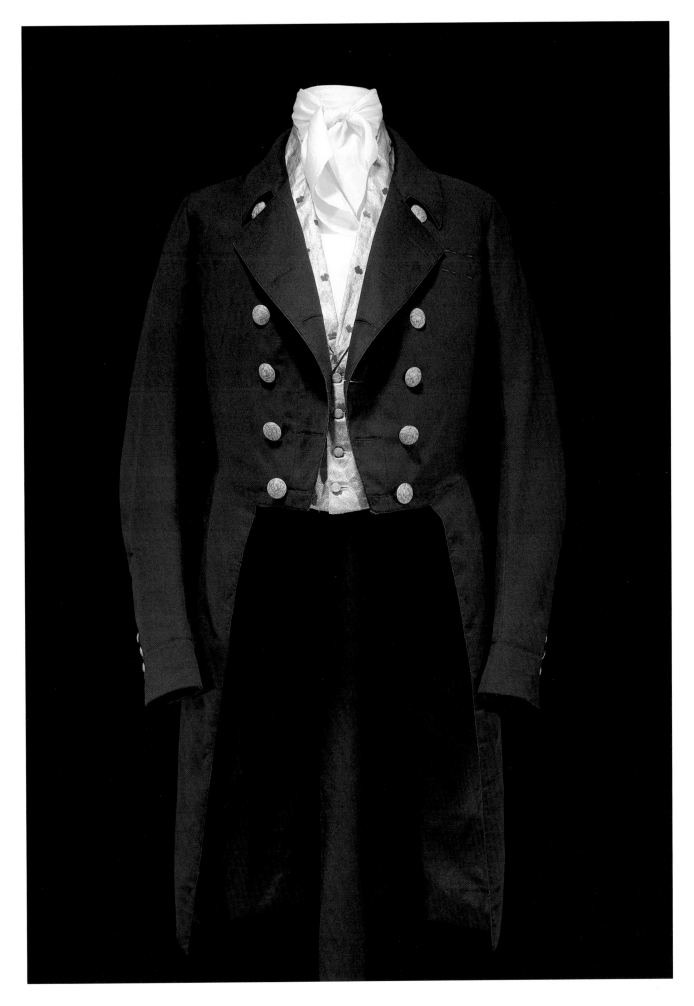

Trousers of King Ludwig I of Bavaria. Germany, c. 1832/40. Nos. 256, 257

Girl's Dress.
Hungary, c. 1835. No. 260

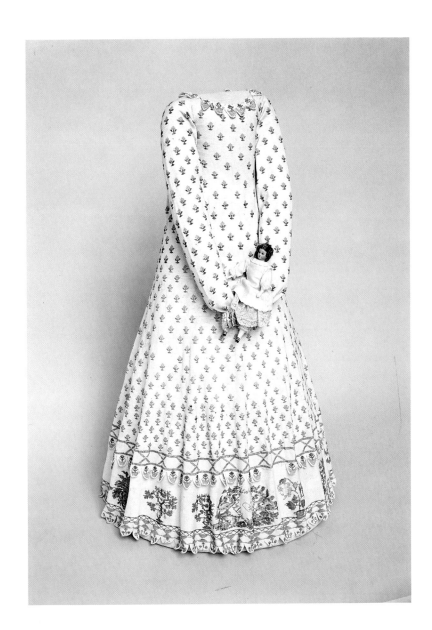

Shawl worn by
Queen Caroline of Bavaria.
Detail. France, c. 1820/25.
No. 263

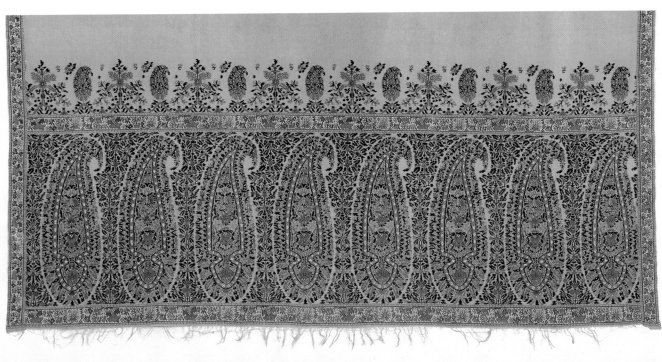

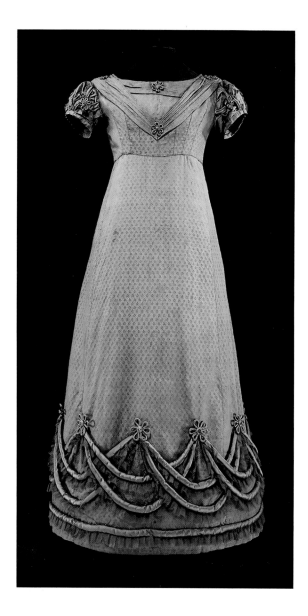

Silk Dress. Germany, c. 1820/25. No. 258

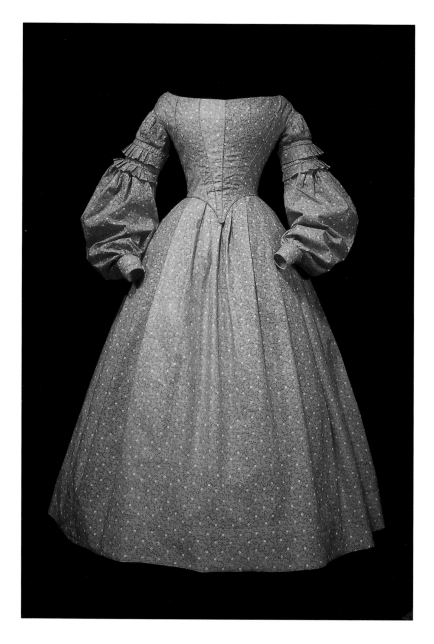

Cotton Dress. Southern Germany, c. 1838. No. 261

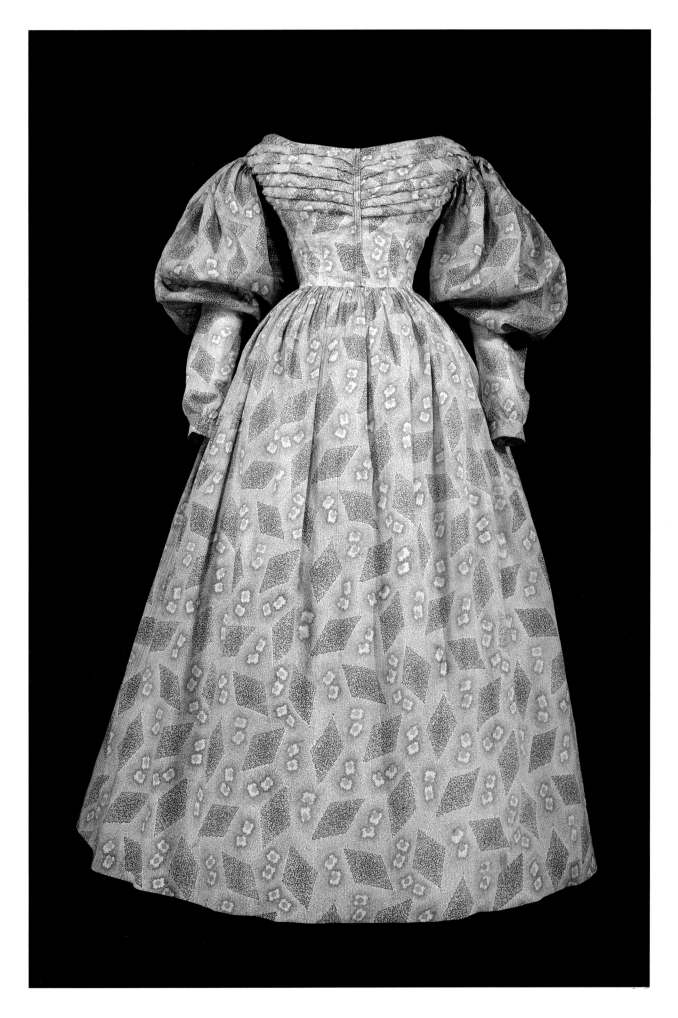

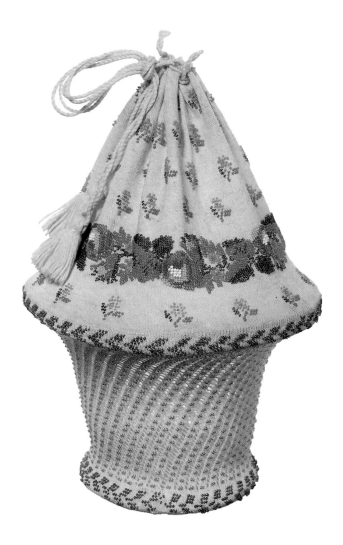

Work Basket.
Germany, c. 1830. No. 265

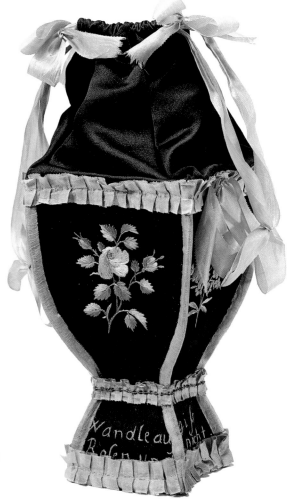

Work Basket. Southern Germany, c. 1855. No. 266

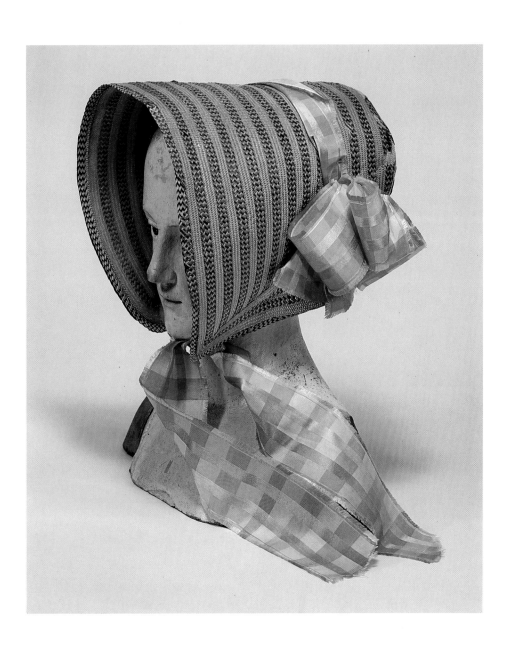

Straw Bonnet worn by
Queen Caroline of Bavaria.
Munich, J. G. Peter,
c. 1835/40. No. 262

Women's Shoes. Germany, c. 1830/35. No. 264

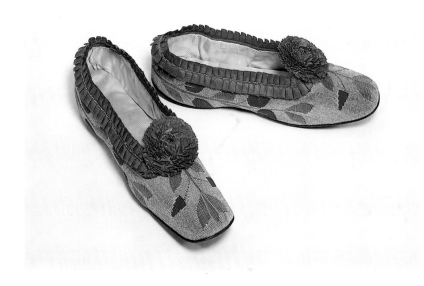

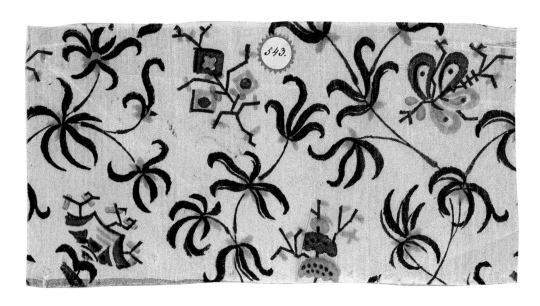

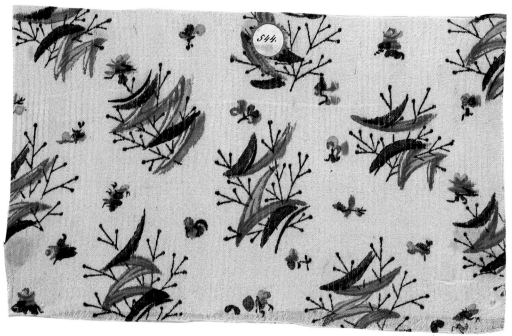

Two Textile Samples. Vienna, Josef Fehr, 1829. No. 251

Textile Sample Card. Kettenhof, Salomon and Veit Meyer, 1829. No. 252

Aus der Kettenhofer Zia- und Katunfabrik, 1829.

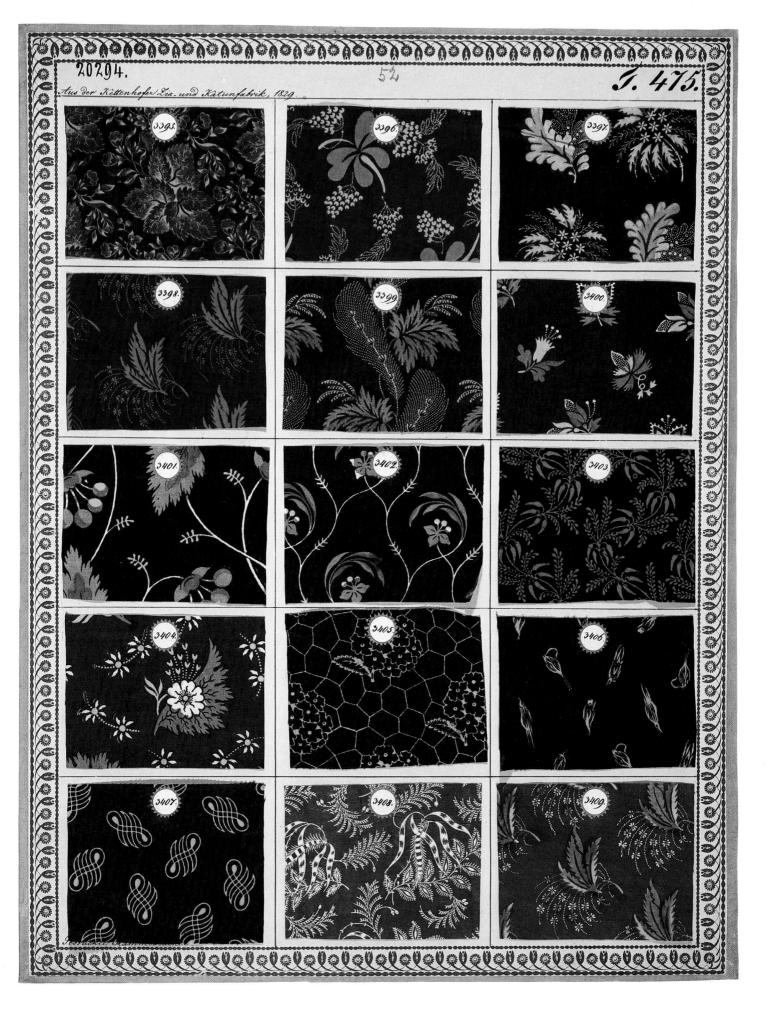

Detail of a Textile Sample Card.
Vienna, Paul Mestrozi,
1820. No. 247

Below:
Textile Sample. Vienna,
Christian Georg Hornbostel,
1821. No. 248

Textile Sample. Vienna, Peter Gianicelli, 1826. No. 250

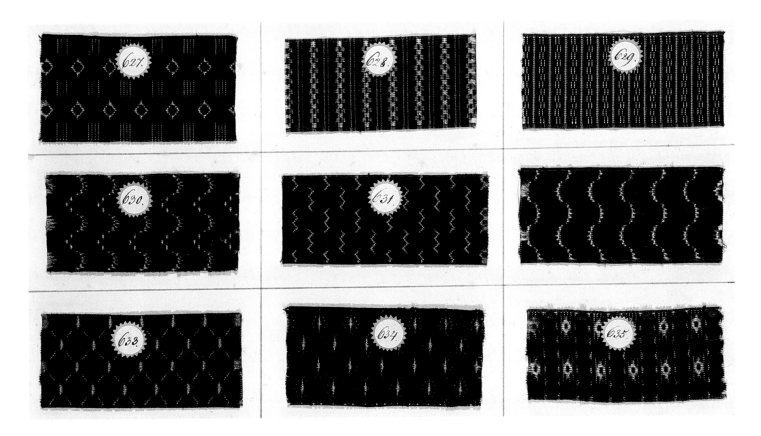

Nine Textile Samples. Vienna, Paul Mestrozi, 1819. No. 246

Three Textile Samples. Vienna, Josef Fehr, 1824. No. 249

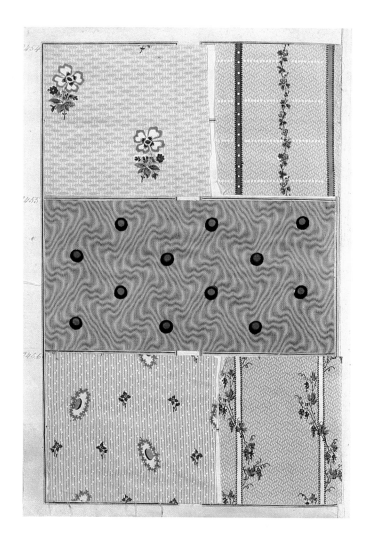

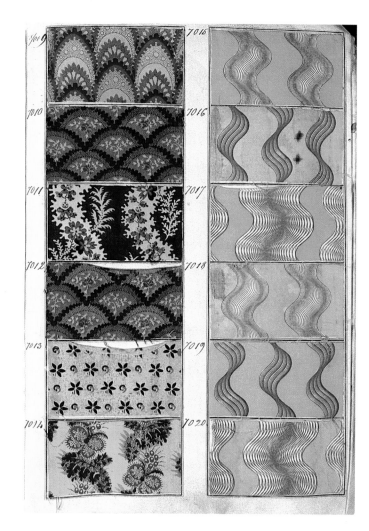

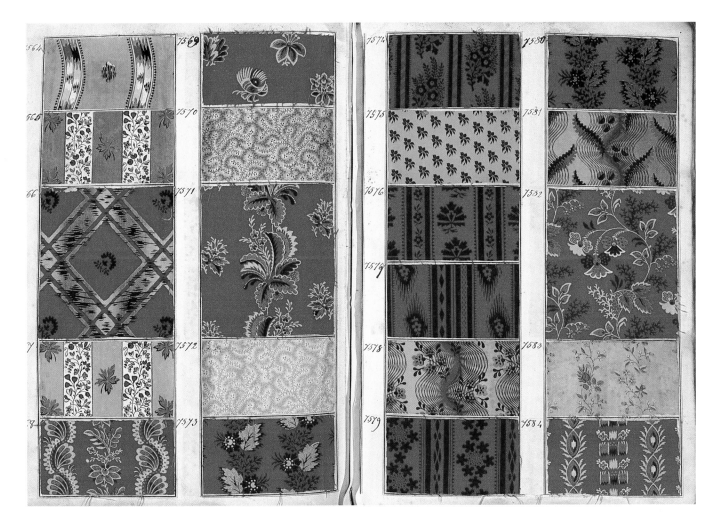

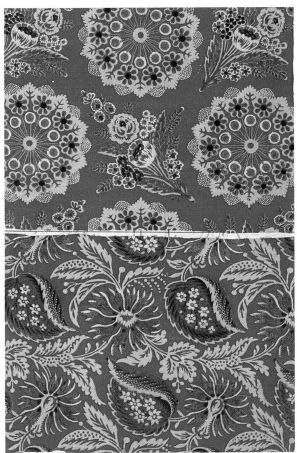

Four Pages from a
Textile Sample Book.
Augsburg, Neue Augsburger
Kattunfabrik, 1831–34

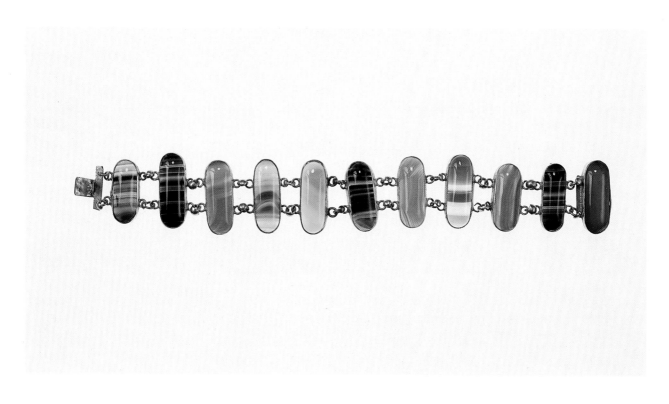

Bracelet. Idar-Oberstein, c. 1835. No. 273

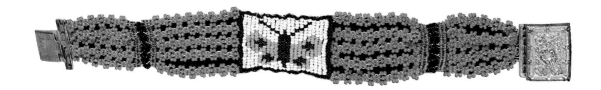

Bracelet. Germany, c. 1820. No. 271

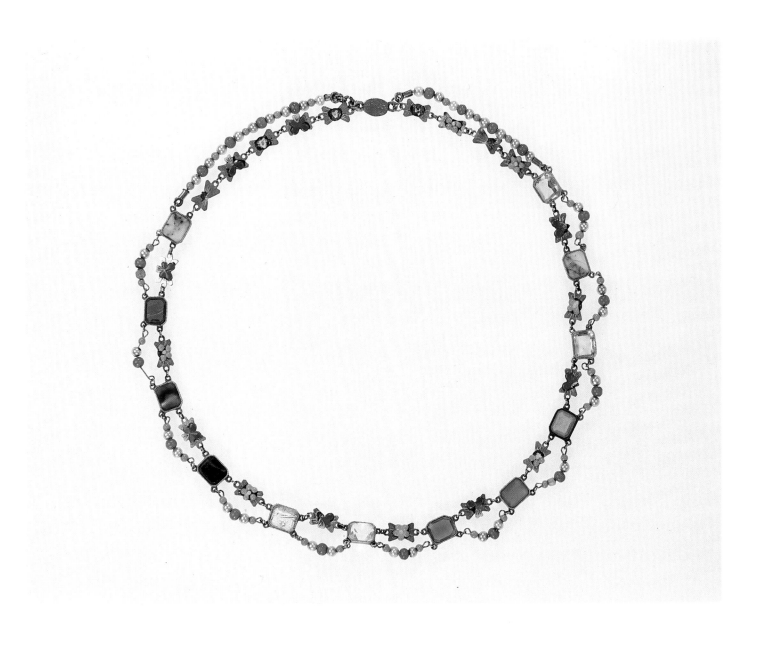

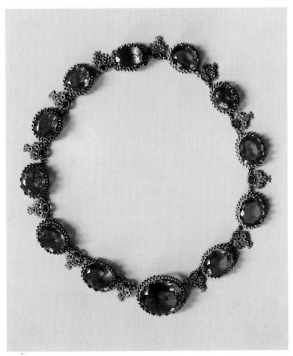

Friendship Necklace.
Germany, c. 1820.
No. 268

Necklace.
Southern Germany, c. 1820.
No. 267

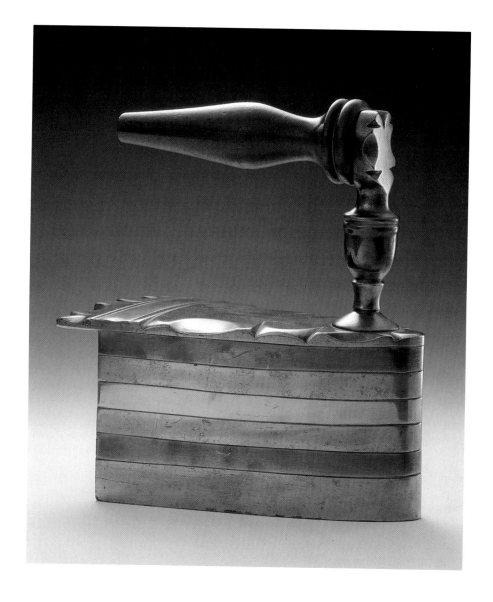

Flatiron.
Netherlands, c. 1815.
No. 280

Wool Basket.
Southwest Germany.
c. 1820. No. 282

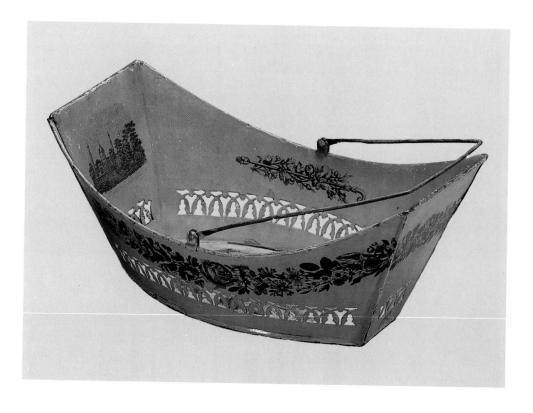

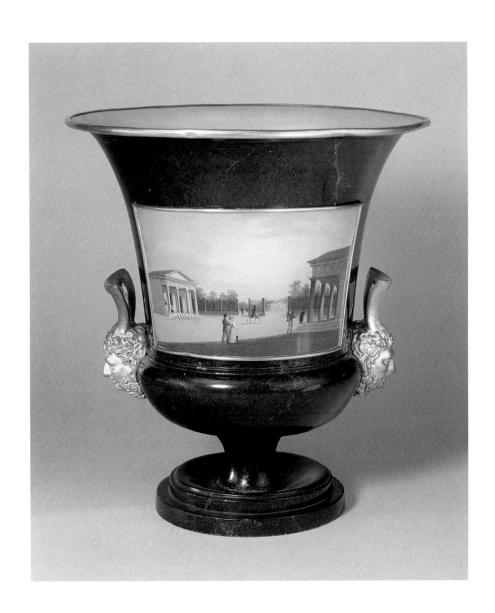

Cachepot.
Berlin, c. 1820.
No. 281

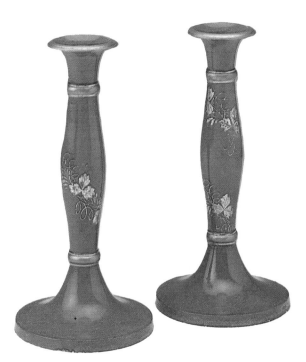

Candlesticks. Brunswick, Stobwasser, c. 1820. No. 283

161

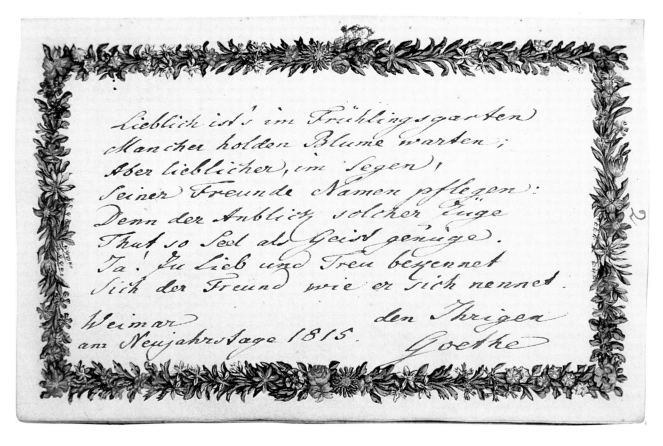

Lieblich ist's im Frühlingsgarten
Mancher holden Blume warten;
Aber lieblicher, im Segen,
Seiner Freunde Namen pflegen:
Denn der Anblick solcher Züge
Thut so Seel als Geist genüge.
Ja! In Lieb und Treu bezennet
Sich der Freund wie er sich nennet.

Weimar den Ihrigen
am Neujahrstage 1815. Goethe

Page from the Album of Antonie Brentano, 1815. No. 285

Album of Maria von Speth, 1813. No. 284

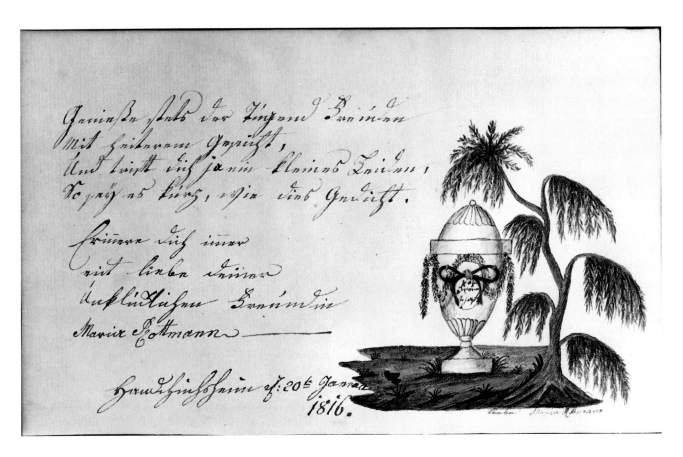

Page from an Album, 1816. No. 286

Album of Engravings, 1822. No. 287

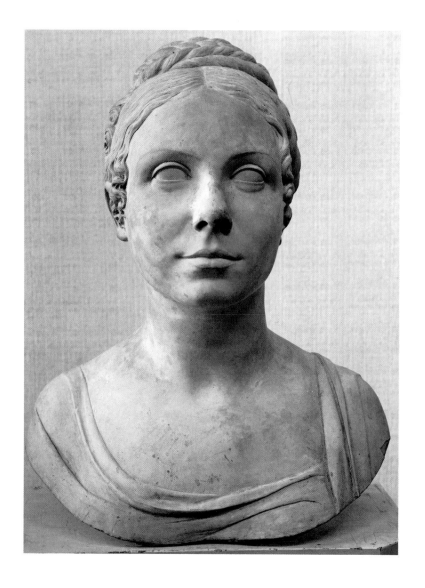

Josef Maria Christen, *Bust of an Unidentified Lady of Bern*, 1816/18. No. 80

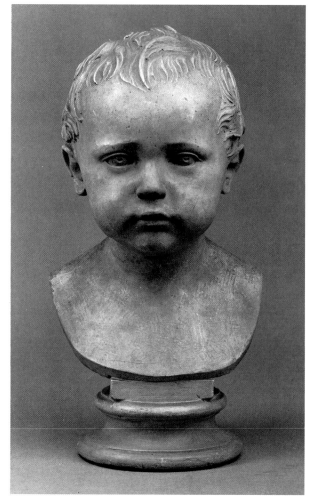

Johann Gottfried Schadow, *Bust of Julius Schadow*, 1827. No. 88

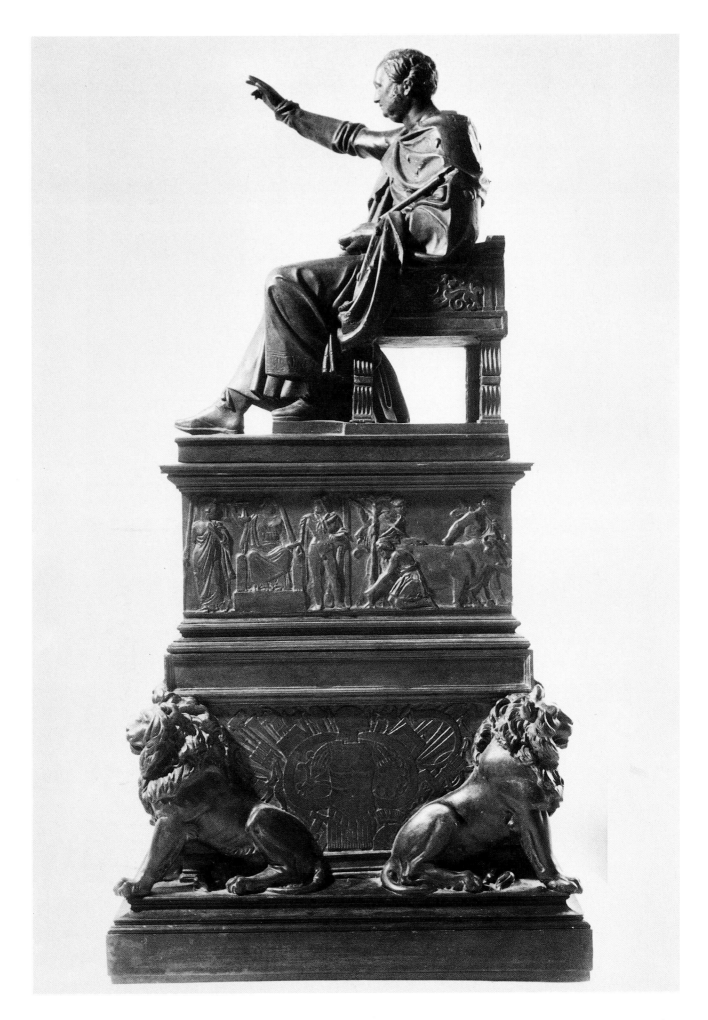

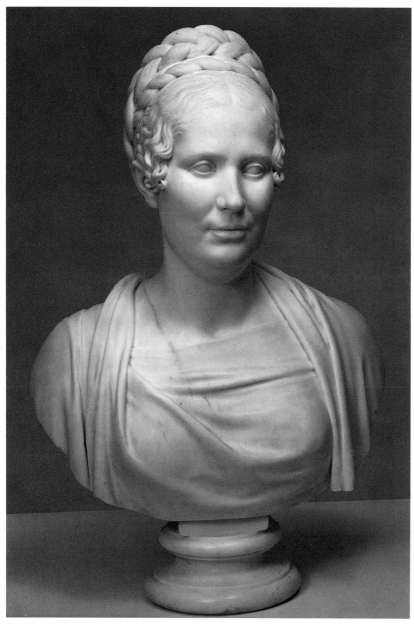

Johann Heinrich Dannecker
Bust of Frau Emilie Pistorius, 1816. No. 82

Xaver Heuberger. *Half-Figure Portraits of Three Children*, 1851. No. 83

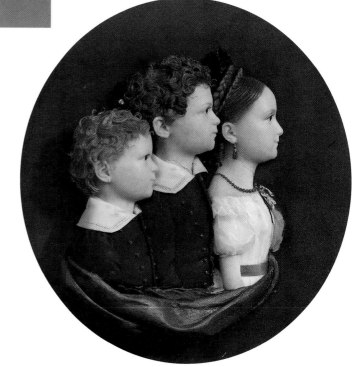

Christian Friedrich Tieck
Bust of Crown Princess Elisabeth of Prussia, 1824. No. 92

Konrad Weitbrecht, *Boy Learning a Lesson*, c. 1825. No. 93

Tumbler. Bohemia, c. 1820. No. 185

Tumbler (*Ranftbecher*).
Northern Bohemia (?), 1820/30. No. 187

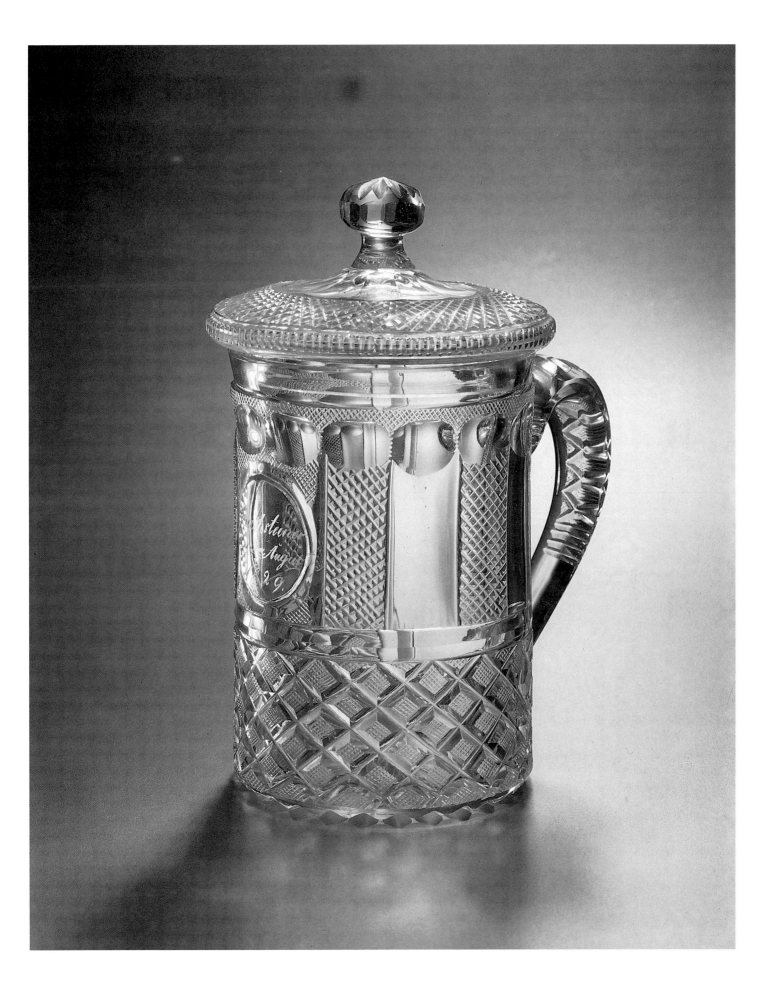

Tankard. Bohemia, 1829. No. 191

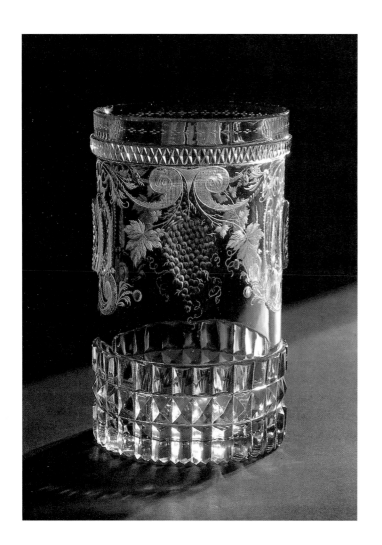

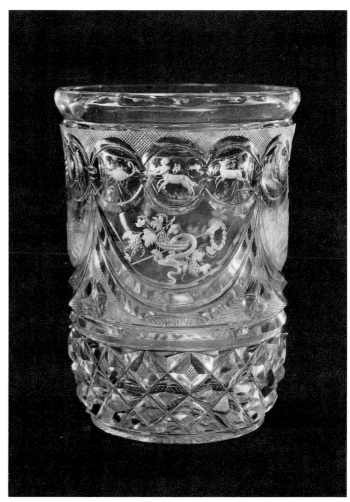

Tumbler. Northern Bohemia, c. 1820. No. 183

Tumbler. Bohemia, c. 1830. No. 194

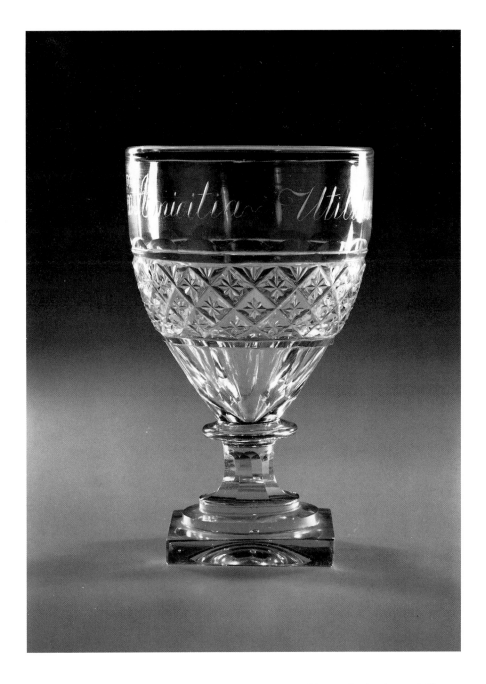

Goblet. Netherlands, 1856. No. 210

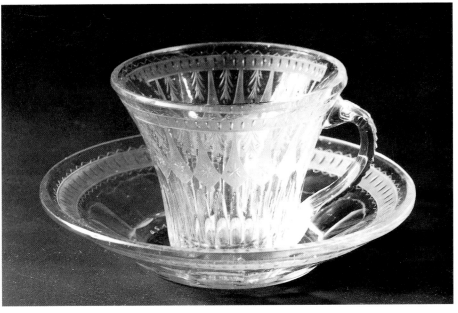

Cup and Saucer.
Bohemia, 1818. No. 180

Caster. Amsterdam,
Jean Theodore Oostermeyer, 1817. No. 227

Teapot and Box. Amsterdam, Jan Anthonius de Haas, 1820/21. No. 226

Coffeepot. Amsterdam, Diederik Lodewijk Bennewitz, 1824. No. 223

Two Pastry Containers. Amsterdam, J.H. Stellingwerf's Widow, 1829. No. 228

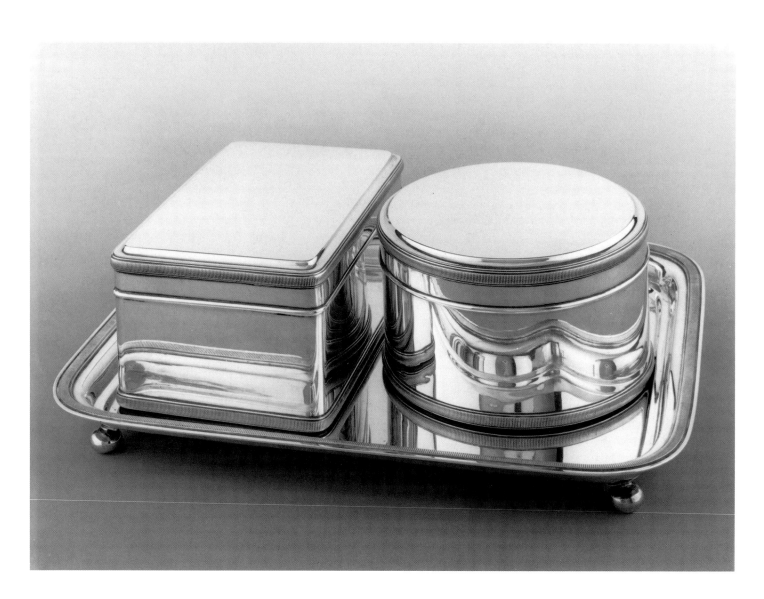

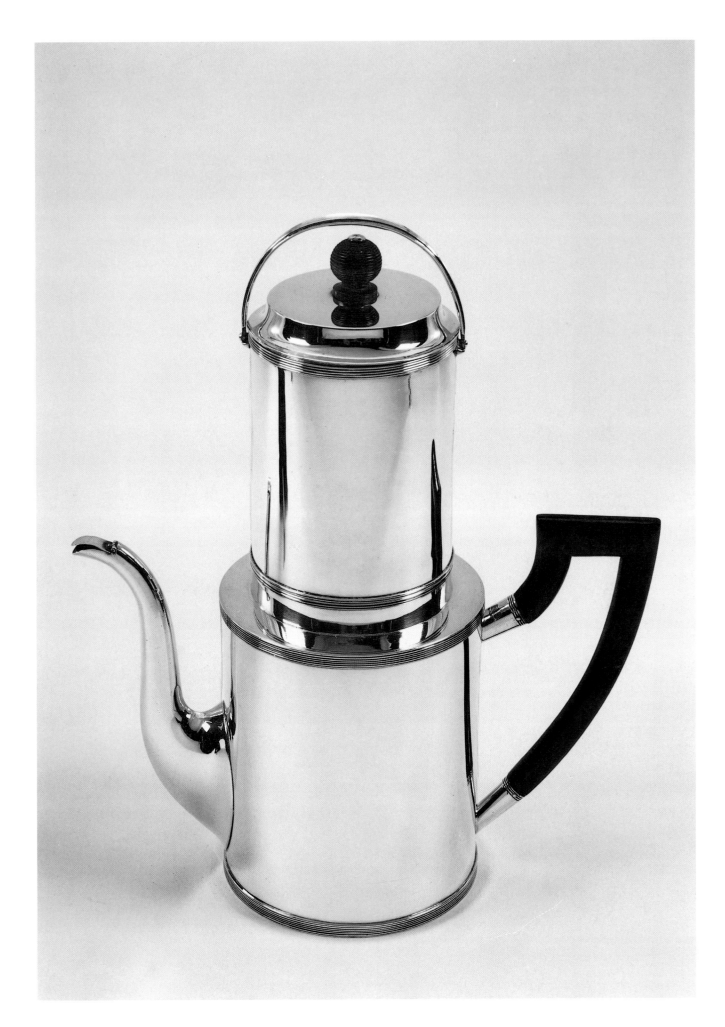

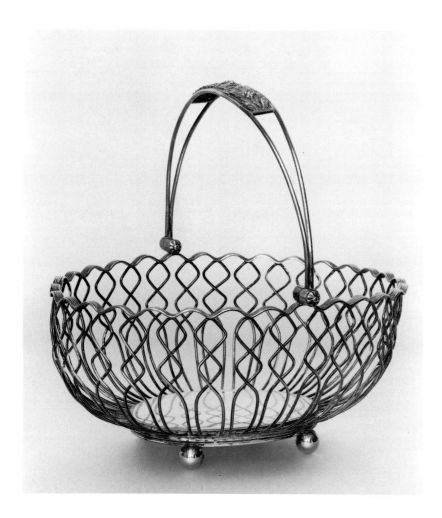

Basket with Handle. Copenhagen, Rasmus Brock, 1828. No. 251

Teapot with Warmer.
Berlin, Gottlob Ludwig Howaldt, c. 1825. No. 250

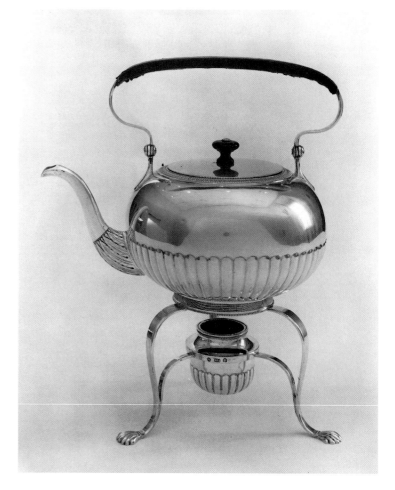

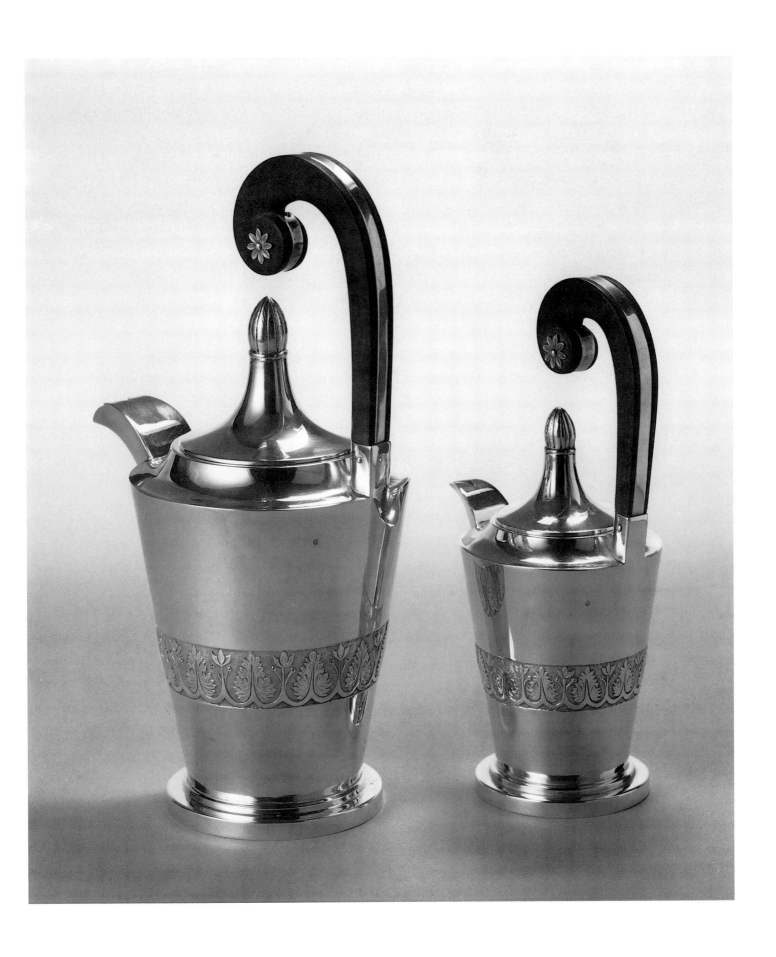

Two Coffeepots. Vienna, Anton Köll, 1817. No. 240

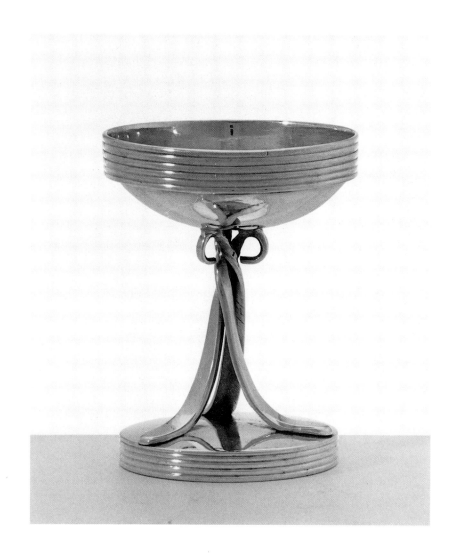

Saltcellar. Vienna,
Peter Höckh, probably 1825. No. 239

Snuffbox.
Vienna, 1818. No. 238

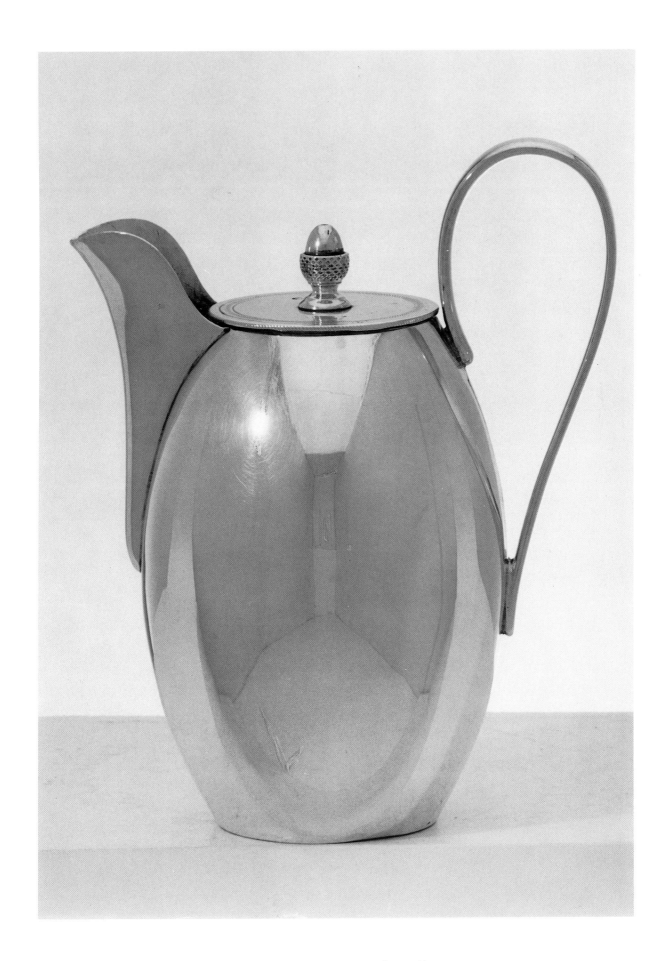

Coffeepot. Vienna, Anton Kreissel, 1817. No. 241

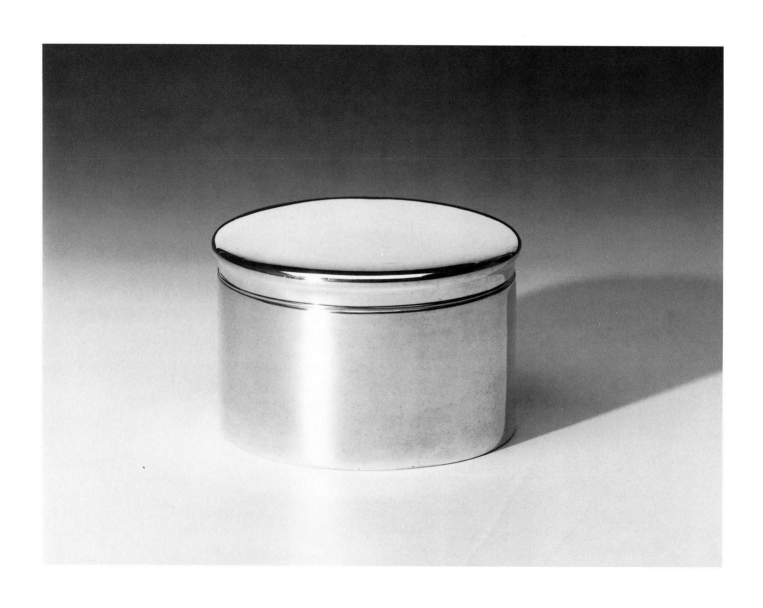

Box. Vienna, Andreas Weichesmüller, 1824. No. 243

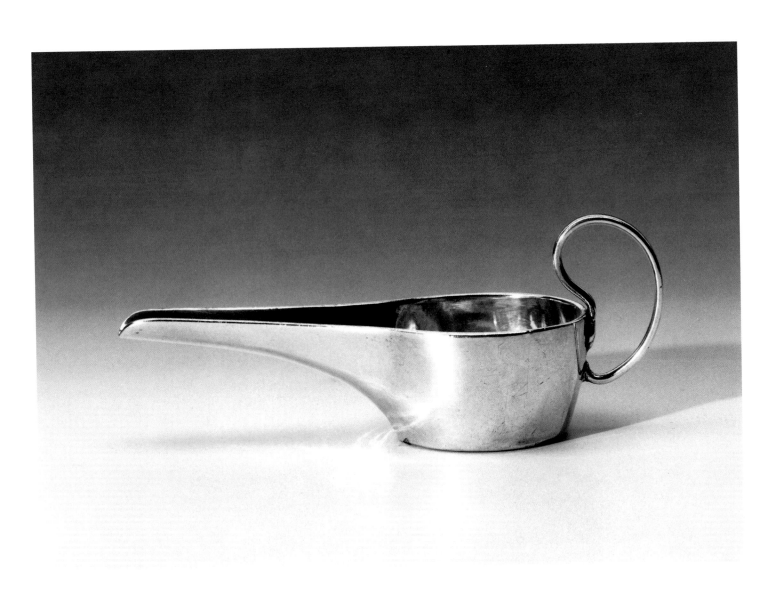

Sauceboat. Vienna, Karl Wallnöfer, 1829. No. 242

Commentaries

By Georg Himmelheber, Winfried Baer (w. b.),
Saskia Durian-Ress (s.d.-r.), Irmtraud Himmelheber (i. h.),
Otto Krätz (o. k.), Melanie Maier (m. m.), Brigitte Thanner (b. t.),
Lilla Tompos (l. t.), and Hertha Wellensiek (h. w.)

Abbreviations

R³ Marc Rosenberg, *Der Goldschmiede Merkzeichen*,
 3rd ed., 4 vols. (Frankfurt am Main, 1922–28)
S Helmut Seling, *Die Kunst der Augsburger Goldschmiede 1529–1868*,
 3 vols. (Munich, 1980)

2

Painting and Stage Design

1

WILHELM AHLBORN plate, p. 55

The Temple of Kôm Ombo in Egypt

1830. Oil on canvas, 14⅝ x 18⁵/₁₆″ (37.2 x 46.5 cm)
Inscribed "W. A. Rom 1830"
Niedersächsisches Landesmuseum, Hanover.
KM 222

Reference: Schreiner, cat. no. 13.

The composition is built up of strata that
resemble stage flats: a shallow foreground sec-
tion with a skull; a middle ground with temple
ruins sharply silhouetted against the sunrise;
and the misty mountains in the background.
 A pupil of Hummel and Schinkel, Ahlborn
was especially interested in architecture. This
painting was probably based on sketches and
information brought back from Egypt by the
architect Friedrich Maximilian Hessemer.

2

JAKOB ALT

The Cholera Chapel near Baden

1832. Oil on canvas, 20¼ x 26⁹/₁₆″ (51.5 x 67.5 cm)
Inscribed "J. Alt. 1832"
Österreichische Galerie, Vienna. KM 3662

References: *Katalog der Österreichischen Galerie,*
p. 40; Frodl, pp. 38, 109, 242.

The Cholera Chapel was dedicated after the
second epidemic of the disease to strike Vienna,
and Alt depicted the building shortly after it
had been finished.
 In the foreground, a tree in shadow stands
out against the sky and a triangular, tree-
covered hill illuminated by late-afternoon sun.
The pervading browns and greens of the com-
position are accented by points of brilliant
white, in the chapel, the bridge, and a few tiny
figures.

3

FRIEDRICH VON AMERLING

Portrait of Henriette Pereira-Arnstein with her Daughter

1833. Oil on canvas, 59 x 47¼″ (150 x 120 cm)
Österreichische Galerie, Vienna. 2593

Reference: *Bürgersinn und Aufbegehren,*
cat. no. 5/1/2.

Amerling was the most popular, and perhaps
the finest, portraitist in Vienna until well after
mid-century. His double portrait depicts the
wife and daughter of the Viennese banker and
art patron Heinrich Freiherr von Pereira.
Seated at a table, they are musing over a pas-
sage from the book open in front of them.

The textures of the various materials of the
women's dresses are masterfully rendered but
without pedantic attention to detail. Evoking
the love and shared interests of mother and
daughter, the composition also faithfully
records the appearance of upper-middle class
ladies of two different age-groups in Vienna
during the Biedermeier period.

4

EMILIUS DITLEV BAERENTZEN

The Winther Family plate, p. 59

1827. Oil on canvas, 27¾ x 25¹³/₁₆″ (70.5 x 65.6 cm)
Inscribed "Em. Btz. 1827"
National Galleries of Scotland, Edinburgh.
NG 2451

Nineteenth-century Danish artists began rela-
tively early to place group portraits in a narra-
tive context. This one is no exception, with
newborn puppies being shown to the child, tea
being served, and the master of the house – a
prosperous Copenhagen jeweler – looking up
from the letter he had been reading. Yet anec-
dotal as the picture may be, it makes no direct
sentimental appeal to the spectator, who is kept
at a certain distance from the intimate domes-
tic scene.

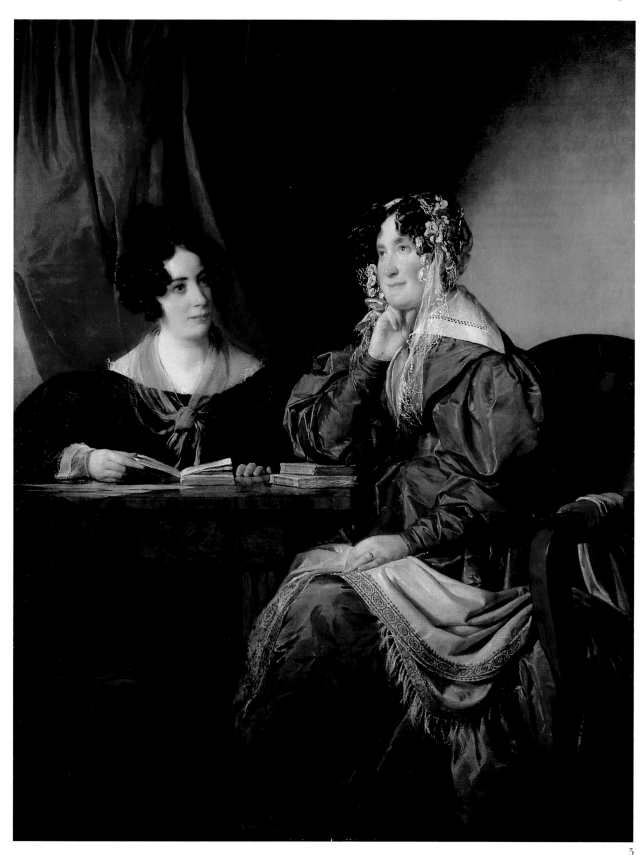

3

5

KASPAR BENEDIKT BECKENKAMP

Herr and Frau Heinrigs
with Two Sons plate, p. 56

1824. Oil on canvas, 68⅞ × 57½" (175 × 146 cm)
Inscribed "C. B. Beckenkamp pinxit 1824"
Kölnisches Stadtmuseum, Cologne. 50232

Reference: Elisabeth Moses, "Caspar Benedikt Beckenkamp," *Wallraff-Richartz-Jahrbuch*, 2 (1925), pp. 61, 75 f.

Maria Margarete Heinrigs, née Simons, is portrayed here with the sixth and seventh of her eight sons (the others are depicted in no. 6). Johann Heinrigs opened a printing shop for engravings in 1817 in Cologne and won several official awards as a calligrapher. As in most of the relatively rare group portraits of the Biedermeier period, only the small child is shown actively communicating with the other sitters.

6

KASPAR BENEDIKT BECKENKAMP

The Sons of Herr Heinrigs,
Calligrapher plate, p. 56

1828. Oil on canvas, 69⅛ × 57¼" (175.5 × 145.5 cm)
Inscribed "H. Beckenkamp pinxit 1828"
Rheinisches Landesmuseum, Bonn. 49.5

Reference: Goldkuhle, p. 45 f.

The artist has depicted six of the eight Heinrigs sons grouped around a table, all occupied and yet strangely isolated from one another, with the result that the painting gives the impression of being composed of six individual portraits.

While there is ample space in the foreground for the youngest boy's toys, the chairs, table, and piano have been compressed into the shallow background space to such an extent that the wall with the large picture that completes the family (no. 5) appears close to the viewer. Both paintings are among the extremely rare lifesize group portraits produced in the Biedermeier period.

7

KARL BEGAS

The Begas Family plate, p. 57

1821. Oil on canvas, 30⅛ × 33¹¹⁄₁₆" (76.5 × 85.5 cm)
Wallraf-Richartz-Museum, Cologne. 1556

References: Schadow, vol. 1, p. 147; Lilly Parthey, *Tagebücher aus der Berliner Biedermeierzeit* (Leipzig, 1928), p. 246; Ludwig Geiger, ed., *Briefwechsel zwischen Goethe und Zelter* (Leipzig, n. d.), p. 257 f.; Ludwig Geiger, in *Goethe Jahrbuch*, 19 (1898), p. 65; Andree, p. 20.

The two youngest boys are placed on the central axis of the composition, emphasized by the painting and bureau-cabinet. While they are actively occupied, the remainder of the family is posed with rather stiff formality, holding pipe, guitar, or handwork like attributes. The figure on the far right, cut off by the edge of the canvas, is a self-portrait of the artist in the act of sketching.

A section of the floor has been left empty in the foreground. As in a relief, neither the feet of the seated boy nor the material falling from the mother's lap cross the imaginary line demarcating the foreground plane. This effect of shallow space is found in the background as well, where the sashless window at the right allows the view of Cologne's cathedral and St. Andreas Church to seem like a painting hanging on the wall.

Describing the composition to Goethe, Zelter wrote that Begas had "achieved the most beautiful things in one: presence, spirit, calm, and truth."

8

WILHELM BENDZ

The Raffenberg Family plate, p. 58

1830. Oil on canvas, 17⁵⁄₁₆ × 15⁹⁄₁₆" (44 × 39.5 cm)
Inscribed "W. Bendz 1830"
Kunstforeningen, Copenhagen

References: *Dansk Kunst 1825–1855*, exhibition catalogue (Copenhagen, 1915), cat. no. 38; *Dansk Kunsthistorie*, p. 408; *L'age d'or*, cat. no. 10.

Group portraits were especially popular in Denmark, and they generally showed members of a family in their home environment occupied in some characteristic pastime.

Depicted here are Michael Raffenberg seated on the sofa with his bride, and his mother standing behind them. All three are lost in contemplation of a painting that doubtless represents Michael's deceased father.

Not a genre scene, the composition cannot be called a slice of life in the modern sense either. Apart from its portrait character, it is a sensitive rendering of the ties of love and sympathy that exist among the three, as well as a record of a life-style typical of the era.

12

9

DETLEV KONRAD BLUNCK

The Engraver C. E. Sonne plate, p. 58

1826. Oil on canvas, 27¼ x 22¹/₁₆" (69.3 x 56 cm)
Statens Museum for Kunst, Copenhagen. 51

References: *Kjøbenhavns Morgenblad* (1826);
Lilly Martius, in *Nordelbingen*, 14 (1938), p. 276;
C.W. Eckersberg og hans elever, exhibition
catalogue (Copenhagen, 1983), cat. no. 99.

The engraver is depicted in his workshop, look-
ing up from his plate and out of the picture past
the viewer. The space is severely limited, the
back wall looming up abruptly behind the
figure. The close-cropped view seems arbitrar-
ily chosen, as does the point in time, for
although Sonne does not really appear to be
working, he does not seem to be posing for his
portrait either.

10

DETLEV KONRAD BLUNCK

Portrait of the Painter
Frederik Thöming plate, p. 61

1831. Oil on canvas, 23⁷/₁₆ x 19⁵/₁₆" (59.5 x 49 cm)
Inscribed "D. C. Blunck Rom. Febr. 1831"
Kunsthalle, Kiel. 388

Reference: Schlick, p. 34.

Depicted in a bright yet mild and diffuse light,
this fashionably dressed young man has the
penetrating gaze of an artist. Frederik Thöm-
ing, like Blunck, received his training at the
Copenhagen and Munich academies.

13

11

JOHANN HERMANN CARMIENCKE

Morning on the Alster River
near Poppenbüttel plate, p. 62

1833. Oil on paper, 10¼ x 14" (26 x 35.5 cm)
Inscribed "H.C. 1833 19. Juni Poppenbüttel
Morgens"
Kunsthalle, Hamburg. 1148

Reference: Krafft, p. 34.

This view of the Alster Valley in morning light
was doubtless executed on the scene, and with
comparative rapidity. From a point on the
sketchily rendered rise in the foreground, the
artist has depicted a single bend in the river,
framing it with a hill on the left and dense
woods at right and center that obscure the hori-
zon.

　At about the time this sketch was made, Car-
miencke left his teacher in Dresden, Dahl, to
enroll at the Copenhagen Academy.

12

JOHAN CHRISTIAN CLAUSEN DAHL

Julie Vogel in her Garden

1825 – 28. Oil on canvas, 19¹¹/₁₆ x 23⅜" (50 x 60 cm)
Inscribed "Julie Vogel, geb. Gensiken als Braut in
dem Garten ihrer Sommerwohnung bei Dresden
JDahl pinx 1825 Beendet Juli 1828"
Private collection

References: *Dahls Dresden*, exhibition catalogue
(Oslo, 1980), cat. no. 70; *Johann Christian Dahl:*
Ein Malerfreund Caspar David Friedrichs, exhibi-
tion catalogue (Munich, 1988), cat. no. 58.

Hollyhocks and sunflowers, the benches paral-
lel to the picture plane, the house – everything
in this scene has been rendered with the same
care devoted to the figure of the young woman,
bride of the painter Carl Vogel von Vogelstein.
The intimacy of the garden is increased by the
dense foliage of the trees on the left, whose
trunks frame a distant view of Dresden beyond
the Elbe River as if seen through a window.

　The pictorial space, whose true extent can be
inferred from the wall and trees on the left,
seems unnaturally constricted, resulting in a
shift in the relative scale of the things rep-
resented.

13

JOHAN CHRISTIAN CLAUSEN DAHL

Landscape with Cloudy Sky

1828. Oil on cardboard, 8¼ x 8¼" (21 x 21 cm)
Inscribed "d 1.st Julj 1828/D"
Österreichische Galerie, Vienna

It was the Biedermeier concern for truth to
nature that led to a careful study of clouds,
their formations, textures, and movements.
Goethe's investigations in this field were
passed on to German artists through the work
of Carl Gustav Carus.

　The Biedermeier artist who devoted perhaps
most attention to the changing aspect of the sky
was Dahl, numerous of whose cloud studies
have survived, most of them dated precisely to
the day.

14

LUDWIG DEPPE plate, p. 63

Houses on the Mühlengraben, Berlin

C. 1820. Oil on canvas, 17¹⁵/₁₆ x 22¹/₁₆″ (45.5 x 56 cm)
Inscribed "Ludw. De [...]"
SHK Dr. Louis Ferdinand Prinz von Preussen,
Berlin

References: Börsch-Supan, "'Vergessene' Ber-
liner Maler des 19.Jahrhunderts," *Weltkunst*, 51
(1981), p. 3462; Börsch-Supan, 1982, p. 33 f.

This picture, Deppe's only surviving work, is a
careful and sensitive rendering of the courtyard
side of typical Berlin houses of the period,
including their signs of poverty and decay and
revealing, as Börsch-Supan writes, "the aes-
thetic charm of the random and insignificant."
The view is framed at the sides by sections of
fire wall, while the presence of the Mühlengra-
ben canal in the middle ground is merely
suggested by the railings running strictly paral-
lel to the picture plane in foreground and back-
ground.

15

FELIX MARIA DIOGG plate, p. 60

Portrait of Colonel Joachim Forrer

1827. Oil on canvas, 33¹/₁₆ x 26⁹/₁₆″ (84 x 67.5 cm)
Inscribed "F. M. Diogg ad Rappschvil/Canton
St. Gallen 1827"
Kunstmuseum, St. Gallen. G 1888.3

Reference: Walter Hugelshofer, *Felix Maria*
Diogg: Ein Schweizer Bildnismaler (Zurich and
Leipzig, 1939), no. 264.

Diogg has depicted Colonel Forrer in a self-
confident pose, gazing earnestly into the dis-
tance. Still, this is no glorification of a military
leader in the traditional mode, for there is no
victorious gesture, no battle raging in the back-
ground, nor even a map of a campaign.
 Joachim Forrer, Divisional Commander and
Military Inspector of the Canton of St. Gallen,
Switzerland, fought in Spain from 1808 to 1811
and in Russia in 1812.

16

 plate, p. 65

CHRISTOFFER WILHELM ECKERSBERG

Portrait of Emilie Henriette Massmann

1820. Oil on canvas, 21¹/₁₆ x 17¹/₈″ (53.5 x 43.5 cm)
Statens Museum for Kunst, Copenhagen. 4559.

References: Emil Hannover, *C. W. Eckersberg*
(Copenhagen, 1898), no. 263; Voss, p. 37 f.;
Danish Painting, cat. no. 15.

The young woman's pose is rather unconven-
tional, seated sideways on the chair with her
right arm resting on its back as she gazes atten-
tively at the beholder. The graceful contours of
her cheek and throat, neck, shoulder, and
puffed sleeves stand out clearly against the
plain background, which is lent a certain depth
by modulations of light.

At the time this portrait was painted Hen-
riette Massmann was the fiancée of Wilhelm
Casper von Benzon, a court chamberlain also
portrayed by Eckersberg.

17

CHRISTOFFER WILHELM ECKERSBERG

View of Nyholm plate, p. 64

1826. Oil on canvas, 7¹¹/₁₆ x 12³/₄″ (19.6 x 32.4 cm)
Inscribed "E 1826."
Den Hirschsprungske Samling, Copenhagen. 1982
catalogue, no. 103

References: Emil Hannover, *C. W. Eckersberg*
(Copenhagen, 1898), no. 365; Bramsen, p. 29;
Dansk Guldålder, exhibition catalogue (Stock-
holm, 1964), cat. no. 67; Norman, p. 87 f.

The composition is divided horizontally into
three sections: the foreground with the large
anchors; the surface of the water; and the far
shore with ships whose masts stand out against
the sky like a grid. Everything has been com-
pressed into a shallow space, beneath a sky that
takes up almost two thirds of the composition.
 In 1838 Eckersberg employed the anchors at
the right, in lateral inversion, in a perspective
drawing (see *Tegeninger af C. W. Eckersberg*,
exhibition catalogue [Copenhagen, 1983],
cat. no. 137).

18

JOHANN HEINRICH CHRISTIAN ELI

Flower Still Life plate, p. 66

1833. Oil on canvas, 21¹/₄ x 24³/₈″ (54 x 62 cm)
Städtisches Museum, Brunswick. 64

The large bunch of dahlias is placed on the
table so that the stems run diagonally through
the painting, creating a veil of blossoms and
leaves that almost completely fills the picture
plane. Even the seashell, knife, and vase are
treated as integral parts of this flat, tapestry-
like composition.

19

MARIE ELLENRIEDER

Self-Portrait plate, p. 66

1818. Oil on canvas, 20⁷/₈ x 17″ (53 x 43.2 cm)
Staatliche Kunsthalle, Karlsruhe. 783

Reference: Lauts, p. 58.

This self-portrait at the age of twenty-seven
was done before Ellenrieder's sojourn in Rome.
It is a closely cropped view, with the coiffure
intersected by the top edge of the canvas. The
dress is rendered broadly, with little attention
to detail, and the whole is set off against a neu-
tral background.

20

AUGUST VON DER EMBDE

Portrait of Louise Reichenbach

1820. Oil on canvas, 42⁷/₈ x 31⁷/₈″ (109 x 81 cm)
Staatliche Kunstsammlungen, Kassel. AZ 37

Reference: Herzog, p. 22.

A child, holding a pet dove and with a faraway
expression on her face, is seated in a fairy-tale
setting that seems to anticipate the studio back-
drops used by photographers. There is no
impression of depth, the background having
the appearance of a tapestry. Like many of his
contemporaries, Embde has devoted special
care to a botanically precise rendering of the
flowers and bushes.
 Little Countess Reichenbach, born in 1813,
was the eldest child of Wilhelm II, Elector of
Hesse, from his liaison with Emilie Ortlepp,
daughter of a Berlin goldsmith.

21

THOMAS ENDER plate, p. 67

Courtyard of the Palazzo Venezia

1819/23. Oil on panel, 9¹/₄ x 13″ (23.5 x 33 cm)
Kunsthalle, Bremen. 949–1966/31 (on permanent
loan from the Federal Republic of Germany)

Reference: Gerkens, p. 99.

Unfinished arcades on the left and a low build-
ing on the right lead the eye to the palazzo
itself, a complex of structures depicted in
superimposed layers parallel to the picture
plane. The roofline is punctuated by two mas-
sive towers silhouetted against a pale sky.
 The buildings lie for the most part in shadow:
the sun illuminates only parts of the arcades,
the tops of the trees, and a strip of foreground.

22

THOMAS ENDER

Grossglockner Mountain with
Pasterze Glacier

1832. Oil on canvas, 15¹/₈ x 21¹/₁₆″ (38.5 x 53.5 cm)
Inscribed "Thom. Ender, nach der Natur 1832"
Österreichische Galerie, Vienna. 6068

References: Walter Koschatzky, *Thomas Ender*
(Graz, 1982), fig. 55; Frodl, pp. 38, 122, 246 f.

Ender was commissioned in 1828 by Archduke
Johann of Austria to depict the Alpine land-
scapes of Salzburg, Carinthia, and the Steier-
mark. On hikes through the region Ender
created countless watercolors, some of which
he later worked up into oil paintings. Apart
from faithfully rendering the appearance of the
landscape, he succeeded in conveying the awe-
some impression made on him by the moun-
tains and glaciers.

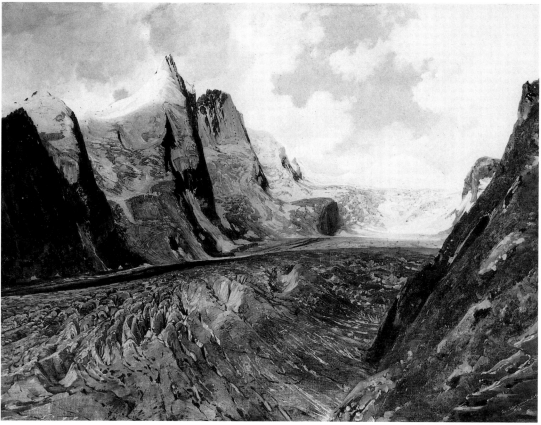

22

23

CHRISTIAN EZDORF plate, p.68

An Iron Forge in Scandinavia

1827. Oil on canvas, 23⅝x34¼" (60x87cm)
Inscribed "C.Ezdorf 1827"
Städtische Galerie im Lenbachhaus, Munich.
G 334

After modeling himself on Ruisdael and Everdingen in his early career, Ezdorf traveled extensively in Scandinavia, thereafter specializing in northern European landscapes. The dramatic juxtaposition of two elements, fire and water, is the true subject of this picture, in which nature dwarfs humans and animals.

Massive foothills frame the scene like stage flats, and a high mountain range on the horizon provides a dramatic backdrop. Little trace of Dutch influence remains.

24

ERNST FRIES

View over Treetops

C. 1826. Oil on paper, 9⅞x13⁹/₁₆" (25 × 34.5 cm)
Kurpfälzisches Museum der Stadt Heidelberg,
Heidelberg. G 189

Reference: *Deutsche Romantiker*, cat.no.67.

From a high viewpoint the artist has depicted a dense grove of trees partly illuminated by strong sunlight. Other areas of the foliage lie in deep shadow, while the background almost dissolves in the sun's glare.

The sketch dates from the close of Fries's stay in Italy, a period marked by the influence of Camille Corot.

25

KARL LUDWIG FROMMEL

Hohensalzburg Castle

Probably 1817. Oil on paper, 13¹/₁₆x19³/₁₆"
(33.2x48.7cm)
Private collection, Munich

Frommel probably painted this view of Hohensalzburg Castle in 1817, on his return journey from Rome, where he had lived since 1812. The view from the Kapuzinerberg mountain includes the Nonnberg Convent and the dome of St. Kajetan (just visible in the unfinished section at the bottom) and extends across a wide plain to the Hochthron range. The complex structure of the imposing castle, its walls catching the sun, and the mountains veiled in light mist are rendered with light, rapid brushstrokes, while the plain has been left in a sketchy state and the roofs of the town in the foreground omitted altogether.

26

EDUARD GAERTNER

View into a Courtyard frontispiece

1827. Oil on canvas, 18⅛x13" (46x33cm)
Inscribed "E.Gaertner fec: 1827"
Staatliche Galerie Schloss Moritzburg, Halle

Reference: *Kunst in Berlin 1648–1987*, exhibition catalogue (Berlin [GDR], 1987), cat.no.F 34.

This picture of dense shrubbery seen through an archway may have been painted in Paris before Gaertner's return to Berlin the same year. The composition is articulated in terms of two planes: the walls of the archway in the extreme foreground, and crumbling masonry, rising terrain, and foliage in the background. The air is suffused with sunlight, underscoring the sense of tranquillity and immutability that the artist apparently wished to convey.

27

FRIEDRICH GAUERMANN

Landscape near Miesenbach

C. 1830. Oil on canvas, 12⅜x17½" (31.5x44.5cm)
Österreichische Galerie, Vienna. 2815

References: Rupert Feuchtmüller, *Friedrich Gauermann* (Vienna, 1962), p.205; Norman, p.40.

Gauermann, who was initially influenced by seventeenth-century Dutch painting and turned to dramatic genre pictures at an early date, produced a large number of *plein air* landscape sketches. Among the few which he developed into finished compositions was this view of the Schneeberg mountain silhouetted against the sky. A silhouettelike treatment also

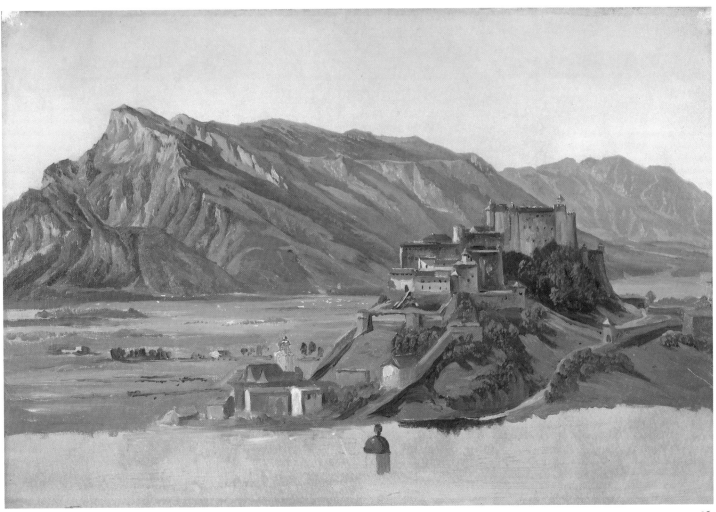

25

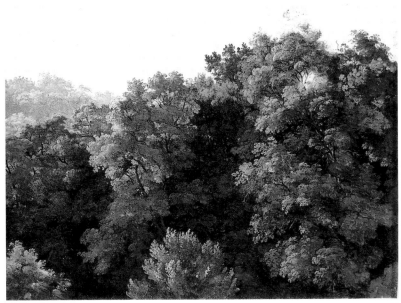

24

characterizes the groups of trees and the woods that divide the composition into separate sections.

28

JOHANN JAKOB GENSLER

Hollyhock plate, p. 73

1827. Oil on canvas, 13¹³/₁₆ x 6¹/₁₆" (35.1 x 15.4 cm)
Inscribed "Agst. 25.1827"
Kunsthalle, Hamburg. 1318

Reference: Krafft, p. 83.

Rapid, sure brushwork characterizes this depiction of a hollyhock stem with two open and two wilted flowers and numerous buds against a green background. A slight inclination to the left suggests that the flowers are swaying in the wind. Gensler painted this study at the age of nineteen, shortly before he enrolled at the Munich Academy.

191

27

29

KARL FRIEDRICH GÖSER

Self-Portrait in the Studio plate, p. 70

1835. Oil on canvas, 18¼ x 18⁷/₁₆" (46.4 x 46.8 cm)
Städtische Sammlungen (Braith-Mali-Museum),
Biberach an der Riss. 6317

Reference: Herbert Hoffmann and Kurt Diemer,
Katalog der Gemälde und Skulpturen bis 1900,
Städtische Sammlungen Biberach, (Biberach,
1975), p. 116 f.

In this portrait of himself at work, Göser carica-
tures the cramped conditions, both physical
and mental, in which provincial artists of the
period were forced to live. There is hardly room
in his studio for his household utensils and dog,
let alone for the lady, accompanied by her
daughter, whose portrait he is painting. The
scene is closely observed by inquisitive neigh-
bors, whose nosiness we as viewers share, for
we look through an imaginary windowpane to
which a miniature of a putto chasing dolphins
is attached at the upper left.

Resigned and melancholy as it may be, the
image conveys a criticism of the artist's time
and fellow citizens that is far more direct and
honest than that contained in comparable
paintings from the immediately following
period.

30

CONSTANTIN HANSEN

The Artist's Sisters plate, p. 69

1826. Oil on canvas, 25¹³/₁₆ x 20¹/₁₆" (65.5 x 56 cm)
Inscribed "C. Hansen – 2 –"
Statens Museum for Kunst, Copenhagen. 3004

References: Emil Hannover, *Maleren Constantin
Hansen* (Copenhagen, 1901), no. 15; *Dansk
Kunsthistorie,* p. 366 f.; *L'age d'or,* cat. no. 74.

With this portrait of his two sisters, Hansen,
then twenty-two years of age and still a student
at the Copenhagen Academy, produced a mas-
terpiece. The heads and figures are modeled
with merciless precision, and plunged in light
so harsh that reflections from the girls' dresses
affect the color of their skin. Yet what a sensi-
tive rendering this is of sisterly affection and
concentration on shared interests, in which
contemplation and activity – expressed in the
pose of the younger sister – are held in balance.

31

KARL HASENPFLUG plate, p. 74

The Garrison Church in Potsdam

1827. Oil on copper, 24¹⁵/₁₆ x 32" (63.3 x 81.3 cm)
Inscribed "C. Hasenpflug 1827"
Berlin Museum, Berlin. GEM 80/7

Reference: *Berlinische Notizen 1981: Erwer-
bungen des Berlin Museums 1964–1981,* p. 98 f.

In this view of the Royal and Garrison Church,
the western elevation lies in shadow, while the
strongly foreshortened facade is bathed in sun-
light that sharply accentuates the individual
elements of its articulation. Visible beyond the
bridge over the canal, the Stadtschloss (Town
Palace) closes the composition at the rear. The
tower clock in the painting was originally fitted
with a clockwork mechanism that kept real
time.

32

ADOLF VON HEYDECK

View of Rome

1815. Oil on paper, 13³/₈ x 18½" (34 x 47 cm)
Inscribed "1815"
Von der Heydt-Museum, Wuppertal. 139

Reference: Laxner-Gerlach, p. 85.

The view from the Piazza SS. Trinità dei Monti
includes the church of S. Carlo al Corso in the
right foreground and, in the background,
St. Peter's and the Vatican. The jumble of
houses is compressed into a narrow band
between a purposely unfinished foreground
and a large expanse of bright sky.

33

JOHANN ERDMANN HUMMEL plate, p. 73

Ernst Wilhelm Brücke as a Boy

1823. Oil on oak, 13 x 11¹³/₁₆" (33 x 30 cm)
Wallraf-Richartz-Museum, Cologne. 2524

Reference: Andree, p. 50 f.

This basically realistic portrait of a four-year-
old boy is lent a Neoclassical air by the toga and
wreath, as well as by the circular shape enclos-
ing the image, which recalls a medallion even
though it actually represents an oval window.

Ernst Wilhelm Brücke, later professor of
anatomy in Vienna, was the son of the painter
Johann Gottfried Brücke.

34

CHRISTIAN ALBRECHT JENSEN

Portrait of the Artist's Wife plate, p. 71

C. 1825. Oil on canvas, 18¹³/₁₆ x 15¹/₁₆"(47.8 x 38.3 cm)
Den Hirschsprungske Samling, Copenhagen.
1982 catalogue, no. 179

References: Sigurd Schultz, *C.A. Jensen*
(Copenhagen, 1932), no. 76; *Dansk Kunsthistorie*,
p. 321; Nørregård-Nielsen, p. 164.

Jensen has depicted his wife in almost full
figure in a format between lifesize and minia-
ture that was very popular during the Bieder-
meier period. She is dressed to go out, and
seems to have sat down for a moment before
leaving. The chair stands in an indeterminate
spatial relationship with the background,
another feature typical of the Biedermeier por-
trait.

35

JOHAN LAURENTZ JENSEN

Still Life with Fruit plate, p. 72

1833. Oil on canvas, 9½ x 12⅞" (24.1 x 32.7 cm)
Inscribed "I.L. IENSEN. 1833."
Thorvaldsens Museum, Copenhagen. B 231

Reference: *The Thorvaldsen Museum*, p. 101.

Appearing tangibly close to the viewer, various
fruits are placed on a marble slab whose edge
runs parallel to the picture plane. The arrange-
ment has nothing of the careful contrivance
characteristic of seventeeth-century Dutch still
lifes. Bunches of grapes, the orange, and the
walnut lie extremely close together; one leaf
extends forward, the other back; and the group-
ing fills almost the entire canvas, appearing to
have been compressed into the format.

The painting was purchased by Thorvaldsen
from the artist.

36

JUST ULRICH JERNDORFF

Landscape with Cliffs plate, p. 76

C. 1830. Oil on canvas, 11 x 15⅜" (28 x 39 cm)
Landesmuseum für Kunst und Kulturgeschichte,
Oldenburg. LMO 15520

A path in the foreground is lined with bushes
that obscure all but a short stretch of the
stream, but not the bridge beyond, which
demarcates the lower third of the composition.
The middle third is taken up by a cliff that falls
off to the left, where it is counterpointed by a
gentle slope and two young trees silhouetted
against the sky. Nothing disturbs the lucid com-
position of this objectively rendered landscape.

32

37

GEORG FRIEDRICH KERSTING plate, p. 75

Young Woman Sewing by Lamplight

1828. Oil on canvas, 15⅞ x 13⁷/₁₆" (40.3 x 34.2 cm)
Inscribed "GK."
Bayerische Staatsgemäldesammlungen,
Neue Pinakothek, Munich. 14603

Reference: *Münchner Jahrbuch der bildenden*
Kunst, 32 (1981), p. 248.

The sitter is probably the wife of the artist, portrayed in their home. The elaborate play of light and shade was intended less to create a dramatic effect than to evoke the comfort and security of home. Kersting's interiors were extremely popular during the artist's lifetime.

There is a preliminary drawing for this painting, dated 1828, in the Germanisches Nationalmuseum, Nuremberg.

38

FRIEDRICH WILHELM KLOSE plate, p. 77

The Astronomical Observatory, Berlin

C. 1835. Oil on canvas, 12³/₁₆ x 9⁷/₁₆"(31 x 24 cm)
SKH *Dr. Louis Ferdinand Prinz von Preussen, Berlin*

Reference: Börsch-Supan, 1982, p. 36.

From a point slightly above street level the artist has depicted Dorotheenstrasse with the royal stables in the background, which at that time housed the academies and, in the tower, the observatory.

Klose was a pupil of the scene painter Karl Wilhelm Gropius, and the light in this street scene does indeed have something theatrical about it, with over two thirds of the objectively rendered architecture lying in shadow.

39

WILHELM VON KOBELL

Horseman and Stable Boy plate, p. 79

1827. Oil on oak, 8¹¹/₁₆ x 8⁷/₁₆" (22 x 21.5 cm)
Inscribed "W. Kobell/1827"
Kunstmuseum, St. Gallen. G 1938.8

Reference: Siegfried Wichmann, *Wilhelm von Kobell* (Munich, 1970), cat. no. 1410.

A gentleman on horseback, his dog, and a stable boy leading two mounts stand on a stagelike rise in the foreground, behind which the terrain falls off so steeply that the middle ground is obscured. Visible in the background are the village of Rottach-Egern, Tegernsee lake, and the distant Alps.

40

WILHELM VON KOBELL

Alpine Meadow plate, p. 78

1829. Oil on canvas, 11⅞ x 14¹⁵/₁₆" (30.1 x 38 cm)
Inscribed "Wilhelm Kobell 1829"
Staatliche Kunsthalle, Karlsruhe. 649

Reference: Lauts, p. 138.

Absolute silence reigns in this scene of a dairymaid and child, who are tending their cattle on the verge of an Alpine slope, dressed in their Sunday best. The stagelike atmosphere is increased by illumination from the low-lying sun. An invisible declivity separates foreground from background, where a mountain range is silhouetted against an expanse of cloudy sky.

41

CHRISTÉN KØBKE

View of Langelinie from
Copenhagen Citadel plate, p. 80

C. 1832. Oil on canvas, 9³/₁₆ x 13" (23.3 x 33 cm)
Statens Museum for Kunst, Copenhagen. 3480

Reference: Hans Edvard Nørregård-Nielsen, *Købke og Castellet,* exhibition catalogue, (Copenhagen, 1981), cat. no. 10.

Visible across the canal and the strip of coast known as Langelinie is Copenhagen's naval base, where the masts of anchored ships stand out starkly against the sky. The terrain, with its wall and moat, shrubbery and trees, has been compressed into a narrow band, while over two thirds of the composition are occupied by the sky with a large cloud formation in the center.

Like many artists of the period, Købke devoted himself intensively to the study of clouds (see also no. 13).

44

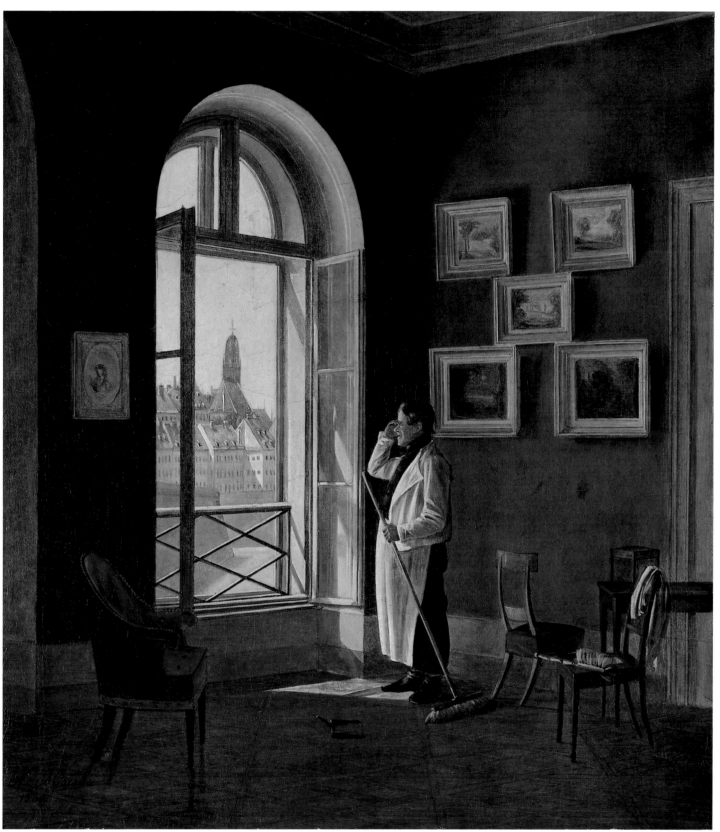

45

42

CHRISTEN KØBKE

Study of a Nude Boy plate, p. 81

1833. Oil on canvas, 22¹⁵/₁₆ x 9³/₁₆″ (58.3 x 48.7 cm)
Inscribed "4.7.1833"
Statens Museum for Kunst, Copenhagen. 6177

References: Mario Krohn, *Maleren Christen Købkes Arbejder* (Copenhagen, 1915), no. 64; *Dänische Malerei*, cat. no. 38.

This carefully executed study of a nude boy was done in the studio of Eckersberg, whose private student Købke became after twenty years spent at the Copenhagen Academy. Despite the complicated pose, every part of the figure has been integrated in a single plane that parallels the wall and the wooden chest.

43

JOHANN AUGUST KRAFFT

Judge Jakob Wilder plate, p. 82

1819. Oil on canvas, 18¹/₂ x 15⅜″ (47 x 39 cm)
Kunsthalle, Hamburg. 1195

Reference: Krafft, p. 164.

Krafft rendered the sitter's glasses and the objects on the table in the foreground with just as much care and sensitivity as he devoted to the features of the 79-year-old gentleman, whose profile is clearly outlined against the green wall. There seems to be hardly enough space between the wall and the table for the vol-uminous figure. Every detail in the composition stands out clearly in the bright, yet neutral, light, whose source in the window at the left is suggested only by the shadow above the sitter's head.

44

LEOPOLD KUPELWIESER

Portrait of a Lady

1827. Oil on canvas, 27³/₁₆ x 21⅝″ (69 x 55 cm)
Inscribed "Kupelwieser 1827"
Österreichische Galerie, Vienna. 2829

References: Rupert Feuchtmüller, *Leopold Kupelwieser und die Kunst der österreichischen Spätromantik* (Vienna, 1970), p. 247.

Kupelwieser was one of the few artists who still managed to produce religious paintings of a certain individuality as late as the 1840s. The truthfulness necessary for this also informs his portrait of a lady, whom he has depicted in a plain blue dress, without jewelry, and in quite undramatic lighting against a homogeneous dark background.

45

NIKOLAUS MOREAU

View from a Room in the Diana Baths

1830. Oil on canvas, 15⁹/₁₆ x 13⁹/₁₆″ (39.5 x 34.5 cm)
Inscribed "N. Moreau 1830"
Museen der Stadt Wien, Vienna. 95.189

Reference: *Bürgersinn und Aufbegehren*, cat. no. 12/1/18.

The fact that the room depicted here was located in a public bathing establishment in Vienna is really secondary. It could be any untidy room in that city which a servant was sweeping when he paused to look out over the roofs of the town, the view including the church of Maria am Gestade. Rather than relating an anecdote, the artist has captured a real, random moment in time.

46

CHRISTIAN E. B. MORGENSTERN

On the Swedish Coast plate, p. 83

1828. Oil on paper, 9¹⁵/₁₆ x 13″ (25.2 x 33.1 cm)
Kunsthalle, Hamburg. 1127

Reference: Krafft, p. 230.

More than on the coastline, ocean, and distant vista usually associated with seascapes, the artist's interest has concentrated on the mountains obscuring the horizon, the woods, and the farmhouses grouped in the middle ground. The path in the foreground, instead of leading directly to the houses, disappears in an intervening depression that is suggested by rapidly rendered rocky outcrops. The foreground has been left vague.

47

HANS JAKOB OERI plate, p. 84

Portrait of Johann Jakob Stolz

1818. Oil on canvas, 26⅜ x 22¹/₄″ (67 x 56.5 cm)
Schweizerisches Landesmuseum, Zurich. LM 52788

The summary treatment of the sitter's dark coat against the dark background, and the concentration of light in the head, serve to focus all interest on the sitter's rather heavy features, which are seen relatively close up and in a strictly frontal view.

Johann Jakob Stolz, a native of Zurich, was active as a theologian in Bremen.

48

JULIUS OLDACH

The Artist's Mother

1824. Oil on canvas, 21⁷/₁₆ x 16³/₄″ (54.5 x 42.5 cm)
Kunsthalle, Hamburg. 1103

Reference: Krafft, p. 239.

Katharina Maria Oldach was the wife of a Hamburg baker. Her son has depicted her here within a painted oval frame, looking calmly and expectantly at the viewer. Lace collar and bonnet have been rendered with great fidelity, yet, instead of detracting from the rather unassuming face, they serve to heighten its expression.

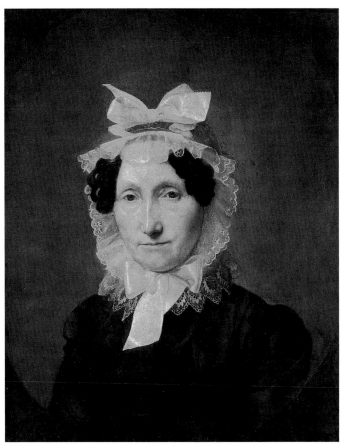

48

51

49

MORITZ DANIEL OPPENHEIM plate, p. 85

The Jung Brothers with their Tutor

1826. Oil on canvas, 39¾ x 46⅛″ (101 x 117 cm)
Inscribed "MOppenheim pinxit/MDCCCXXVI"
Wallraf-Richartz-Museum, Cologne. 1108

Reference: Andree, p. 94 f.

The three sons of the Rotterdam shipowner Jung were educated in Frankfurt by the tutor Heinrich Wilhelm Ackermann. Although the boy on the left has opened his collecting box and his tutor has removed a specimen, and although the boy on the right is holding an open book, there would appear to be no real interaction among the four, who, attentive or lost in thought, are simply sitting patiently for their portrait, arranged in a line as if in a relief.

50

MORITZ DANIEL OPPENHEIM

Portrait of Ludwig Börne plate, p. 84

1833. Oil on canvas, 19¼ x 16⅛″ (48.9 x 41 cm)
Inscribed "MOppenheim/1833"
Freies Deutsches Hochstift, Goethe-Museum,
Frankfurt. IV-1949-6

Reference: Sabine Michaelis, *Freies Deutsches Hochstift: Katalog der Gemälde* (Tübingen, 1982), cat. no. 145.

The quick intelligence of Börne, writer and publisher, is wonderfully conveyed by Oppenheim's vivid portrait. Börne was a committed opponent of the political and cultural reaction of his age. From 1818 to 1821 he edited *Die Waage*, subtitled "A Periodical for Middle-Class Life, Science, and Art," and after the July Revolution of 1830, he emigrated to Paris.

51

DOMENICO QUAGLIO

The Old Riding School and Café Tambosi, Munich

1822. Oil on canvas, 24⅜ x 32¹¹/₁₆″ (62 x 83 cm)
Inscribed "gemalt von Dominic Quaglio 1822"
Bayerische Staatsgemäldesammlungen,
Neue Pinakothek, Munich. WAF 786

Reference: Brigitte Trost, *Domenico Quaglio* (Munich, 1973), no. 125.

Visible at right center is the Old Riding School, which was demolished later in the same year that the painting was done. In front of it to the right is Café Tambosi, a favorite Munich gathering place in the early Biedermeier period. The view is bordered by Klenze's gateway to the Hofgarten on the right and, on the left, by a corner of the Theatinerkirche.

The sunny square is populated by figures seen from a distance whose groupings and activities convey a fascinating impression of life in a bygone era.

52

DOMENICO QUAGLIO

Residenzstrasse, Munich plate, p. 86

1826. Oil on canvas, 24¹³/₁₆ x 32¹¹/₁₆" (63 x 83 cm)
Inscribed "gemalt von Dominic Quaglio 1826"
Bayerische Staatsgemäldesammlungen,
Neue Pinakothek, Munich. WAF 790

References: Brigitte Trost, *Domenico Quaglio*
(Munich, 1973), no. 155; *Bayerische Staats-*
gemäldesammlungen, p. 260 f.

By employing perspective tricks, Quaglio has
expanded the actually quite narrow lane, rotat-
ing the facades out toward the picture plane.
Visible at the left are two sections of the Resi-
dence that were demolished the year the paint-
ing was done to make way for Klenze's King's
Tract; the Palais Törring can be seen in the
background. Bright sunlight accentuates the
facades on the left, while the row of houses on
the right and the street itself lie in shadow.

53

PETER VON RAUSCH

Boy with Bow and Arrow plate, p. 90

1826. Oil on canvas, 22⁷/₁₆ x 18⁵/₁₆" (57 x 46.5 cm)
Inscribed "M. Rausch fe. 1826"
Stiftung Pommern, Kiel. B 1069/17 471

Reference: *Stiftung Pommern*, p. 171 f.

The boy dressed in a jacket of military cut is a
good archer, judging by the dead bird at his
side. Children were permitted to display a cer-
tain amount of activity and movement in
Biedermeier pictures, though this never went
so far as to confer narrative character on the
portrait. Here, for example, the scene remains
closely cropped and the background is merely
hinted at.

54

JOSEF REBELL

View of the Gulf of Naples plate, p. 88

C. 1815. Oil on cardboard, 9¹/₈ x 12¹/₈" (23.2 x 30.8 cm)
Staatliche Kunsthalle, Karlsruhe. 2286

Reference: Lauts, p. 191.

For this rapidly executed sketch the painter
chose a viewpoint from which the far shore
with Mount Vesuvius appears parallel to the
picture plane. The rocky shore in the fore-
ground is merely roughly indicated.

55

JØRGEN ROED plate, p. 90

Portrait of Emil Wilhelm Normann

1830. Oil on canvas, 11¹³/₁₆ x 9⁵/₈" (30 x 24.5 cm)
Inscribed "IR [intertwined] 1830"
Statens Museum for Kunst, Copenhagen. 4903

References: *Dänische Malerei*, cat. no. 56; *C. W.*
Eckersberg og hans elever, exhibition catalogue
(Copenhagen, 1983), cat. no. 224.

Roed was still a student of Eckersberg's when
he portrayed his painter friend Normann, who
was ten years his elder, in the uniform of a naval
officer. Soon Roed was to devote himself
almost exclusively to architectural views.

The sitter's penetrating gaze and folded arms
lend the portrait a strong, immediate presence
that is increased by the neutral background
forming a screen immediately behind the
figure.

56

JOHANN MARTIN VON ROHDEN

Tivoli seen from the West plate, p. 89

C. 1815. Oil on paper, 17¹³/₁₆ x 24¹⁵/₁₆" (45.3 x 63.3 cm)
Niedersächsisches Landesmuseum, Hanover.
PNM 572

References: Schreiner, cat. no. 857; *Deutsche*
Romantiker, cat. no. 75.

The subject of the waterfalls at Tivoli, popular
with painters since the seventeenth century
and depicted several times by Rohden, is
painted in a noticeably detached manner here.
The elements of the landscape resemble the
cutout flats in a toy theater, with a backdrop
consisting of a largely undifferentiated hill.
The abstract flatness of the image is augmented
by an almost monochrome palette.

57

MARTINUS RØRBYE

Copenhagen Prison plate, p. 87

1831. Oil on canvas, 18¹¹/₁₆ x 24¹³/₁₆" (47.5 x 63 cm)
Inscribed "M. Rørbÿe/1831"
Statens Museum for Kunst, Copenhagen. 206

References: *Kunstblatt* (Copenhagen, April 12,
1852); *Martinus Rørbye*, exhibition catalogue
(Copenhagen, 1981), cat. no. 24; *Danish Painting*,
cat. no. 45; Normann, p. 102 f.

Visible through the great arch is Copenhagen
prison, located in the center of the city. It is a
sunny day, and people are going about their
business or merely passing the time – women
with children, officials and idlers, servants and
beggars, some of whose poses and activities
probably refer to the concepts of justice and
punishment. The empty foreground lies in
shadow, and a "grumpy old man" carrying a
lantern is striding into it toward the spectator.

58

KARL VON SALES plate, p. 90

Portrait of Magdalena von Erstenberg

1816. Oil on canvas, 27³/₁₆ x 21⁵/₈" (69 x 55 cm)
Inscribed "C. P. Sales pinx/1816."
Private collection

Karl von Sales trained at the Vienna Academy,
and in this early Biedermeier portrait traces of
the dramatic, Neoclassical school of Friedrich
Heinrich Füger are still much in evidence. The
oriental turban was a favorite accessory of
ladies with intellectual aspirations at that time.

Magdalena Freifrau von Erstenberg, née
Freiin von Geramb, was the wife of the *chargé*
d'affaires for Brunswick in Vienna.

59

WILHELM VON SCHADOW

Portrait of Felix Schadow plate, p. 93

C. 1830. Oil on canvas, 24 x 20¹/₁₆" (61 x 51 cm)
Private collection, Munich

Reference: Gläser, p. 81.

Felix, born in 1819, was the son of Gottfried
Schadow and his second wife, Henriette
Rosenstiel. The boy's delicate features are
modeled by mild light. The rich yellow of the
vest and the bright red of the book evoke the
cheerfulness of childhood.

The unsigned painting has been attributed
to Karl Begas and Eduard Magnus. However,
recent research by Helmut Börsch-Supan
suggests that it is a work of Felix's older half
brother, Wilhelm.

60

JAKOB SCHLESINGER plate, p. 91

Portrait of Christian Philipp Köster

C. 1827. Oil on canvas, 39³/₈ x 29⁷/₈" (100 x 76 cm)
Kurpfälzisches Museum der Stadt Heidelberg,
Heidelberg. G. 2044

References: Poensgen, p. 22; Schneider, p. 177.

So frank and penetrating is this portrayal of a
self-confident personality that not even the
massive intervening balustrade can create dis-
tance between sitter and viewer. Christian
Philipp Köster was an artist who worked
primarily as a restorer – from 1810 for the Bois-
serée Collection, between 1824 and 1831 at the
Berlin Museum. His book *Über Restauration*
alter Ölgemälde (On the Restoration of Old Oil
Paintings) was published in Heidelberg in
1827.

61

ERDMANN SCHULTZ

Still Life with Fruit plate, p. 92

1831. Oil on canvas, 27⁹/₁₆ x 22¹³/₁₆" (70 x 58 cm)
Wallraf-Richartz-Museum, Cologne. 2913

References: Andree, p. 113; *Stilleben – Natura*
Morta, exhibition catalogue (Cologne, 1980),
p. 66.

The still life in a semicircular niche recalls
similar ones in seventeenth-century Dutch art,
but in contrast to them, the niche is almost
completely filled with a strongly two-dimen-
sional arrangement in which even many of the
leaves are placed parallel to the picture plane.
The extent to which the components – the
seashells, for example – still had symbolic

meaning, remains an open question. The glass goblet was a very modern product at the time the painting was executed.

62

KARL ADOLF SENFF

The Wreathmaker plate, p.95

1828. Oil on canvas, 54³/₄ x 39⁵/₈" (139.2 x 100.8 cm)
Inscribed "Adolfo Senff fec. Roma 1828"
Bayerische Staatsgemäldesammlungen,
Staatsgalerie, Regensburg. 14991
Reference: Heilman, p. 73 f.

This pretty girl in pseudo-classical dress represents the wreathmaker Glycera, who was loved and portrayed by Pausias of Sykion. Senff has depicted her seated on a wall, parallel to the picture plane as in a relief and gazing directly at the viewer.

The artist was probably inspired to treat the touching story that Pliny relates in two passages of the *Historia Naturalis* (XXI, 3, and XXXV, 11 and 40) by Goethe's long poem "Der Neue Pausias und sein Blumenmädchen" of 1796.

The "Raffaelo dei fiori," as Senff was known to his Roman colleagues, has depicted the flowers with the utmost care. In spite of the landscape vista on the left, the background, with its trees and vegetation, creates an effect of shallow space, closing off the composition like a backdrop.

63

KARL ADOLF SENFF plate, p.94

Antique Vase with Bunch of Flowers

1828. Oil on canvas, 18⁹/₁₆ x 14³/₈" (47.1 x 36.6 cm)
Inscribed "Adolfo Senff. 1828."
Thorvaldsens Museum, Copenhagen. B 161
Reference: Torben Melander, "Vaserne på Thorvaldsens Museum," *Meddelelser fra Thorvaldsens Museum* (1982), pp. 75 f., 98.

Senff lived in Rome in the house of his friend and mentor, Thorvaldsen. In a vase from Thorvaldsen's collection he has depicted a large bunch of wild flowers that fills almost the entire upper half of the canvas. Light falling from the left plunges some of the flowers on the right in deep shadow, while a second light source illuminates the indeterminate background so strongly that the contours of the flowers are clearly silhouetted against it and the vase even casts a faint shadow into the foreground.

64

EDUARD DAVID STEINER

Self-Portrait plate, p.97

1832. Oil on canvas, 45¹/₄ x 33⁵/₈" (115 x 85.5 cm)
Inscribed "Eduard Steiner v. Winterthur geboren 23. März 1811 von sich selbst gemalt Anno 1832 Seiner lieben Mutter zum Geschenk den 13. April 1832"
Kunstmuseum, Winterthur. 192

Reference: Hans Hoffmann, *Zürcher Bildnisse aus fünf Jahrhunderten* (Zurich, 1952), p. 109.

The 21-year-old artist has depicted himself critically but with self-confidence, having donned his best coat for the purpose. The heavy curtain hanging at the upper right underscores the pose, while Winckelmann's *Kunst des Altertums* (The Art of Antiquity) and Sulzer's *Lexicon der schönen Künste* (Dictionary of Fine Arts) on the shelf at the upper left show the young artist to be a conscientious student of his craft.

65

LEOPOLD STÖBER

Self-Portrait with Family plate, p.98

1827. Oil on canvas, 39³/₈ x 45⁵/₈" (100 x 116 cm)
Inscribed "L: Stöber. 1827"
Sammlungen des Fürsten von Liechtenstein,
Schloss Vaduz. 2125
Reference: *Deutsche Malerei 15.–19. Jahrhundert aus den Sammlungen des regierenden Fürsten von Liechtenstein* (Vaduz, 1979), no. 25.

The young artist with mahlstick and palette is attempting to convince his skeptical father, the gilder and calligrapher Christoph Ignaz Stöber, that he is on the right track with his art. He is the sole active figure in the composition; the rest of the family is peacefully gathered around him in a boxlike room that appears far too small to contain them.

66

DAVID SULZER plate, p.96

Three Young Ladies of Winterthur

1822. Oil on canvas, 73¹/₄ x 46¹/₂" (186 x 118 cm)
Inscribed "Sulzer pinx. 1822"
Kunstmuseum, Winterthur. 567
Reference: Hugelshofer, pl. 96 f.

Three young ladies are depicted standing next to one another, arm in arm. As Sulzer specialized in portraits, the dresses held little interest for him, and the background scarcely any at all. The sunshade and broad-brimmed hat largely obscure the sky as well.

67

JOHANN CHRISTIAN TUNICA

Portrait of A. Giem plate, p.82

1823. Oil on canvas, 43³/₄ x 36¹/₄" (111 x 92 cm)
Städtisches Museum, Brunswick. 402
Reference: Klaus-Ulrich Gählert, "Ein eigenhändiges Werkverzeichnis des Braunschweiger Hofmalers Christian Tunica," *Braunschweigisches Jahrbuch*, 39 (1958), pp. 130–49, no. 72.

The sitter – an artist – is seated before a table with a fresh canvas on an easel behind him. He has turned toward the viewer with a confident gaze. The canvas, a proud confirmation of his

profession, serves as a backdrop for the figure and adds a lighter tone to the otherwise somber background.

68

JAN VELTEN

Düsseldorf Harbor plate, p.100

1832. Oil on canvas, 20¹/₁₆ x 24" (51 x 61 cm)
Inscribed "IV [intertwined] 1832"
Wallraf-Richartz-Museum, Cologne. 2469
Reference: *Die Düsseldorfer Malerschule,* cat. no. 262.

It was not so much the wharves populated by strollers and carters that interested the painter as the grid formed by the ships' masts and rigging, their sails and flags. The foreground and dark quay wall lie in shadow.

69

ADOLF FRIEDRICH VOLLMER

Landscape in Holstein plate, p.101

1827. Oil on paper, 8¹¹/₁₆ x 12¹/₈" (22 x 30.8 cm)
Inscribed "AV. d 13 July 1827 Niendel"
Kunsthalle, Hamburg. 1159
Reference: Krafft, p. 352.

The expanse of hilly countryside is punctuated by the rows of trees and hedges typical of the region's enclosures, with the result that the eye experiences the depth of the image stepwise, moving into the distance from one strip of meadowland to the next. The foreground remains indeterminate.

70

KARL WAGNER

At the City Wall of Rome plate, p.99

1823. Oil on paper, 12¹/₈ x 17¹/₁₆" (31.7 x 43.4 cm)
Inscribed "Rom d. 12. Febr. 23."
Kunsthalle, Bremen. 424–1934/5
Reference: Gerkens, p. 352.

This sketch is a perfect example of the Biedermeier artist's discovery of the random, the incidental: an agave sprouting at an angle among the brushwood on an old, crumbling wall is depicted with all the care of a portrait. The wall and tower themselves are merely sketched in briefly in order to provide a backdrop for the foreground.

71

FERDINAND GEORG WALDMÜLLER

Portrait of Joseph Noé plate, p.102

1821. Oil on canvas, 23 x 18⁵/₁₆" (58.5 x 46.5 cm)
Inscribed "Waldmüller 1821"
Kunsthalle, Bremen. 645–1954/15
References: Grimschitz, no. 77; Maria Buchsbaum, *Ferdinand Georg Waldmüller* (Salzburg, 1976), fig. 16.

72

74

JOHANN EDUARD WOLFF plate, p. 99

Susanne Schinkel and her Daughter

C. 1826. Oil on canvas, 24 x 20¹/₂" (61 x 52 cm)
Staatliche Schlösser und Gärten, Berlin.
GKI 30135
Reference: Börsch-Supan, 1982, p. 39.

The wife of the great architect is shown here in a completely natural pose with her daughter Elisabeth; both gaze candidly at the viewer. Although the girl leans against her mother, there is nothing anecdotal about the image, which remains a straightforward, objective double portrait.

The unfinished painting reveals the artist's characteristic touch with particular clarity.

75

SEVERIN BUEMANN plate, p. 105

Interior of the Theater in Leopoldstadt

1832. Etching, 6⁷/₈ x 9⁷/₈" (17.5 x 25 cm)
Inscribed "Buemann del. et. sc."
Collection Prof. Dr. Hellmuth Matiasek

The playwright Ferdinand Raimund was associated from 1817 with the theater in Vienna's Leopoldstadt district (opened in 1781), initially as an actor, then as producer, and finally, from 1828 to 1830, as its "artistic director." Almost all his plays had their premieres there.

This etching from the sixth volume of the *Gallerie interessanter und drolliger Scenen* (Gallery of Interesting and Amusing Scenes) shows the theater's auditorium after its renovation.

76

GIUSEPPE QUAGLIO plate, p. 104

Set Design for Poissl's *Prinzessin von Provence*

1825. Watercolor on paper, 11⁹/₁₆ x 15¹/₄"
(29.3 x 38.8 cm)
Deutsches Theatermuseum (formerly Clara Ziegler Stiftung), Munich. Quaglio Collection 543

For the reopening of the National Theater, Munich, on January 2, 1825 (see no. 168), Royal Theater Director Johann Nepomuk Freiherr von Poissl composed *The Princess of Provence*. The present design for a "fantastic hall" was never executed.

Waldmüller's many talents included an outstanding one for portraiture. The nature of this portrait would seem to indicate that the artist was a friend of the sitter. Owing to the immediacy of the mobile features, and to a vitality that is emphasized by shifting the figure slightly off axis and depicting the shoulders asymmetrically, the image seems veritably to leap out of the frame.

Noé, living in Vienna in 1821, was later French cultural attaché in Munich.

72

FERDINAND GEORG WALDMÜLLER

The Alpine Cottage on Hoisernradalm

1834. Oil on panel, 12⁵/₁₆ x 10¹/₄" (31.3 x 26 cm)
Inscribed "Waldmüller 1834"
Museen der Stadt Wien, Vienna. 10.130

References: Grimschitz, no. 382; *Bürgersinn und Aufbegehren*, cat. no. 5/1/40.

A deserted plateau occupies the foreground – more than a quarter of the image. It is brightly illuminated, as is the cottage at the left, and behind it the terrain presumably falls off sharply into a canyon. Perspective depth is terminated by a steep mountain range, leaving a strip of sky at the top whose area approximately corresponds to that of the foreground.

Although the rough brushwork would seem out of keeping with the objectivity of the depiction, it perfectly conveys the awesome majesty of the scene.

73

FRIEDRICH WASMANN

Girl's Head in Lost Profile

C. 1831/32. Oil on paper, 13 x 9³/₄" (33 x 24.8 cm)
Staatliche Kunstsammlungen, Kassel. AZ 4462

Wasmann, who moved to Meran in 1830 for health reasons, depicted the surrounding countryside and its inhabitants in numerous rapidly executed sketches. His interest often concentrated on such details as the elaborate coiffures of the farmwomen of South Tyrol, which he drew and painted time and again (see Peter Nathan, *Friedrich Wasmann* [Munich, 1954], nos. 439, 472).

77

KARL FRIEDRICH SCHINKEL plate, p. 103

Set Design for Rossini's *Otello*

1821. Aquatint, 11⅛ x 15⅝" (28.3 x 39.7 cm)
Inscribed "Schinkel del; Thiele sc."
Deutsches Theatermuseum (formerly Clara Ziegler
Stiftung), Munich. Koester Collection 544

In his view of a Venetian port for Rossini's opera *Otello* (premiered in Naples in 1816), Schinkel transposed his architectural ideas into exotic terms. The design was included in *Sammlung von Theater-Dekorationen: Erfunden von Carl Friedrich Schinkel* (Collection of Stage Designs: Invented by Carl Friedrich Schinkel), published in installments by Ludwig Wilhelm Wittich between 1819 and 1824.

Before accepting a position as Royal Scene Painter in 1815, Schinkel earned his living by executing illusionistic backdrops for the theater of Ferdinand Gropius. These views of foreign cities, landmarks, or sensational events measured up to a hundred feet in length.

78

KARL FRIEDRICH SCHINKEL plate, p. 103

Set Design for Spontini's *Olympia*

1821. Aquatint, 16¼ x 20⅞" (41.2 x 53 cm)
Inscribed "Schinkel del.; Jügel sc."
Deutsches Theatermuseum (formerly Clara Ziegler
Stiftung), Munich. 554 St. O.

Reference: Schöne, cat. no. 121.

Immediately after his appointment as conductor in Berlin in 1820, Spontini began work on a German version of his opera on the antique subject of Olympia. The libretto was translated by E. T. A. Hoffmann and the sets designed by Schinkel. The premiere on May 14, 1821, was a resounding success.

In 1813 Schinkel had published a memorandum suggesting reforms in theater construction and scenery in an attempt to arouse "true and ideal illusion" in the audience.

79

JOHANN CHRISTIAN SCHOELLER plate, p. 105

A Scene from Ferdinand Raimund's *Der Alpenkönig und der Menschenfeind*

1829. Steel engraving, colored, 8⁷⁄₁₆ x 10¹³⁄₁₆"
(21.4 x 27.5 cm)
Inscribed "Schoeller del.; Zinke sc."
Deutsches Theatermuseum (formerly Clara Ziegler
Stiftung), Munich. IV 3353

Raimund's fairy-tale play *The Alpine King and the Misanthrope*, premiered in October 1828 at the theater in Vienna's Leopoldstadt district, was an unprecedented success. This engraving, which appeared in the third volume of *Gallerie interessanter und drolliger Scenen* (Gallery of Interesting and Amusing Scenes), shows the scene in which the charcoal burner's family bid farewell to their home in a song that soon became famous.

73

Sculpture

80

JOSEF MARIA CHRISTEN plate, p. 164

Bust of an Unidentified Lady of Bern

1816/18. Terra-cotta, height 15¹⁵/₁₆" (40.5 cm)
Öffentliche Kunstsammlung, Kunstmuseum, Basel.
P 37
Reference: *Öffentliche Kunstsammlung, p. 38.*

The young woman with a coiffure typical of the period (see also no. 82) gazes calmly before her in a manner so personal that we may assume it was indeed highly characteristic of the sitter. Despite the fact that the iris is not indicated (usually the case in Biedermeier sculpture), an immediate relationship is established with the viewer, who is thus induced to concentrate on the front view of the piece. Tradition stipulated classical Roman costume, but here it is merely hinted at.

81

JOSEF MARIA CHRISTEN

Calliope

1824. Tinted plaster, height 10¹/₂ (26.7 cm)
Bayerisches Nationalmuseum, Munich. R 6332
References: Peter Volk, "Ein silberner Tafelauf-satz für König Maximilian I. von Bayern," *Pantheon,* 33 (1975), p. 142, cat. no. M 4; Lorenz Seelig, *Modell und Ausführung in der Metallkunst* (Munich, 1989), p. 49.

In 1823 King Maximilian I Joseph of Bavaria commissioned a large centerpiece for a dining table from Ludwig Schwanthaler and Josef Maria Christen, a Swiss sculptor then active in Munich. Among other things, Christen modeled twelve figurines to top the elaborate silver candelabras, a series of three goddesses and nine Muses to which this Calliope belonged. The models were immediately acclaimed, yet the project could not be completed on account of the king's death.

82

JOHANN HEINRICH DANNECKER

Bust of Frau Emilie Pistorius plate, p. 166

1816. Marble, height 27³/₈" (69.5 cm)
Württembergisches Landesmuseum, Stuttgart.
1966–332
Reference: Christian von Holst, *Johann Heinrich Dannecker, der Bildhauer,* exhibition catalogue (Stuttgart, 1987), cat. no. 142 b.

In spite of the detailed naturalistic treatment of the features and perfect surface finish, the sculptor has rendered his sitter with a certain detachment. Middle-class modesty has precluded any show of emotion or agitation, and this was to become the predominant trait of the Neoclassical bust in the Biedermeier period. The fact that this middle-class woman is not dressed in the fashion of the day becomes apparent only on longer scrutiny.

Emilie Pistorius, née Feuerlein, was known primarily for her efforts, together with her husband, to improve education and establish kindergartens in the southwest German kingdom of Württemberg.

83

XAVER HEUBERGER plate, p. 166

Half-Figure Portraits of Three Children

1831. Wax relief on slate, diameter 4³/₈" (11.2 cm)
Germanisches Nationalmuseum, Nuremberg.
PL 2193
References: *Anzeiger des Germanischen National-museums* (1912), p. 31; Reinhard Büll, *Vom Wachs,* vol. 1 (Frankfurt, 1953), essay 7/2, p. 488.

The three siblings are rendered with naturalistic fidelity, even down to the tiniest details of the clothing. The group is skillfully composed within the roundel, and the problem of the "severed" bust has been solved by a piece of fabric draped around the bottom of the three figures. Made as souvenirs of a certain time in the sitters' lives, wax images of this kind represent important documents of the period and its life-style.

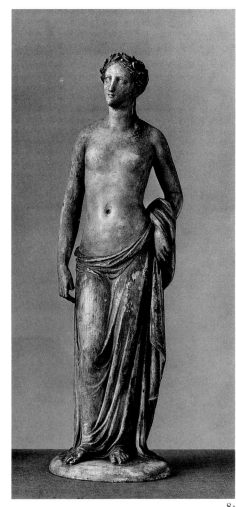

81

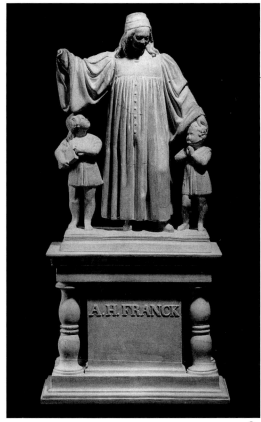

84

84

CHRISTIAN DANIEL RAUCH

Model for the Francke Monument in Halle

1825. Plaster, height 20¹/₁₆" (56 cm)
Inscribed "A. H. FRANCK"
Staatliche Museen Preussischer Kulturbesitz,
Skulpturengalerie, Berlin. Mold no. 5000/59

References: *Schorns Kunst-Blatt,* 8 (1827), p. 10;
F. Hesekiel, *Aktenmässiger Bericht über das dem
Gründer des Halleschen Waisenhauses A. H.
Francke errichtete Denkmal* (Halle, 1830); Fried-
rich and Karl Eggers, *Christian Daniel Rauch,*
vol. 2 (Berlin, 1878), pp. 347–54; Jochen Kleinert,
"Christian Daniel Rauch und das bürgerliche
Standbild: Ein Beitrag zur Entstehung des
Francke-Denkmals," *Beiträge der Winckelmann-
Gesellschaft,* 10 (1980), pp. 77–83.

August Hermann Francke, theologian and
philologist, became professor at the University
of Halle in 1692. He exerted great influence on
the development of education, establishing the
Francke Foundation in Halle, which included
an orphanage and high school (*gymnasium*), a
school for the poor, and a free school.

Honoring an important man of the middle-
class in the form of a monument represented a
new type of sculptural task that was soon to
involve an unexpectedly large number of
works. In the wake of Schadow's monument to
Luther (erected 1821; see no.87), Rauch
created the most significant early examples of
this genre with his Francke and Dürer monu-
ments (erected 1829 and 1840, respectively).

Francke is represented as a protector and
educator of children, but without resorting
either to the storytelling of a genre scene or to
allusions to medieval personifications of schol-
arship. The sculptor has depicted him simply as
a friend of children who has won their love and
respect.

The model was exhibited in Berlin in 1826,
Rauch having finished it within eight days of
receiving the commission. The pedestal is
based on a design by Schinkel. (See also p. 23).

85

CHRISTIAN DANIEL RAUCH

Model for the Monument to King Maximilian I Joseph in Munich

1825–26. Tinted plaster, height 44¹/₂" (112.5 cm)
*Inscribed "MAX IOSEPHO / REGI BAVARIAE / CIVES
MONACENSES / MDCCCXXIV"*
Staatliche Museen Preussischer Kulturbesitz,
*Skulpturengalerie, Berlin (formerly Rauch
Museum). Mold no. 5000/58*

References: *Schorns Kunst-Blatt,* 8 (1827), p. 11;
Friedrich and Karl Eggers, *Christian Daniel
Rauch,* vol. 2 (Berlin, 1878), pp. 358–91; Eschen-
burg, p. 28 f.

In 1820 the Magistrate of the City of Munich
decided to honor the first king of Bavaria with
a monument. Klenze immediately began
developing ideas for it and suggested Max-
Joseph-Platz as a site. In 1823–24 he submit-
ted various designs, all of them with a seated
figure. In October 1825, after Ludwig I had

succeeded to the throne, Rauch received the
commission for the monument. He brought the
bozzetto for the seated figure to Munich in
April 1826, where he collaborated with Klenze
on the design of the pedestal. From the result-
ing clay model a plaster cast was made and
shown at the Berlin Academy exhibition in
1826. Rauch altered the pedestal in 1827, this
time with the aid of Schinkel, inserting a
female figure between the two lions on each
side (figs. 33, 34, p. 24). By September 1830 the
monument was ready for casting in bronze, the
first project to be undertaken by the recently
established Stiglmaier foundry. On October 13,
1835, the monument was finally unveiled with
great ceremony. (See also p. 23 f.)

86

CHRISTIAN DANIEL RAUCH

General Friedrich Wilhelm von Bülow

C. 1825. Cast iron, height 21" (53.4 cm)
*Inscribed "FRIEDRICH WILHELM III / DEM GEN. GRAF
BÜLOW / VON DENNEWITZ. / IM JAHRE 1822"*
Staatliche Schlösser und Gärten, Berlin. Ks IV/189

Reference: Arenhövel, 1982, cat. no. 207.

From 1819 to 1822 Rauch created a number of
monuments in Berlin to Prussian generals who
had distinguished themselves in the Napo-
leonic Wars, including Bülow. The model for
this small replica, by August Kiss, was cast in
the Royal Prussian Iron Foundries in both Ber-
lin and Gleiwitz.

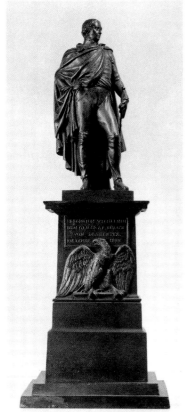

86

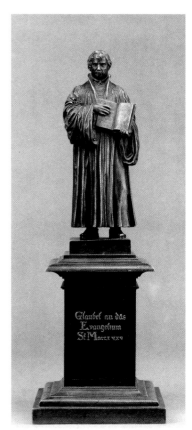

87

The position of the right arm, with hand resting on hip, causes the cape falling over the general's shoulder to form a frame and foil for the figure. The resulting extension into the plane is underscored by the position of the head, which is turned to one side; indeed, the entire monument is designed in terms of frontality alone.

87

JOHANN GOTTFRIED SCHADOW

Martin Luther

After 1821. Bronze, height 16½" (42 cm)
Inscribed "Glaubet an das / Evangelium / St. Marc.
IV.XV"
Staatliche Museen Preussischer Kulturbesitz,
Nationalgalerie, Berlin. NG 12/54

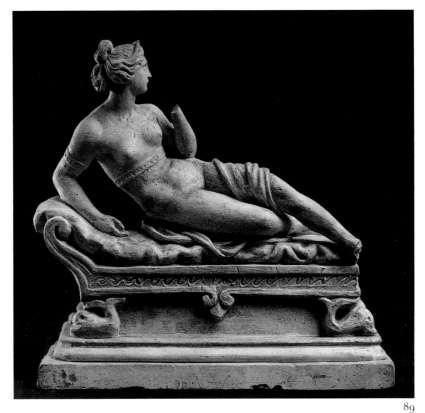

References: Johann Gottfried Schadow,
Kunstwerke und Kunstansichten (Berlin, 1987),
pp. 69–73, 137–41, 463 f., 609–12; Fritz
Bellmann, Marie-Luise Harksen, and Roland
Werner, *Die Denkmale der Lutherstadt Wittenberg*
(Weimar, 1979), pp. 47, 214.

In 1801 the Vaterländisch-literarische Gesellschaft (Patriotic Literary Society) issued a proclamation in the County of Mansfeld calling for the erection of a Luther monument. In 1804 they appealed directly to the king of Prussia, who entrusted Schadow with the planning. Schadow traveled to the various places where Luther had been active, examined all the portraits he could find, and, in 1817, submitted a design based largely on the ledger of Luther's

grave in Jena. He was not able to model the statue until 1819; in early 1821 the cast was finished and, in October of that year, the monument was unveiled in Wittenberg, having been fitted with a cast-iron baldachin designed by Schinkel.

With this statue of Luther standing calmly and looking straight in front of him, Schadow created a draped figure that was characteristically Biedermeier in its emphasis on the front plane. Schinkel, however, thought it "overloaded with too many little folds."

Small-scale reproductions of large sculptures had been popular since the Renaissance. Such replicas of the Luther sculpture, in somewhat simplified form, were also cast in iron in Gleiwitz and at the Carlshütte foundry.

88

JOHANN GOTTFRIED SCHADOW

Bust of Julius Schadow plate, p. 164

1827. Plaster, height 14³⁄₁₆" (36 cm)
Staatliche Museen Preussischer Kulturbesitz,
Nationalgalerie, Berlin. NG 2/63

Reference: Hans Mackowsky, *Die Bildwerke*
Gottfried Schadows (Berlin, 1951), no. 288.

Despite the intense gaze, this realistic representation of Schadow's three-year-old son has something detached and static about it. This plaster original reveals the master's touch, especially in the modeling of the hair.

Julius Schadow was one of the sons from the sculptor's second marriage.

89

LUDWIG SCHWANTHALER

Reclining Venus

C. 1830. Plaster, height 10¼" (26 cm)
Bayerisches Nationalmuseum, Munich. R 7791 a

Reference: Frank Otten, *Ludwig Michael*
Schwanthaler (Munich, 1970), p. 152, fig. 308.

The most significant member of a large family of Upper Austrian and Munich sculptors, Ludwig Schwanthaler had established his reputation by the late 1830s and received many important commissions. His was a highly original talent and he was most prolific, producing an enormous oeuvre (most of which, sadly, was destroyed in World War II). This *bozzetto* of Venus reclining on a chaise longue is a delightful small-scale translation of the austerely Neoclassical, much acclaimed marble sculpture by Antonio Canova representing Paolina Borghese as Venus (1804/08).

90

BERTEL THORVALDSEN

Mother and Child

1820–21. Plaster, height 12¹¹⁄₁₆" (32.3 cm)
Thorvaldsens Museum, Copenhagen. A 77

References: Sigurd Schultz, "Thorvaldsen og Vor Frue Kirk," *Danmarks Kirker*, vol. 2 (Copenhagen, 1949), p. 209 f.; *Thorvaldsen: Drawings and Bozzetti*, exhibition catalogue (London, Heim Gallery, 1973), cat. no. 86.

This is a study for a group in the pediment of the Church of Our Lady in Copenhagen (see fig. 15, p. 16). The *bozzetti* for all the figures in this project, preserved in Thorvaldsens Museum, provided the basis for the full-size clay figures modeled in 1821–22. For the execution in marble, which was not carried out until 1878, durable plaster casts were required, and these, the real originals, may be seen in the same museum.

Thorvaldsen has given the mother the features of Vittoria Caldoni, of whom he modeled a bust in 1821. The beautiful daughter of a vintner had been brought to Rome the year before by August Kestner, and soon she was modeling for almost all the artists in the foreign colony there.

91

BERTEL THORVALDSEN

The Genii of Life and Death

1825 or winter 1826/27. Plaster, height 16⁵⁄₁₆"
(41.4 cm)
Thorvaldsens Museum, Copenhagen. A 157

References: Jørgen Birkedal Hartmann, *Thorvaldsen a Roma* (Rome, 1959), p. 11; *Thorvaldsen: Drawings and Bozzetti*, exhibition catalogue (London, Heim Gallery, 1973), cat. no. 90; J. B. Hartmann, *Antike Motive bei Thorvaldsen* (Tübingen, 1979), pp. 58 f., 119 f.

This was Thorvaldsen's first study in the round for the right-hand group on the tomb of the Duke of Leuchtenberg in St. Michael's Church, Munich. The artist drew inspiration from the Ildefonso Group, one of the most famous antiquities at the time.

The genie of death holding an inverted, guttering torch, a common motif in ancient Roman sculpture, was revived during the Renaissance and again in the Neoclassical era, by such sculptors as Antonio Canova and Philipp Jakob Scheffauer.

The life-size group was modeled in 1827 by Thorvaldsen's closest collaborator, Pietro Tenerani, who also executed the marble version, completing it in 1830.

92

CHRISTIAN FRIEDRICH TIECK plate, p. 167

Bust of Crown Princess Elisabeth of Prussia

1824. Bronze, height 25³/₁₆″ (64 cm)
Inscribed "Sans Souci 5. August 1824, F. Tieck fec."
(reverse), "ELISABETH KRONPRINZESSIN VON PREUS-
SEN" (on bust)
Staatliche Schlösser und Gärten, Berlin. KS III/115

Reference: Börsch-Supan, 1978, no. 47.

Elisabeth Ludovika of Bavaria, daughter of King Maximilian I Joseph, was married in 1823 to Crown Prince Friedrich Wilhelm (IV) of

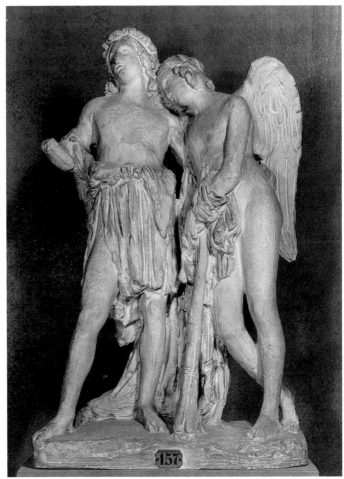

91

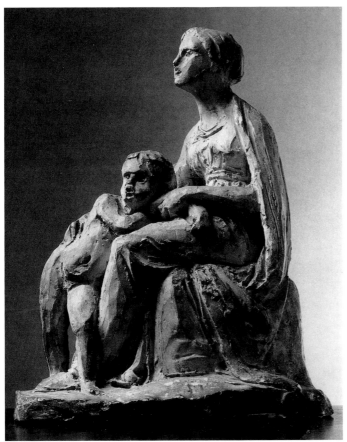

90

Prussia. Tieck's bust, created just under a year after the marriage, conveys all the natural charm of the 23-year-old woman, with her thoughtfully intent features and fashionable coiffure. Her self-absorption is expressed with eloquent mastery, and quite without the self-consciously antique air often found in Neoclassicism. As Börsch-Supan has noted, "The swelling plasticity with which the forms of the face are sharply and clearly defined can be seen as the expression of both mental and physical magnetism."

93

KONRAD WEITBRECHT

Boy Learning a Lesson plate, p. 167

C. 1825. Marble, 7⁷/₈ x 5⁷/₈″ (20 x 15 cm)
Inscribed "F. WEITBRECHT"
Staatsgalerie, Stuttgart. P 736

Classical influences can still be detected in this relief, particularly as the figure is rendered in the nude, yet the realistic depiction of the boy's schoolbag immediately establishes a reference to the contemporary world. The boy is quietly meditating on something he has read; no action is to be expected. The relief was also cast in iron at the Wasseralfingen foundry in Württemberg.

94

SOUTHERN GERMANY

Vitrine

plate, p. 106

*C. 1815. Walnut, carcase pine and spruce, bronze,
gilded, and glass, 71¼ x 44⅝ x 22″ (181 x 113.5 x
56 cm)
Private collection, Munich*

The vitrine, a very popular piece of furniture in
the Biedermeier period, was used to display
treasured objects – fine glassware, painted
cups, presentation pieces of silver. The Neo-
classical design of this piece is governed by
cabinetmaking techniques: plain blocks for the
base and impost of the columns, and applied
moldings for the pediment. A special feature –
and proof of the craftsman's skill – is the convex
front with arched opening, which is articulated
by finely arranged bars. Surface ornament is
provided solely by the grain patterns of the wal-
nut veneer.

95

VIENNA

Vitrine

*C. 1820. Walnut, carcase spruce, and glass,
65⅛ x 44⅞ x 18⅞″ (165.5 x 114 x 48 cm)
Bundesmobiliensammlungen, Vienna. Ef 13*

Apart from the high base with drawer, the piece
consists entirely of a graceful framework with
inserted glass panes that permit the objects dis-
played on its shelves to be seen from every
angle. Its quality lies in superb construction
combined with fine, variously treated walnut
veneer.

96

MARK BRANDENBURG

Bureau-Cabinet

plate, p. 106

*C. 1815/20. Birch, carcase pine, and bronze, gilded,
57⅞ x 36¼ x 19⅞″ (147 x 92 x 50.5 cm)
Private collection*

The upward-tapering piece is articulated by
means of a series of superimposed rectangular
slabs and ornamented by a large, inset arched
panel, smaller black recesses, gilded fittings, a
gilded leaf-molding beneath the extremely flat
pediment, and the vivid grain of the birchroot
veneer. It is a sign of rational planning that the
cabinetmaker executed a second version of the
piece, this time in mahogany (see *Weltkunst*, 57
[1987], p. 2250).

97

BERLIN

Bureau-Cabinet

*C. 1820. Mahogany, carcase pine, interior parts
oak, 73⅝ x 46½ x 21⅝″ (187 x 118 x 55 cm)
Collection Dr. G. Albert*

A simple outline, massive base, broad entabla-
ture, and tapering curved top lend this piece its
compact character. Its austere shape is under-
scored by the absence of metal fittings. Superb
craftsmanship, even in such nonvisible compo-
nents as the rabbeted drawer bottoms and the
frame-and-fill construction of the rear wall,
combined with a demonstration of special skill
in the curving doors in the top, indicate that the
piece was probably made for a master's certifi-
cate.

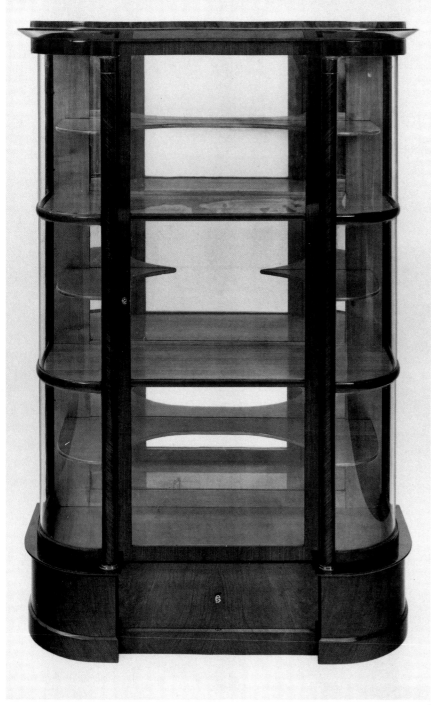

95



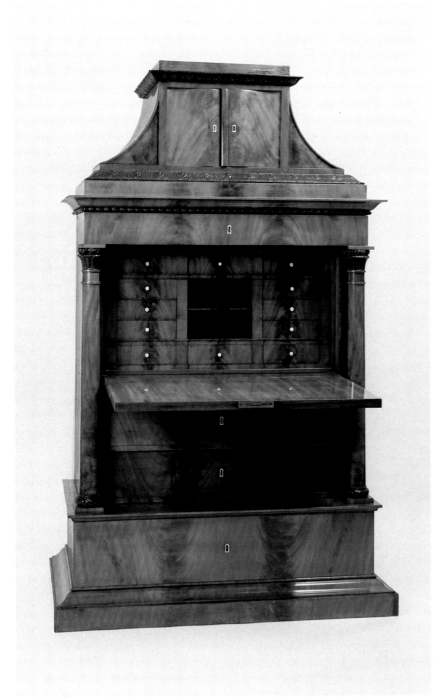

by the inscription. Made in the Bohemian town of Asch (Aš), which lies near the border with Franconia and Thuringia in Germany, it reveals more stylistic influence from these areas than from the capital, Vienna.

99
COPENHAGEN

Chest of Drawers

C. 1815. Birch, interior parts pine, 337/8 x 45 1/8 x 24 7/8" (86 x 114.5 x 63 cm)
Private collection

The front is articulated by drawers projecting or receding by little more than the thickness of a board. Columns with turned bases and capitals extend between the tall, square feet and the stepped top, beneath which a row of small corbels extends along the front. Lucid, simple forms, light birchwood, and the complete eschewal of metal fittings put Copenhagen pieces of this type among the most convincing and beautiful Biedermeier furniture made anywhere (see also no. 117).

100
MARK BRANDENBURG

Chest of Drawers plate, p. 108

C. 1815/20. Birch, interior parts pine, 331/8 x 421/8 x 22" (84 x 107 x 56 cm)
Private collection, Munich
Reference: Pressler, fig. 56.

The staining of the arched panel and of the ingenious chamfered edges, together with the black moldings, provide this piece with a restrained color scheme. Apart from these features, it has no ornamentation, let alone architectonic articulation; even the fact that it has three drawers is played down in the design. In such extreme simplification, the Biedermeier furniture made in the Mark Brandenburg went beyond the products of any other region.

98
ASCH, JOHANN FRIEDRICH WUNDERLICH

Bureau-Cabinet plate, p. 107

1826. Cherry, interior parts birch, maple, and walnut, gilded fittings, and ivory inlays, 84 5/8 x 47 1/4 x 22 1/2" (215 x 120 x 57 cm)
Inscribed "Angabe des ververtigers dießes meisterstückh oder Seckretaer. / Dieses Meisterstück hatt gemacht. / Johann Friedrich Wunderlich, ein Tischler, in Asch. / Den anfang 1tn Julieus 1825. biß den 12te Aprill. 1826. / mein Vatter ist Johannes Wunderlich. Schuhmacher Meister in Asch / oder der sogenante Haberschuster / auf dem Stein. No. 163. verfertiget bey Tischlermeister Gotthelf Martin / Gerstner in der Wirtengasse No 11. / Mein Alter war 22 1/2 Jahr / Verkauft habe ich dieses Stück

den 19te Feb: 1828 an Herrn Wunschheim [?] Doctor de Jure in Eger / vor 80 Preishische Taler / oder 144 fl Rhe." (First line, and last three, added at a later date.)
Glasgalerie Michael Kovacek, Vienna

This very tall bureau-cabinet has a sumptuous air despite its typically Biedermeier eschewal of architectonic detailing and rich ornamentation. Its dignity stems from balanced proportions, sensitive articulation of the surfaces, and outstandingly beautiful wood. More elaborate inlay work and a correspondingly richer color scheme are found in the interior. The importance of this extremely fine piece is increased

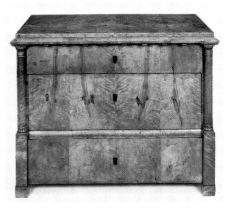

99

101

MUNICH

Chest of Drawers

*C. 1820. Walnut and poplar, stained green, carcase
spruce, and embossed brass fittings, 31 1/2 x 47 1/4 x
23 5/8" (80 x 120 x 60 cm)*
*Fürst Thurn und Taxis Kunstsammlungen,
Regensburg. St.E. 11465*

A pediment is suggested on the upper drawer in
a highly original manner, by means of contrast-
ing veneers. This is a particularly clear example
of the typically Biedermeier translation of
Neoclassical architectural elements into two-
dimensional ornament in wood. The gilded
bronze bases and capitals of the corner col-
umns, the alternation of walnut and curly root-
grain veneer, and the slightly projecting top,
with its black painted design, make this piece,
which was probably produced in a Munich
workshop, an especially fine specimen of
Biedermeier furniture.

102

MUNICH

Chest of Drawers plate, p. 108

C. 1825. Cherry, 33 5/8 x 46 1/2 x 22 5/8"
(85.5 x 118 x 57.5 cm)
Collection Rainer Klessen, Tokyo
Reference: Pressler, fig. 35.

The plain rectangular piece, with its small col-
umns, is enriched by the boldly painted frieze
on the projecting upper section and on the
sides. The top is flush with the body of the
piece, a characteristic feature of Bavarian
chests of drawers.

103

VIENNA

Desk plate, p. 111

*C. 1830. Cherry, mahogany inlays, interior parts
birch, carcase spruce, 41 3/8 x 64 3/4 x 28"*
(105 x 164.5 x 71 cm)
Private collection, Munich

The striking type of oval desk with top and
superstructure supported by two massive cylin-
ders was invented by the renowned Viennese
furnituremaker Josef Danhauser and soon
imitated by other Viennese masters. The imagi-
native design is enhanced by delightful inlaid
tendril decor and by outstanding craftsman-
ship throughout. Three drawers are concealed
in the top of each cylinder.

104

VIENNA, JOSEF DANHAUSER

Table plate, p. 110

C. 1820. Walnut, carcase spruce, 31 1/4 x 48 x 34 5/8"
(79.5 x 122 x 88 cm)
Private collection, Munich

Both large, round tables and smaller sofa tables
were popular pieces of furniture during the
Biedermeier period. Sofa tables could be
rectangular, sometimes with folding exten-
sions, or oval, usually with two legs and occa-
sionally with four. The umbrella-shaped legs of
this table and the original form of its floorpiece
would suggest that it was designed by Josef
Danhauser, who from 1814 ran an "Establish-
ment for All Objects of Furnishing" in Vienna
which, for the most part, manufactured pieces
of his own design.

105

VIENNA

Table plate, p. 111

*C. 1820. Mahogany and rosewood, partly gilded
and colored dark green; height 33 1/4" (84.5 cm),
diameter 26 3/4" (68 cm)*
Private collection, Munich

The figure of a kneeling, winged ephebe sup-
porting the top makes this piece less a utility
object than an autonomous work of art, a rare
thing in the Biedermeier period. The table was
apparently made by a cabinetmaker active in
Vienna who also produced two small globe
tables bearing all the typical Viennese charac-
teristics (see Martina Kirfel, in *Weltkunst*,
56 [1986], p. 3360).

The figure is based on classical representa-
tions of Atlas, a common feature in the fine and

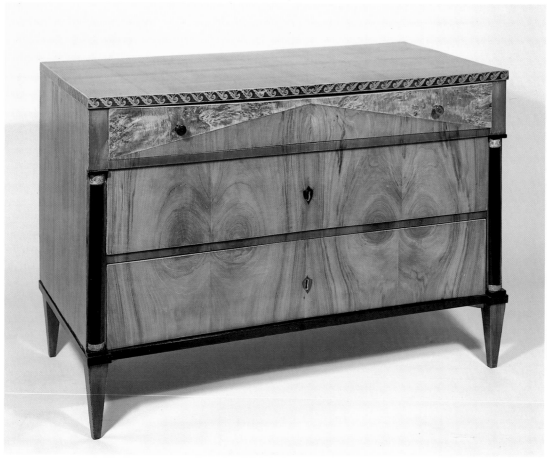

101

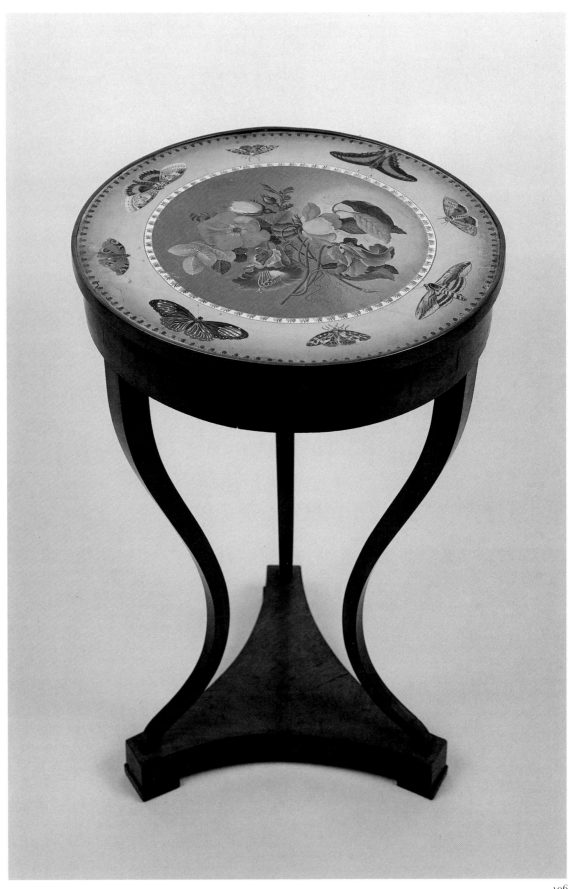

decorative arts since the Renaissance. The blackish-green patina was intended to imitate bronze.

The consummate skill of the craftsman is indicated by the graceful curve of the bowl shape that provides a transition from the top of the table, with its drawers, to the figure below.

106

SCHLESWIG-HOLSTEIN

Table

C. 1825. Mahogany, carcase pine; height 30⁵/₁₆″ (77 cm), diameter 18⁷/₈″ (48 cm)
Museum für Kunst und Kulturgeschichte der Hansestadt Lübeck, Lübeck. 1897–263

This table, with legs curving strongly inward, is notable for its top, which is painted with the greatest delicacy, probably by a gifted amateur. Another example of amateur work from the period is the tabletop decorated by Adele Schopenhauer, who showed it to Goethe in 1829 (H.H. Houben, *Die Rheingräfin* [Essen, 1935], p.55).

107

UPPER RHINE

Sewing Table

C. 1820. Walnut; height 28³/₄″ (73 cm), diameter 20¹/₂″ (52 cm)
Städtische Museen, Freiburg. 11143

This extremely rational design comprises seven circular elements, three quarter-arc supports, and a cylinder. It is a representative example of Biedermeier cabinetmakers' penchant for geometric forms and for the visible manifestation of construction principles.

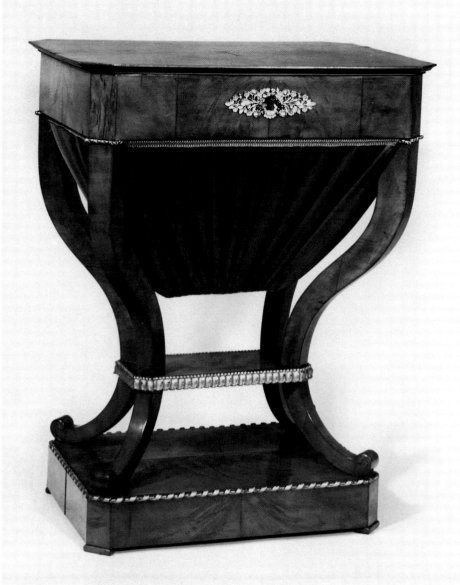

109

107

108

VIENNA

Globe Table plate, p. 110

C. 1820. Mahogany, walnut, and maple; height 37″ (94 cm), diameter 16¹/₂″ (42 cm)
Collection Dr. Schmitz-Avila

Globe tables were among the most finely crafted pieces made by Biedermeier cabinetmakers, involving considerable technical skill in the carving and joining of the two interpenetrating hemispheres. The mirror gloss of the surface indicates not only the master's devotion to his work, but also his love of the beautiful material. The gracefully curving legs seem pressed into the spherical top like the handles of a ceramic vessel. A special feature is the hexagonal central column which, rather than supporting the globe, is pointed to evoke a pivot.

109

SOUTHERN GERMANY

Sewing Table

C. 1825. Cherry, and gilded moldings, 31⁵/₁₆ x 24¹³/₁₆ x 18¹/₂″ (79.5 x 63 x 47 cm)
Fürst Thurn und Taxis Kunstsammlungen, Regensburg

Biedermeier women spent a great deal of time at their sewing tables, and the craftsmen of the period accordingly devoted considerable care to their design. The sharply curved legs of this piece stand on a pedestal which, like the gilded moldings, underscores its precious character. The sack underneath the top was used to store unfinished sewing.

BAVARIA

Etagère

C. 1815. Yew, birch, cherry, rosewood, and ash;
height 32¼" (82 cm), diameter 12¾" (32.5 cm)
Fürst Thurn und Taxis Kunstsammlungen,
Regensburg. St.E. 1313

A sensitive use of diverse woods, the marquetry
of the top, and the tiny slips of black wood that
transform the supports into columns, make this
simple stand a delightful piece of furniture.

VIENNA

Etagère

C. 1820. Walnut and cherry, 59⅞ x 35⅜ x 16⅜"
(152 x 90 x 41.5 cm)
Bundesmobiliensammlungen, Vienna. MD 033719

Light pieces of furniture were characteristic of
the Biedermeier period, and the *étagère* was
one of the most common types. Made in count-
less variants, such shelves were used to store
household items of all kinds, as well as sheet
music and books. This unornamented piece

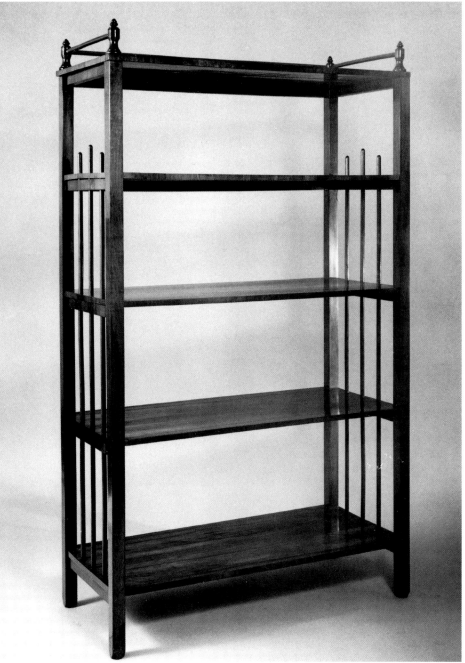

111

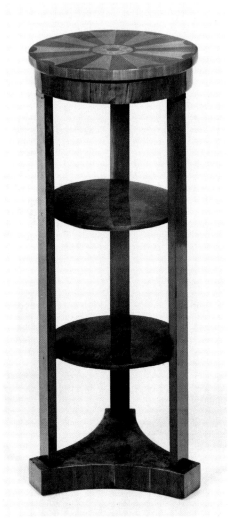

110

derives its special charm from the rods inserted
through the ends of the shelves and ending at
different heights below the top.

VIENNA

Sofa plate, p. 113

C. 1825. Mahogany and maple, carcase spruce,
42⅛ x 81⅛ x 24⅝" (107 x 206 x 62.5 cm)
Collection J. Schindele

Reference: Neumeister auction catalogue no. 224
(Munich, Oct. 17, 1984), cat. no. 468.

The imaginative form of the S-shaped legs,
which end in an abstract bird's head at the
frame, suggests that this piece was designed by
a follower of Josef Danhauser, the inventive
Viennese cabinetmaker. From this point it was
only a short step to the bentwood furniture
manufactured by Michael Thonet in Boppard
only a few years later. The upholstery of this
piece has been renewed.

113

VIENNA

Upholstered Chair

plate, p. 112

*C. 1815. Walnut; height 26³/₄″ (68 cm), width 21⁷/₈″
(55.5 cm)*
Bundesmobiliensammlungen, Vienna. L 6169

Chairs with a similarly curved, inclined back-
rest and round seat – sometimes even a re-
volving seat – emerged in the late eighteenth
century, but the legs of this piece, with their
curved ends, and the volute-shaped ends of the
back are characteristic of Biedermeier design.

114

SOUTHERN GERMANY

Desk Chair

*C. 1820. Walnut, maple, and birch,
36⁵/₈ x 25¹/₄ x 22¹/₂″ (93 x 64 x 57 cm)*
*Fürst Thurn und Taxis Kunstsammlungen,
Regensburg*

Folding chairs had been the prerogative of rul-
ers ever since classical antiquity. Neoclassical
designers adopted the form, but not its hierar-
chical function; nor were their chairs made to
be folded. Biedermeier cabinetmakers appa-
rently enjoyed the elastic, interweaving curves
of this type of furniture, which they frequently
fitted with an arched backrest.

115

VIENNA

Desk Chair

*C. 1825. Mahogany, carcase beech,
28¹/₈ x 23¹/₄ x 19¹/₄″ (71.5 x 59 x 49 cm)*
*Fürst Thurn und Taxis Kunstsammlungen,
Regensburg. St.E. 2326*

The sides of this chair consist of two superim-
posed ovals, the lower one halved, the upper
one three-quarters and terminating in an oval
backrest. These regular curves, together with
the square seat, lend the piece the appearance
of an engineering construction, to which the
turned rung provides a conscious contrast. The
red leather upholstery is original.

The chair comes from the estate of Maximi-
lian, Count Montgelas, and was part of the fur-
nishings of his residence Schloss Zaitzkofen in
Bavaria.

A similar chair is illustrated in *Moderne Ver-
gangenheit*, cat. no. 15.

116

VIENNA

Armchair

*C. 1825. Walnut, carcase beech, 34 x 22⁵/₈ x 21¹/₈″
(86.5 x 57.5 x 53.5 cm)*
*Fürst Thurn und Taxis Kunstsammlungen,
Regensburg. St.E. 9581*

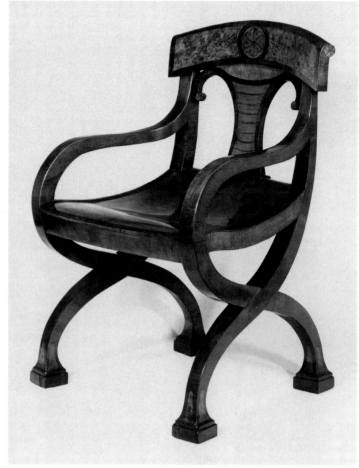

114

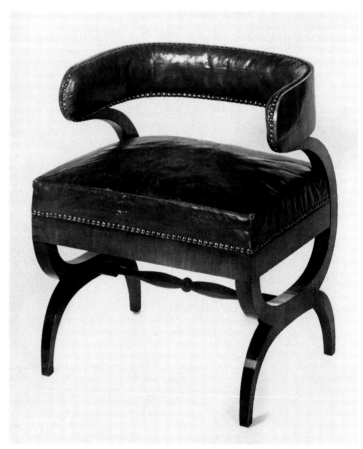

115

The rear legs continue without transition into the back, whose broad, flat arch leads in a graceful curve to the voluted arms. This type of armchair design was to remain extremely popular long after the Biedermeier period came to a close.

117

COPENHAGEN

Upholstered Chair

C. 1815. Birch, 30⁷/₈ x 18¹/₈ x 16¹/₈" (78.5 x 46 x 41 cm)
Den Hirschsprungske Samling, Copenhagen. 11

The elements of this plain chair have been reduced to what is technically necessary, its sole ornament being the simplified lily blossoms of the horizontal back brace. Light-colored birchwood underscores the cool austerity of the piece. The upholstery has been renewed.

118

SOUTHERN GERMANY

Upholstered Chair

C. 1820. Cherry, 33¹/₄ x 18¹/₈ x 17³/₄"
(84.5 x 46 x 45 cm)
Historisches Museum, Frankfurt. x 19791a

The curved backrest is a common feature of Biedermeier chairs, while the lyre and arrow – popular motifs that do not really belong together – show the extent to which individual decorative forms acquired a life of their own in the period. Additional decoration is provided on the chairback by *grisaille* painting, which resembles inlay work.

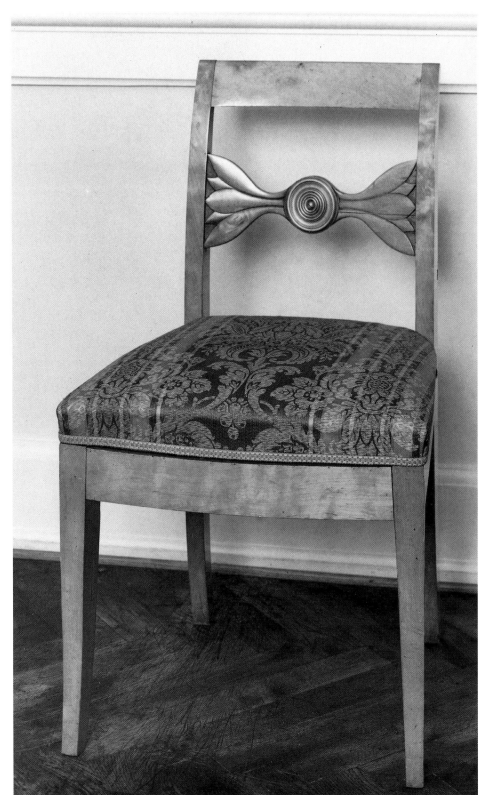

117

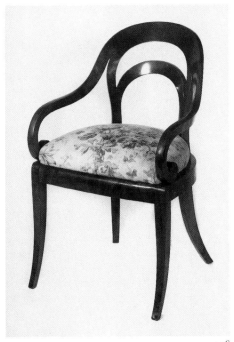

116

119

WESTPHALIA

Upholstered Chair plate, p. 112

C. 1825. Birch, 32⁵/₈ x 18¹/₈ x 19¹/₈" (83 x 46 x 48.5 cm)
Private collection, Munich

The lyre, a popular motif since the late eigh-
teenth century, is here reduced to a planar,
graphic ornament in the backrest, just as the
entire chair is reduced to the simplest basic ele-
ments. The upholstery has been renewed.

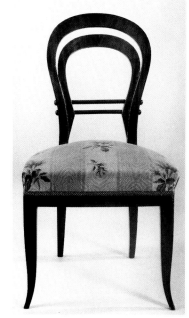

120

120

VIENNA, JOSEF DANHAUSER

Upholstered Chair

C. 1825. Mahogany, carcase beech,
36⁵/₈ x 19¹/₄ x 19¹/₈" (93 x 49 x 48.5 cm)
Bundesmobiliensammlungen, Vienna. L 6141

Reference: *Bürgersinn und Aufbegehren*, cat.
no. 8/4.

The back and the rear legs of the chair form a
unity, each leg continuing through the tall arch
of the back, between which is a smaller arch
held in place by two inserted rods. The aes-
thetic charm of the piece lies in its transparent
construction, anticipating the chairs of bent
beechwood made by Michael Thonet about
twenty years later.

 A drawing for this model exists in the Öster-
reichisches Museum für angewandte Kunst,
Vienna (see *Moderne Vergangenheit*, cat.
no. 138).

121

VIENNA

Upholstered Chair plate, p. 112

C. 1825. Walnut, carcase maple and spruce,
36¹/₄ x 17³/₄ x 20⁷/₈" (92 x 45 x 53 cm)
Kunsthandel Schlapka KG, Munich

The curved back found so frequently in Bieder-
meier chairs is here combined with a vase-
shaped baluster with painted fluting. The
special charm of the piece arises from a combi-
nation of strongly grained wood, illusionistic
painted decoration, and unusual outline. The
green leather upholstery is original.

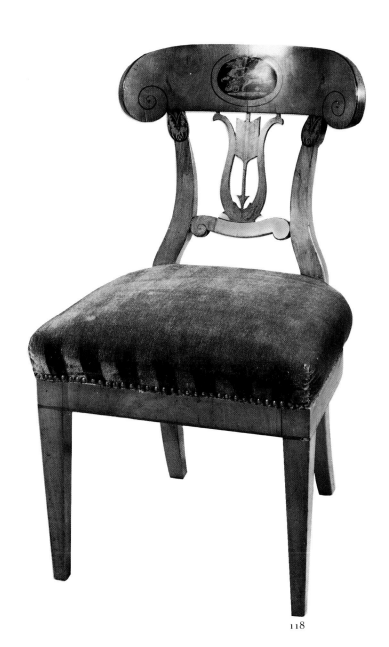

122

VIENNA

Upholstered Chair plate, p. 112

C. 1830. Walnut, carcase beech, 35¹/₄ x 17¹/₂ x 17¹/₂"
(89.5 x 44.5 x 44.5 cm)
Bundesmobiliensammlungen, Vienna.
MD 028 562

The back consists of a broad, flat, wide-flaring
twin volute whose ends rest on abstract bird's
heads. The upholstery has been renewed.

118

123

BASEL (?)

Children's Swing

C. 1820. Walnut, 51¹/₈ x 31¹/₈ x 25⁵/₈"
(130 x 79 x 65 cm)
Historisches Museum, Basel. 1902.105

How versatile the elements of Biedermeier furniture were may be seen from this indoor swing, whose frame resembles a fire screen (see no. 125). The supports of frame and swing are in the form of slender columns, like those found in more orthodox pieces of furniture of the time. The rounded wall of the seat is inset into the elongated plinths of the columns.

124

NETHERLANDS

Pole Screen plate, p. 109

C. 1815. Mahogany and beadwork embroidery,
height 50³/₈" (128 cm)
Stedelijk Museum "De Lakenhal," Leiden. 2713

The height of the oval screen, with its bead-work embroidery, can be adjusted to protect the user's head from the heat coming from a stove or fire. (For beadwork embroidery, see also nos. 137, 220, 260).

125

MUNICH, JOHANN GEORG HILTL

Fire Screen plate, p. 109

1821. Mahogany, maple, walnut, and silk, painted
and embroidered, 60⁵/₈ x 44¹/₄ x 8¹/₈"
(154 x 112.5 x 20.5 cm)
Inscribed "Verfertiget zu München in der hiltlischen
Meubel Fabrik", "Der höchsten / Huldin alles Gut-
ten und / Schönen, widmet ihre ersten / Versuche
des jugendlichen / Fleihses in allertiefster / Ehr-
furcht / Juliana Reuhs / Oberrechnungs Raths /
Tochter / München 1821."
Private collection

Although the elements of this piece recall the Empire style, the eschewal of gilded fittings and the use of woods of different colors guards against any heaviness in the forms. The black decoration was printed on the wood by a process perfected by Hiltl himself. The embroidery, framed like a picture, was evidently the work of an amateur, as the inscription on the reverse of the pediment confirms: "With the deepest devotion Juliana Reuhs, Senior Fiscal Councillor's daughter, dedicates the first results of her youthful endeavor to the highest protectress of all that is beautiful and true. Munich, 1821." In the corresponding position on the observe is a wreath containing a C made of stars. This alludes to Queen Caroline, wife of Maximilian 1 Joseph of Bavaria and dedicatee of the embroidery.

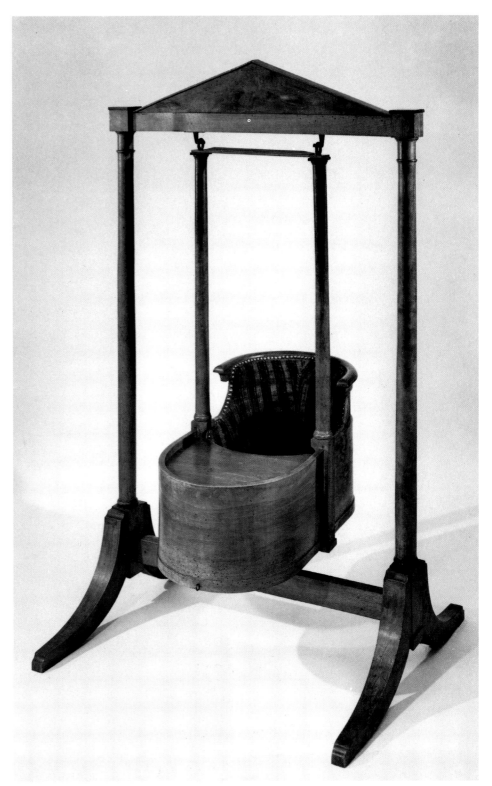

123

126

SOUTHERN GERMANY

Mirror

C. 1825. Cherry, partly stained black,
68⅞ x 20½ x 16" (175 x 52 x 40.5 cm)
Fürst Thurn und Taxis Kunstsammlungen,
Regensburg

Biedermeier cabinetmakers' penchant for (apparently) bent elements is well illustrated by the stand of this mirror, whose four rods, held together at two points by ring moldings and flaring outward at top and bottom, vaguely recall the responds in Gothic churches, which were also often bound to each other by moldings.

127

VIENNA

Clothes Stand

C. 1815. Walnut, 79⅞ x 23 x 10" (203 x 58.5 x 25.5 cm)
Fürst Thurn und Taxis Kunstsammlungen,
Regensburg. St.E. 12068

The beauty of this everyday object lies in the reduction of its design to what is absolutely necessary. Its origin in the Biedermeier period can be deduced only from such decorative details as the scroll ends of the tripod supports and the ball at the upper center.

128 plate, p. 110

NETHERLANDS

Portable Stove (*Teekomfoor*)

C. 1815. Mahogany, brass, and pewter, feet gilded;
height 18⅞" (48 cm), diameter 12⅝" (32 cm)
Stedelijk Museum "De Lakenhal," Leiden. 4010

The *teecomfoor* was an indispensable part of living room furnishings in the Netherlands, the coastal regions of Germany, and in Denmark. Produced with varying degrees of decoration, it was designed to hold a container in which hot coals were placed to keep the tea above warm. The wooden basket design was particularly popular; here it rests on three carved dolphins of the kind frequently found in Biedermeier furniture and metal objects.

129

VIENNA

Birdcage and Stand

C. 1825. Walnut, iron wire painted green, and brass
ring; height of stand 39⅛" (99.5 cm), height of cage
22½" (57 cm)
Bundesmobiliensammlungen, Vienna. MD 034116

The increased emphasis on the pleasures and comforts of the home during the Biedermeier period was accompanied by a desire to bring nature indoors, leading to a fashion for potted plants, cut flowers, and captive songbirds that was probably more widespread than at any time before or since. There was no living room, humble or grand, without its birdcage; the one illustrated here once stood in the Hofburg (Royal Palace) in Vienna.

130

BORNHOLM, N. ESPERSEN

Shelf Clock

C. 1815/20. Mahogany, height 26" (66 cm)
Inscribed "N. Espersen, Bornholm"
Det Danske Kunstindustrimuseum, Copenhagen.
A 30/1925

From its beginnings as a clockmaking center in the mid-eighteenth century, the Danish island of Bornholm in the Baltic Sea had produced cases of highly original design. That of the present clock, composed of regular geometric shapes, has, on the front, a *grisaille* painting of a pair of billing doves in an arched niche and a figure of Atlas supporting the celestial globe – the clockface. With its "masonry" base and conical roof, the cylindrical "tower" resembles a miniature lighthouse or, conversely, an enlarged chessman.

131

STUTTGART, FRIEDRICH BAADER

Table Clock plate, p. 115

C. 1820. Cherry, enamel, and bronze, gilded,
30¾ x 19⅛ x 8⅞" (78 x 48.5 x 22.5 cm)
Inscribed "Fried: Baader / in Stuttgart"
Stadtarchiv, Stuttgart. s 221 c

Reference: *Baden und Württemberg*, cat. no. 1006.

The clock is notable for its unusual, extremely precise works and for its case, a highly original design with heptagonal top and stained black ornamentation. This is the only known work by the clockmaker Baader.

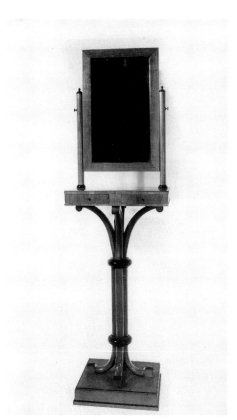

126

127

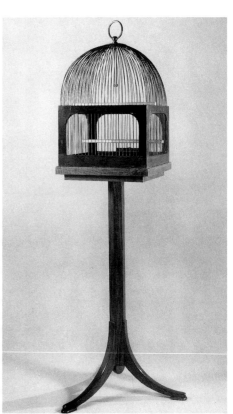

129

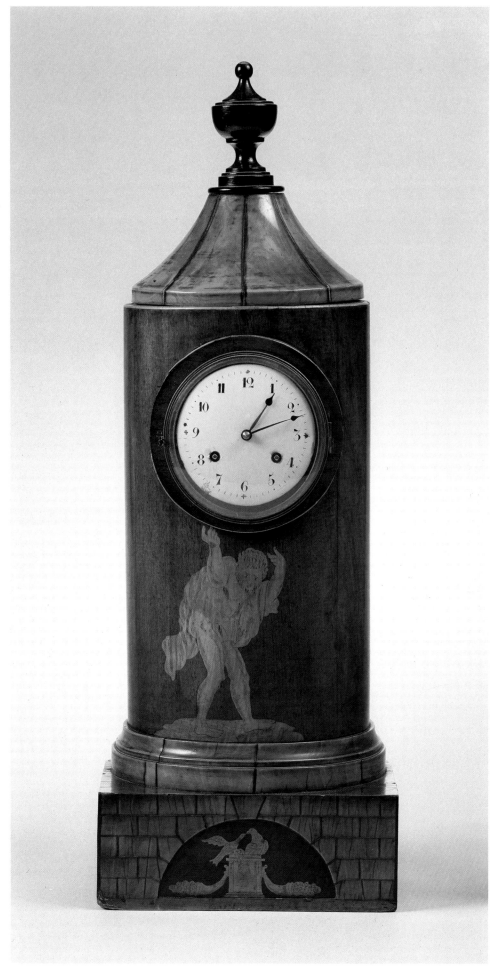

132

132

132

MUNICH, M. W. FIEGL

Table Lighter

*C. 1825. Bird's-eye maple, brass, and glass,
19¼ x 9⅝ x 9⅞" (49 x 24.5 x 25 cm)
Inscribed "M. W. FIEGL IN MÜNCHEN"
Deutsches Museum, Munich. 75679*

Invented at the end of the eighteenth century, "voltaic lighters" remained fashionable and in widespread use down to the 1870s and were especially popular during the Biedermeier period. Elaborately designed and manufactured in great numbers, these lighters were status symbols in middle-class homes.

When the cock is opened, hydrogen produced by the action of sulfuric acid on zinc in a glass vessel inside the lighter flows between the wires of a spark discharger and is ignited. The electric spark is produced with the aid of a "voltaic electrophore" – a flat cake of resin charged with static electricity by striking it repeatedly with a piece of cat's fur. By applying a metal cover an opposite charge can be induced which is then grounded through the spark discharger.

O.K.

133

AUSTRIA

Box

*C. 1815. Ash, 7⅞ x 5 x 5³⁄₁₆" (20 x 12.7 x 13.2 cm)
Museum Carolino Augusteum, Salzburg. 65/54*

Made in the form of a goblet, but rectangular, this small box is a superb piece of craftsmanship. It was probably intended to be displayed in a vitrine rather than to serve a practical purpose.

134

VIENNA

Box

*C. 1815. Walnut, mother-of-pearl, and steel,
2⁹⁄₁₆ x 3⁹⁄₁₆ x 1¹⁵⁄₁₆" (6.5 x 9 x 5 cm)
Private collection, Munich*

The delicate color scheme of this plain box is produced by the light hue of the whorled veneer, the darker edging, the laminated mother-of-pearl in the Neoclassical medallions, and the polished steel of the fittings. The handle design consists of a snake biting its own tail, a symbol of eternity commonly found on objects of the period that were intended as gifts of friendship or remembrance.

135

SOUTHERN GERMANY

Jewel Casket plate, p. 115

*C. 1825. Walnut, pearwood, stained black, birch, and brass, 9³⁄₁₆ x 6⁹⁄₁₉ x 4¾" (23.4 x 16.7 x 12 cm)
Private collection, Munich*

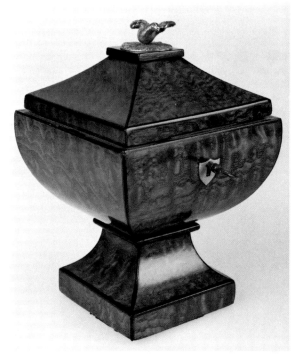

134

133

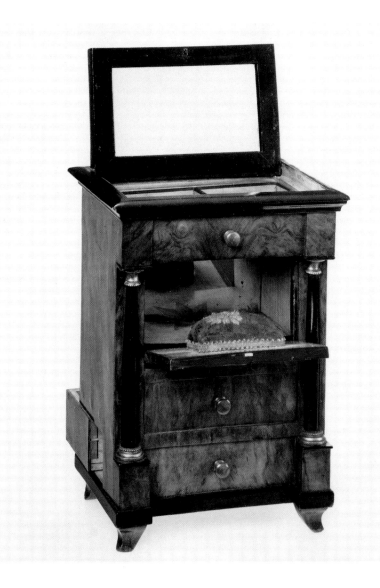

135

Cabinetmakers of all eras have enjoyed creating caskets in the form of miniature furniture, so this miniscule Biedermeier bureau-cabinet stands in a long tradition. The hinged desk board is fitted with a cushion for brooches and pins, and the top contains a mirror and compartments for rings. There is a secret drawer at the bottom which is accessible from the back of the casket.

136

SWITZERLAND

Sewing Box plate, p. 114

*C. 1830. Mahogany and brass, 3¹⁵/₁₆ x 7¹¹/₁₆ x 5¹/₈″
(10 x 19.5 x 13 cm)
Schweizerisches Landesmuseum, Zurich.* LM 13077

The form of a Roman sarcophagus is still detectable in this piece, which contains a wide range of original handiwork implements and accessories.

137

NORTHERN GERMANY

Needlework Box plate, p. 114

*C. 1835. Mahogany, paper, and glass,
2³/₄ x 8¹/₄ x 8¹/₄″ (7 x 21 x 21 cm)
Kunsthandel Schlapka KG, Munich*

The box houses numerous paper containers in two sizes which are decorated with embossed gilt paper borders and filled with glass beads of all kinds. Beadwork was a very popular pastime in the Biedermeier period, and a great number of different techniques were used (see nos. 124, 220, 260).

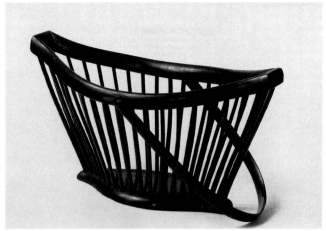

138

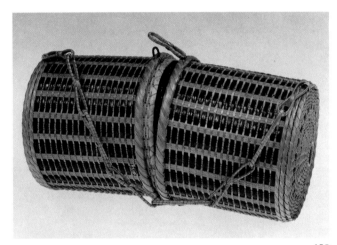

139

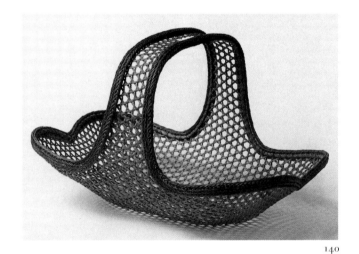

140

138

SOUTHWEST GERMANY

Wool Basket

C. 1820. Wood, stained black, 4³/₄ x 9" (12 x 23 cm)
Städtische Museen, Freiburg. 1640

A closely spaced grid of uprights connects the base of the basket with the multiple curves of its upper edge. Similar wooden baskets frequently formed an integral part of sewing tables in the Biedermeier period.

139

UPPER FRANCONIA

Wool Basket

1820/30. Wickerwork, length 7¹/₁₆" (18 cm)
Bayerisches Nationalmuseum, Munich. 85/106

The cylindrical basket is fitted with a chain for carrying over the arm, and has a hole in the top for extracting yarn during knitting. A pattern is created by the alternation of stained and unstained wicker.

140

SOUTHWEST GERMANY

Wool Basket

C. 1825. Wickerwork, 5¹/₂ x 9¹/₁₆" (14 x 23 cm)
Städtische Museen, Freiburg. 1641

Made of wide-meshed wicker, basket and handle are conceived as a single, continous form that curves on all sides.

141

ANSBACH

Milk Jug
plate p. 116

C. 1815. Porcelain, height 7¹¹/₁₆" (19.6 cm)
Marks: L (underglaze blue), No. 5. l. S. (inscribed)
Bayerische Verwaltung der staatlichen Schlösser,
Gärten und Seen, Munich. 1297 ANS

Reference: Martin Krieger, "Die Ansbach-Bruck-berger Porzellanfabrik des Christoph Friedrich Löwe," *Keramos*, 99 (1983), pp. 3–42, figs. 4b and 11.

The Ansbach Porcelain Factory, originally owned by the Margraves of Brandenburg, passed to the King of Prussia and then to the King of Bavaria, before becoming a private company in 1808. Among the few pieces to have survived from this period is a superb coffee and tea service, to which this jug belongs. The charming decoration depicts a scene from *Hermann und Dorothea* and is based on an illustration by Franz Ludwig Catel in the 1799 Vieweg edition of Goethe's epic. M. M.

142

BERLIN

Lidded Cup and Saucer
plate, p. 117

1814. Porcelain; a) cup, height 5⁹/₁₆" (14.1 cm) (with lid), b) saucer, diameter 6¹/₂" (16.6 cm)
Marks: Scepter (underglaze blue), O, II (inscribed)
Inscribed a) "Sich und seinen Nachkommen erbaute dieses Gartenhaus / Carl Philipp Möring, Kaufmann / im Jahre 1810 und 1811 zu Pankow. / Erfunden und erbaut von Zelter.", b) "Sich und seinen Nachkommen / erbaute dieses Orangerie-Haus / Carl Philipp Möring, Kaufmann / im Jahre 1814 und 1815 zu Pankow. / Erfunden und gebaut von L. Catel."
Berlin Museum, Berlin. KGK 66.7 a–c

Reference: Ponert, no. 83.

The respected and well-to-do Berlin businessman Carl Philipp Möring received this cup from his daughter as a Christmas gift in 1814. Detailed instructions for the decoration were provided, with particular importance attached to the two views of the park – the inscription proudly gives the names of the architects who designed and built the garden house and orangery depicted in them. Family pride is also expressed in the coat-of-arms, bearing the date 1609, on the saucer, while the animals represented in the four oval medallions symbolize four continents and thus allude to the Mörings' wide-ranging business connections.

"Outside town" parks and gardens played an important role in middle-class recreation during the Biedermeier period. H. W.

143

BERLIN
plate, p. 119

DECORATION: GOTTFRIED WILHELM VÖLKER (?)

Pieces from a Coffee and Tea Service

1817/23. Porcelain; a) tray, 14⁵/₈ x 11⁵/₁₈"
(37.2 x 29.5 cm), b) teapot, height 6³/₁₆" (16 cm),
c) creamer, height 5³/₁₆" (13.5 cm)
Marks: Scepter (underglaze blue), 12, 16, 24 (impressed)
Staatliche Schlösser und Gärten, Berlin. B 410, 411, 413

Reference: H. W. Lack and W. Baer, "Pflanzen aus Kew auf Porzellan aus Berlin," *Wildenowia*, 16 (1986), pp. 285–312.

Every piece in the service bears a botanically exact representation of plants in natural colors set off by partly etched gold decor. The names of the plants are painted on the undersides in black Roman lettering. Most of the plants depicted come from habitats outside Europe, especially Australia, whose plant species were known only from a few botanical gardens at that time. The majority were reproduced from the *Botanical Magazine*, edited by W. Curtis in London and published in numerous volumes from 1791 onward, and from *Andrews' Botanist's Repository* (1798). Of the twenty-nine plant names on the extant pieces of the service (besides those included here, another bowl and four plates, cups, and eggcups), twenty-four are found in the second edition of William T. Aiton's *Hortus Kewensis* (London, 1810–15).

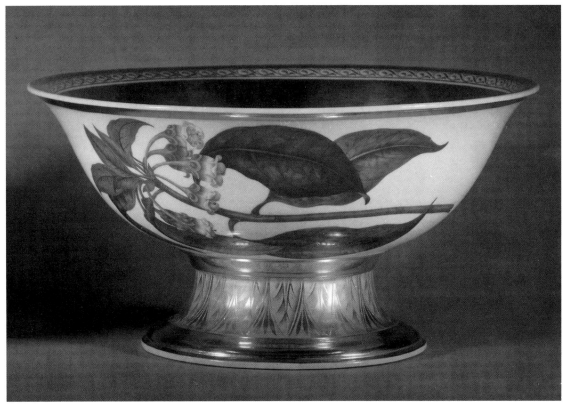

143

The plants include a large number named in honor of botanists who were closely associated with the British Empire. According to Lack, this indicates that the recipient was very probably either one of the leading English botanists of the period, perhaps Joseph Banks, or the Horticultural Society or the Linnean Society of London. The latest design in Curtis used for the service dates from 1817, which is thus a *terminus post quem* for its execution. The rarity and expense of the publications employed for the decor suggests that the service was commissioned by a connoisseur in the field, most likely Alexander von Humboldt. His brother, Wilhelm, went to London as Prussian ambassador in September 1817, and Alexander followed a month later. W. B.

The objects on display in vitrines in Biedermeier living rooms said much about their owners' social position and life-style. Cups played a particularly important part in this – status symbols whose decor reflected the interests and pleasures of the middle-class society of the time.

Painted decoration and inscriptions based on patterns supplied by the customer could be ordered from almost every factory. Thus, countless cups with references to family celebrations, lovingly conceived and often finely executed, were produced during the Biedermeier period, gifts that not only served as memorabilia but also upheld family tradition as they were passed down from generation to generation.

 H. W.

After Napoleon's defeat the Berlin Porcelain Factory received a number of commissions for elaborate services in honor of war heroes – above all, for the Duke of Wellington, but also for many Prussian generals. The same designs, with different decoration, were also made as royal gifts. On the occasion of their marriage in 1825, Prince Frederick of the Netherlands and Princess Luise of Prussia received a service bearing views of Berlin which was entered on July 9, 1825, in the *Conto-Buch des Königs von 1818–1850* as "a dining and dessert set for fifty places." The elaborate service, which originally comprised 528 pieces, included this cylindrical cooler. According to the *Conto-Buch*, it was one of a series of twelve "bottle holders with colored prospects on both sides, a polished gold ground, and colored flower festoons." The oval-shaped views in engraved gold frames were based on drawings done by Friedrich A. Calau about 1820. W. B.

144

BERLIN

Cup and Saucer plate, p. 117

1819. Porcelain; a) cup, height 3⁷/₁₆″ (8.8 cm), b) saucer, diameter 5³/₈″ (13.6 cm)
Marks: Scepter (underglaze blue), painter's mark (reddish brown), slash (brown)
Inscribed a) "Der liebevollsten Mutter geweiht von kindlicher Dankbarkeit", b) "Am 15. August 1819"
Private collection, Munich

Reference: Wellensiek, pp. 144f.

145

BERLIN

Wine Cooler plate, p. 118

1825. Porcelain; height 7¹¹/₁₆″ (19.5. cm), diameter 7¹/₁₆″ (18 cm)
Marks: Scepter (underglaze blue), painter's mark, 12 (impressed)
Inscribed "Die neue Wache in Berlin", "Monbijou in Berlin"
Staatliche Schlösser und Gärten, Berlin. KS VIII. 193 B, 2

Reference: Börsch-Supan, 1985, p. 52.

146

BERLIN

Breakfast Service plate, p. 116

1828. Porcelain; a) tray, 14¹/₂ × 11⁵/₁₆″ (36.8 × 28.7 cm), b) coffeepot, height 6⁷/₈″ (17.5 cm), c) cup, height 4⁵/₈″ (11.7 cm)
Marks: Scepter (underglaze blue), eagle above KPM Berlin Museum, Berlin. KGK 64/8–14

Reference: Ponert, no. 243.

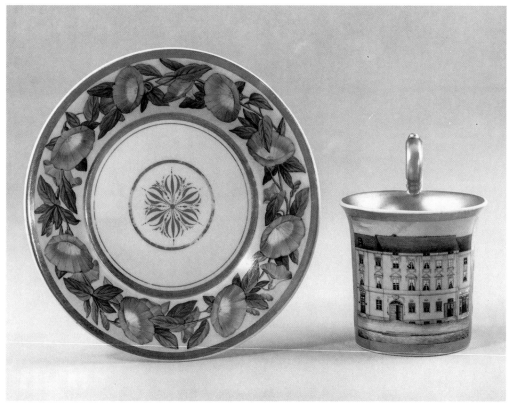

147

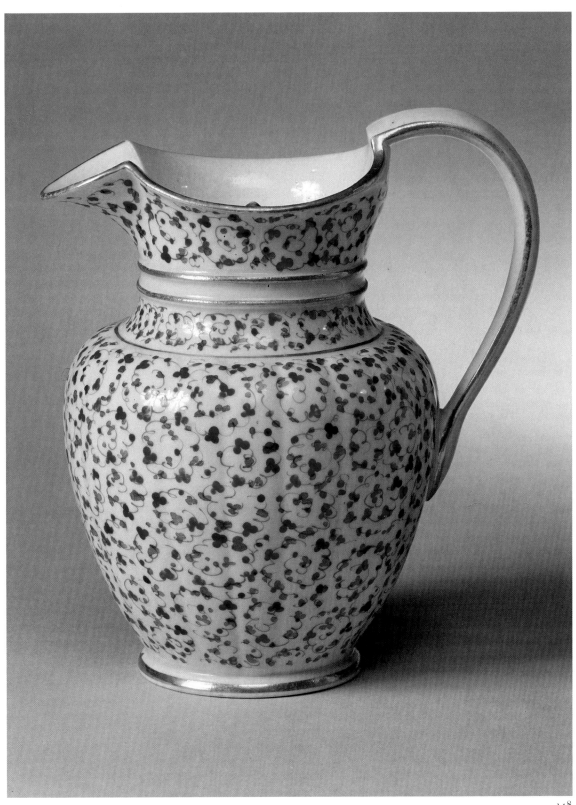

This *déjeuner* or *tête à tête* service comprises two cups, three pots, and a sugar bowl, all of which fit on a matching tray and are decorated with a laurel-wreath pattern. Each leaf bears the title of an opera and its leading role, including works by Gluck, Mozart, Rossini, Weber, Spontini, and Auber. Owner of the service was the Berlin tenor Karl Adam Bader, one of the major singers of the period (see, for example, Gustav Parthey, *Jugenderinnerungen*, vol. 2 [Berlin 1907], p. 89). Bader apparently received it as a gift from his wife, the actress Sophie Laurent, on January 10, 1829, his fortieth birthday.

147
BERLIN

Cup and Saucer

C. 1830/35. Porcelain; a) cup, height 4¾" (12 cm),
b) saucer, diameter 7⅛" (18.1 cm)
Marks: Scepter (underglaze blue), various inscribed
marks
Berlin Museum, Berlin. KGK 76.35 a–b
Reference: Ponert, no. 272.

With the growing scarcity of building land in Biedermeier cities, multistory apartment houses began to play an increasingly important role. They had become socially accepted places to live and were also good investments. Families were proud of their real estate, as indicated by the growing number of depictions of such buildings on the presentation cups of the time. The present cup, with its detailed painting of a facade, once belonged to the Berlin historian Friedrich Adolf Maerker. The morning-glory pattern on the saucer symbolizes friendship and family togetherness. H. W.

148
COPENHAGEN

Milk Jug

C. 1825/30. Porcelain, height 7½" (19 cm)
Mark: Wave
Det Danske Kunstindustrimuseum, Copenhagen.
50/1957

The bulbous jug, with its large cloverleaf spout has a rather stolid air. Its decoration is highly original – short tendrils consisting of wavy spirals and dots that cover the entire surface like a textile pattern.

149
FÜRSTENBERG

Coffee Service

plate, p. 121

C. 1820. Porcelain; a) pot, height 5³/16" (13.2 cm),
b) sugar bowl, height 2¹⁵/16" (7.4 cm), c) cup,
height 2¼" (5.8 cm), d) saucer, diameter 5¹¹/16"
(14.4 cm)
Marks: Model nos. 1, 3, 19 (underglaze blue)
Städtisches Museum, Göttingen. EB 1933
Reference: Spies, p. 14f.

After 1815 the porcelain factory owned by the Duke of Brunswick-Lüneburg produced services for everyday use in large quantities and a great variety of designs. The present service is listed in a pattern card issued before 1828 as the "vase form." With its delicate, sparing decoration, this design, which was probably developed in the early years of the century, is a particularly attractive example of Biedermeier tableware.

150
FÜRSTENBERG

Cup and Saucer

plate, p. 122

C. 1825. Porcelain; a) cup, height 3" (7.5 cm),
b) saucer, diameter 5⁵/16" (13.5 cm)
Marks: F, model no. 19 (underglaze blue), 11 F
(overglaze gold)
Kestner-Museum, Hanover. 1912.294
Reference: *Fürstenberger Porzellan*, cat. no. 171.

At Fürstenberg, as in other Biedermeier porcelain factories, the rose was the most popular flower motif, whether depicted with botanical accuracy or in simplified, decorative form. Although the Fürstenberg factory developed numerous new shapes of cup, it continued to produce the traditional ones: the prototype for this cup with climbing-rose decoration was designed in 1805 and manufactured from 1806 as part of a tea and coffee service known as "vasiform" ware. H. W.

151
FÜRSTENBERG

Cup and Saucer

plate, p. 122

C. 1825. Porcelain; cup, height 4⅛" (10.2 cm),
b) saucer, diameter 5⅝" (14.2 cm)
Marks: F, model nos. 35, 38 (underglaze blue),
NH, 35HE (impressed)
Kestner-Museum, Hanover. 1914.121
References: *Fürstenberger Porzellan*, cat. no. 168;
Wolff Metternich, p. 70.

The Fürstenberg factory was particularly adept at supplying the demand for collector's cups, developing a great variety of new designs. By 1860 it was offering a total of ninety-one models, and the range of hand-painted decors available was probably no less extensive.
Whether the image of a young lady with roses on her hat was taken from a fashion journal, copied from a painting, or represents a specific individual is unknown. H. W.

152
FÜRSTENBERG

Cup and Saucer

plate, p. 120

C. 1830/35. Porcelain; a) cup, height 2¹³/16" (7.1 cm),
b) saucer, diameter 5¾" (14.6 cm)
Marks: F, model no. 48 (underglaze blue)
Städtisches Museum, Brunswick. 1982/20

Depicted on the cup is the *Rosstrappe* (Horse's Hoofprint), a scenic wonder in the Harz Mountains consisting of a huge, hoof-shaped indentation in one of the granite cliffs seven hundred feet above the romantic Bode River Valley. Legend has it that the impression was made by the horse of a princess who, to escape her pursuers, leaped across the river to safety. H. W.

153
FÜRSTENBERG

Cup and Saucer

plate, p. 120

C. 1830/35. Porcelain; a) cup, height 2¾" (7 cm),
b) saucer, diameter 5⅞" (15 cm)
Marks: F, model no. 48 (underglaze blue)
Städtisches Museum, Brunswick. 1983/24, 1982/21

The cup is adorned with a depiction of the Petri-Tor in west Brunswick, a city gate designed by the architect Peter Joseph Krahe, who supervised building in the duchy from 1803 and freed the city from its constricting Baroque fortifications. To replace the old city gates he constructed guard and customs houses spaced far enough apart to give an unhindered view of the countryside beyond.
 H. W.

154
FÜRSTENBERG

Cup and Saucer

plate, p. 120

C. 1830/35. Porcelain; a) cup, height 2¹¹/16" (6.9 cm),
b) saucer, diameter 4⅛" (10.4 cm)
Marks: F, model no. 48 (underglaze blue)
Historisches Museum am Hohen Ufer, Hanover.
VM 29299

In this detailed view of a domestic interior mother and daughter sit opposite one another at a sewing table, their chairs standing on the characteristic Biedermeier pedestals. Intended as a memento of a home and those who lived there, the cup was probably decorated on the basis of a drawing provided by the customer, perhaps by a painter outside the factory. H. W

155
FÜRSTENBERG. DECORATION BY
JOHANN HEINRICH CHRISTIAN ELI

Cup and Saucer

plate, p. 123

C. 1835. Porcelain; a) cup, height 3⁹/16" (9 cm),
b) saucer, diameter 6⁵/16" (16 cm)
Marks: F, model no. 56 (underglaze blue)
Kulturgeschichtliches Museum, Osnabrück. A 3548

The decoration of this cup, a sprig of pelargonium, is the work of Johann Heinrich Christian Eli, who joined the Fürstenberg painting department in 1818, at the age of eighteen (see also no. 18). The continuous wreath of flowers on a tinted ground is typical of his style, as are

the precision and plasticity that lend the decor a certain heaviness. Contemporary observers accordingly noted a lack of "pleasing deftness" in his touch. Nevertheless, Eli achieved rapid fame, and died at an old age in 1881 as Royal Painter of Flowers, Fruit, and Insects. H. W.

156

MEISSEN

Coffee Service plate, p. 125

C. 1815/20. Porcelain; a) tray, 11⅛″ x 11⅛″ (28.2 x 28.2 cm), b) coffeepot, height 7⅛″ (18.1 cm), c) teapot, height 5⅞″ (14.9 cm), d) creamer, height 4¾″ (12 cm), e) sugar bowl, height 2⁹⁄₁₆″ (6.5 cm), f) cup, height 2¹³⁄₁₆″ (7.1 cm), g) saucer, diameter 5¹¹⁄₁₆″ (14.4 cm)
Mark: Crossed swords (underglaze blue)
Landesmuseum, Oldenburg. LMO 94

The coffee or tea table became a focus of domestic life during the Biedermeier period, and beautiful services were highly prized. They consisted of cups and saucers, various pots, a sugar bowl, and frequently a tray, but never included plates: coffee or teatime had not yet become a meal, and no cakes or sandwiches were served along with the beverage.

A large number of new designs came into use after 1814, including this service with the factory designation L (see fig. 66, p. 58), which was available with four different cup designs. As in the previous century, insect decors were based on the illustrations in zoological publications, with the difference that the earlier informal and asymmetrical distribution was now replaced by a carefully choreographed butterfly ballet. H. W.

157

MEISSEN

Coffee Service plate, p. 124

1817/18. Porcelain; a) coffeepot, height 8⅝″ (21.9 cm), b) teapot, height 6⁹⁄₁₆″ (16.7 cm), c) creamer, height 5¼″ (13.3 cm), d) sugar bowl, height 2⅝″ (6.6 cm), e) cup, height 3″ (7.7 cm), f) saucer, diameter 5⅜″ (13.7 cm)
Mark: Crossed swords (underglaze blue)
Landesmuseum, Oldenburg. LMO 13 362

In 1817 a new underglaze color, chrome green, was developed at the Meissen factory. To employ it to best effect, Johann Samuel Arnhold designed a monochrome green vine leaf decor that same year which showed an unerring sense for the taste of the period. It rapidly became popular and, throughout the nineteenth century, remained, along with the underglaze blue "onion pattern," one of the most widespread china decors in middle-class households.

The present service, designed in 1814, probably by Johann Daniel Schöne, was designated in the Meissen stocklists by the letter Q. It was available with three different shapes of cup (see fig. 66, p. 58). H. W.

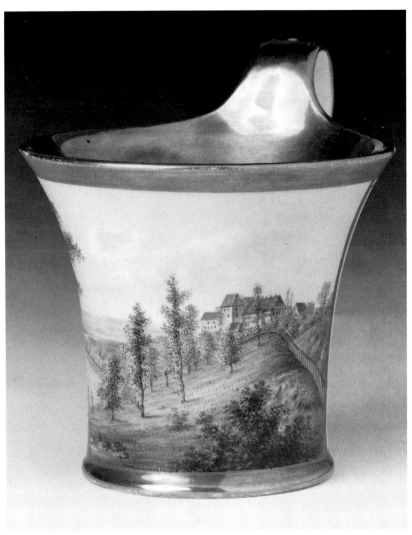

149

158

MEISSEN

Cup and Saucer plate, p. 124

1820. Porcelain; a) cup, height 3¹¹⁄₁₆″ (9.3 cm), b) saucer, diameter 5″ (12.7 cm)
Marks: Crossed swords, I (underglaze blue)
Inscribed "den 31.sten July 1820"
Private collection, Munich

Reference: Wellensiek, pp. 104–5.

There is a secret message concealed in the decor of this cup in the form of an acrostic. Read in the correct order, the first letters of the German names of the flowers on the saucer spell *Liebe* (love), while those on the cup spell *Dank* (gratitude). A good knowledge of flowers was necessary to solve the puzzle, but botany was part of general education in the flower-loving Biedermeier era. The popularity of gardening led to the cultivation of hundreds of different flower varieties that were a favorite subject of discussion and correspondence, though most are no longer known today. (See also no. 218.) H. W.

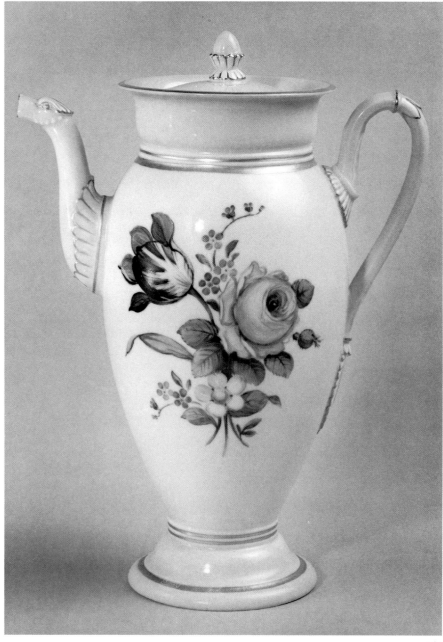

159

160

MEISSEN

Plate plate, p. 125

C. 1825. Porcelain, diameter 9³/₈″ (23.9 cm)
Mark: Crossed swords (underglaze blue)
Museum für Kunst und Gewerbe, Hamburg.
1896.185

Reference: Jedding, fig. 1.

The painstakingly precise rendering of the
Church of Our Lady in Dresden was certainly
based on an engraving. Bright sunlight lends
great vitality to the depiction of the elaborate
architecture.

161

METTLACH

JEAN FRANÇOIS BOCH-BUSCHMANN

Coffeepot

C. 1820. Cream-colored earthenware, height 9¼″
(23.5 cm)
Kunstgewerbesammlung der Stadt Bielefeld,
Bielefeld. 1953/174

Notably simple and lucid vessel designs were
developed by the manufacturers of cream-
colored earthenware in the Biedermeier
period. This cylindrical pot, with sharply
indented top, was produced in similar form at
Schramberg and Schäftlarn (see *Baden und
Württemberg*, cat. no. 1227, and *Biedermeiers
Glück und Ende*, cat. no. 4.12.6).

162

NYMPHENBURG

Cup and Saucer plate, p. 126

C. 1820. Porcelain; a) cup, height 3¹¹/₁₆″ (9.4 cm),
b) saucer, diameter 5¹/₈″ (13 cm)
Mark: Shield (impressed)
Bayerisches Nationalmuseum, Munich. 15/107

The most popular floral motif in the eighteenth
century, the rose again played a leading role in
Biedermeier decoration. *Les Roses*, a multi-
volume collection of illustrations based on
watercolors by Pierre Joseph Redouté and a
work of great artistic and botanical impor-
tance, was published from 1817 to 1824.
Although porcelain factories used simpler
models, they did so with considerable botanical
knowledge and artistic sensitivity, as this cup
with its band of roses shows. H. W.

163

NYMPHENBURG

Cup plate, p. 126

C. 1820/25. Porcelain, height 3¹¹/₁₆″ (9.3 cm)
Marks: Shield, II (impressed), inscribed mark
Bayerisches Nationalmuseum, Munich. Ker 3822

Reference: *Wittelsbach und Bayern*, cat. no. 1318.

159

MEISSEN

Coffeepot

C. 1824. Porcelain, height 8¹¹/₁₆″ (22 cm).
Marks: Crossed swords, II (underglaze blue)
Staatliche Museen Preussischer Kulturbesitz,
Kunstgewerbemuseum, Berlin. 1982,3

The Meissen stocklists for 1821–23 contain
three different versions of the T service, to
which this coffeepot belongs (see fig. 66, p. 38).
The bunch of flowers, spread loosely over the
surface of the pot, quite consciously refers – for
sales reasons – to patterns that had been cur-
rent in the 1760s and 1770s, though here they
have been thinned out, depicted with greater
simplicity and concision, and given an open
contour.

The man in a tailcoat standing on the shore of the Tegernsee lake with his spaniels is Maximilian I Joseph, who had been crowned first King of Bavaria in 1806. Kind and helpful, jovial and personally unassuming, he soon became extremely popular with his subjects. The monarch loved the Tegernsee Valley, where, in the second decade of the nineteenth century, he acquired the former monastery and converted it into a country seat.

The scene is based on an anonymous engraving (see Joseph Maillinger, *Bilder-Chronik der Kgl. Haupt- und Residenzstadt München*, vol. 1 [Munich, 1876], no. 1975) which was also used in slightly altered form for the decoration of snuffboxes and pipe bowls (see *Biedermeiers Glück und Ende*, cat. no. 1.21). H. W.

164

NYMPHENBURG

Cup and Saucer plate, p. 128

Probably 1824. Porcelain; a) cup, height 3³/₈″ (8.5 cm), b) saucer, diameter 6¹¹/₁₆″ (17 cm)
Mark: Shield (impressed)
Inscribed b) "Andenken von einem treuen Unterthan des Königs" (top), "Joh. Bapt. Findl" (underside)
Bayerisches Nationalmuseum, Munich. Ker 2176, 2177

Reference: Rainer Rückert, "Wittelsbacher Porzellane," *Kunst & Antiquitäten*, no. 2 (1980), pp. 24–32.

When this cup bearing a depiction of the Oktoberfest was made, the festival, instituted in 1810, had long become a very popular annual event in Munich. The Nymphenburg painter took the main features of his view from an etching by Heinrich Adam, which was probably executed about 1824. The exquisite cup, whose form was listed in the company catalogue for 1831 as a bouillon cup, was presented to the King of Bavaria on the occasion of the twenty-five-year jubilee of his reign by the Munich innkeeper Johann Baptist Findl. H. W.

165

NYMPHENBURG

Vase plate, p. 127

C. 1825. Porcelain, height 12³/₈″ (31.4 cm)
Marks: Shield, P (impressed), 6 (inscribed)
Städtisches Reiss-Museum, Mannheim

After becoming "artistic supervisor" of the Nymphenburg factory in 1822, the architect Friedrich Gärtner introduced "forms of great nobility and decoration of the purest order" (Nagler, 1857). This was particularly true of the large ornamental vases produced at the time, as this example of the simplest model shows. Above a salmon pink base decorated with gold leaves it bears a continuous panorama of the English Garden in Munich.

166

NYMPHENBURG. DECORATION BY FRANZ XAVER NACHTMANN (?)

Sugar Bowl plate, p. 128

C. 1825. Porcelain, height 7¹/₂″ (19 cm)
Marks: Shield (impressed), mold no. XIII, 21 (inscribed)
Bayerisches Nationalmuseum, Munich. 54/8d

Reference: *Münchner Jahrbuch der bildenden Kunst*, 6 (1955), p. 276f.

The particularly graceful floral decoration of this sugar bowl, which comes from a nine-part service, breaks with tradition in its realistic depiction of the plants growing in a strip of earth at the bottom (see also no. 216). The careful spacing of the plants to avoid overlappings, the sureness with which they are distributed over the surface, and the botanically precise representation of the flowers betray the hand of a skilled painter. This was possibly Franz Xaver Nachtmann, who had worked as a flower painter at Nymphenburg since 1823.

167

NYMPHENBURG

Bouillon Cup and Saucer plate, p. 126

C. 1825/30. Porcelain; a) cup, height 3¹¹/₁₆″ (9.4 cm), b) saucer, diameter 6³/₁₆″ (15.7 cm)
Marks: Shield, mold no. 3 (impressed)
Inscribed "Schongau"
Bayerisches Nationalmuseum, Munich. 71/14

Reference: *Münchner Jahrbuch der bildenden Kunst*, 23 (1972), p. 225.

City dwellers began to show an interest in the rural environment during the Biedermeier period, which may explain why the Nymphenburg factory increasingly employed Bavarian landscapes in the decoration of its products. The painters based their work on prints, or, as was probably the case with the view of Schongau on this bouillon cup, on small-format watercolors. H. W.

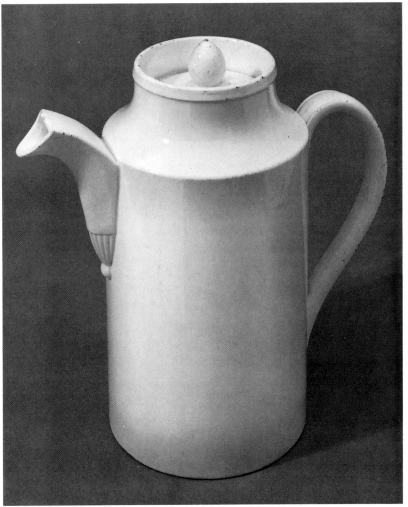

161

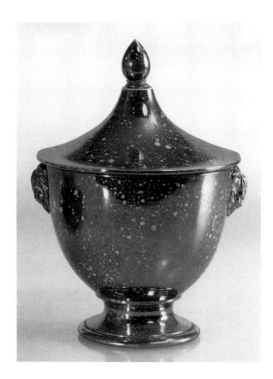

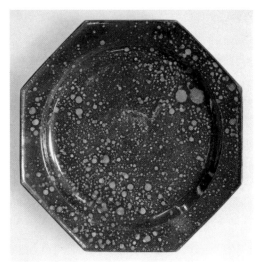

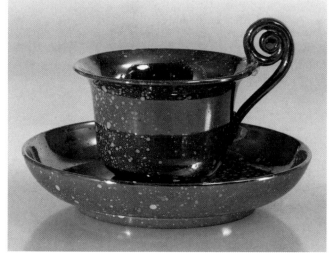

169

168

NYMPHENBURG

Cup and Saucer

plate, p. 126

C. 1825/30. Porcelain; a) cup, height 3⁹/₁₆" (9.1 cm),
b) saucer, diameter 5³/₁₆" (13.2 cm)
Marks: Shield, P (impressed)
Inscribed "Das neue Hof Theater in München"
Bayerisches Nationalmuseum, Munich. 63/35

One of the most impressive new buildings of
the period in Munich, the National Theater
was depicted again and again in paintings and
prints. The Nymphenburg decorator of this cup
and saucer based his view on an anonymous
etching done around 1825 that apparently
enjoyed wide distribution. It shows the square
and the theater after the latter had been rebuilt

by Leo von Klenze – Karl von Fischer's original
building (erected 1811–18) had burned down
in 1823 – and before the monument to Maxi-
milian I Joseph had been unveiled in the
square in 1835 (see no. 85).

Cups of this type, which were adorned with
many other views of the city, were popular
travel souvenirs and an important part of the
Nymphenburg range of products. H. W.

169

SAARGEMÜND

Pieces from a Service

C. 1825. Earthenware; a) plate, diameter 7³/₄"
(19.7 cm), b) cup, height 3³/₁₆" (8.1 cm), c) saucer,
diameter 5¹/₂" (13.9 cm), d) sugar bowl, height 6⁵/₁₆"
(16.1 cm)
Württembergisches Landesmuseum, Stuttgart.
12086, 12151

The simple design of this service, with its lus-
trous copper glaze resembling porphyry, is
underscored by the octagonal contour of the
plate and the lucid forms of the cup and sugar
bowl. The urn shape of the latter, with its con-
cave pointed lid, was very popular in the
Biedermeier period.

The efforts of the Saargemünd factory to lend the inexpensive material the appearance of precious stone accords with similar inventions on the part of glassmakers (see nos. 194–201). The matching coffeepot and milk jug are in the Metropolitan Museum of Art, New York.

170

SCHREZHEIM

Vase

plate, p. 129

C. 1820. Faience; height 5¼″ (13.4 cm), diameter 4¾″ (12 cm)
Badisches Landesmuseum, Karlsruhe. Lga 2143

Cream-colored earthenware, inexpensive and produced in great quantities by the many new factories established at the time, led virtually to the demise of faience manufacture. Nevertheless, individual pieces like this vase continued to be made, in designs whose beauty derives from their simplicity.

171

THURINGIA (?)

Cup and Saucer

C. 1830. Porcelain, height 3⅛″ (8.5 cm)
Inscribed "Die Marienkirche in Lübeck"
Museum für Kunst und Kulturgeschichte der Hansestadt Lübeck, Lübeck. 1925/9
Reference: Pietsch.

Cups adorned with views of historic sites were extremely popular during the Biedermeier period, reflecting an increased interest in travel and curiosity about places far from home. They were either decorated in series in the factories that produced them or sold unpainted to private workshops, where they were painted in accordance with customers' wishes. The views were invariably based on an existing depiction.

The interior view of St. Mary's Church in Lübeck shown on the present cup goes back to a drawing by Anton Radl, of which Johann Baptist Hössel made an engraving.

172

VIENNA. DECORATION BY
KARL HINTERBERGER

Cup and Saucer

plate, p. 129

1815. Porcelain; a) cup, height 3¹¹⁄₁₆″ (9.3 cm),
b) saucer, diameter 6⁵⁄₁₆″ (16 cm)
Marks: Barred shield (underglaze blue), production year 815 (stamped), decorator's no. 130
Private collection
Reference: Wellensiek, p. 124 f.

This cup model, with a handle known as the "Pan" design, was on the Vienna factory lists from the year 1811. An elaborate design, it was reserved for particularly expensive finishes, as may be seen in the present cup, with its swan motif and luster painting – that is, colors applied in several stages to produce a delicate, metallic shimmer. The imaginative decoration, in gold and silver-gray heightened by engraved gold ornament, shows that the costly elegance of the Empire style still played a certain role in early Biedermeier decorative art.　　H. W.

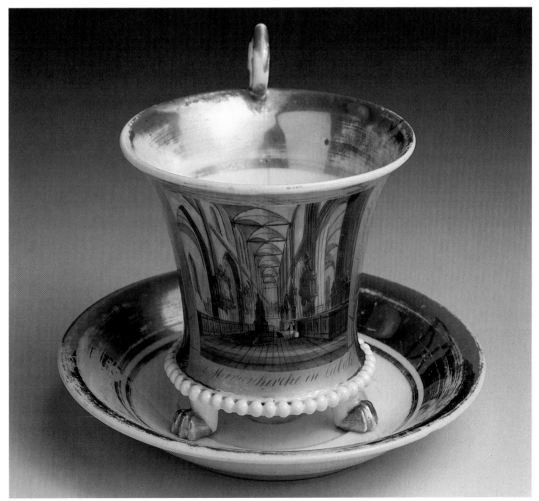

171

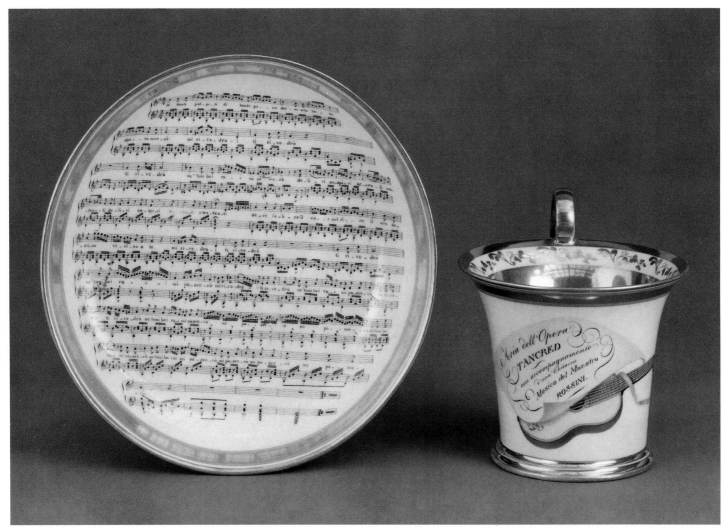

173

173

VIENNA

Cup and Saucer

*C. 1817. Porcelain; a) cup, height 4⁵/₁₆" (11 cm),
b) saucer, diameter 7¹/₈" (18.1 cm)
Marks: Barred shield (underglaze blue), production
year 817 (stamped), 26 (impressed)
Inscribed a) "Aria dell'Opera Tancred con accom-
pagnamento d'una Chitarra Musica del Maestro
Rossini"
The Metropolitan Museum of Art, New York,
Bequest of R. Thornton Wilson, 1977.
1977.216.39,40.*

Reference: W. B. Honey, *European Ceramic Art,*
vol. 1 (London, 1952), p. 650.

The premiere of the opera *Tancredi,* given in
February 1813 in Venice, marked the beginning
of the young Rossini's fabulous career. The first
Vienna performance, on December 17, 1816,
was received with equal acclaim. As the decora-
tion on the saucer indicates, the aria "Di tanti
palpiti" soon became a popular piece. H. W.

174

VIENNA

Cup and Saucer plate, p. 129

*1824/25. Porcelain; a) cup, height 3¹/₈" (8 cm),
b) saucer, diameter 6³/₁₆" (15.7 cm)
Marks: Barred shield (underglaze blue), production
years 824, 825 (stamped), 7, 12, 40 (impressed)
Private collection*

The Vienna factory was renowned for the high
quality of its floral decoration long after the
first quarter of the nineteenth century. The
decorators were required to make botanical
watercolor studies, hundreds of which are now
in the collection of the Museum für an-
gewandte Kunst in Vienna. The final compo-
sitions were built up from these separate
studies, often irrespective of whether the flow-
ers depicted bloomed at the same time or not.

The prototype of the E 227 cup was probably
first manufactured in 1817. H. W.

175

ZELL AM HARMERSBACH

Coffeepot

*C. 1820. Cream-colored earthenware, height 7¹/₄"
(18.5 cm)
Mark: ZELL 2 (impressed)
Badisches Landesmuseum, Karlsruhe. V 7780*

The austere geometric form of the pot – a trun-
cated cone – is set off at base and rim by a sim-
ple molding, while the straight handle is very
well conceived in ergonometric terms: a starkly
convincing design achieved through reduction
to the simplest terms.

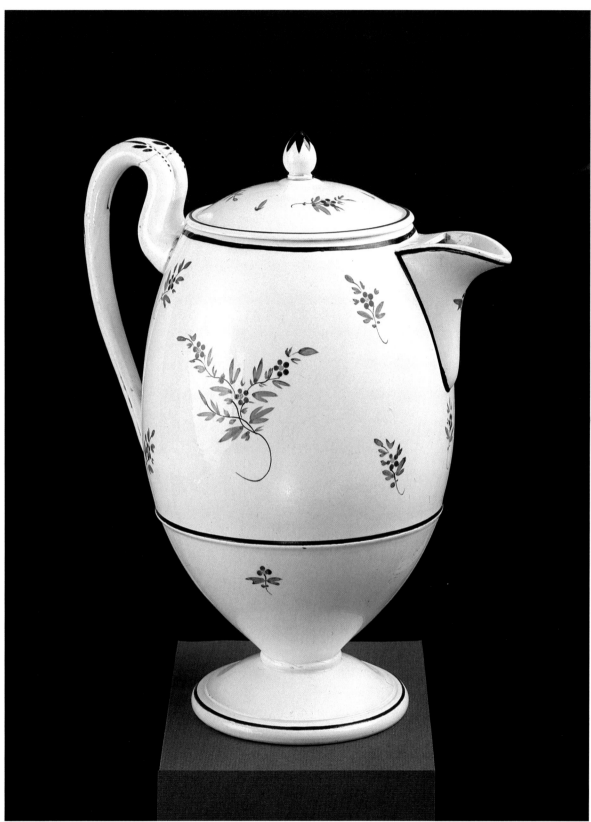

176

176

ZELL AM HARMERSBACH

Coffeepot

C. 1820. Cream-colored earthenware and transfer printing, height 9⁷/₈" (25 cm)
Städtisches Museum, Freiburg. 2990

The egg-shaped pot stands on a slightly convex foot, while the lid is set off by a half-round molding that is repeated on the lower third of the pot. The "strewn flower" decoration is printed.

More than any other Central European manufacturer of cream-colored earthenware, the Zell factory devoted itself to the development of new and extremely simple vessel designs.

177

ZELL AM HARMERSBACH

Jug

C. 1825. Cream-colored earthenware and transfer printing, height 7¹/₂" (19 cm)
Mark: ZELL 3 (impressed)
Badisches Landesmuseum, Karlsruhe. c 6333

While the strict oval of the body is emphasized by medallions with romantic landscapes, the strong curve of rim and spout is accompanied by a continuous grapevine pattern. The decoration is printed.

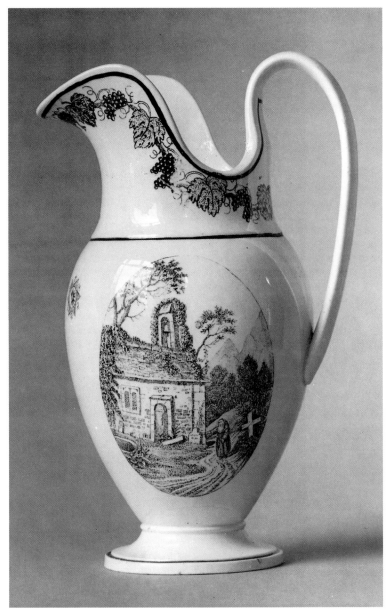

177

175

Glass

With the production of coffee services, glass manufacturers entered a new field in the early nineteenth century. Such elaborately decorated cups as this one, however, were intended solely as showpieces. B. T.

in Blottendorf around 1810, who made it her specialty to engrave entire names and mottoes in this fashion.

The Biedermeier love of flowers and penchant for mementos are combined in this glass in a particularly charming way. B. T.

178

Tumbler plate, p. 130

1816. Clear glass, with translucent enamel painting and yellow staining, height 3⅞" (9.9 cm)
Inscribed "C: Mo: v. Scheidt, pin: Berlin 1816",
"Das Brandenburger Thor; 1814"
Kunstmuseum, Düsseldorf. 1940–180

Reference: Heinemeyer, no. 442.

Karl von Scheidt lived and worked in Dresden, but in 1816 went temporarily to Berlin (see also no. 204), where he created this tumbler with a representation of the Brandenburg Gate. The date of 1814 in the inscription commemorates the return of Gottfried Schadow's sculpture to the top of the gate (Napoleon had taken it to Paris seven years previously).

Scheidt decorated another glass with an identical border design that same year (Robert Schmidt, *Die Gläser der Sammlung Mühsam* [Berlin, 1914], no. 345). B. T.

179

BLACK FOREST

Tankard plate, p. 139

C. 1825. Clear glass and blue threading, height 4¹⁵⁄₁₆" (12.5 cm)
Städtische Museen, Freiburg. 7555

The sole ornament of this plain, tapered tankard is a broad wave of blue glass applied to the lower part – a joyfully robust design that is a far cry from the threaded glass based on old Venetian models that was also produced in the Biedermeier period. B. T.

180

BOHEMIA

Cup and Saucer plate, p. 171

1818. Clear glass, cut and engraved; a) cup, height 2½" (6.3 cm), b) saucer, diameter 5⁵⁄₁₆" (13.5 cm)
Inscribed a) "Ewige Liebe W. B.", b) "G. B. 1818"
Kunstsammlungen der Veste Coburg, Coburg. a. S. 1491

Reference: Pazaurek, p. 27, fig. 12.

The flaring sides of the cup are completely covered with ornamentation: arch facetting, drooping flowers, diamonds with cut stars, a matte band with polished olives and zigzag border, and, on the front, a medallion with inscription. The arch facetting and matte band are repeated on the saucer in slightly altered form.

181

BOHEMIA (HAIDA?)

Tumbler

C. 1820. Clear glass, cut and engraved, height 4¹¹⁄₁₆" (11.9 cm)
Inscribed "Souvenir"
Bayerisches Nationalmuseum, Munich. 67/66

Reference: Rückert, cat. no. 975.

The word "souvenir" is engraved in "floral writing" around the upper part of the flaring tumbler. Diamond-cut patterning on the bottom miter-cut rays around the base complete the decoration.

Letters composed of flowers had existed since the eighteenth century, but it was apparently Mathilde Riedel, a glass engraver active

182

BOHEMIA

Cup and Saucer

C. 1820. Clear glass, cut and engraved; a) cup, height 2½" (6.4 cm), b) saucer, diameter 5⁵⁄₁₆" (13.5 cm)
Kunstsammlungen der Veste Coburg, Coburg. a. S. 1492

Reference: Pazaurek, p. 27, fig. 13.

The bell-shaped cup was based on porcelain designs of the period (see no. 164). While the base is decorated in diamond-cut patterning, the sides have a matte-engraved garland that is repeated, halved, on the saucer. B. T.

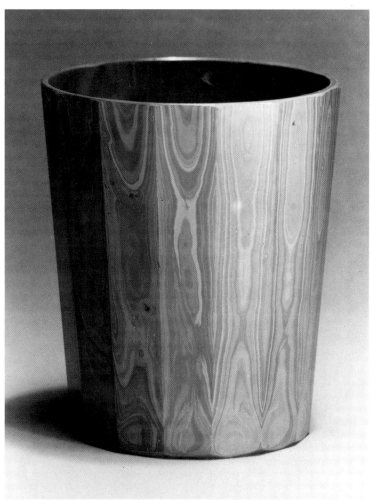

178

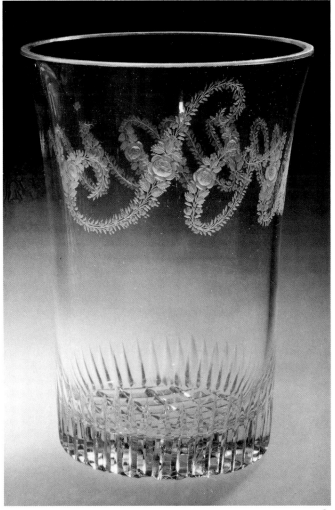

181

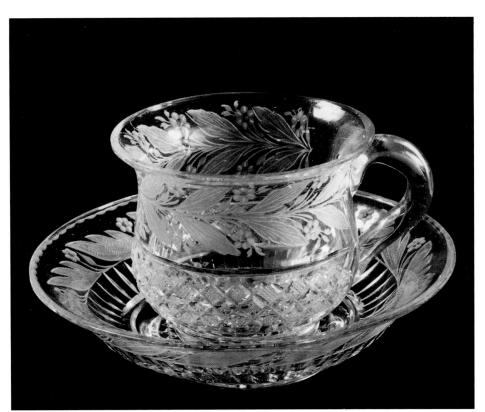

182

183

Tumbler plate, p. 170

C. 1820. Clear glass, cut and engraved, height 4½"
(11.5 cm)
Inscribed "D. L."
Glasgalerie Michael Kovacek, Vienna

This is a fine example of a relatively small group of glasses known as cutter-engraver pieces which were made in Silesia and northern Bohemia into the 1820s. In contrast to the generally observed practice of strict specialization, these pieces were cut and engraved by the same craftsman, lending their decor a special harmony and unity.

The high-relief ornament of the cylindrical tumbler – diamond-cut bands at top and bottom, and medallions with monograms on the sides – reveals the greatest technical mastery. An engraved pattern of vine leaves, tendrils, and ribands completes the decor. B. T.

184

BOHEMIA

Jug

1820. Crystal glass, cut, height 8⁷/₁₆" (21.5 cm)
Tiroler Landesmuseum Ferdinandeum, Innsbruck.
GL 122

The sides of the elongated egg-shaped jug are adorned with diamond-point cutting that encompasses the piece like a jeweled breastplate. The long, narrow handle provides an interesting contrast to the beaklike spout. B. T.

185

BOHEMIA

Tumbler plate, p. 168

C. 1820. Clear glass, cut and engraved, height 3½"
(8.9 cm)
Badisches Landesmuseum, Karlsruhe,
Heine Collection, no. 172. 85/183
Reference: Baumgärtner, 1977, no. 172.

The floral decoration so popular in the Biedermeier era is found both on painted and on engraved glassware. The bunch of different, painstakingly depicted flowers on the present tumbler reveals the high technical standard of Bohemian glass engraving at the time.

The symbols on the pedestal of the flower bowl indicate that the decoration has a Christian significance. B. T.

186

BOHEMIA

Bowl plate, p. 136

1820/30. Cased glass, cut, engraved, and gilded;
height 2¼" (5.8 cm), diameter 7½" (19 cm)
Kunstgewerbesammlung der Stadt Bielefeld,
Bielefeld. G 83

Horizontal bands with blue casing alternate with colorless, cut stripes adorned with engraved and gilded flowers. The bowl is articulated by radial fields of different height that are divided up into areas like building blocks.

Colored glass and gilded decoration were very popular in the Biedermeier period. B. T.

187

NORTHERN BOHEMIA (?)

Tumbler (*Ranftbecher*) plate, p. 168

1820/30. Crystal glass, cut, height 4¹¹/₁₆″ (11.9 cm)
Bayerisches Nationalmuseum, Munich. 67/70

Reference: Rückert, cat. no. 983.

Biedermeier glass cutters excelled in the invention of new forms of ornament, for each of which they found a fitting name in the graphic language of the craft. The projecting bottom of this type of tumbler, for instance, was known as an "edge" (*Ranft*), and is decorated with "diamonds" and "nips." The concave facetted sides are adorned with high-relief cut decoration, "palmettes" alternating with "crosshatched rings" on the lower section and, above them, an "oval chain frieze" with the "eye-cut" motif.

In the course of the Biedermeier period, cut ornament increasingly replaced engraved ornament and soon ousted it completely. B. T.

188

BOHEMIA, BUQUOY FACTORY plate, p. 137

Cup and Saucer in Original Case

1820/30. Hyalith, gilded; a) cup, height 3¹/₄″
(8.3 cm), b) saucer, diameter 6³/₁₆″ (15.7 cm)
Glasgalerie Michael Kovacek, Vienna

Reference: Roehling, p. 85.

Vessels made from Hyalith, a dense black glass invented in 1816 by Count von Buquoy and notable for its shiny surface and extreme hardness, were frequently decorated with *chinoiseries* in gold, leading, in the present case, to a dual illusion – a porcelain cup design that is actually made of glass and has the appearance of East Asian lacquer work. The cup, with its gilded inside and specially made leather case, was an exquisite collector's item and not intended for use.

189

BOHEMIA, DOMINIK BIEMANN (?)

Tumbler

C. 1825. Clear glass, cut and engraved, height 4⁵/₁₆″
(11 cm)
Collection Heinrich Heine, Karlsruhe

Reference: Schenk zu Schweinsberg, no. 313;
Baumgärtner, 1981, p. 87 f., figs. 116–19, 139.

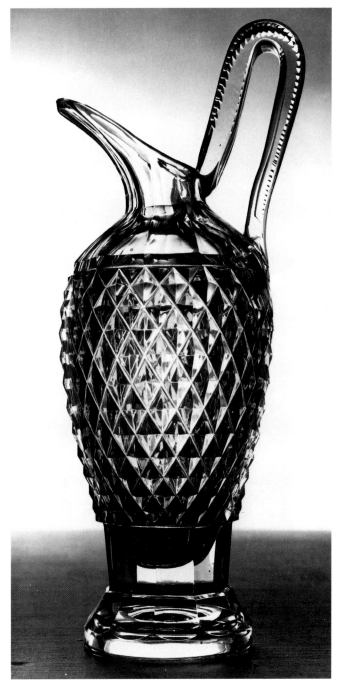

184

The facetted tumbler, with diamond-cut patterning that resembles Mannerist ashlar masonry, bears a bust of Goethe in an oval medallion. Biemann based his image of the poet on a medal of 1824 by Jean François Antoine Bovy, which in turn was based on a bust by Christian Daniel Rauch and which served as a model for a large number of cut and modeled portraits of Goethe. B. T.

190

BOHEMIA, BUQUOY FACTORY

Lidded Jar plate, p. 155

C. 1825. Hyalith, cut, height 6″ (15.3 cm)
Kestner-Museum, Hanover. 1968,20

Reference: Mosel, no. 311.

The jar of marbled red glass is notable for its lucid, geometric design. With the exception of the band around the rim, it is composed solely of flat surfaces, with two rows each of twelve cut, interlocking facettes on jar and lid. Sealing-wax red Hyalith was manufactured principally at the Buquoy works from 1819 on. B. T.

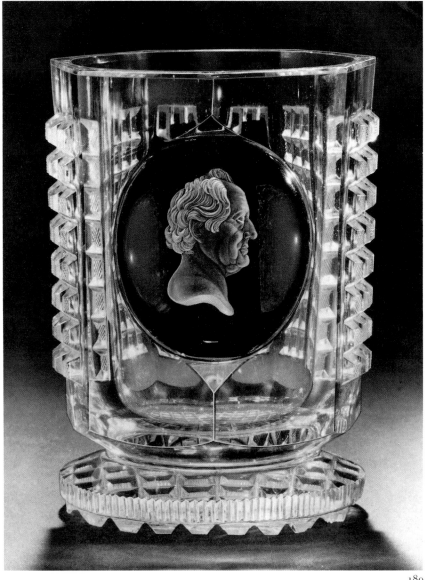

189

193

BOHEMIA, DOMINIK BIEMANN

Tumbler

*C. 1830. Crystal glass, cut and engraved, height
5⁵/₁₆″ (13.5 cm)
Inscribed "D. BIMAN"
Österreichisches Museum für angewandte Kunst,
Vienna. GL 2123*

References: Suzanna Pešatová, "Dominik
Biemann," *Journal of Glass Studies*, 7 (1965),
p. 103, cat. no. 49; *Bürgersinn und Aufbegehren*,
cat. no. 6/1/59.

The rendering of such details as the coiffure,
earring, and even eyelashes of the sitter in her
fashionable dress reveals great technical mas-
tery. Before Biemann engraved this portrait, the
conical tumbler was facetted by a glass cutter
who left the raised oval medallion standing and
adorned the bottom with a dense pattern of
stars. B. T.

194

BOHEMIA

Tumbler plate, p. 170

*C. 1830. Clear glass, cut and engraved, height 4³/₄″
(12 cm)
Private collection*

The dominating cut decoration of this heavy
tumbler is enriched by very fine intaglio
engraving – signs of the zodiac in the twelve
"eyes" below the rim, wreaths in the areas
created by the festoonlike hangings (probably
intended to contain a monogram), and
emblems of Hunting, Health, and Music. B. T.

191

BOHEMIA

Tankard plate, p. 169

*1829. Clear glass, cut and engraved, height 6⁵/₁₆″
(16 cm)
Inscribed "Buchsteiner d. 24ten August 1829"
Kunstmuseum, Düsseldorf. 1962–4*

Reference: Heinemeyer, no. 463.

The elaborate decoration of the cylindrical
tumbler consists almost exclusively of the dia-
mond-cut shapes popular since the Empire
period. Varying in size, and arranged in fields,
they cover almost the entire vessel. As the
inscription in the medallion indicates, the
piece was one of the mementos so beloved of
the Biedermeier era. Tumblers of this kind
were used to serve punch, a favorite beverage of
the day. B. T.

192

BOHEMIA

Tumbler plate, p. 136

*C. 1830. Clear glass, cut and engraved, with pink
staining, height 5³/₁₆″ (13.2 cm)
Badisches Landesmuseum, Karlsruhe. Heine
Collection 188*

Reference: Baumgärtner, 1977, no. 188.

A special feature of this tumbler, with its eight-
part, roller-cut base, is the series of rose-
colored medallions, cut in high relief and deco-
rated with flowers in matte and polished
engraving. B. T.

195

BOHEMIA, FRIEDRICH EGERMANN,
BLOTTENDORF

Tumbler plate, p. 132

*C. 1830. Lithyalin, cut and gilded, height 4″
(10.2 cm)
Tiroler Landesmuseum Ferdinandeum, Innsbruck.
GL 149*

In 1829, thirteen years after the invention of
Hyalith (see no. 188), Friedrich Egermann, the
proprietor of a glass-painting firm, introduced
Lithyalin, a marbled glass resembling semipre-
cious stone. By means of careful cutting the
various colored layers of the glass – in the pres-
ent case, blue and reddish brown – were
revealed to produce textures and patterns of
great variety. Such glasses bear witness to the
technical inventiveness of the Biedermeier era
and to its love of color. B. T.

196

BOHEMIA, FRIEDRICH EGERMANN,
BLOTTENDORF

Lidded Tumbler plate, p. 131

*1830. Lithyalin, cut, and bronze, gilded, height
5¹/₈" (13 cm)
Österreichisches Museum für angewandte Kunst,
Vienna. Gl 2359*
Reference: Trenkwald, cat. no. 906.

The tumbler is of similar design to no. 194, but
has a facetted peaked lid with a flower-shaped
knob of gilded bronze. The exterior is strikingly
marbled, while the interior is in monochrome
dark red. In 1830 Egermann donated this ves-
sel, probably as an outstanding product of
his firm, to the Fabriksproduktenkabinett in
Vienna, a state institution that collected
exemplary products of handicraft and industry.
 B. T.

197

BOHEMIA, FRIEDRICH EGERMANN,
BLOTTENDORF

Tumbler plate, p. 133

*C. 1830. Lithyalin, cut and gilded, height 4¹/₄"
(10.8 cm)
Private collection*

The gilded edges of the raised medallions on
this pentagonal tumbler suggest settings of pre-
cious metal. The effect of applied semiprecious
stones makes the vessel – whose color resem-
bles agate or carnelian – appear even more
costly and exquisite.

The monogram cw with a count's crown was
incised at a later date. B. T.

198

BOHEMIA, FRIEDRICH EGERMANN,
BLOTTENDORF

Tumbler plate, p. 132

*C. 1830. Lithyalin, cut, height 4¹/₄" (10.8 cm)
Private collection*

The gracefully flaring tumbler with ten facets is
notable for its extremely elaborate marbling,
principally in gradations of blue, which makes
it a truly exquisite piece. B. T.

199

BOHEMIA

Vase plate, p. 134

*C. 1830. Lithyalin, cut, height 9¹³/₁₆" (25 cm)
Badisches Landesmuseum, Karlsruhe. 70/25*

The numerous color nuances of the glass and
the facettes cut in different directions give rise
to a rich and lively marbled pattern. The charm
of the piece lies in the contrast between this
irregular patterning and the austerity of the
vessel's shape. B. T.

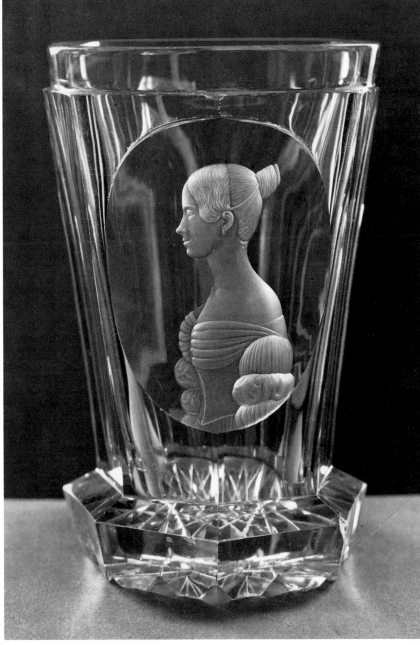

193

200

BOHEMIA

Lidded Bowl plate, p. 132

*C. 1830. Agate glass, cut, height 5⁵/₁₆" (13.5 cm)
Kunstmuseum, Düsseldorf. 1964–5*
Reference: Heinemeyer, no. 488.

This particularly well-balanced design, with a
pointed knob on the gracefully curved lid,
receives its sole decoration from the colored
pattern of the glass, which recalls agate.
Biedermeier glassworkers continually sought
new methods of imitating a great variety of
materials. B. T.

201

BOHEMIA, BUQUOY FACTORY

Lidded Bowl plate, p. 134

*C. 1830. Hyalith, partly gilded; height 4¹/₂"
(11.5 cm), diameter 7⁷/₁₆" (18.9 cm)
Kunstmuseum, Düsseldorf. 1940–205*
Reference: Heinemeyer, no. 483.

The striking sealing-wax red bowl with slightly
convex lid derives its effect from tense propor-
tioning, the contrast between the facetted sides
and the round lid, with its large, cut rosette, the
strictly functional design of the knob, and the
fine gold lines. B. T.

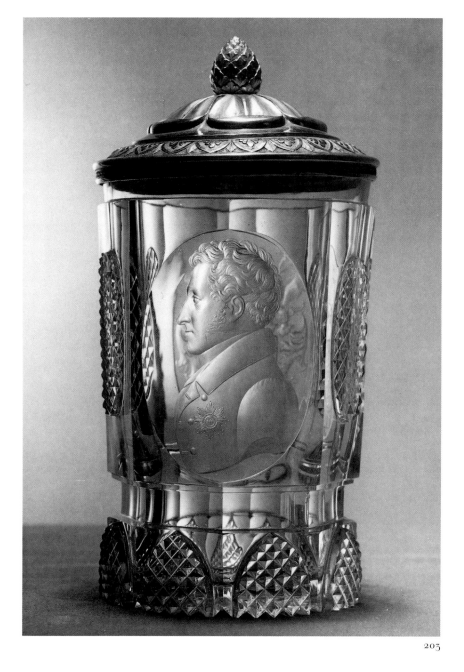

203

This glass bears probably the finest of Biemann's numerous portraits – a bust of Duke Ernst I of Saxe-Coburg-Gotha in an oval medallion. The opposite side bears the duke's coat of arms. Facetted over its whole height, the tumbler is also adorned with diamond-cut medallions whose pattern is repeated in the pointed arches on the base. A silver-gilt lid lends a further touch of splendor to a superb piece.

The tumbler was probably made in Gotha, where the artist sojourned in late 1830. While the duke is portrayed here in civilian clothes and wearing the medal of an order on his breast, on a goblet in the Gotha Schlossmuseum – also by Dominik Biemann – he wears gala uniform with a complete array of medals and decorations.

With justifiable pride, Biemann showed this piece at the 1831 exhibition in Prague. B. T.

204

BOHEMIA

Tumbler

C. 1830/35. Clear glass, cut and engraved, height 5⅛" (13 cm)
Private collection

Reference: Baumgärtner, 1981, p. 88, fig. 120.

The lower third of this bell-shaped tumbler on a rosette base bears a cut pattern very popular in the Biedermeier period, while the upper two-thirds are left smooth to take an unframed portrait bust. The sitter, turned slightly to the right and superbly drawn and modeled in matte engraving, is probably Alois Senefelder, the inventor of lithography. B. T.

205

DRESDEN, KARL VON SCHEIDT

Tumbler plate, p. 130

c. 1815. Clear glass with translucent enamel painting and gilding, height 4½" (11.4 cm)
Inscribed "C. v. S."
Bremer Landesmuseum, Focke-Museum, Bremen. 68.303

References: Pazaurek, p. 165 f., fig. 143; Spiegl, 1981, p. 143.

Scheidt learned the technique of painting glass with translucent enamel colors in Samuel Mohn's workshop in Dresden. While his teacher used floral borders simply to heighten the portraits and town views on his pieces, Scheidt, in this slightly flaring tumbler, employed decoration of the same type as the sole ornament. (See also no. 178.) B. T.

202

BOHEMIA

Lidded Box plate, p. 133

C. 1830. Lithyalin, cut; height 3" (7.6 cm), width 3⁹⁄₁₆" (9 cm)
Kunstmuseum, Düsseldorf. P 1968–1

The rounded edges, the slightly convex lid, and especially the fine marbling of the glass make this box a typical example of the timeless clarity and simplicity of form found in so many products of Biedermeier applied art. B. T.

203

BOHEMIA, DOMINIK BIEMANN

Lidded Tumbler

1830/31. Crystal glass, cut and engraved, lid silver-gilt, height 6⅞" (17.5 cm)
Inscribed "BIMAN"
Kunstsammlungen der Veste Coburg, Coburg. a. S. 749

Reference: *Kunstsammlungen der Veste Coburg*, p. 97.

206

DRESDEN, WILHELM VIERTEL

Tumbler

plate, p. 130

1817. Clear glass with translucent enamel painting, height 4¹/₁₆″ (10.3 cm)
Inscribed "W. Viertel px 1817 Dresden, Beger'sche Kunsthandlung / Weesenstein"
Staatliche Museen Preussischer Kulturbesitz, Kunstgewerbemuseum, Berlin. 1972,67

References: Pazaurek, p. 170, fig. 149; *Kataloge des Kunstgewerbemuseums*, 10 (Berlin, 1985), no. 272.

A travel souvenir, this tumbler, with its border of forget-me-nots at the top, is adorned with a panoramic view of the landscape near Dresden, with Weesenstein Castle seen against hilly countryside from a point on the opposite side of the valley.

Wilhelm Viertel decorated the piece in the year of his move from Dresden to Vienna, where he collaborated with Gottlob Samuel Mohn, the son of his teacher. B. T.

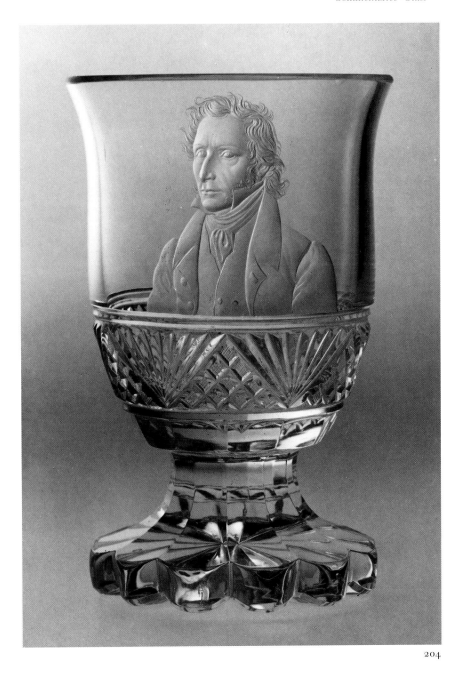

204

207

NORTHERN GERMANY

Bowl

plate, p. 139

1815/25. Blue glass; height 2¹/₂″ (6.3 cm), diameter 7⁷/₈″ (20 cm)
Städtisches Museum, Brunswick. 75/43

The effect of this simple vessel derives from its uncompromising form – the sides flare outward with a force that seems contained by the ring at the rim – and from the brilliant blue of its material. B. T.

208

JOACHIMSTHAL, JOSEF ZICH

Tumbler

plate, p. 138

1832. Agate glass, cut, height 5″ (12.8 cm)
Österreichisches Museum für angewandte Kunst, Vienna. Gl 2361

Reference: Trenkwald, cat. no. 964.

Josef Zich, head of the Joachimsthal glassworks and inventor of several improved methods of glass finishing, was one of the first manufacturers to produce "stone glass" similar to Friedrich Egermann's Lithyalin (see no. 195). The present tumbler, which Zich submitted in 1832 for inclusion in the Fabriksproduktenkabinett in Vienna (see no. 196), is a further example of the multifarious techniques of glass processing developed during the Biedermeier period. B. T.

209

NETHERLANDS (?)

Goblet

C. 1820. Clear glass, cut, height 4³/₈″ (11.1 cm)
On loan to the Museum Boymans-van Beuningen, Rotterdam. B 178

Stringency of design and decoration characterize this glass with square base. The horizontal ribs provide an interesting contrast to the flared facets of the thick stem. B. T.

210

NETHERLANDS

Goblet

plate, p. 171

1836. Clear glass, cut and engraved, height 5⁹/₁₆″ (14.1 cm)
Inscribed "Ex Amicitia Utilitas. 1836"
Stedelijk Museum "De Lakenhal," Leiden. 3725

Reference: *Stedelijk Museum*, cat. no. 151.

The two rings at the foot of the short, facetted stem contrast with the square base. The tapering bowl is divided horizontally into three sections: arched facets, a band of diamonds containing stars, and the motto – "From Friendship Springs Advantage" – which was presumably that of the student fraternity to which the goblet belonged. B. T.

211

SAXONY OR NORTHERN BOHEMIA

Tumbler plate, p. 138

*C. 1830/35. Chrysodiaphanous glass, height 3⅞"
(9.9 cm)
Bayerisches Nationalmuseum, Munich. 68/46*
Reference: Rückert, cat. no. 912.

The method of glass processing called
"chrysodiaphanous finish" was invented in the
early 1830s. It involved gilding the outer sur-
face of the vessel and then applying a coat of
brown lacquer that was textured with gold pow-
der. The underlying layer of gold is thus visible
only from the inside of the vessel. B. T.

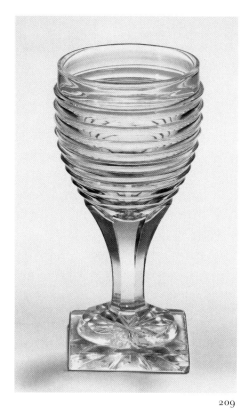

209

212

VIENNA, GOTTLOB SAMUEL MOHN

Tumbler plate, p. 142

*1814. Clear glass with translucent enamel painting,
silver-yellow staining, and gilding, height 3⅞"
(9.8 cm)
Inscribed "G. Mohn f. 14"
Museum für Kunst und Gewerbe, Hamburg.
1957,73*
References: *Jahrbuch der Hamburger Kunst-
sammlungen*, 3 (1958), p. 240; Spiegl, 1981, p. 149.

Glasses with floral decoration by Gottlob
Samuel Mohn are rare, and extremely early,
examples of the Biedermeier love of flowers.

Mohn used this particular depiction of a
bunch of garden flowers, superbly executed
and enclosed in a rectangular frame with
angled corners, on at least one further occasion
(see *Glas aus vier Jahrhunderten*, exhibition
catalogue [Vienna, Glasgalerie Michael Kova-
cek, 1982], p. 55). A similarly decorated glass of
even more stringent design is in the Öster-
reichisches Museum für angewandte Kunst,
Vienna (Spiegl, 1981, pl. VII). B. T.

213

VIENNA, ANTON KOTHGASSER (?)

Lamp Screen

*C. 1815. Maple, mother-of-pearl, steel, and glass,
height 15⅜" (39.1 cm)
The Metropolitan Museum of Art, New York,
Gift of Dr. Eugen Grabscheid, 1982. 1982.97.3.*
Reference: Pazaurek, p. 215.

The late eighteenth century brought a re-
awakened interest in stained glass. The first
products of the revival, by decorators of porce-
lain and glass vessels, were relatively small
paintings on glass. The panels of the present
screen may be considered an intermediate
stage between vessels and windows.
 This small, delicate appliance in the form of
a screen has the charm of a finely crafted toy. A
certain unfamiliarity with the technique of
painting on glass is revealed by the fact that the
views of Vienna on the panels are reversed from
their actual appearance.
 The employment of light maple in connec-
tion with mother-of-pearl and steel moldings
is characteristic of a Vienna workshop that
collaborated mainly with the miniaturist Bal-
thasar Wigand.

214

VIENNA, ANTON KOTHGASSER

Tumbler

*C. 1815. Clear glass with translucent enamel
painting, silver-yellow staining, and gilding,
height 4 1/16" (10.3 cm)
Inscribed "A: K:", "Ehret die Frauen! Sie flechten
und weben himmlische Rosen ins irdische Leben."
Germanisches Nationalmuseum, Nuremberg.
Gl. 495*
Reference: *Anzeiger des Germanischen National-
museums* (1969), p. 232.

Glasses inscribed with the first lines of Schil-
ler's "Frauenlob" – "Honor women! They
wreathe and weave heavenly roses into life on
earth" – were popular gifts and tokens of
friendship and were made in a great variety of
designs. On this cylindrical tumbler, Anton
Kothgasser framed the inscription in forget-
me-nots and roses, golden Cupid's arrows and
tendrils of ivy. The delicacy and brilliance of
color is characteristic of this artist's work. B. T.

215

VIENNA, ANTON KOTHGASSER

Tumbler

*C. 1815. Clear glass with translucent enamel paint-
ing, silver-yellow staining, and gilding, height 3⅞"
(9.8 cm)
Inscribed "Ehret die Männer! Sie sorgen und
heben, jedes Bedürfnis im häuslichen Leben."
Museen der Stadt Wien, Vienna. 116.472*
References: Pazaurek, p. 204, fig. 195; *Bürgersinn
und Aufbegehren*, cat. no. 6/1/21.

The glass with verses in praise of men – "Honor
men! They provide for and fulfill every need of
domestic life" – is much rarer than that bearing
lines from Schiller's "Frauenlob" (no. 214).
Here too, forget-me-nots, ivy, and Cupid's
arrows (pointing upward!) symbolize friend-
ship and love, but Kothgasser replaced the
roses on the women's glass by sunflowers. B. T.

216

VIENNA, ANTON KOTHGASSER

Tumbler (*Ranftbecher*) plate, p. 142

*C. 1820. Clear glass, cut, with translucent enamel
painting and gilding, height 4 3/16" (10.7 cm)
Inscribed "AK"
Badisches Landesmuseum, Karlsruhe. Heine
Collection 137.*
Reference: Baumgärtner, 1977, no. 137.

The particular charm of this piece derives from
the continuous depiction of an oatfield that
shimmers through from the opposite side to
lend the motif an appearance of perspective
depth. Cornflowers, sweet-peas, and butter-
flies provide accents of color.
 There is a glass bearing the same decoration
in the collection of the Kunstgewerbemuseum,
Berlin (*Kataloge des Kunstgewerbemuseums*, 10
[Berlin, 1985], no. 273). B. T.

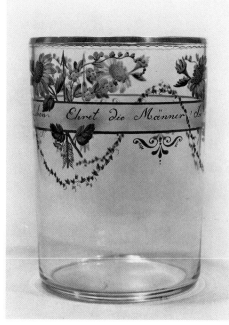

215

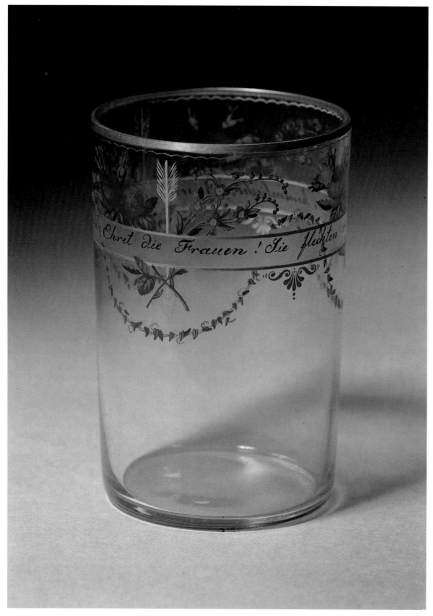

214

letters of the German names of the flowers depicted here spell out the name Theres.

An almost identical tumbler exists in a private collection (Spiegl, 1981, p. 159). B. T.

219

VIENNA, ANTON KOTHGASSER

Tumbler (*Ranftbecher*) plate, p. 142

C. 1825/30. Clear glass, cut, with translucent enamel painting, silver-yellow staining, and gilding, height 4⁷/₁₆″ (11.3 cm)
Badisches Landesmuseum, Karlsruhe. Heine Collection 144

Reference: Baumgärtner, 1977, no. 144.

The painted decoration of this conical tumbler consists of a goldfish on one side and a silver-gray fish on the other that appear to swim in the glass. Other, delicate color accents are provided by the gilded ribs of the projecting base, the gilded rim, the cut star on the bottom, and the band of silver-yellow staining, ornamented with gilded tendrils, around the top. B. T.

220

VIENNA plate, p. 143

Tumbler with Glass Bead Band

C. 1825/30. Clear glass, cut and engraved, and colored glass beads, height 4¹/₈″ (10.5 cm)
Badisches Landesmuseum, Karlsruhe, Heine Collection, no. 179

Reference: Baumgärtner, 1977, no. 179.

The slightly concave tumbler is adorned with a sheath of glass beads in a pattern of flowers, between cut arch facets below and engraved floral design above. Glass beadwork came into fashion in the eighteenth century and was especially popular during the Biedermeier epoch, both as a domestic handicraft used to decorate gifts and as a cottage industry supplying the glass factories. (See also no. 124.) B. T.

221

VIENNA, ANTON KOTHGASSER

Tumbler plate, p. 140

C. 1830. Clear glass, cut, with painting in opaque colors, silver-yellow staining, and gilding, height 4³/₁₆″ (10.9 cm)
Private collection (formerly Ruhmann Collection)

Reference: Leopold Rupprecht, "Die Gläser der Sammlung Ruhmann in Wien," *Belvedere,* 11 (1927), p. 123, no. 15.

Above the gilded area at the bottom, this tumbler bears a delightful continuous depiction of Cupid performing various tricks on a tightrope stretched between quivers that emerge from bunches of flowers – roses, but also the symbolically evocative pansy (*pensée*) and forget-me-not.

Glasses bearing the same decoration are preserved in the Kunstgewerbemuseum, Düsseldorf (1940–183), and in a private collection (Trenkwald, cat. no. 272). B. T.

217

VIENNA, ANTON KOTHGASSER

Tumbler (*Ranftbecher*)
with Leather Case plate, p. 141

C. 1820. Clear glass, cut and engraved, with translucent enamel painting, silver-yellow staining, and gilding, height 4¹/₂″ (11.5 cm)
Inscribed "AK", "Vüe de la place, dite Graben à Vienne."
Bayerisches Nationalmuseum, Munich. 47/2

Reference: Rückert, cat. no. 911.

Anton Kothgasser decorated a great number of glasses with views of Vienna, rendered with the precision typical of him. As patterns he frequently employed the *Sammlung von 36 Ansichten der Residenzstadt Wien,* a series of engravings published from 1778 onward – in this case No. 18, a view of the broad Graben

street. The series was used extensively by decorators of porcelain as well.

The tumbler is illustrated here with its original leather case. B. T.

218

VIENNA, ANTON KOTHGASSER

Tumbler (*Ranftbecher*) plate, p. 141

C. 1825. Clear glass, cut, with translucent enamel painting, height 4¹/₄″ (10.8 cm)
Kunstmuseum, Düsseldorf. 1940–182

Reference: Heinemeyer, no. 447.

Glasses with floral decoration that contained a hidden message were favorite gifts during the Biedermeier period (see also no. 158). The first

Silver and Cutlery

222

AMSTERDAM, EGIDIUS ADELAAR

Bowl

1820. Silver, height 4⁵/₈" (11.8 cm)
Marks: Head of Minerva, Meestertekens 2687,
annual letter L
Rijksmuseum, Amsterdam. 1978–131

Reference: Verbeek, fig. 16.

Flaring upward in a graceful curve, the bowl stands on a base that appears to consist of two circular slabs, the uppermost of which is edged with grooving – a so-called "fillet band" – that is repeated on the inside of the lip.

223

AMSTERDAM

DIEDERIK LODEWIJK BENNEWITZ

Coffeepot · plate, p. 173

1824. Silver, height 9³/₁₆" (23.4 cm)
Marks: Head of Minerva, Meestertekens 2438,
annual letter P
Rijksmuseum, Amsterdam. 1972–25

Reference: Verbeek, fig. 37.

With an approximately rectangular cross section, the body of the pot bulges sharply outward above a slablike base. The horizontal fluting at the top, looking almost machine-made in its strict regularity, forms a deliberate contrast with the elegant curves of the vessel. Bennewitz's other works are also characterized by a forceful and highly individual formal canon.

224

AMSTERDAM, JACOBUS CARRENHOF

Coffeepot with
Filter Attachment · plate, p. 175

1816. Silver, height 11⁵/₈" (29.5 cm)
Marks: Head of Minerva, Meestertekens 5901,
annual letter G
Rijksmuseum, Amsterdam. 1978–126

Reference: Verbeek, fig. 32.

Apart from the Empire designs of his early period, the Amsterdam goldsmith Carrenhof was a consistent representative of Biedermeier simplification, reducing forms to the point of completely unornamented geometric volumes that reveal the full beauty of the silver.

225

AMSTERDAM, JACOBUS CARRENHOF

Teapot with Warmer

1821. Silver, height 8¹/₁₆" (20.5 cm)
Marks: Head of Minerva, Meestertekens 5211,
annual letter M
Museum Boymans-van Beuningen, Rotterdam.
MBZ 105

References: A. L. den Blaauwen, *Nederlands zilver* (The Hague, 1979), no. 166; Verbeek, fig. 44.

The austere, forceful semicircular shape of the pot is augmented by the flat lid and rectangular handle. The warmer seems to consist solely of two of the fillet bands so popular in the Biedermeier period, connected by sturdy supports. The shape of the fluted, spherical feet is echoed in the knob on the lid.

226

AMSTERDAM, JAN ANTHONIUS DE HAAS

Teapot and Box · plate, p. 172

1820/21. Silver; a) pot, height 4⁵/₈" (11.8 cm),
b) box, height 3¹¹/₁₆" (9.4 cm).
Marks: Head of Minerva, DH above hare in
rhombus, annual letters L, M
Rijksmuseum, Amsterdam. 1978–130, 134

Reference: Verbeek, fig. 46.

The upward sweep of the vessels' edges stands in tense contrast to the low curve of the slightly concave lids. The sole ornament consists of fillet bands at the upper and lower edges. The large handle projecting above the body of the pot, its shape resembling part of a meander, was a favorite motif of many silversmiths of the period.

227

AMSTERDAM

JEAN THEODORE OOSTERMEYER

Caster · plate, p. 172

1817. Silver, height 8⁵/₈" (21.9 cm)
Marks: Head of Minerva, Meestertekens 5613,
annual letter H
Rijksmuseum, Amsterdam. 1978–128a

Reference: Verbeek, fig. 77.

A variation on a vessel type popular since the late eighteenth century, the caster acquires special charm from its wholly unconventional concave lid. This provides a tense contrast with the body of the vessel, an effect that is repeated in the base. Casters of this type, used for salt and pepper, had been in use in the Netherlands since around 1600.

222

225

229

228

AMSTERDAM
J. H. STELLINGWERF'S WIDOW

Two Pastry Containers plate, p. 174

1829. Silver; a) tin, 2⁷/₈ x 5⁷/₈ x 3¹⁵/₁₆"
(7.3 x 15 x 10 cm), b) tin, diameter 4⁷/₈" (12.4 cm),
c) tray, 11 x 8¹¹/₁₆" (28 x 22 cm)
Marks: Head of Minerva, Meestertekens 11406,
annual letter U
Haags Gemeentemuseum, The Hague.
EM6-1984 A/B/C

A round and a rectangular pastry container on a tray had been *de rigueur* for high tea in the Netherlands since the eighteenth century. The stringent design of the present pieces is relieved by one smooth and two finely fluted moldings and by a concave molding around the flat lids of the containers.

229

AUGSBURG, GEORG CHRISTOPH NEUSS

Candlesticks

1815. Silver, height 10³/₈" (26.3 cm) (each)
Marks: S 302, S 2665
Kestner-Museum, Hanover. 1920, 27 A, B

References: Helmut Seling, *Die Kunst der Augsburger Goldschmiede 1529–1868*, vol. 3 (Munich, 1980), p. 435, no. 2665c, fig. 1093; Hildegard Hoos, ed., *Kerzenleuchter aus acht Jahrhunderten*, exhibition catalogue (Frankfurt am Main, 1987), cat. no. 157.

The candlesticks are distinguished from countless variations on the usual form for such objects by their highly original inverted funnel shape, which is crowned by a stylized oil-lamp. The design is based on the juxtaposition of polished rounded surfaces.

230

BERLIN, GOTTLOB LUDWIG HOWALDT

Teapot with Warmer plate, p. 176

C. 1825. Silver, height 12³/₈" (31.5 cm)
Marks: Scheffler 14, 18, 326
Berlin Museum, Berlin. KGM 69.4

The sweeping curve of the handle and the flat lid provide a tense contrast to the flattened spherical shape of the pot. The lamp is integrated in a highly original manner into the stand, which has a light, sprung appearance.

231

COPENHAGEN, RASMUS BROCK

Basket with Handle plate, p. 176

1828. Silver wire, 8¹¹/₁₆ x 8⁷/₈ x 8⁷/₁₆"
(22 x 22.5 x 21.5 cm)
Inscribed "d 29 April 1828"
Marks: Copenhagen 1828, Rasmus Brock [Bøje, 1060], warden mark I. G. G. Fabricius, month mark March/April
Nationalmuseet, Copenhagen. 272/1913

233

Reference: A. Bøje, *Danske Guld og Sølv Smedemaerker før 1870*, 3rd ed. (Copenhagen, 1979), p. 209.

The handle has an inlaid plate decorated with embossed flowers and leaves; the hinges are faced with cast rosettes.

232

COPENHAGEN, NICOLAI CHRISTENSEN

Tea Caddy

1820. Silver; height 3⅞" (9.8 cm), diameter 2¾" (7 cm)
Marks: Copenhagen 1820, Nicolai Christensen, guildmaster Frederik Fabricius

Det Danske Kunstindustrimuseum, Copenhagen. 5/1945

The barrel shape has an innate tension that was very much in keeping with the stylistic propensities of the Biedermeier era. Simple engraved ornament emphasizes the upper end of the vessel without interrupting the sweep of the overall form.

233

HANOVER

ANTON GEORG EBERHARD BAHLSEN

Sugar Bowl

C. 1830. Silver, and blue glass, 5⅛ x 5½ x 4¹/₁₆" (13 x 14 x 10.3 cm)
Mark: BAHLSEN
Historisches Museum am Hohen Ufer, Hanover. VM 17583

The effect of the piece derives from the combination of glossy blue glass with polished silver. The legs extend upward in an elegant curve to cradle the bowl, which is adorned with the grapevine motif so popular in the Biedermeier period.

234

HANOVER, JOHANN GOTTLIEB MATTHIAS

Creamer

C. 1815. Silver, partly gilded, height 3⁹/₁₆" (9 cm)
Marks: MATTHIAS, hallmark 12
Kestner-Museum, Hanover. 1963,40

Reference: Wolfgang Scheffler, *Goldschmiede Niedersachsens* (Berlin, 1965), p. 741.

The strongly expanding form and grooved base of this creamer reveal Dutch influence. The lip merges with the handle in an extremely graceful curve.

235

MUNICH, ANTON WEISHAUPT

Tumbler

1817. Silver, gilded, height 3" (7.6 cm)
Marks: R³ 3463, W:haupt

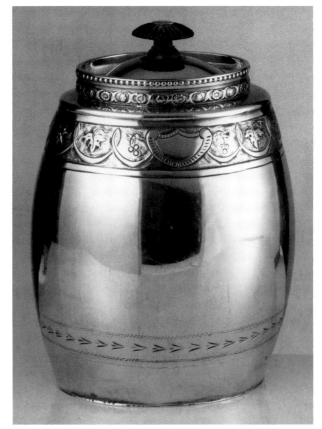

232

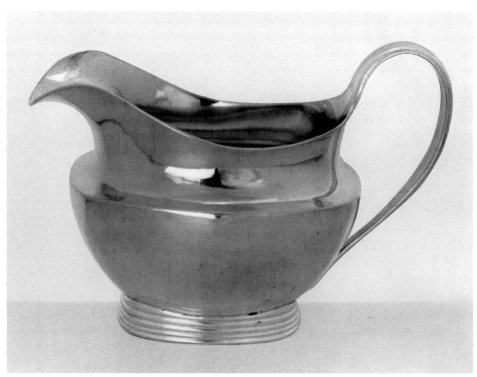

234

*Bayerisches Nationalmuseum, Munich, on perma-
nent loan from the Benno und Therese Danner'sche
Kunstgewerbestiftung. L 86/225*
Reference: *Münchner Jahrbuch der bildenden
Kunst*, 38 (1987), p. 248 f.

Widening slightly toward the top and com-
pletely without decoration, the tumbler is
round inside and has seventeen facets on the
outside. The simple object acquires presence
and a certain weight through the austerity of its
form. Weishaupt also produced highly complex
pieces for the Munich court.

236

STUTTGART, JOSEPH HIRSCHVOGEL

Sugar Bowl

*C. 1825. Silver; height 5⁵/₁₆″ (13.5 cm), diameter
4¹/₂″ (11.5 cm)
Marks: Stuttgart, HvL, annual letter Q
Inscribed "AS"
Württembergisches Landesmuseum, Stuttgart.
G 4892*

The vessel is dominated by the contrast
between its flattened spherical shape, the low,
stepped base with short shaft, and the wide rim
that flares out above the lid.

237

VIENNA

Salt and Pepper Holder

*1818. Silver, height 3¹/₈″ (8 cm)
Mark: Vienna 1818
Private collection*

Tubs made of staves held together by metal
rings were a favorite Biedermeier pattern for
small vessels made of precious materials.

238

VIENNA

Snuffbox plate, p. 178

*1818. Silver; length 3⁷/₁₆″ (8.7 cm), diameter 1³/₁₆″
(3 cm)
Mark: Vienna 1818
Private collection, Vienna*

The stringent geometric form of this pocket-
size cylindrical snuffbox is heightened by
equally stringent grooving.

239

VIENNA, PETER HÖCKH

Saltcellar plate, p. 178

*Probably 1825. Silver, height 3¹/₈″ (7.9 cm)
Marks: Vienna 18[?]5, PH [Knies, p. 13]
Private collection, Vienna*

The organic forms of the three stylized reeds,
intertwined and rolled at the ends, stand in
deliberate contrast to the geometric forms of
the grooved base and bowl.

235

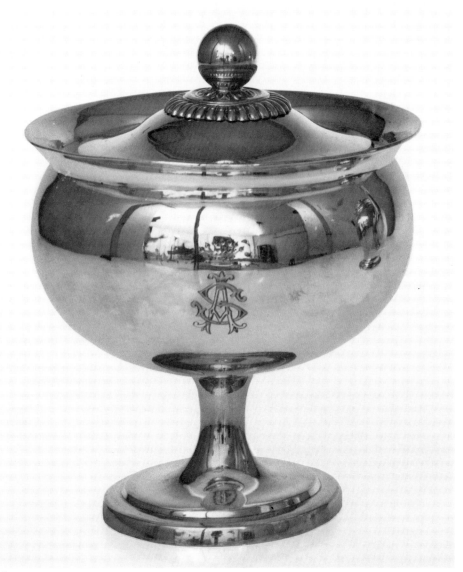

236

240

VIENNA, ANTON KÖLL

Two Coffeepots plate, p. 177

1817. Silver, interior gilded, and ebony; heights
a) 9⁷/₁₆" (24 cm), b) 7¹¹/₁₆" (19.5 cm)
Marks: Vienna 1817, AK, tax stamp FT [Knies, p. 13]
Germanisches Nationalmuseum, Nuremberg.
HG 12227

Reference: *Anzeiger des Germanischen National-*
museums (1985), p. 101.

The smooth, conical pot has a stepped base and
a lid that tapers upward in a sharp curve from
the raised, indented rim. Continuing the line of
the side, the handle sweeps upward to end in a
scroll – an ingenious, elegant solution that is
practical as well.

241

VIENNA, ANTON KREISSEL

Coffeepot plate, p. 179

1817. Silver, height 5¹/₈" (13 cm)
Marks: Vienna 1817, AK
Private collection, Vienna

The body of the vessel consists of an ellipsoid
truncated at corresponding points at top and
bottom. The curves of the large spout are
echoed by those of the tall handle. A stylized
acorn knob is the sole decorative appurte-
nance.

242

VIENNA, KARL WALLNÖFER

Sauceboat plate, p. 181

1829. Silver, length 10⁵/₈" (27 cm)
Marks: Vienna 1829, Wallnöfer [in italics]
Private collection, Vienna

Formed from a single sheet of silver, the body of
this piece represents a superb technical
achievement. Nonetheless, the most important
consideration for Biedermeier craftsmen in
producing household implements remained
utility. With this sauceboat, the Viennese
goldsmith Wallnöfer proved beyond the
shadow of a doubt that rational, functional
design can indeed be allied with beauty of
form.

243

VIENNA, ANDREAS WEICHESMÜLLER

Box plate, p. 180

1824. Silver; height 2" (5 cm), diameter 3¹/₄" (8.3 cm)
Marks: Vienna 1824, AW [Knies, p. 29]
Private collection, Vienna

The unornamented, truncated cylinder is
articulated solely by means of the projecting lip
of the lid, which appears to have been formed
under pressure. Simplicity of form, perfection
of workmanship, and the shimmer of the pre-
cious material lend this piece great dignity.

244

WÜRZBURG, HEINRICH RIESING

Cup and Saucer

C. 1835. Silver, partly gilded; a) cup, height 3³/₁₆"
(8.1 cm), b) saucer, diameter 5³/₈" (13.7 cm)
Marks: R³ 4943, RIESING [inscribed in a rectangle]
Mainfränkisches Museum, Würzburg. 62166

The popularity of cups as gifts in the Bieder-
meier period led even silversmiths to produce
them. Like most of the elaborately painted
porcelain or glass pieces, they were intended
solely for display.

245

GERMANY

Three Table Knives

C. 1830. Ebony and steel, gilded and blued, length
8¹/₁₆" (20.5 cm) (each)
Deutsches Klingenmuseum, Solingen. 104–106

After cups and boxes, caskets and bags, albums
and pipebowls, knives too became suitable as
gifts during the Biedermeier era. The subjects
employed in the elaborate decoration of the
blades were no different from those used on
cups or glasses: town views (in the present case,
of Bonn), hunting scenes, and motifs or mot-
toes pertaining to friendship.

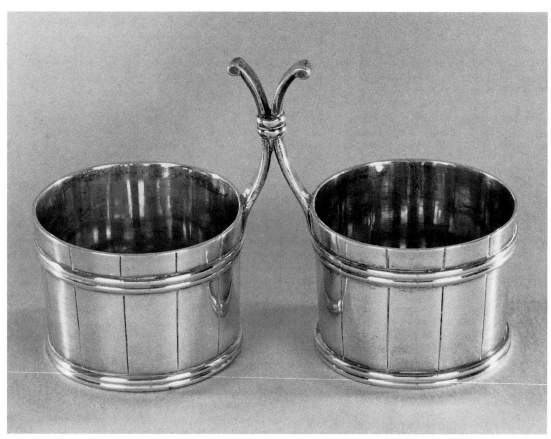

237

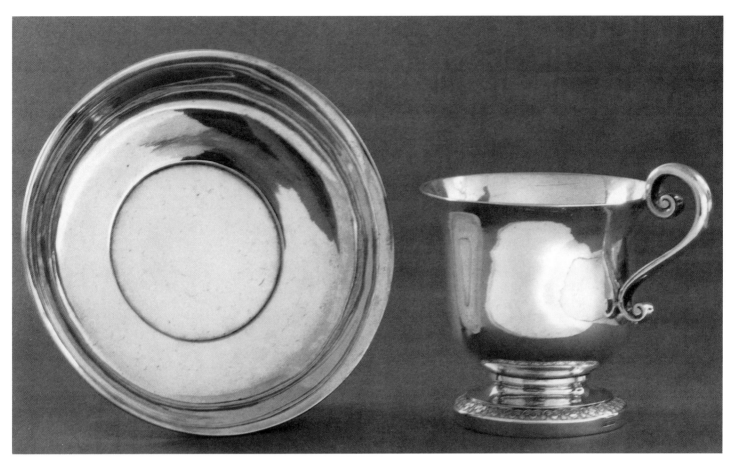

244

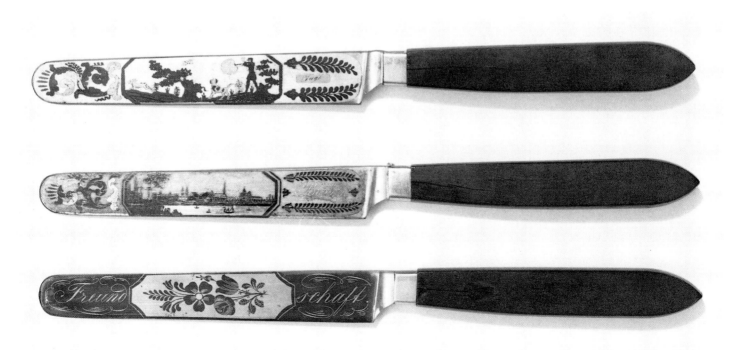

245

Fashion and Textiles

246

VIENNA, PAUL MESTROZI

Nine Textile Samples plate, p. 155

1819. Velvet, 17⁵/₁₆ x 13³/₁₆" (44 x 33.5 cm) (card)
Inscribed "Aus der Mestrozischen Fabrik in Wien, 1819."
Österreichisches Museum für angewandte Kunst, Vienna. TGM 23074

Under the Austro-Hungarian monarchy textile manufacturers regularly submitted samples of their latest wares to the Fabriksprodukten-kabinett in Vienna (see no. 195). The present pieces from a sample card of the Wiener Weberei, founded by Josef Mestrozi in 1777, were known as "miniature velvets" – small-patterned materials for men's vests.

247

VIENNA, PAUL MESTROZI plate, p. 154

Detail of a Textile Sample Card

1820. Silk, 17 x 13¼" (43.2 x 33.6 cm) (card)
Inscribed "Von Paul Mestrozi in Wien, 1820."
Österreichisches Museum für angewandte Kunst, Vienna. TGM 23077

Over a yard long, the material consists of "15 differently patterned silk stuffs from the Jacquart [sic] loom." The mechanical loom invented by Jacquard in 1805 came into widespread use in the course of the Biedermeier period. As the manufacturer noted, his samples illustrate "the perfection of this machine and the great variety of designs of which it is capable."

In Vienna, Mestrozi and Hornbostel (see no. 248) competed with one another in the introduction of new textile machinery.

248

VIENNA, CHRISTIAN GEORG HORNBOSTEL

Textile Sample plate, p. 154

1821. Gauze, 17¹/₈ x 13¹/₈" (43.5 x 33.5 cm) (card)
Inscribed "Aus der Hornborstel'schen [sic] Seiden-zeugfabrik in Wien, 1821."
Österreichisches Museum für angewandte Kunst, Vienna. TGM 23043

The sample is one of eight on a card produced by Hornbostel's Wiener Seidenfabrik. They consist of variously patterned pieces of silk gauze, some including straw, for dresses and handkerchiefs.

Christian Georg Hornbostel employed mechanical looms of his own design as early as 1816, and introduced a number of other improvements in spinning and weaving.

249

VIENNA, JOSEF FEHR

Three Textile Samples plate, p. 155

1824. Poplin, 17¹/₈ x 13³/₁₆" (43.5 x 33.5 cm) (card)
Inscribed "Von Joseph [sic] Fehr dem Jüngern in Wien, 1824", "Ecorces d'arbres, quadrilliert"
Österreichisches Museum für angewandte Kunst, Vienna. TGM 22491

These cotton materials with a silk weft, part of a card containing six samples, bear so-called Scottish patterns in lively colors. The inscription describes them as "checked bark."

Fehr was known for his "half-merinos" of wool and cotton, "in all colors, including striped, checked, embroidered, and printed." (See also no. 251.)

250

VIENNA, PETER GIANICELLI

Textile Sample plate, p. 154

1826. Velvet, 17¹/₈ x 13³/₁₆" (43.5 x 33.5 cm) (card)
Inscribed "Von dem Seidenzeug-Appreteur Peter Gianicelli in Wien, 1826."
Österreichisches Museum für angewandte Kunst, Vienna. TGM 23196

The piece forms part of a card containing seven samples of velvet material patterned by a new process: although they appear to have been cut, the patterns are in fact impressed. In 1825 Gianicelli received a patent on his "machine of cast iron ... by means of which patterns of the most varied kind can be impressed in silk and cotton materials of every sort using punched metal rollers."

251

VIENNA, JOSEF FEHR

Two Textile Samples plate, p. 152

1829. Poplin, 16⁵/₁₆ x 13³/₁₆" (43 x 33.5 cm) (card)
Inscribed "Von Jos. Fehr in Wien, 1829."
Österreichisches Museum für angewandte Kunst, Vienna. TGM 22497

The pieces of cotton fabric with a silk weft, from a card containing three samples, are printed in lively patterns and were intended for women's dresses. (See also no. 249.)

252

KETTENHOF (VIENNA)

SALOMON AND VEIT MEYER

Textile Sample Card plate, p. 153

1829. Calico, 16⁵/₁₆ x 13³/₁₆" (43 x 33.5 cm)
Inscribed "Aus der Kettenhofer Ziz- und Kattun-fabrik, 1829."
Österreichisches Museum für angewandte Kunst, Vienna. TGM 20294

The fifteen samples, made from a calico known as cambric, are printed in very dark colors and were intended for use in aprons, blouses, and scarves.

The Kettenhof chintz and calico factory was established by Count Cajetan von Blümegen in 1770. After leasing it in 1827, the Meyer brothers soon expanded the enterprise into the largest calico producer in the Austro-Hungarian Empire.

253

GERMANY plate. p. 145

Tailcoat of King Ludwig I of Bavaria

C. 1830. Cashmere, silk, and brass buttons; length 40¹/₈" (102 cm), width of back 15" (38 cm)
Bayerisches Nationalmuseum, Munich. T 5843

The tailcoat is made of extremely fine black cashmere. The waist-length front is cut straight, while the back has a middle seam, two sharply tapering seams, and half-round sleeve seams running over the shoulder. The long, straight, seamless tails overlap and form a slit that runs the entire length of the coat from the waist downward. The sleeves are particularly long and narrow, with slightly flared cuffs. Hemispherical brass buttons, with tendril decoration, are arranged in pairs to form a "V" down the double breast. There are pairs of buttons at the top and on the hem of the slit, and three smaller ones on the cuffs. All edges are finished with narrow braided silk trimming. The lining is of black silk (*cannelé*), and there is thick, woolen-core padding in the shoulders and around the hips.

A dating of circa 1830 is indicated by the straight cut of the garment, the long sleeves, the flaring cuffs, and the collar, with its characteristic finger-width gap between the upper section and the lapels. To quote the *Journal des Dames et des Modes* for 1828, "For a collar to be fashionable, one must be able to insert one's finger between the turned-down part and the lower part" (I, p. 694). S. D.-R.

254

GERMANY plate, p. 144

Vest of King Ludwig I of Bavaria

C. 1832/35. Wool with silk, silk, and cotton; length 20⁷/₈" (53 cm), width of front 15¹/₂" (39.5 cm), pattern repeat 1³/₄ x 1¹⁵/₁₆" (4.4 x 4.9 cm)
Bayerisches Nationalmuseum, Munich. T 5374

The waist-length, double-breasted vest of wool-and-silk fabric bears a red and green pattern (tabby *liseré* with pattern weft). The hem extends downward at the center, the slit pockets have narrow diagonal flaps. The narrow, rounded, turndown collar and the lapels are lined with wine-red velvet. The small buttons are arranged in a V-shape and made from the same material as the vest; the two lapel buttons are covered with velvet. All edges are finished with a narrow silk trim in the four colors of the fabric (plied yarn of white, red, brown, and green silk). The back is made of black silk, with two straps and a buckle for regulating width. The lining is of cream-colored cotton.

In the early 1850s cashmere patterns became popular in men's as well as women's fashions. An example is the finely patterned, probably French, material of this vest, which shows a characteristic formal repertoire of stylized vases with inscribed palmettes alternating with rows of forked tendrils flanked by trefoil shields. Also characteristic of the 1850s is the close-fitting collar, which superseded the broad shawl collar popular in the late 1820s.

In 1852 the *Journal des Dames et des Modes* noted: "Men are beginning to wear cashmere waistcoats with palms or other designs" (I, p. 54). s.d.-r.

255

GERMANY plate, p. 144

Vest of King Ludwig I of Bavaria

1837. Silk and cotton; length 24³/₄" (63 cm), width 16⅞" (43 cm)
Inscribed "Am 25. Dec. 1837."
Bayerisches Nationalmuseum, Munich. T 5375

The sleeveless, single-breasted vest with narrow shoulders has a broad, close-fitting shawl collar and a single row of buttons in the center. The flaps of the slit pockets taper toward the lateral seams. The lower hem extends downward to a point. The side and back pieces are lined with unbleached cotton; the width of the back can be adjusted by means of two broad straps tied with laces. The front hem is doubled with white wool.

The weave of the silk is satin with brocading and pattern wefts. An agitated linear pattern is created on the white ground by the pattern weft of silver lamella, while vertical rows of heart-shaped leaves in the sequence red, red and green, green are produced by additional brocading weft in chenille.

White or light-colored waistcoats dappled with leaf motifs in bright colors came into fashion as early as 1820. However, these were usually made of cotton piqué, a material very popular in the 1820s: "The new vest materials are white, chamois, butter- or straw-yellow piqués with patterns of small leaves in sky blue, purple, rust brown, chamois" (*Journal des Dames et des Modes*, I [1820], p. 446).

The background shimmering with linear ornament and the brilliant colors of the contrasting leaf motifs in the present vest are characteristic of the 1850s, as are certain details of the cut. s.d.-r.

256

GERMANY plate, p. 146 (left)

Trousers of King Ludwig I of Bavaria

C. 1832/35. Linen, cotton, and bone buttons; overall length 52¼" (134 cm), waist 37" (94 cm), pattern repeat 1⁹/₁₆ x ¹³/₁₆" (4 x 2 cm)
Bayerisches Nationalmuseum, Munich. T 5531

The waistband, cut waist-high in front and considerably higher at the back, is adjustable

by means of a belt with a metal buckle. The straight ends of the legs are equipped with leather-lined, buttoned straps, while the slit side pockets have loose flaps that button at the side seam. Pockets and waistband are lined with cream-colored cotton. The subtle coloring of the check results from a two-colored warp and the two tones of the weft: wide, light-brown and light-blue stripes are divided vertically by narrow, dark-brown stripes.

Stripes and checks were very popular in men's fashion in the 1850s: "In trousers one wears blue checked linen and striped calico" (*Allgemeine Modenzeitung* [1852], p. 167). s.d.-r.

257

GERMANY plate, p. 146 (right)

Trousers of King Ludwig I of Bavaria

1840. Linen, cotton, and wooden buttons; overall length 50⅜" (128 cm), waist 35⅞" (91 cm), pattern repeat ¼ x ¼" (0.6 x 0.6 cm)
Inscribed "Monat May 1840"
Bayerisches Nationalmuseum, Munich. T 5538

The fine check in dark brown, light brown, cream, and light blue was produced with two-colored warp and two-colored weft, whereby the checks alternate in terms of weave as well – warp twill and weft twill.

For the cut, see no. 256: the narrower waist and shorter legs of the present garment were characteristic of men's trousers in the late 1850s. s.d.-r.

258

GERMANY

Silk Dress

plate, p. 148

C. 1820/25. Silk (cannelé, satin, gauze, taffeta); overall length 48⅜" (123 cm), hem length 81⅞" (208 cm), pattern repeat 1¾ x 1" (4.5 x 2.5 cm)
Bayerisches Nationalmuseum, Munich. 23/30

The colors of the finely patterned, dark lilac and brown silk (*droguet*) have faded. The short, close-fitting bodice is tailored to the figure by means of three front darts and fastened at the back with hooks and eyes. A pleated trim frames the oval neckline, running from the shoulders in a shallow V-shape that ends just above the high waist. The skirt consists of a wide center section, two narrow side sections, and two rear sections that are heavily gathered and fastened by means of a cord. The lower part of the skirt is adorned with "satin puffs" consisting of crossed, twin arcs over short, pleated tulle flounces; they are fastened by means of satin-covered rosettes. Similar rosettes decorate the bodice and flank the intertwined satin bands on the puffed sleeves. Stuffed satin tubes and tulle flounces are repeated on the hems of the skirt and sleeves. The lining is made of a dark-brown silk taffeta. A dress of very similar cut and decoration was illustrated in the *Journal des Dames et des Modes* for 1821 (II, plate 48). s.d.-r.

259

SOUTHERN GERMANY
FABRIC: AUGSBURG

Summer Dress

plate, p. 149

C. 1830. Cotton, printed, and metal fasteners; overall length 48⅞" (124 cm), hem length 123¼" (313 cm), sleeve length 37" (94 cm)
Bayerisches Nationalmuseum, Munich. T 6337

The closely-fitting bodice has three darts, a piped middle seam, and hook fasteners at the back. Its oval neckline is set off by horizontal quilted pleats, while the long gigot sleeves are richly gathered at the shoulder and end in narrow cuffs. The full, gathered skirt has a slit at the back of the waist. All seams and hems are piped. The light, fine cotton fabric is printed in four colors: a light-gray ground with lilac polka dots; large lilac diamonds filled with branching, sinuous lines and arranged vertically in wavy rows; and irregular octagons in white with superimposed yellow diamonds, arranged in pairs.

The color scheme, the formal repertoire, and the close weave of the picots at specific points were characteristic of Augsburg cotton printing until the early 1850s. s.d.-r.

260

HUNGARY

Girl's Dress

plate, p. 147

C. 1835. Cotton and glass beads, overall length 32⅞" (83.5 cm)
Iparmüvészeti Muzeum, Budapest. 76.129
References: E. László-Dósza, *Historic Hungarian Costume from Budapest*, exhibition catalogue (Manchester, 1979), cat. no. 47; Lilla Tompos, *A gyöngy és a divat* (Budapest, 1979), cat. no. 5; *Müvészet és mesterség* (Budapest, 1985).

The long-sleeved girl's dress, with a straight skirt that flares toward the hem, is made of white cotton embroidered with colored glass beads. The round neckline is gathered with a ribbon and, like the sleeves and lower part of the skirt, is adorned with rows of embroidered flaps. The pattern of glass beads consists of pink flowers with green leaves and, between the geometric bands at the bottom of the skirt, a capital "S" in a heart framed by climbing roses that are flanked by fruit trees and potted plants.

Glass beadwork was a very popular form of decoration in the Biedermeier period (see also nos. 124, 157, 220). l.t.

261

SOUTHERN GERMANY
FABRIC: AUGSBURG

Cotton Dress

plate, p. 148

C. 1836/38. Cotton, printed, and metal fasteners; overall length 50¼" (129 cm), hem length 140⅛" (356 cm), waist 26⅜" (67 cm)
Bayerisches Nationalmuseum, Munich. NN 3593

The front of the bodice is made up of four vertical, piped insets that taper to a point at the waist. The sleeves are pleated at the shoulder and are taken up above the elbow by means of two piped bands with pleated flounces. The back, fastened with hooks, is tailored by means of two curved darts extending from shoulder to waist. The skirt has simple, wide pleats in front and is gathered at the back.

The attractive pattern of delicate red tendrils over a fine background of dots scattered with white "eyes" was apparently one of the most popular tendril patterns produced by the Neue Augsburger Kattunfabrik and is still being made today in a slightly varied form. A comparison of the sleeve and bodice design with garments illustrated in contemporary fashion journals enables the dress to be dated to between 1856 and 1858. S.D.-R.

262

MUNICH, J.G. PETER

Straw Bonnet worn by
Queen Caroline of Bavaria plate, p. 151

*C. 1835/40. Straw and silk; length 10¼" (26 cm),
circumference 22⅞" (58 cm)
Inscribed: "J.G. Peter / Stroh und Baastwaren /
Fabrikant / Schwabingerstrasse No. 51 / in
München" (printed label)
Bayerisches Nationalmuseum, Munich. T 4797*

The bonnet is made of natural and dark-brown patterned Florentine straw braid, the pieces sewn together lengthwise and forming concentric circles at the back. Toward the rear, it is trimmed with a pink-and-turquoise checked silk ribbon that is tied in a double bow on the left. Two bands of the same silk ribbon are attached for tying under the wearer's chin. The lining is of cotton gauze.

The long, narrow shape of the bonnet and the decoration of the ribbons indicate a date in the late 1830s. Comparable bonnet designs were illustrated as late as 1841 in the *Journal des Dames et des Modes* (March 1841, fig. 5).
 S.D.-R.

263

FRANCE

Shawl worn by Queen
Caroline of Bavaria plate, p. 147

*C. 1820/25. Silk and cotton, 50⅝ x 106½"
(128.5 x 270.5 cm)
Bayerisches Nationalmuseum, Munich. T 4791*

The cashmere shawl of yellow silk (twill weave 2/2 s) is decorated on the narrow sides with a wide border of palm design produced by pattern weft in dark red, light red, green, dark green, light blue, turquoise, ocher, and white cotton. The eight upright palm fronds are filled with palmettes, starworts, lotuses, and rosettes. Around this inner field is a narrow border consisting of blue rosettes on white-leafed stems which is surrounded in the lower, indented area by a wreath of radial feathered leaves and, in the upper area, by lotuses and palmettes. The area between the palm fronds is occupied by an elaborate pattern of stems with rosettes and cruciform flowers, some of them in vases and with radial feathered leaves. Around these borders and on the long sides of the shawl are narrow borders of tendrils and lotus or cruciform blossoms on a white ground (the borders are sewn onto the long sides). Above the broad borders, smaller stylized palm trees and flowering trees extend into the yellow field.

The weave and the pattern of the shawl indicate French manufacture (see Monique Levi-Strauss, *Cashmere* [Frankfurt am Main, 1987], figs. p. 66f.). S.D.-R.

264

GERMANY

Women's Shoes plate, p. 151

*C. 1830/35. Silk and silver lamella, tapestry woven,
satin, silver braid, and leather; length 9" (23 cm),
width 2⅛" (5.5 cm) (each)
Bayerisches Nationalmuseum, Munich. 28/3062
Reference: Modisches aus alter Zeit: Accessoires
aus vier Jahrhunderten, exhibition catalogue
(Munich, 1979), fig. 19.*

The tapestry weaving of the heelless shoes with flat toes consists of silk and accents of silver lamella in a pattern of branches with red and green leaves on a natural, off-white background. The edges are trimmed with a twin flounce of wine-red satin and a large rosette of the same material is attached to the front of the opening. The shoes are lined with white satin and their leather soles are very narrow. Ladies' shoes with extremely flat toes of this kind were not illustrated in fashion journals until the early 1830s. S.D.-R.

265

GERMANY

Work Basket plate, p. 150

*C. 1830. Cotton, knitted, glass beads, cardboard,
and wood; height 8½" (21.5 cm), largest diameter
5⅜" (13.5 cm)
Bayerisches Nationalmuseum, Munich. 24/372
Reference: Modisches aus alter Zeit: Accessoires
aus vier Jahrhunderten, exhibition catalogue
(Munich, 1979), fig. 26.*

The cotton yarn is knitted primarily in purled stitches, with the ribbed pattern of the lower part made of ladder stitches. The round bottom of the basket is reinforced with cardboard, and a wooden ring runs around the middle of the bag, which is gathered at the top by a cotton cord with tassel. An arrowhead pattern on the base and middle ring is formed of very fine dark-blue beads, while the ribs are accentuated by pairs of amber yellow beads knit into the cotton. The upper part of the bag is decorated with a pattern of scattered dark-blue flowers on either side of a wide, continuous ring of roses and forget-me-nots in various shades of green, blue, red, pink, and yellow. S.D.-R.

266

SOUTHERN GERMANY

Work Basket plate, p. 150

*C. 1835. Satin, embroidered, cardboard, and
paper, printed; height 7½" (19 cm), width 4⅛"
(11 cm)
Inscribed "Wandle auf Rosen und / Vergissmein-
nicht / Dein Leben sey heiter / wie Sonnenlicht."
Bayerisches Nationalmuseum, Munich. T 5799
Reference: Modisches aus alter Zeit: Accessoires
aus vier Jahrhunderten, exhibition catalogue
(Munich, 1979), fig. 32.*

The four-sided reinforced fabric bag is indented above the base and has concave sides. The basket consists of black satin embroidered in color, with edges, flounces, and bows made of pink silk taffeta. There is an inner bag of black satin with cord-pull closure. A flower adorns each of the four sides: a rose, forget-me-not, carnation, and violet (?), embroidered in green, red, ocher, lilac, blue, and white. Beneath these is an embroidered verse. The floor of the bag is decorated with pink paper printed in a pattern of small black flowers.

 S.D.-R.

Jewelry

267

SOUTHERN GERMANY

Necklace plate, p. 159

C. 1820. Gold and amethysts, length 17¹/₈" (44 cm)
Städtische Kunstsammlungen, Augsburg. 5961
Reference: Marquardt, cat. no. 31.

The elaborate necklace consists of twelve rose-cut amethysts that increase in size toward the largest stone in the center and are interspersed with small, facetted stones of narrow oval shape, to which tiny cast flowers are attached (see also no. 268).

A piece of such splendor was certainly part of a parure. I.H.

268

GERMANY

Friendship Necklace plate, p. 159

C. 1820. Gold, precious stones, glass beads, and enamel, length 16" (40.5 cm)
Bayerisches Nationalmuseum, Munich. 58/34
References: *Münchner Jahrbuch der bildenden Kunst*, 11 (1960), p. 252; Marquardt, cat. no. 32.

The first letters of the German names of the twelve stones (the most precious of which are imitations) spell the word *Freundschaft* (friendship). The meaning of the piece is underscored by links in the form of *pensées* (pansies) and forget-me-nots, and perhaps also by the colors of the bead garlands, which signify faithfulness, love, and purity. I.H.

269

BERLIN (?)

Necklace

1820/30. Steel wire, length 21¹/₄" (54 cm)
Staatliche Schlösser und Gärten, Berlin.
Ks IV/327
Reference: Arenhövel, 1982, cat. no. 333.

The relatively large links consist of closely arranged spirals of twisted wire, a finely crafted pattern that softens the severely graphic effect of the piece. (See also nos. 272, 279.) I.H.

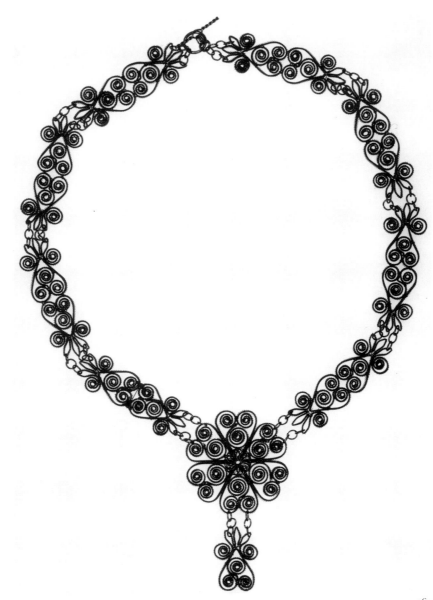

269

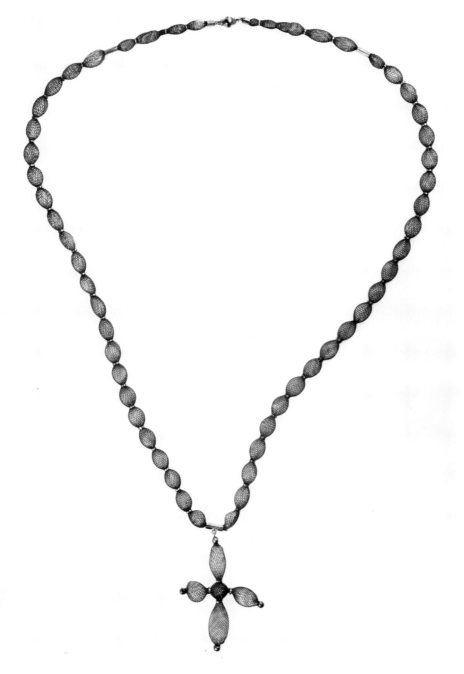

270

GERMANY

Necklace

C. 1820/25. Human hair and silver gilt, overall length approx. 35½" (90 cm)
Bayerisches Nationalmuseum, Munich.
Kr. A 904

The elaborately braided length of human hair is divided by small metal rings into 55 "beads," with a five-part cross pendant in the center. Popular custom has always attributed special significance to human hair, to offer it being considered a sign of humility. Particularly fashionable in the nineteenth century, jewelry made of hair was given as a token of love or as a memento (see also no. 286). I. H.

271

GERMANY

Bracelet plate, p. 158

C. 1820. Glass beads and brass, gilded, length 6¹¹⁄₁₆" (17 cm)
Collection Dr. Hella Reelfs, Berlin

Glass beadwork was popular in the Biedermeier period, and printed instructions were available for every type of pattern and weave. This bracelet, with its beads strung together to form blossoms and its butterfly in the center, was probably intended for a child. (See also no. 260.) I. H.

272

BERLIN (?)

Bracelet

1820/30. Steel wire, length 7¹¹⁄₁₆" (19.5 cm)
Staatliche Schlösser und Gärten, Berlin. Ks IV/323
Reference: Arenhövel, 1982, no. 334.

A special type of jewelry, probably made in Berlin, consisted of twisted wire of various gauges, woven wire, and wire mesh so fine as to resemble tulle. These pieces represented the first attempt to employ machine-made materials and forms in the design of jewelry. (See also nos. 269, 279.) I. H.

270

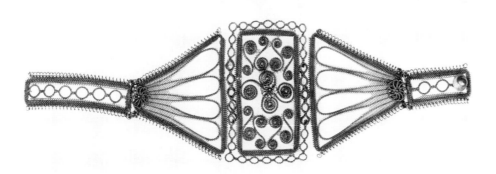

272

273

IDAR-OBERSTEIN

Bracelet plate, p. 158

C. 1835. Agate and tombac, length 7¹¹/₁₆″ (19.5 cm)
Private collection, Munich

Bracelets of this kind, with semiprecious stones of various colors and patterns, were common travel souvenirs in the Biedermeier period. The special charm of this piece lies in the combination of the simple, flattened oval form of the stones in their plain settings with the globular shapes on the round links. I. H.

274

SOUTHERN GERMANY

Hairpin

C. 1830/35. Brass, gilded, length 8⅛″ (20.7 cm)
Kurpfälzisches Museum der Stadt Heidelberg, Heidelberg. ST 540

During the Biedermeier period a great deal of care and imagination was devoted to women's hairdressing, which could include hairpieces and additional adornments. Originally, hairpins in the form of arrows, intended for insertion through a bun, certainly represented an allusion to Cupid's darts. (See also Marquardt, fig. 120 and cat. no. 243, and Arenhövel, 1982, cat. no. 284.) I. H.

275

BERLIN, JOHANN KONRAD GEISS (?)

Belt

1820/30. Cast iron, partly gilded, length 28¹/₂″
(72.5 cm)
Staatliche Museen Preussischer Kulturbesitz,
Kunstgewerbemuseum, Berlin. W-DI 19a

Reference: Arenhövel, 1982, cat. no. 508.

The forty-eight links of the belt, each about two inches long, are extremely delicately crafted. They show the popular vine leaf motif in a variant consisting of a stem bearing three leaves and two clusters of grapes. I. H.

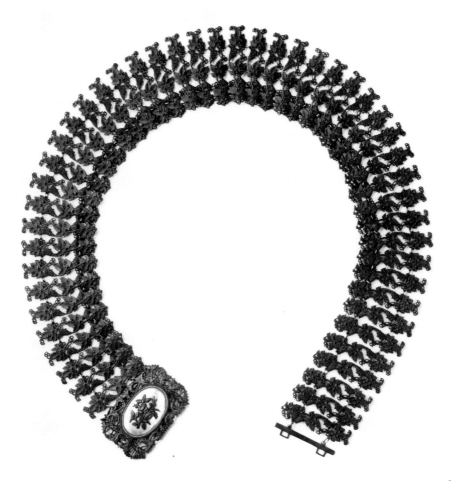

275

Metalwork

276

ROYAL PRUSSIAN FOUNDRIES

Incense Burner

1815/25. Cast iron, height 5⁷/₁₆" (13.8 cm)
Staatliche Schlösser und Gärten, Berlin. Ks IV

Reference: Arenhövel, 1982, cat. no. 380.

Incense burners of this type were cast in great numbers at the royal Prussian foundries in Berlin, Gleiwitz, and Sayn. The present piece cannot be attributed to any one of the three, since they frequently employed the same prototypes and molds, especially for household implements. It is illustrated in the Gleiwitz sales catalogue for 1847 (plate II, fig. 11). B. T.

277

ROYAL PRUSSIAN FOUNDRIES

Pocket Watch Stand

C. 1820/25. Cast iron, height 9¼" (23.4 cm)
Staatliche Museen Preussischer Kulturbesitz,
Kunstgewerbemuseum, Berlin. W-C 24

Reference: Arenhövel, 1979, cat. no. 458.

The circular housing for a watch in the center of this strictly frontal, three-part design is crowned by a lyre and contrasts with the cuboid base. The popular vine leaf ornament is found on both housing and base, where it serves to frame an antique sacrificial scene.

This model was apparently cast in great quantities, including a number of variations (see, for example, Arenhövel, 1982, cat. no. 485). It was illustrated in both the Gleiwitz foundry price list (plate III, fig. 15) and the Sayn sales catalogue (plate IV, fig. 11). B. T.

278

BERLIN FOUNDRY
ALFRED RICHARD SEEBASS (?)

Candle Shade

C. 1830. Cast iron and lithophane, height 9⁷/₁₆"
(24 cm)
Städtische Museen, Freiburg. K 56/11

The pierced frame of stylized foliage is supported by a putto of similar design to those found in many products of the Seebass foundry (see, for example, Arenhövel, 1982, cat. no. 474). The candle shade itself consists of a lithophane, that is, a thin porcelain plate bearing an image impressed, as it were, in negative relief, which is visible only when illuminated from behind. It depicts one of those romantically sentimental scenes that were gaining in popularity at the time: a coy maiden is being presented by another girl to the enthroned god of love. B. T.

279

BERLIN (?)

Ornamental Basket

C. 1830. Woven iron wire, height 2½" (6.4 cm)
Staatliche Museen Preussischer Kulturbesitz,
Kunstgewerbemuseum, Berlin. WC-118

Reference: Arenhövel, 1982, cat. no. 510.

To have made a vase-shaped basket entirely from twisted iron wire is typical of the innovativeness of Biedermeier craftsmen. Intended primarily as decoration, baskets of this kind were used at most to hold jewelry taken off before retiring for the night. (See also nos. 269, 272.) B. T.

280

NETHERLANDS

Flatiron
plate, p. 160

C. 1815. Iron, brass, and copper, 8¹¹/₁₆ x 7¹¹/₁₆ x 4¾"
(22 x 19.5 x 12 cm)
Kölnisches Stadtmuseum, Cologne. KSM 1985/679

In the Biedermeier period even pure utility objects could be the subject of beautiful design, as is witnessed by the bands of shimmering brass and copper used to articulate the smooth walls of this iron.

281

BERLIN

Cachepot
plate, p. 161

C. 1820. Sheet zinc with lacquer painting, height
10³/₈" (26.4 cm)
Berlin Museum, Berlin

The cachepot, its design based on the ancient Greek *krater* with cast fauns' heads as handles, is finished in marbled lacquer and bears a framed depiction of the Potsdam Gate and

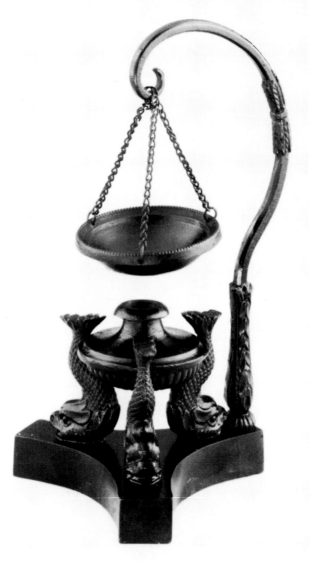

276

guardhouses in Berlin. The piece may well be a product of the Berlin branch of the Stobwasser Lacquer Factory, which was established as early as 1772.

282

SOUTHWEST GERMANY

Wool Basket plate, p. 160

C. 1820. Sheet iron, painted and printed; height 3¾″ (9.5 cm), diameter 5½″ (14 cm)
Städtische Museen, Freiburg. 1638

The simple gondola-shaped design is adorned with a frieze of pierced arches around the base and a printed floral wreath above. The narrow sides are decorated on the inside with printed views of the park of Schloss Schwetzingen in the grand duchy of Baden. (See also nos. 138–40.)

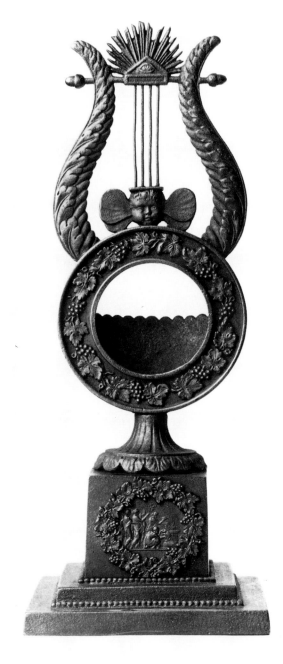

277

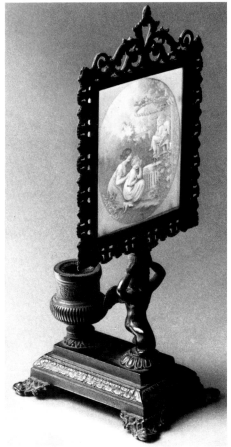

278

279

283

Two Candlesticks plate, p. 161

C. 1820. Zinc with lacquer painting, height 9⁷/₁₆"
(24 cm) (each)
Private collection

A single sweep of opposing curves, running from base to candle socket and interrupted at two points by rings, forms the contour of these simple objects. Their brilliant red lacquer finish is heightened by painted gold decoration.

In addition to an extensive range of lacquerwork boxes, this Brunswick company, established in 1764, also provided furniture and a great variety of household utensils with lacquer finishing.

Paper

284

HEIDELBERG

Album of Maria von Speth plate, p. 162

1813. Binding Morocco leather over cardboard,
5³/₁₆ x 8¹/₄" (13.2 x 21 cm)
Private collection, Munich

This box in the form of a book served to contain loose sheets of paper which could be sent to friends from whom the owner wished to have a memento. This usually took the form of verses accompanied by a more or less sentimental picture.

285

WEIMAR

Page from the Album
of Antonie Brentano plate, p. 162

1815. From octavo volume with gilt-edged pages
and silk endpapers, bound in kid, 6⁷/₁₆ x 4⁵/₁₆"
(16.3 x 11 cm)
Inscribed "Lieblich ist's im Frühlingsgarten / Mancher holden Blume warten; / Aber lieblicher, im Segen, / Seiner Freunde Namen pflegen: / Denn der Anblick solcher Züge / Thut so Seel als Geist genüge. / Ja! Zu Lieb und Treu bekennet / Sich der Freund wie er sich nennet. / den Ihrigen / Goethe."
Freies Deutsches Hochstift and Frankfurter
Goethe-Museum, Frankfurt

Reference: *Jahrbuch des Freien Deutschen Hochstifts* (1986), pp. 355–58.

The first three pages in the volume bound in dark-violet leather are framed with very delicately painted garlands. The first page, illustrated here, bears an entry by Goethe, dated New Year's Day, 1815. Further entries are by members of the Brentano family and friends, including Christian Georg (II) Schütz and Edward von Steinle, who made the final entry in 1843. Goethe had the album made for Antonie Brentano and sent it to her husband on February 12, 1815.

286

MARIA ROTTMANN

Page from an Album plate, p. 163

1816. Watercolor and human hair on paper,
4¹/₈ x 6⁷/₈" (10.5 x 17.5 cm)
Inscribed "Geniesse stets der Tugend Freuden / Mit heiterem Gesicht, / Und trifft dich je ein kleines Leiden, / So sey es kurz, wie dies Gedicht. / Erinnere Dich immer / mit Liebe Deiner / unklücklichen Freundin / Maria Rottmann / Handschuhsheim d. 20ten Januar 1816"
Private collection, Munich

Maria Rottmann signed her poem an "unhappy friend" and accompanied it with an illustration from her own hand. The Urn of Friendship is adorned with a lock of her hair, a common token of friendship at the time (see also no. 270).

287

KARL VON GRAIMBERG
AND THOMAS A. LEGER

Album of Engravings plate, p. 163

1822. Engravings in cardboard box covered in Morocco leather, 3¹⁵/₁₆ x 6³/₁₆" (10 x 15.7 cm)
Inscribed "Dessiné par Ch de Graimberg. Mis en perspective par T. Ad. Leger. Gravé par Lemaitre."
Private collection, Munich.

This little box in the form of a book contains twenty-eight copperplate engravings with views of the castle at Heidelberg and of other places of interest in the vicinity. The scenes are based on drawings made by Karl von Graimberg as mementos for members of Heidelberg University.

Appendix

Chronology

	CURRENT EVENTS	ART AND ARCHITECTURE	LITERATURE AND THE HUMANITIES	MUSIC	SCIENCE AND TECHNOLOGY
1814	Congress of Vienna begins. Constitution drawn up in Nassau (does not come into force until 1818). Compulsory military service introduced in Prussia. Unrestricted navigation on the Rhine to the North Sea. Napoleon exiled to Elba; first Treaty of Paris. Louis XVIII crowned King of France; grants constitution. Pope Pius VIII revives Inquisition and Jesuit Order. End of War of 1812 between Britain and the United States.	Weinbrenner, St. Stephan's Church, Karlsruhe. Dannecker completes *Ariadne*. Eckersberg, *Portrait of Thorvaldsen*.	Chamisso, *Peter Schlemihls wundersame Geschichte*. Goethe, *Dichtung und Wahrheit*, vol. 3. Brothers Grimm complete *Fairy Tales* (begun 1812). Gotthilf Heinrich Schubert, *Symbolism of Dreams*. Görres establishes daily newspaper *Der Rheinische Merkur*.	Beethoven, *Fidelio* and 8th Symphony. Schubert, *Gretchen am Spinnrade*.	Fraunhofer discovers lines of absorption. Freund Steam Engine Company established in Berlin.
1815	Germanic Confederation established; ratifies Act of Confederation. Final treaty of Congress of Vienna signed. Hanover becomes a kingdom. *Burschenschaften* (student fraternities) established in Jena. Treaty of Swiss Confederation, guaranteeing constitution and territory to 22 cantons. Return of Napoleon; Battle of Waterloo; Napoleon exiled to St. Helena. Holy Alliance between Russia, Austria, and Prussia. Willem I crowned King of Holland and Belgium. Helgoland becomes British. Denmark cedes Norway to Sweden.	C. D. Friedrich, *Greifswald Harbor*. Koch, *Landscape with St. Benedict*. Rauch completes sarcophagus for Queen Luise. Thorvaldsen, *Day and Night*. Prussia purchases Giustiniani Collection. G. Schadow becomes director of Berlin Academy.	Eichendorff, *Ahnung und Gegenwart* Uhland, *Poems*. First edition of Schiller's complete works. Kotzebue, *History of the Holy Roman Empire*. Moller, *Monuments of German Architecture* (completed 1851). Savigny, *History of Roman Law*. F. Schlegel, *History of Ancient and Modern Literature*.	Schubert, 2nd and 3rd symphonies, *Erlkönig*.	Technical College established in Vienna. First University Clinic for Surgery established in Erlangen. Swiss Association of Natural Science Research founded in Basel. Tulla begins regulation of Rhine. Voigtländer opens optics factory in Vienna. Mälzel invents the metronome. First Trade Exhibition held in Munich.
1816	Constitutions introduced in Saxe-Weimar-Eisenach, Schwarzburg-Rudolstadt, and Saxe-Coburg-Saalfeld. Diet of the German Confederation convenes in Frankfurt. Wilhelm I crowned King of Württemberg. Fröbel establishes his private country school. Görres emigrates to Switzerland	Klenze begins Glyptothek, Munich (opened 1830). Schinkel begins Neue Wache, Berlin. Dannecker's *Ariadne* erected in Frankfurt. Thorvaldsen, *Hebe*. Overbeck begins frescoes in Villa Massimo, Rome. J. C. Reinhart, *Waterfall*. Johann Friedrich Städel endows Art School and Picture Gallery in Frankfurt.	Goethe, *Italienische Reise*. Brothers Grimm, *Deutsche Sagen*. E. T. A. Hoffmann, *Die Elixiere des Teufels*. Clausewitz, *On War*. Hegel, *Science of Logic*. Bopp publishes his work on the Indo-Germanic languages. Masterworks of Royal Bavarian Collections published as lithographs by Mannlich, Strixner, and Piloty (begun 1811). First issue of *Das Kunst-Blatt* published by Cotta-Verlag, Stuttgart (renamed *Schorn's Kunst-Blatt* in 1820). Schickh establishes periodical *Wiener Zeitschrift für Kunst, Literatur, Theater und Mode*. Therese Huber becomes editor of periodical *Cotta's Morgenblatt für gebildete Stände*.	Beethoven, *An die ferne Geliebte*. Schubert, 4th and 5th symphonies. Spohr, *Faust*; premiere in Prague conducted by Weber. E. T. A. Hoffmann's opera *Undine* performed in Berlin. Rossini, *Il barbiere di Siviglia*.	Brandes publishes first weather chart. The first (British) steamship docks in Cologne. G. Freund builds his first steam engine in Berlin (eight in operation by 1820). Cockerell establishes machine-building and wool-spinning factories in Berlin. Hornbostel installs his improved mechanical looms in Vienna. First German gas company established in Freiberg, Saxony. Trade exhibitions in Düsseldorf and Leipzig. First German Trade Association founded by Zeller in Munich.

1817 *Burschenschaften* hold Wartburg Festival. Montgelas deposed in Bavaria. Union of Lutheran and Reformed Churches in Prussia.	Klenze begins Palais Leuchtenberg, Munich. R. Schadow, *Girl Tying Her Sandal.* Frescoes by Cornelius, Overbeck, Veit and W. von Schadow completed in Casa Bartholdy, Rome. Dillis, *View of Rome.*	Achim von Arnim, *Die Kronenwächter.* Brentano, *Die mehreren Wehmüller* and *Geschichte vom braven Kasperl und dem schönen Annerl.* Grillparzer, *Die Ahnfrau.* E. T. A. Hoffmann, *Nachtstücke.* Uhland, *Ernst, Herzog von Schwaben.* Boeckh, *Political Economy of Athens.* Hegel, *Encyclopedia of the Philosophical Sciences* and *Lectures on Aesthetics.*		Berzelius discovers selenium and lithium. Chladni, *New Contributions to Acoustics.* A. von Humboldt produces isotherm chart. K. Ritter, *Geography in Relation to Nature and the History of Man.* Koenig & Bauer Mechanical Printing Press Company established (in Oberzell Monastery near Würzburg). Senefelder invents press for lithographic reproduction from metal plates.
1818 Constitutions introduced in Baden, Bavaria, and Saxe-Hildburghausen. Aachen Congress of the Holy Alliance. Württemberg abolishes serfdom. Prussian Savings Bank established in Berlin. Bernadotte becomes Charles XIV, King of Sweden.	Schinkel begins Schauspielhaus, Berlin. Thorvaldsen, *Hope* (for Humboldt's grave) and portrait statue *Princess Baryatinskaya.* Tieck, Necker Statue. C. D. Friedrich, *Woman at the Window.* Department of Glass Painting established for Franck at Nymphenburg Porcelain Factory. First German act for the protection of historical monuments passed in Hesse-Darmstadt. Eckersberg appointed director of Copenhagen Academy.	Achim von Arnim, *Der tolle Invalide auf dem Fort Ratonneau.* Brentano, *Aus der Chronika des fahrenden Schülers.* Grillparzer, *Sappho.* Ersch and Gruber begin publication of *General Encyclopedia of the Sciences and the Arts.* Börne produces first issue of periodical *Die Waage.* First issue of F. von Gentz's *Wiener Jahrbücher für Literatur.* Hegel becomes professor in Berlin.	Beethoven, Hammerklavier Sonata. Schubert, 6th Symphony. Loewe, *Erlkönig.* Weber, Jubilee Overture. Mohr and Gruber, *Silent Night, Holy Night.* First performance of Rossini's *Trancredi* in a German-speaking country (Vienna) First Lower Rhine Music Festival.	Mitscherlich discovers isometry of crystals. Senefelder, *Handbook of Lithography.* Baader demonstrates his prototype railroad. Drais receives patent for his bicycle (invented 1813). Stinnes inaugurates coal-hauling line with steam-driven barges on the Rhine. First circular saw goes into operation in Munich. Stearin candles appear on the market.
1819 Karlsbad Decrees. Central Investigation Committee established. Constitutions introduced in Hanover and Württemberg. First elected representative assembly convenes in Munich. W. von Humboldt dismissed from his various political posts. Jahn and Arndt arrested. Kotzebue assassinated. First large German fire insurance company established by Arnoldi.	Nobile, Theseus Temple in the Volksgarten, Vienna. G. Schadow, Blücher Monument, Rostock. Tieck produces models for sculptures for the Schauspielhaus, Berlin. Cornelius begins murals in the Glyptothek, Munich. C. D. Friedrich, *Two Men Contemplating the Moon.*	Achim von Arnim, *Die Majoratsherren.* Eichendorff, *Das Marmorbild.* Goethe, *West-östlicher Divan.* E. T. A. Hoffmann, *Klein Zaches.* J. Grimm begins *German Grammar* (4 vols. by 1834). Schopenhauer, *The World as Will and Idea.* Stein founds Society of Early German History in Frankfurt. Antiquarian Association founded in Halle.	Hummel, Piano Sonata in F Sharp minor. Lanner establishes his trio. Schubert, Trout Quintet and Mass in A Flat.	Schönlein introduces stethoscope in Germany. Harkort establishes the Mechanical Workshops for the manufacture of steam engines and textile machinery in Wetter on the Ruhr. First steamship crossing from the United States to Europe.

	CURRENT EVENTS	ART AND ARCHITECTURE	LITERATURE AND THE HUMANITIES	MUSIC	SCIENCE AND TECHNOLOGY
1820	Final act for constitution of German Confederation signed in Vienna. Constitution introduced in Hesse-Darmstadt. Arndt dismissed from professorship at Bonn University. Revolutions in Spain, Portugal, Naples, and Sardinia.	C. D. Friedrich, *Chalk Cliffs on Rügen*. Waldmüller, *Portrait of Frau Stierle*. Grand Ducal Museum established in Darmstadt. Prussia acquires Solly Collection.	J. von Lassberg, *Liedersaal* (collection of early German poetry). Passavant, *Views on the Fine Arts*. K. Ritter develops geography into a scientific discipline.	Lanner establishes his quintet in Vienna.	Baer discovers the genesis and development of the cotyledon. Wilhelmine Reichardt ascends in hot-air balloon at the *Oktoberfest*, Munich, and at the Prater, Vienna. First ascent of the Zugspitze mountain by Naus.
1821	Metternich becomes Minister of the Interior and Chancellor of Austria. Students found the secret society *Jünglingsbund*. Elbe River declared open for unrestricted navigation. Greek War of Independence from Turkey begins. Austria annuls constitutions in Naples and Piedmont. Napoleon dies.	Klenze completes Palais Leuchtenberg, Munich. Weinbrenner, City Hall, Karlsruhe. Schinkel, Rauch, and Tieck, Kreuzberg Monument, Berlin. Rauch, *Bust of Goethe*. G. Schadow's Luther Monument unveiled in Wittenberg. Thorvaldsen, *Dying Lion* and *Christ* statue. Schinkel begins publication of his collected architectural designs. Trade Association founded in Berlin.	Grillparzer, *Das goldene Vlies*. E. T. A. Hoffmann, *Serapions-Brüder*. Kleist's *Prinz von Homburg* published posthumously. Wilhelm Müller, *Lieder der Griechen* (to 1824) and *Die schöne Müllerin*. Platen, *Ghaselen: Lyrische Blätter*. Hegel, *The Philosophy of Law in Outline*. Schleiermacher, *The Christian Faith*.	Weber, *Der Freischütz*.	First German jacquard loom installed in Wuppertal.
1822	Congress of the Holy Alliance in Verona. Greece declares independence. Friedrich List sentenced to two year's confinement.	Klenze completes Bazaar Building, Munich. Moller commences St. Ludwig's Church, Darmstadt. Schinkel draws up first plans for (Old) Museum, Berlin. Rauch, Scharnhorst Monument. Thorvaldsen begins pediment figures for Church of Our Lady, Copenhagen. Overbeck, *Entry of Christ into Jerusalem*. First Berlin Trade Exhibition. Prussia acquires Minutoli Collection.	E. T. A. Hoffmann completes *Kater Murr*. Immermann, *Poems*. Rückert, *Östliche Rosen*. Humboldt, *On the Comparative Study of Languages*.	Liszt, Diabelli Variations. Mendelssohn, Symphony in D. Schubert, 8th Symphony ("Unfinished Symphony").	First Convention of German Natural Scientists and Physicians. Niepce invents heliography. Prototype of a veneer-cutting machine developed in Vienna. Spiral drill for metal invented.
1823	Instead of the constitution promised in 1815, Prussia merely creates provincial diets. Unrestricted navigation of Weser River declared.	G. Schadow, *Bust of Goethe*. C. D. Friedrich, *Moonrise over the Sea*.	Goethe, *Marienbader Elegie*. Heine, *Tragedies, including a Lyrical Intermezzo*. Rückert, *Liebesfrühling*. A. W. Schlegel founds Indian Library. Raumer begins *History of the Hohenstaufens and their Era* (completed 1825). Cologne City Council calls Rhine Carnival into being.	Beethoven, *Missa Solemnis* (begun 1818) and completion of 9th Symphony. Schubert, *Rosamunde* and *Die Schöne Müllerin*. Spohr, *Jessonda*. Weber, *Euryanthe*.	Gaussian calculus of error. Geitner develops German silver (nickel alloy). Döbereiner invents hydrogen-platinum lighter. Voigtländer develops opera glass. Danube Steamship Corporation established. Mortgage and Exchange Bank founded in Munich.

	CURRENT EVENTS	ART AND ARCHITECTURE	LITERATURE AND THE HUMANITIES	MUSIC	SCIENCE AND TECHNOLOGY
1824	Constitution introduced in Saxe-Meiningen. Charles x crowned King of France.	Nobile completes Outer Castle Gate, Vienna. Salucci begins Rosenstein Palace, Stuttgart. Schinkel, Anatomy Building, Bonn; begins Werder Church, Berlin. Dannecker finishes *Christ* statue (begun 1815). Blechen, *View into the Court-yard of an Abandoned Monas-tery.* Frommel introduces steel engraving in Germany. Wallraf-Richartz-Museum established in Cologne. Munich Art Association founded.	Hebel, *Biblische Geschichten.* Raimund, *Der Diamant des Geisterkönigs.* Ranke, *Critique of Modern Historiography.*	Schubert, Quartets in A minor and D minor (*Death and the Maiden*). Lanner establishes his orchestra.	Liebig appointed professor at University of Giessen. First atomic theory of crystals. Introduction of reverberatory furnace for iron refining. First steamship on Lake Con-stance. First profile-cutting machine introduced in Vienna.
1825	Ludwig i becomes King of Bavaria. Friedrich List emigrates to United States. Nicholas i crowned Czar of Russia; Decembrist Uprising. Mass immigration of Polish and Russian Jews to Germany begins. Hansemann founds savings bank for workers and a fire insurance company in Aachen.	Schinkel's (Old) Museum begun in Berlin. Rauch begins Monument to Maximilian i Joseph in Munich. E. Hummel, *Free Perspective.* Berlin Art Association founded.	Grillparzer, *König Ottokars Glück und Ende.* Platen, *The Theater as a National Institution* and *Sonnets from Venice.* Ranke appointed professor at Berlin University. Association of the German Book Trade founded.	Beethoven, *Grosse Fuge* in B flat. Schubert, 9th Sym-phony. Johann Strauss i estab-lishes his orchestra.	First German Technical Col-lege founded in Karlsruhe. Prussia introduces state ex-amination in medicine. First railroad company estab-lished in Germany. First deep-shaft coalmine goes into operation in Silesia. First European suspension bridge built in Vienna. Gaslights installed on Unter den Linden, Berlin. Horsedrawn omnibus system introduced in Berlin. First ascent of the Hoher Dachstein mountain, Steier-mark, Austria.
1826	Metternich becomes chair-man of Conference of Minis-ters and thus head of Austrian government. Missolunghi falls in Greek War of Independence from Turkey.	Klenze begins Alte Pinako-thek, Odeon, and King's Tract of the Residence in Munich. Schinkel, Charlottenhof and Klein Glienicke palaces, Berlin. Rauch, Blücher Monument, Berlin. G. Schadow creates his last work, *Reposing Girl.* Tieck, Horse Tamers for the (Old) Museum, Berlin. W. Schadow becomes director of Düsseldorf Academy. Senefelder prints first color lithographs. Iron foundry established in Munich.	Eichendorff, *Aus dem Leben eines Taugenichts.* Hauff, *Lichtenstein.* Heine, *Reisebilder* and *Harz-reise.* Raimund, *Der Bauer als Mil-lionär.* Hölderlin's poems edited by Uhland and Schwab. First critical edition of *Nibe-lungenlied* by Lachmann. First volume of *Monumenta Germaniae Historica* pub-lished.	Liszt, *48 Exercises dans tous les tons.* Mendelssohn, *Midsum-mer Night's Dream.* Spohr, *Die letzten Dinge.* Weber, *Oberon.* Philharmonic Society founded in Berlin.	Liebig installs first chemical teaching laboratory in Giessen. Prussian-Rhenish Steamship Corporation established; begins regular operation from Rotterdam to Cologne. Harkort foundry introduces puddling and rolling machin-ery and institutes health and pension schemes. Gas-lighting introduced in Hanover.
1827	Duke Karl ii of Brunswick abolishes constitution. First life insurance company on cooperative basis estab-lished by Arnoldi in Gotha.	Hübsch, Finance Ministry, Karlsruhe. Schinkel, design for a depart-ment store. Rauch, Blücher Monument, Breslau. Kersting, *Before the Mirror.* Boisserée Collection acquired for Munich. Köster, *On the Restoration of Old Oil Paintings.*	Grabbe, *Scherz, Satire, Ironie und tiefere Bedeutung.* Hauff, *Jud Süss* and *Phanta-sien im Bremer Ratskeller.* Heine, *Buch der Lieder.* Jean Paul, *Selina, oder Über die Unsterblichkeit der Seele.* A. W. Schlegel, *On the Theory and History of the Fine Arts.* Schmeller's *Bavarian Dic-tionary* begins publication. Baedeker establishes publish-ing company for travel guides.	Mendelssohn, 1st Sym-phony and *Die Hochzeit des Canacho.* Schubert, *Winterreise.* Cologne Concert Soci-ety established.	Baer discovers mammal egg. Ohm's law. Wöhler discovers aluminum ore. Ressel invents ship's propeller. Munich Technical College founded.

	CURRENT EVENTS	ART AND ARCHITECTURE	LITERATURE AND THE HUMANITIES	MUSIC	SCIENCE AND TECHNOLOGY
1828	Customs agreement signed by Prussia, Bavaria, Württemberg, and Hesse.	Klenze completes the Odeon, Munich. Rauch, Francke Monument, Halle. Schwanthaler creates figures for the Glyptothek, Munich. Stieler, *Portrait of Goethe*. Delacroix, *Faust* illustrations. Hübsch, *In What Style Should We Build?* Dresden Art Association founded.	Grillparzer, *Ein treuer Diener seines Herren*. Raimund, *Der Alpenkönig*. Goethe-Schiller correspondence published. A. W. Schlegel, *Critical Writings*. K. O. Müller, *The Etruscans*. Grimm, *Precepts of Ancient German Law*. Heine coedits *Die Neuen Allgemeinen politischen Annalen* with Lindner.	Marschner, *Der Vampyr*. Schubert, *Schwanengesang* and String Quintet. Philharmonic Society founded in Hamburg. Bösendorfer establishes piano-making firm in Vienna.	Berzelius discovers thorium. Dresden Technical College founded. Gas-lighting introduced in Dresden. Josua Heilmann invents embroidery machine. Gianicelli invents machine for impressing patterns in velvet.
1829		Gärtner begins St. Ludwig's Church, Munich. C. F. Hansen completes Church of Our Lady, Copenhagen. Moller, theater, Mainz. O. S. Runge, *Girl Teaching Her Brother How to Fish*. Blechen exhibits Italian landscapes. Düsseldorf Art Association founded.	Goethe, *Wilhelm Meisters Wanderjahre*; *Faust Part One* premiered in Brunswick. Grabbe, *Don Juan und Faust*. W. Grimm, *Deutsche Heldensagen*. Kerner, *Die Seherin von Prevorst*. F. von Schlegel, *Philosophy of History*. Laube establishes the journal *Aurora*. First volume of *Baedeker's* guides appears. German Archaeological Institute founded in Rome.	Mendelssohn, *Son and Stranger*; conducts Bach's *St. Matthew Passion* in Berlin. Marschner, *Der Templer und die Jüdin*. Rossini, *Guillaume Tell*. Chopin debuts as pianist in Vienna. Lanner becomes Musical Director of Vienna Ballrooms. Silcher founds choral society in Stuttgart.	A. von Humboldt's expedition to Siberia. Stuttgart Technical College founded. Optical telegraph goes into operation between Berlin and Koblenz.
1830	Political unrest in Hesse, Saxony, Brunswick, and Göttingen (Brunswick Palace set on fire, Duke Karl II of Brunswick deposed). Assembly of the German Diet passes measures to restore and maintain law and order in Germany. July Revolution in France and Belgium. Charles X abdicates; Louis Philippe becomes King of France. Polish revolt against Russia. Revolution in Italy. Greece achieves independence.	Klenze begins Valhalla and completes Glyptothek and War Ministry, Munich. Schinkel completes (Old) Museum, Berlin. Bandel begins Arminius Monument. Rauch begins Dürer Monument for Nuremberg. Blechen, *View over Houses and Gardens*. C. D. Friedrich, *Meadows near Greifswald*. Rottmann begins murals in Court Garden Arcades, Munich (completed 1832). G. Schadow, *The Study of the Skeleton and Human Anatomy*. Vienna Art Association founded.	Grabbe, *Napoleon oder die hundert Tage*. Immermann, *Tulifäntchen*. Dahlmann, *Sourcebooks of German History*. Feuerbach, *Thoughts on Death and Immortality*. G. H. von Schubert, *History of the Mind*. Varnhagen, *Biographical Monuments*.	Mendelssohn, Hebrides Overture. Schumann, Abegg Variations. Klara Wiek has first concert successes. Fanny Elssler's dancing career begins in Berlin.	Issue of official weather statistics instituted in Berlin. *Chemisches Zentralblatt* periodical established. Reichenbach discovers paraffin. Pössl constructs first "dialytic" telescope in Vienna. First German coke-fired cupola furnace installed in Saxony. Thonet develops bentwood process for making chairs. Madersperger invents sewing machine. Romer invents phosphorous match. Construction of suspension bridge between Pest and Ofen, Hungary, begins.
1831	Saxony and Hesse-Kassel receive constitutions. Freedom of the press declared in Baden. Last public execution by the sword in Germany (Bremen). Belgium receives independence from Holland; Leopold I crowned King of Belgium.	Ohlmüller begins the Neo-Gothic Maria-Hilf Church in Munich. Bissen, *Flower Girl*. Hummel, *The Granite Basin*.	Chamisso, *Frauen-Liebe und -Leben*. Goethe, authorized collected works; completes *Dichtung und Wahrheit*. Grün, *Spaziergänge eines Wiener Poeten*. Grillparzer, *Des Meeres und der Liebe Wellen*. Heine, *Reisebilder*. Gutzkow establishes the *Forum der Journal Literatur*. Society of German Archaeology founded in Munich.	Mendelssohn, 1st Piano Concerto. Schumann, *Papillons*.	Liebig discovers chloroform. Haniel, Düsseldorf, builds first German steamship. First bandsaw goes into operation in Berlin.

CURRENT EVENTS	ART AND ARCHITECTURE	LITERATURE AND THE HUMANITIES	MUSIC	SCIENCE AND TECHNOLOGY
1832 Hambach Festival. Assembly of the German Diet bans political associations and public demonstrations. Freedom of the press curtailed. Rotteck and Welcker dismissed from Freiburg University.	Gärtner begins State Library, Munich. Schinkel begins Academy of Architecture, Berlin. Rauch begins *Victory* statues for the Valhalla (completed 1842). Amerling, *Portrait of Franz I.* Bendemann, *The Mourning Jews.* Brunswick Art Association founded.	Goethe, *Faust Part Two.* Gutzkow, *Briefe eines Narren an eine Närrin.* Immermann, *Merlin.* Laube, *Das neue Jahrhundert.* Lenau, *Poems.* Möricke, *Maler Nolten.* Pückler-Muskau, *Briefe eines Verstorbenen.* S. Boisserée, *History and Description of Cologne Cathedral* (begun 1823). Niebuhr, *Roman History.*	Lanner conducts the first promenade concerts in Vienna. Mendelssohn begins *St. Paul.* Spohr, 4th Symphony.	Liebig, *Annals of Chemistry.* Schilling-Cannstadt constructs electromagnetic needle telegraph. First gas-lit house and paved streets in Vienna. Bruck establishes Triest Lloyd, the first international steamship company.
1833 German Customs Union established (comes into force on January 1, 1834). Central Investigation Commission, Frankfurt, prosecutes revolutionary activities. Constitution introduced in Hanover. Friedrich List becomes American Consul in Leipzig.	Menzel, illustrations to Goethe's *Künstlers Erdenwallen.*	Eichendorff, *Die Freier.* Heine, *French Conditions: On the History of Literature and Philosophy in Germany.* Nestroy, *Der böse Geist Lumpazivagabundus oder das liederliche Kleeblatt.* Schlegel and Tieck complete translation of Shakespeare's works (begun 1797). Johann Müller, *Handbook of Psychology.* Kugler becomes Professor of Art History at Berlin Academy and University.	Loewe, *Die Siebenschläfer.* Marschner, *Hans Heiling.* Mendelssohn, 4th Symphony. Wagner, *Die Feen.*	Gauss and Weber invent the telegraph. Friedrich List, *A Saxon Railroad System as the Basis for a Comprehensive German Railroad System.* First swimming school for women established in Vienna. First day nursery established in Munich.
1834 Powers of representative assemblies and state diets restricted; censorship increased; universities under surveillance. German Customs Union comes into force. Büchner founds Society for Human Rights in Darmstadt.	Schinkel, design for a palace on the Acropolis and Scharnhorst Tomb. Blechen, *Rolling Mill near Eberswalde.* G. Schadow, *Polyclitus, or a Study of Human Proportions.* Höfel establishes Xylographic Institute in Wiener-Neustadt.	Büchner, *Der Hessische Landbote.* Eichendorff, *Dichter und ihre Gesellen.* Grillparzer, *Der Traum, ein Leben.* Heine, *Der Salon* (to 1840). Laube, *Die Poeten.* Raimund, *Der Verschwender.* Varnhagen publishes posthumous works of his wife, Rahel. Rotteck and Welcker publish first volume of *Dictionary of State.*	Kreutzer, *Das Nachtlager von Granada.* Wagner begins *Das Liebesverbot.* Schumann founds periodical *Zeitschrift für Neue Musik.*	F. F. Runge produces first aniline dyes. Gabelsberger, *Manual of German Speech Symbols, or Stenography.*
1835 Ferdinand I becomes Emperor of Austria. Prussia bans all publications of *Junges Deutschland.* Assembly of German Diet rescinds right of association and limits rights of itinerant journeymen.	Gärtner begins University of Munich. Schinkel completes Academy of Architecture in Berlin and the "Grosse Neugierde" pavilion in Glienicke, Berlin. Thorvaldsen, model for Equestrian Monument to Elector Maximilian I of Bavaria. Lessing, *Hussite Sermon.* Office for the Preservation of Historical Monuments established in Bavaria.	Bettina Brentano, *Goethe's Correspondence with a Child.* Büchner, *Dantons Tod.* Gutzkow, *Wally, die Zweiflerin.* Nestroy, *Zu ebener Erde und erster Stock.* Platen, *Die Abassiden.* Strauss, *The Life of Jesus, a Critical View.* Löwenthal Publishing Company founded in Mannheim (and closed by government order in December). Kingdom of Saxony introduces general elementary schooling.	Silcher, *Ich weiss nicht, was soll es bedeuten* and *Zu Strassburg auf der Schanz.*	Nuremberg-Fürth railroad begins operation. Dreyse invents firing-pin gun. First Industrial Exhibition in Vienna.

The Age of Neo-Classicism. Exhibition catalogue. London, 1972.

Alsop, Susan Mary. *The Congress Dances: Vienna 1814–1815.* New York, 1984.

Althoefer, Heinz. "Der Biedermeiergarten." Diss. Munich, 1956.

Andrée, Rolf. *Katalog der Gemälde des 19. Jahrhunderts im Wallraf-Richartz-Museum.* Cologne, 1964.

Arenhövel, Willmuth. *Berlin und die Antike.* Exhibition catalogue. Berlin, 1979.

Arenhövel, Willmuth. *Eisen statt Gold.* Exhibition catalogue. Krefeld and Berlin, 1982.

Ausstellung deutscher Kunst aus der Zeit von 1775–1875 in der königlichen Nationalgalerie ("Jahrhundertausstellung"). Berlin, 1906.

Baden und Württemberg im Zeitalter Napoleons. Exhibition catalogue. Stuttgart, 1987.

Balet, Leo, and E. Gerhard. *Die Verbürgerlichung der deutschen Kunst, Literatur und Musik im 18. Jahrhundert.* 2nd ed. Dresden, 1979.

Baumgärtner, Sabine. *Edles altes Glas: Die Sammlung Heinrich Heine, Karlsruhe.* Karlsruhe, 1971.

Baumgärtner, Sabine. *Porträtgläser: Das gläserne Bildnis aus drei Jahrhunderten.* Munich, 1981.

Baumstark, Reinhold. *Wiener Biedermeier: Gemälde aus den Sammlungen des regierenden Fürsten von Liechtenstein.* Exhibition catalogue. Vaduz, 1983.

Bayerische Staatsgemäldesammlungen, Neue Pinakothek: Erläuterungen zu den ausgestellten Werken. Munich, 1982.

Berliner Biedermeier. Exhibition catalogue. Potsdam, 1973.

Berliner Biedermeier: Von Blechen bis Menzel. Exhibition catalogue. Bremen, 1967.

Bernhard, Marianne. *Das Biedermeier: Kultur zwischen Wiener Kongress und Märzrevolution.* Düsseldorf, 1983.

Beye, Peter, and Kurt Löcher. *Katalog der Staatsgalerie Stuttgart: Neue Meister.* Stuttgart, 1968.

Biedermeiers Glück und Ende. Exhibition catalogue. Munich, 1987.

Bloch, Peter. "Das Kreuzberg-Denkmal und die patriotische Kunst." *Jahrbuch Stiftung Preussischer Kulturbesitz,* 11 (1973), pp. 142–49.

Boehn, Max von. *Die Mode: Menschen und Moden im 19. Jahrhundert (1790–1878).* 3 vols. Munich, 1907/08.

Boehn, Max von. *Biedermeier: Deutschland von 1815–1847.* Berlin, 1910.

Böhmer, Günter. *Die Welt des Biedermeier.* Munich, 1968.

Börsch-Supan, Helmut. *Deutsche Romantiker: Deutsche Maler zwischen 1800 und 1850.* Gütersloh, 1972.

Börsch-Supan, Helmut. *Abbilder-Leitbilder: Berliner Skulpturen von Schadow bis heute.* Berlin, 1978.

Börsch-Supan, Helmut. *Der Schinkel-Pavillon im Schlosspark zu Charlottenburg.* 3rd ed. Berlin, 1982.

Bramsen, Henrik. *Danske Marinemalere.* Copenhagen, 1962.

Buchsbaum, Maria. *Deutsche Malerei im 19. Jahrhundert: Realismus und Naturalismus.* Vienna and Munich, 1967.

Bürgersinn und Aufbegehren. Exhibition catalogue. Vienna, 1988.

Dänische Malerei. Exhibition catalogue. Kiel, 1968.

Danish Painting: The Golden Age. Exhibition catalogue. London, 1984.

Dansk Kunsthistorie. Vol. 3. Copenhagen, 1972.

Darby, Michael. "The Viennese at Home: Biedermeier Interiors." *Country Life* (Jan. 25, 1979), pp. 204–7.

Darmstadt in der Zeit des Klassizismus und der Romantik. Exhibition catalogue. Darmstadt, 1978.

Das unromantische Biedermeier: Eine Chronik in Zeitdokumenten 1795–1857. Vienna, 1987.

Das wilde Biedermeier. Special issue no. 4 of *Parnass.* 1987.

Der frühe Realismus in Deutschland: 1800–1850. Exhibition catalogue. Nuremberg, 1967.

Der Verlag Artaria: Veduten und Wiener Alltagsszenen. Exhibition catalogue. Vienna, 1981.

Der Wiener Kongress, 1814–15. Exhibition catalogue. Vienna, 1965.

Dettelbacher, Werner. *Biedermeierzeit in Franken.* Würzburg, 1981.

Deutsche Romantiker. Exhibition catalogue. Munich, 1985.

Die Düsseldorfer Malerschule. Exhibition catalogue. Düsseldorf, 1979.

Doderer, Otto. *Biedermeier.* Mannheim, 1958.

Eberlein, H. Donaldson, and Abbot McClure. "The Biedermeier Style: Its Place in Furniture Design and Decoration." *Good Furniture* (July 1916), pp. 29–39.

Endler, Franz. *Wien im Biedermeier.* Vienna, 1978.

Eschenburg, Barbara. "Das Denkmal König Maximilians I. Joseph in München, 1820–1835." Diss. Munich, 1977.

Faÿ-Hallé, Antoinette, and Barbara Mundt. *Europäisches Porzellan vom Klassizismus bis zum Jugendstil.* Stuttgart, 1983.

Feuchtmüller, Rupert, and Wilhelm Mrazek. *Biedermeier in Österreich.* Vienna, Hanover, and Bern, 1963.

Frodl, Gerbert. *Wiener Malerei in der Biedermeierzeit.* Rosenheim, 1987.

Fürstenberger Porzellan aus drei Jahrhunderten. Exhibition catalogue. Hanover, Bremen, and Brunswick, 1956.

Geismeier, Willi. *Biedermeier.* 2nd ed. Leipzig, 1982.

Gerkens, Gerhard, and Ursula Heidenreich. *Katalog der Gemälde des 19. und 20. Jahrhunderts in der Kunsthalle Bremen.* Bremen, 1973.

German Painting of the 19th Century. Exhibition catalogue. New Haven, 1970.

Gläser, Käte. *Das Bildnis im Berliner Biedermeier.* Berlin, 1932.

Goldkuhle, Fritz, Ingeborg Kruger, and Hans M. Schmidt. *Rheinisches Landesmuseum Bonn: Gemälde bis 1900.* Cologne, 1982.

Goldschmidt-Jentner, Rudolf K. "Die Ahnherren des Biedermeier: Was in keiner Literaturgeschichte und in keinem Lexikon steht." *Ruperto-Carola,* 6 (1954), pp. 70–72.

Grimschitz, Bruno. *Ferdinand Georg Waldmüller.* Salzburg, 1957.

Groër, Leon de. *Decorative Arts in Europe 1790–1850.* New York, 1985.

Grosse Welt reist ins Bad. Exhibition catalogue. Grafenegg, 1980.

Heilmann, Christoph, and Christian Lenz. *Staatsgalerie Regensburg: Deutsche Malerei des 19. Jahrhunderts.* Regensburg, 1986.

Heinemeyer, Elfriede. *Glas.* Kataloge des Kunstmuseums Düsseldorf, vol. 1. Düsseldorf, 1966.

Heinz, Dora. *Linzer Teppiche: Zur Geschichte einer österreichischen Teppichfabrik der Biedermeierzeit.* Vienna and Munich, 1955.

Hellich, Erika. *Alt-Wiener Uhren: Die Sammlung Sobek im Geymüller-Schlössel 1750–1900.* Munich, 1978.

Hermann, Georg. *Das Biedermeier im Spiegel seiner Zeit.* Berlin, 1913. 2nd ed., Oldenburg and Hamburg, 1965.

Herzog, Erich. *Kurhessische Maler 1800–1850.* Kassel, 1967.

Hess, David. *Schweizer Biedermeier.* Zurich, 1936.

Himmelheber, Georg. *Biedermeier Furniture.* London, 1974.

Himmelheber, Georg. "Biedermeier." *The Connoisseur,* 201 (1979), pp. 2–11.

Himmelheber, Georg. *Die Kunst des deutschen Möbels.* Vol. 3, *Klassizismus, Historismus, Jugendstil.* Munich, 1983.

Himmelheber, Georg. "Biedermeier Gothic." *Furniture History,* 21 (1985), pp. 121–26.

Himmelheber, Georg. "Der bürgerliche Wohnraum im Biedermeier." *Weltkunst,* 57 (1987), pp. 2106–09; 58 (1988), pp. 3764–67.

Hofmann, Helga D. *Kleinplastik und figürliches Kunsthandwerk aus den Beständen des Münchener Stadtmuseums 1880–1930.* Exhibition catalogue. Munich, 1974.

Houben, Heinrich Hubert. *Der gefesselte Biedermeier: Literatur, Kultur, Zensur in der guten alten Zeit.* Leipzig, 1924. 2nd ed., Hildesheim, 1973.

Hugelshofer, Walter. *Schweizer Kleinmeister.* Zurich, 1943.

Jedding, Hermann. *Meissener Porzellan des 19. und 20. Jahrhunderts.* Munich, 1981.

Kalkschmidt, Eugen. *Biedermeiers Glück und Ende.* Munich, 1957.

Katalog der Österreichischen Galerie des 19. und 20. Jahrhunderts. Vienna, 1954.

Klassizismus und Romantik: Gemälde und Zeichnungen aus der Sammlung Georg Schäfer, Schweinfurt. Exhibition catalogue. Nuremburg, 1966.

Knies, Carl. *Wiener Goldschmiedezeichen aus den Jahren 1781–1850.* Vienna, 1905.

Krafft, Eva Maria, and Carl-Wolfgang Schümann. *Katalog der Meister des 19.Jahrhunderts in der Hamburger Kunsthalle*. Hamburg, 1969.

Krüger, Renate. *Biedermeier: Eine Lebenshaltung zwischen 1815 und 1848*. 2nd ed. Vienna and Leipzig, 1982.

Kunstmuseum Winterthur: Sammlung der Gemälde und Plastiken des Kunstvereins. Winterthur, 1976.

Kunstsammlungen der Veste Coburg: Ausgewählte Werke. 2nd ed. Coburg, 1978.

L'age d'or de la peinture danoise. Exhibition catalogue. Paris, 1984.

Lauts, Jan, and Werner Zimmermann. *Staatliche Kunsthalle Karlsruhe: Katalog Neuere Meister*. Karlsruhe, 1971.

Laxner-Gerlach, Uta. *Von der Heydt-Museum Wuppertal: Katalog der Gemälde des 19.Jahrhunderts*. Wuppertal, 1974.

Leitich, Ann Tizia. *Wiener Biedermeier*. 2nd ed. Bielefeld and Leipzig, 1941.

Leitich, Ann Tizia. *Verklungenes Wien: Vom Biedermeier zur Jahrhundertwende*. Vienna, 1942.

Lux, Josef August. *Von der Empire- zur Biedermeierzeit*. Stuttgart, 1906. 7th ed., 1930.

Marquardt, Brigitte. *Schmuck: Klassizismus und Biedermeier 1780–1850 – Deutschland, Österreich, Schweiz*. Munich, 1983.

Meisterwerke des 19. und 20.Jahrhunderts der Städtischen Galerie. Kassel, 1947.

Mitgau, Hermann. *Das Biedermeier und die Umformung des Bürgertums*. Wolfenbüttel and Hanover, 1947.

Moderne Vergangenheit 1800–1900. Exhibition catalogue. Vienna, 1981.

Morton, Marsha L. "Johann Erdmann Hummel and the Flemish Primitives." *Zeitschrift für Kunstgeschichte*, 52 (1989), pp.46–67.

Mosel, Christel. *Glas: Mittelalter – Biedermeier*. 2nd ed. Hanover, 1979.

Münchner Landschaftsmalerei 1800–1850. Exhibition catalogue. Munich, 1979.

Neuwirth, Waltraud. *Biedermeiertassen*. Munich, 1982.

Nipperdey, Thomas. *Deutsche Geschichte 1800–1866: Bürgerwelt und starker Staat*. Munich, 1983.

Norman, Geraldine. *Biedermeier Painting*. London, 1987.

Nørregård-Nielsen, Hans Edvard. *Dansk Kunst*. Vol. 1. Copenhagen, 1983.

Öffentliche Kunstsammlung Kunstmuseum Basel: Katalog 19. und 20.Jahrhundert. Basel, 1970.

Pazaurek, Gustav E. *Gläser der Empire- und Biedermeierzeit*. 2nd ed., rev. Eugen Philippovich. Brunswick, 1976.

Philp, Peter. "What is Biedermeier Furniture?" *The Antique Dealer and Collector's Guide* (May 1986), pp.42–45.

Pietsch, Ulrich. "Bekannte Ansichten auf Porzellan." *Kunst und Antiquitäten*, no. 1 (1985), pp.64–71.

Poensgen, Georg. *Das Kurpfälzische Museum in Heidelberg*. Heidelberg, 1963.

Ponert, Dietmar Jürgen. *Katalog des Berlin Museums: Kunstgewerbe 1 – Keramik*. Berlin, 1985.

Pressler, Rudolf, and Robin Straub. *Biedermeier-Möbel*. Munich, 1986.

Roehling, Ingrid. "Zerbrechliche Schätze." In *Das wilde Biedermeier*, pp.82–89.

Rückert, Rainer. *Die Glassammlung des Bayerischen Nationalmuseums*. Munich, 1982.

Schadow, Johann Gottfried. *Kunstwerke und Kunstansichten*. Berlin, 1849. New ed., ed. Götz Eckart, Berlin, 1987.

Schenk zu Schweinsberg, Eberhard. *Bildnisgläser der Sammlung Heine in Karlsruhe*. Frankfurt am Main, 1970.

Schestag, August. "Zur Entstehung und Entwicklung des Biedermeierstiles." *Kunst und Kunsthandwerk*, 6 (1903), pp.263–90; 7 (1904), pp. 415–27; 11 (1906), pp.568–73.

Scheyer, Ernst. *Schlesische Malerei der Biedermeierzeit*. Frankfurt am Main, 1965.

Schlesien in der Biedermeierzeit. Exhibition catalogue. Wertheim, 1987.

Schlick, Johann. *Kunsthalle zu Kiel: Katalog der Gemälde*. Kiel, 1973.

Schmidt, Paul Ferdinand. *Biedermeier Malerei*. Munich, 1923.

Schneider, Arthur von. *Badische Malerei des 19. Jahrhunderts*. 2nd ed. Karlsruhe, 1968.

Schöne, Günther, and Hellmuth Voiesen. *Das Bühnenbild im 19.Jahrhundert*. Munich, 1959.

Schreiner, Ludwig. *Die Gemälde des 19. und 20. Jahrhunderts in der niedersächsischen Landesgalerie Hanover*. Munich, 1973.

Schrott, Ludwig. *Biedermeier in München: Dokumente einer schöpferischen Zeit*. Munich, 1963.

Simon, Karl. "Biedermeier in der bildenden Kunst." *Deutsche Vierteljahresschrift*, 13 (1935), pp.60–90.

Spiegl, Walter. "Kothgasser, Mohn und die Wiener Porzellanmanufaktur." *Weltkunst*, 53 (1983), pp.703–14, 871–81, 1241–47.

Spiegl, Walter. *Biedermeier-Gläser*. Munich, 1981.

Spies, Gerd. *Fürstenberger Porzellan: Empire – Gegenwart*. Exhibition catalogue. Brunswick, 1972.

Stedelijk Museum "De Lakenhal" Leiden: Beschrijvende Catalogus. Leiden, 1951.

Stiftung Pommern: Katalog der Gemälde. Kiel, 1982.

The Thorvaldsen Museum. Copenhagen, 1985.

Trenkwald, Hermann. *Ausstellung von Gläsern des Klassizismus, der Empire- und Biedermeierzeit*. Vienna, 1922.

Vaughan, William. *German Romantic Painting*. New Haven, 1980. 2nd ed., 1982.

Verbeek, J. *Nederlands zilver 1780–1830*. London, 1984.

Vetter, Robert. "Herr Biedermeier in Vienna." *Antiques* (Dec. 1985), pp.698–705.

Vienna in the Age of Schubert. Exhibition catalogue. London, 1979.

Vogel, Hans. *Katalog der Staatlichen Gemäldegalerie zu Kassel*. Kassel, 1958.

Voss, Knud. *Guldaldermalerne og deres billeder på Statens Museum for Kunst*. Copenhagen, 1976.

Waetzold, Stephan. *Meisterwerke deutscher Malerei des 19.Jahrhunderts*. New York, 1981.

Waissenberger, Robert. *Schausammlung Historisches Museum*. Vienna, 1984.

Waissenberger, Robert. *Wien 1815–1848: Zeit des Biedermeier*. Vienna, 1986.

Weiglin, Paul. *Berliner Biedermeier*. Bielefeld and Leipzig, 1942.

Wellensiek, Herta. *Hundert alte Tassen*. Munich, n. d.

Wiener Porzellan 1718–1864. Exhibition catalogue. Vienna, 1970.

Wiener Porzellan. Exhibition catalogue. Berlin-Köpenick, 1982.

Wilkie, Angus. *Biedermeier*. New York, 1987.

Wirth, Irmgard. *Berliner Biedermeier*, Berlin, 1972.

Wittelsbach und Bayern. Vol. 3/2, *Krone und Verfassung*. Exhibition catalogue. Munich, 1980.

Wolff Metternich, Beatrix Freifrau von. *Fürstenberg Porzellan*. Brunswick, 1976.

Ziersch, Amélie. *Bilderbuch – Begleiter der Kindheit*. Exhibition catalogue. Munich, 1986.

Index of Names

Numerals in italics
refer to pages
with illustrations

Photograph Credits

Table.
Schleswig-Holstein,
c. 1825. No. 106